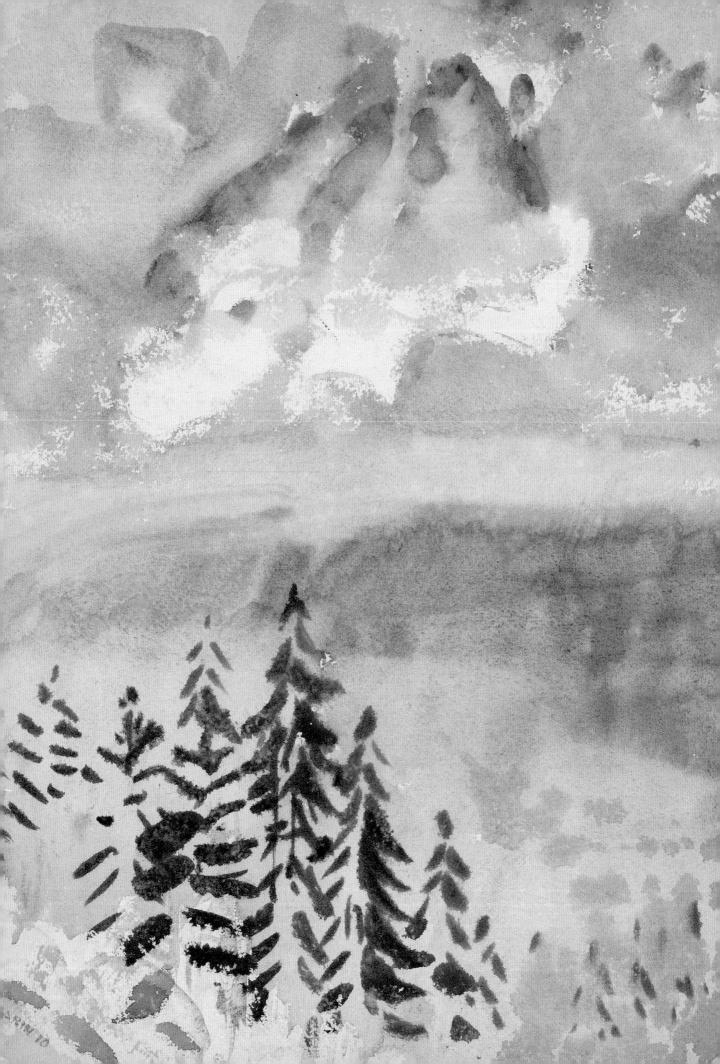

FACTURE

Conservation
Science
Art History

Volume 2
Art in Context

Volume editors
Daphne Barbour
E. Melanie Gifford

National Gallery of Art, Washington
Distributed by Yale University Press, New Haven and London

**Produced by the Publishing Office,
National Gallery of Art, Washington**

Judy Metro, *editor in chief*
Chris Vogel, *deputy publisher*
Wendy Schleicher, *design manager*

Designed by Brad Ireland
Edited by Ann Hofstra Grogg

John Long, *assistant production manager*
Mariah Shay, *production assistant*

Typeset in Arno Pro

Separations by Prographics, Rockford,
Illinois

Printed and bound in Hong Kong by
Toppan

10 9 8 7 6 5 4 3 2 1

**Distributed by Yale University Press,
New Haven and London**

www.yalebooks.com/art

**Library of Congress
Cataloging-in-Publication Data**

LCCN 2013200694
ISBN 978-0-300-21708-7
ISSN 2327-2023

Display Illustrations (details)

p. ii: John Marin, *Tyrol Series* (p. 91, fig. 8)

p. v: Andy Warhol, *129 Die in Jet* (p. 164,
fig. 4)

pp. vi–vii: Auguste Rodin, *La France*
(p. 59, fig. 4)

p. viii: Bernardino Luini, *Portrait of
a Lady* (p. 141, fig. 1)

pp. xiii, 3: Giotto, *Madonna and Child*
(p. 4, fig. 1)

p. 19: Andrea Briosco, known as Riccio,
The Entombment (p. 20, fig. 1)

p. 55: Auguste Rodin, *The Thinker
(Le Penseur)* (p. 69, fig. 16)

p. 83: John Marin, *West Point, Maine*
(p. 96, fig. 15)

p. 111: Mark Rothko, *No. 22* (p. 120, fig. 7)

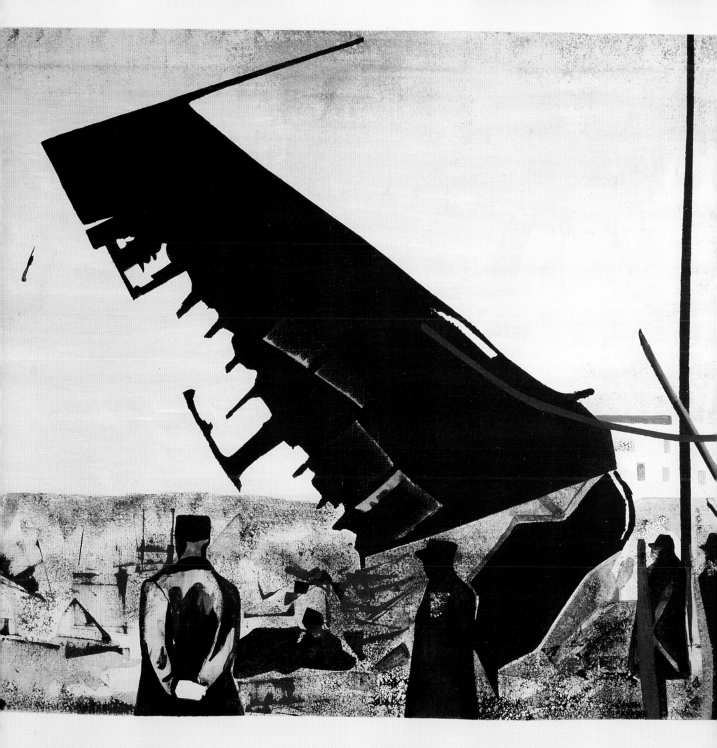

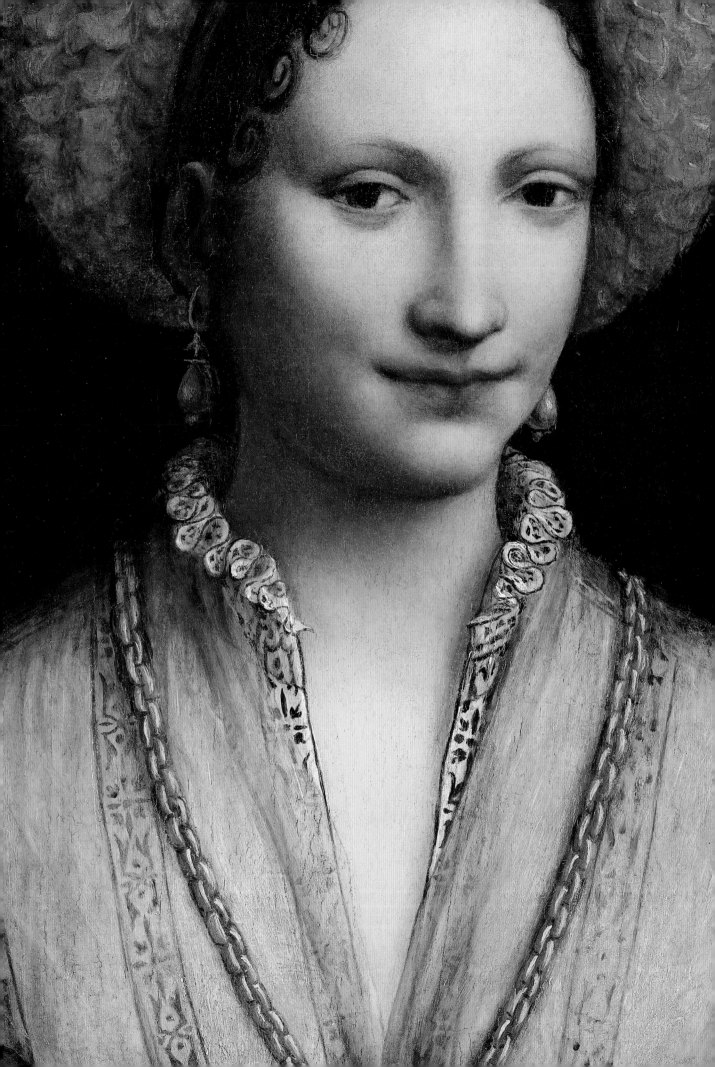

Facture, volume 2, presents great works of art in new contexts. Examining the art of two very different eras — the Italian Renaissance and the twentieth century — the essays in this volume share a common approach. They start with meticulous material and analytical study of works of art, then place the findings in a broader historical context, providing new perspectives on well-known works.

Technical study of Giotto's *Madonna and Child*, in the collection of the National Gallery of Art, situates this work in the context of the artist's surviving oeuvre. The painting shares intriguing technical similarities with three other panels by Giotto, new evidence that these works originally formed a much larger altarpiece. Giotto's use of previously unrecognized art materials may offer further evidence linking the paintings. Another essay considers an autograph bronze relief by Riccio, *The Entombment*. In this first technical overview of Riccio's reliefs, the essay considers the National Gallery relief in the context of thirty-two documented and three undocumented reliefs by the artist. The conclusions, which challenge previous proposals on the origins and dating of *The Entombment,* revise understanding of its place in Riccio's oeuvre.

Essays on works from the twentieth century include a study of Auguste Rodin's bronze sculptures that, by focusing on the National Gallery's Simpson Collection, examines works cast during the artist's lifetime, under his supervision. Combining archival research and technical analysis of seven bronzes, this article explores Rodin's close creative exchange with his primary bronze founder and patinator, illuminating his personal aesthetic. Another essay presents John Marin's choice of watercolor pigments in the context of contemporary color theory. As the authors draw on a wealth of contemporary documentation and extensive technical study, they demonstrate that early in his career Marin employed a severely restricted palette of just three primary colors, recommended by writers influenced by an already old-fashioned color theory. They show that later, Marin's exposure to new ideas in Paris and in the New York circle of Alfred Steiglitz encouraged a dramatic expansion of his range of pigments. Mark Rothko's pivotal early works known as multiforms are the subject of another essay. Detailed analysis of the multiforms in comparison with Rothko's later works reveals not only the birth of Rothko's abstraction but also creative experimentation with the paint medium that presages the enigmatic paint surfaces of his mature work.

Two shorter "In Focus" contributions arose from unique opportunities for technical study. An exhibition of Andy Warhol's paintings, *Warhol: Headlines*, allowed researchers to study select paintings from the exhibition and compare them with a work in the National Gallery's collection.

The authors evaluate Warhol's early choices of paint medium, revealing previously unrecognized experimentation at the moment of his transition between two artistic contexts: his early work as a commercial artist and the pop art for which he is known today. A second contribution stems from research carried out in conjunction with a major conservation treatment of Bernardino Luini's *Portrait of a Lady*. Costume history revealed the restrained opulence of the lady's garments, technical analysis illuminated the painter's refined technique as he made delicate variations of tones of black, and conservation treatment uncovered Luini's subtle modulations of black on black.

With the publication of the second volume of *Facture*, the National Gallery of Art continues the dialogue among art historians, scientists, and conservators. We are privileged to sustain the conversation.

Mervin Richard
Chief of Conservation

ACKNOWLEDGMENTS

The publication of volume 2 of *Facture* relied on the collaboration and goodwill of numerous colleagues. We are extremely grateful to all.

Special thanks go to Mervin Richard, chief of conservation at the National Gallery of Art, for the unstinting support that ensures *Facture*'s continued success. We are also grateful to our conservation colleagues for their generous contributions: Barbara H. Berrie, Michelle Facini, Jay Krueger, Douglas Lachance, Suzanne Lomax, Katy May, Michael Palmer, Dylan Smith, Shelley Sturman, and Kimberly Schenck. Administrative responsibilities were adeptly accomplished by Michael Skalka, Michelle LeBleu, and Nicola Wood. Harry Cooper, David Essex, Ruth Fine (retired), Alison Luchs, and Debra Pincus provided vital curatorial insight. We are also indebted to Lali Nasr from the publishing office and to Lorene Emerson, Lee Ewing, Ken Fleisher, Alan Newman, and Barbara Wood from the division of visual services for creating, locating, and procuring specialized images and permissions.

Many generous colleagues both in the United States and in Europe reviewed essays and contributed their expertise to the volume. In the United States they include Christine Daulton and Neil Printz of the Andy Warhol Foundation, New York; Matt Wrbica, the Andy Warhol Museum, Pittsburgh; Judy Walsh, Buffalo State College; Joseph Godla and Julia Day of the Frick Collection, New York; Francesca Bewer, Harvard University Art Museums; Mark Sandona, Hood College, Frederick, Maryland; Steve Roy, private practice, Hopewell Junction, New York; Arlene Balkansky, Library of Congress, Washington, D.C.; Denise Allen, Jim Draper, Larry Becker, Linda Borsch, and Richard Stone (retired) of the Metropolitan Museum of Art, New York; Annette Manick, Museum of Fine Arts, Boston; William Brown, North Carolina Museum of Art, Raleigh; Simona Cristanetti, Oriental Institute of Chicago; Andrew Lins, Philadelphia Museum of Art; Renee Maurer, the Phillips Collection, Washington, D.C.; Andrew Baxter, private practice, Richmond, Virginia; Barry Daly, University of Maryland; Jessica Stewart, independent scholar, Washington, D.C.; Jacqueline Marie Musacchio, Wellesley College, Wellesley, Massachusetts; Carol Mancusi-Ungaro, Whitney Museum of American Art, New York; and Jens Stenger, Yale University, New Haven.

We are also grateful to many international colleagues: Tonny Beentjes, University of Amsterdam; Elisabeth Ravaud, Centre de recherche et de restauration des musées de France, Paris; Karen Serres, Courtauld Institute of Art; Paola Ricciardi, Fitzwilliam Museum, Cambridge; Mary Westerman Bulgarella and Roberta Orsi Landini, independent scholars, Florence; Claudia Cremonini, Adriana Augusti, and Serena Bidorini, Galleria Giorgio Franchetti alla Ca' d'Oro; Susanna Bracci, Istituto per la Conservazione e la

Valorizzazione dei Beni Culturali, Florence; Stephan Diederich and Kathrin Kessler of the Museum Ludwig, Cologne; Philippe Malgouyres, Marc Bascou, and Dominique Thiébaut of the Musée du Louvre, Paris; Catherine Chevillot, François Blanchetière, Véronique Mattiussi, Hélène Pinet, and Sandra Boujot of the Musée Rodin, Paris; Mario Kramer and Ulrich Lang of the Museum für Moderne Kunst, Frankfurt; Larry Keith, National Gallery, London; Flemming Friborg, Line Clausen Pedersen, and Rebecca Hast of the Ny Carlsberg Glyptotek, Copenhagen; Cecilia Frosinini, Opificio delle Pietre Dure, Florence; Veneranda Arca del Santo and the friars of the Basilica di San Antonio, Padua; Cinzia Pasquale, private practice, Paris; Peta Motture, Victoria and Albert Museum, London; and Julian Gardner, University of Warwick.

The biennial publication of an institutional journal demands the commitment of many additional National Gallery colleagues: to all our heartfelt appreciation. Members of the editorial board devoted themselves to ensuring the success of this volume. An enormous debt of gratitude is owed to Mira Patel, conservation editorial assistant, who patiently coordinated the initial phases of the volume. In the National Gallery's publishing office, Judy Metro and freelance editor Ann Hofstra Grogg ensured expert editing, Chris Vogel and Wendy Schleicher provided valuable insight to Brad Ireland's beautiful design, and John Long gave expert production support.

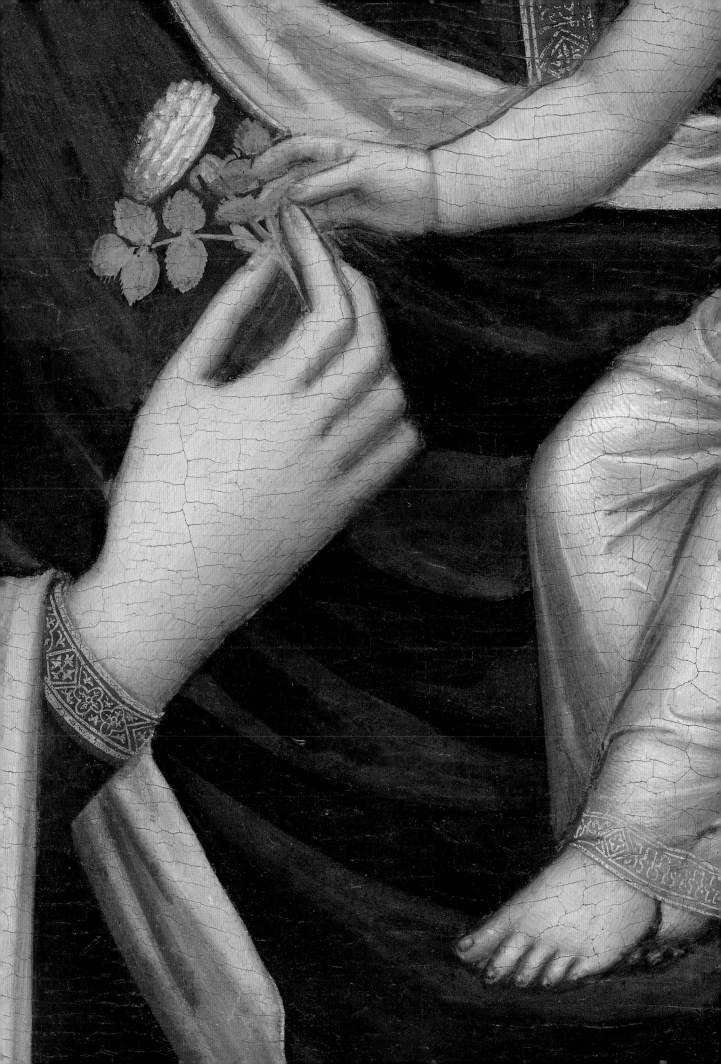

ESSAYS

The Creation of Giotto's *Madonna and Child*: New Insights

Joanna R. Dunn, Barbara H. Berrie, John K. Delaney,
and Lisha Deming Glinsman

The great Florentine artist and architect, Giotto di Bondone (probably 1266 – 1337) had an important influence on Italian art in the late thirteenth century. He is renowned for bringing to painting a novel, naturalistic aesthetic that contrasted with the more hieratic, stylized painting of his predecessors. Many decorative fresco cycles are attributed to Giotto and his workshop, as well as a number of large crucifixes and panels from altarpieces. There remain many uncertainties regarding attribution and dating, however, as well as some dispute over the extent of workshop practice in works given to Giotto. Recent technical investigations shed light on these discussions, especially by providing information on Giotto's painting practice and materials that should help determine authorship and relationships among his works.

Madonna and Child in the National Gallery of Art is a well-preserved panel with an important though not precisely known place in Giotto's oeuvre (fig. 1).[1] Findings from a recent technical study augment understanding of the way this panel was painted and may, by comparison with other works by Giotto and his contemporaries, help to date this panel and fix its place in the context of Giotto's works. The painting was examined using stereomicroscopy and a variety of imaging and analytical instrumental methods. The panel structure was imaged by computerized tomography (CT). Preparatory underpainting was imaged by false-color hyperspectral infrared reflectography. Using x-ray fluorescence (XRF) analysis, we were able to identify the elements present in certain colors that allow the inference of particular materials without taking samples.[2] In addition, a few cross section samples were obtained for examination by optical microscopy (OM) and scanning electron microscopy with energy dispersive x-ray analysis (SEM-EDX). Fiber-optic reflectance spectroscopy (FORS) provided molecular information, allowing identification of various organic and inorganic materials.[3]

The painting, known as the Goldman Madonna after its first American owner, Henry Goldman, is dated to circa 1310/1315. Giotto's ability to express sensitive and emotive qualities is demonstrated here by the charming depiction of the Christ Child reaching with one hand for a rose held by the Holy Mother and grasping her finger with the other while she gazes outward pensively (see fig. 1). This is one of the earliest depictions of the rose in a

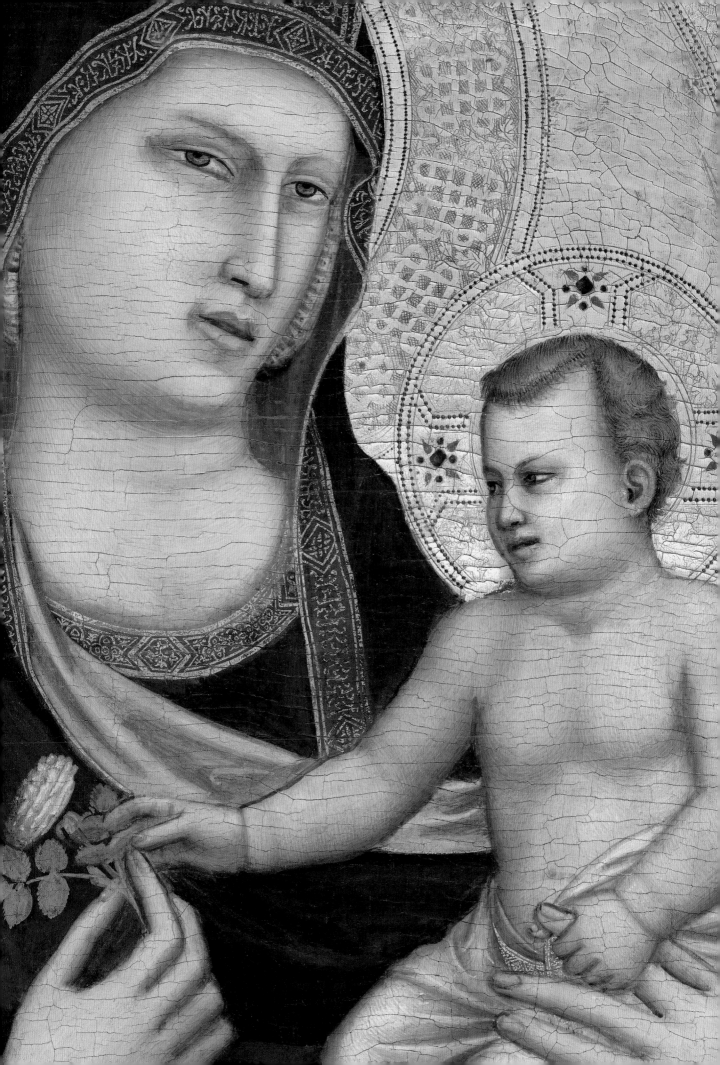

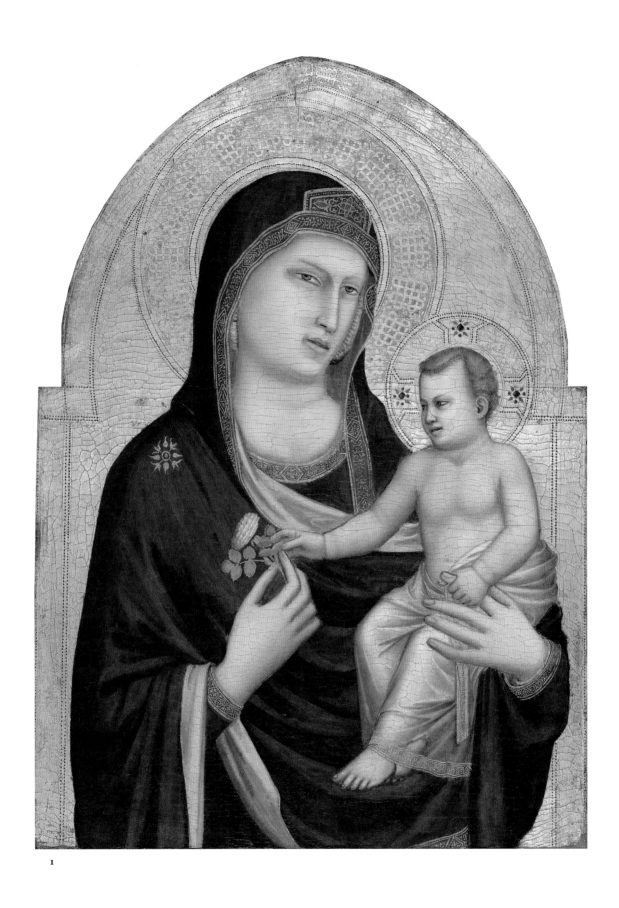

1

painting of the Madonna.[4] In Trecento Florence, the image of the Holy Mother with the Christ Child was often the center panel of a triptych or of a five-paneled polyptych. Panels proposed as part of the altarpiece with the Goldman Madonna are *Saint Lawrence* and *Saint John the Evangelist* in the Musée Jacquemart-André, Abbaye Royale de Chaalis, and *Saint Stephen* in the Museo Horne, Florence. A fifth panel has not been identified. A possible reconstruction of such a polyptych is shown in figure 2.[5]

Figure 1
Giotto, *Madonna and Child*, c. 1310/1315, tempera on panel, 85.4 × 61.8 cm, National Gallery of Art, Washington, Samuel H. Kress Collection.

Figure 2
Reconstruction of a proposed polyptych by Giotto, prepared by Elisabeth Ravaud. In addition to the National Gallery's *Madonna and Child* in the center, the panels show (left to right): *Saint John the Evangelist*, *Saint Stephen*, and *Saint Lawrence*. From Dominique Thiébaut, ed., *Giotto e compagni* (Musée du Louvre, Paris, 2013), 145.

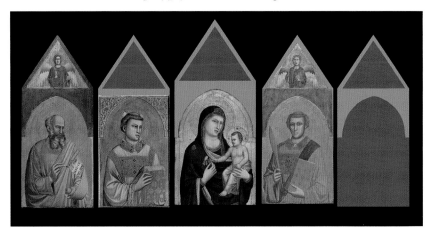

2

Construction and Preparation of the Panel

Evidence that the Goldman Madonna was part of a triptych or polyptych is found from examination of the wooden panel, which was constructed from a single plank of poplar[6] with vertical grain. It was thinned, the edges were trimmed, and a heavy cradle with closely spaced members was adhered to the back. The cradle obstructs the view of the back of the panel and interferes with x-radiography. The CT scan undertaken to learn more about the original support showed three holes located approximately 6 centimeters above the bottom edge of the panel and another located in the center of the arch, approximately 4.5 centimeters from the top of the panel. It is likely that these holes were from the nails that originally attached battens that crossed and united the panels in a polyptych.[7] A batten would not have been placed at the very top of the arch unless the panel was taller, which we assume it was. If the panel had originally been the size it is today, the batten would have been located at the spring of the arch, but the x-radiographs, CT scans, and visual examination do not reveal any evidence of a batten in that area.

Although the painted and gilded design was always arched, it is likely that the rectangular panel for the Goldman Madonna was taller, terminating in a gable containing an additional painted decoration, similar to those extant on *Saint John the Evangelist* and *Saint Lawrence* panels at the Musée Jacquemart-André (see fig. 2). As in these two panels, in the Goldman Madonna the area outside the arch would not have been gilded. The framing elements of the altarpiece would have been nailed and glued to these areas.[8]

The preparation of the wooden support was typical for those from Giotto's workshop. The weave pattern of a layer of fabric on the wood was very faintly visible in areas throughout an archival x-radiograph obtained before the panel had its present cradle.[9] Its presence was confirmed by microscopic examination of crevices along the edges where threads could be seen; we

therefore concluded that fabric covered the entire panel.[10] The preparatory layer is thick gesso;[11] there is no visual evidence in the cross sections of a layer of *gesso sottile*, only *gesso grosso* (fig. 3).[12]

The Gilding

The background of the Goldman Madonna is gilded, as would be expected. But, while the gilding appears to be quite traditional, there are some aspects that distinguish it. XRF and SEM-EDX show that the leaf is very pure gold, without traces of silver, as has been found in some other panels.[13] The sheets of gold leaf foil of the gilded background were laid down on an unusual preparation comprised of two layers of bole, the lower one green and the upper one red. These are visible in a cross section from the gilded background (see fig. 3).[14] Both layers are very thin: the green bole is about 4 – 5 micrometers thick and may taper even thinner at the edges of the panel; the red bole is about 5 – 6 micrometers thick. EDX analysis shows that the bole layers are pure earths. The elemental composition of the lower layer, an aluminosilicate containing potassium, iron, and magnesium, is consistent with a green earth[15] while the composition of the upper layer is quite like traditional red, so-called Armenian bole.[16]

Cennino Cennini (c. 1370 – c. 1440), a Florentine artist whose *Il Libro dell'Arte* codified painting practice of his time, explained that gilding can be done on green earth bole.[17] Its use, as well as gilding directly on the gesso, using glue or egg white, has been found in Dugento and Trecento panels.[18] Giotto used a green earth bole alone in several works, including the Peruzzi altarpiece[19] and *The Pentecost* in the National Gallery, London, and other panels associated with it.[20] A thin layer of green earth is present under red bole in the *Saint Lawrence*, *Saint John the Evangelist*, and *Saint Stephen* panels[21] associated with the Goldman Madonna on stylistic grounds. So far as we know, the use of red and green boles together is unusual,[22] but until we better understand how frequently the combination occurs, this use remains circumstantial evidence for definitively associating the panels.

The gilded background of the panel is bordered on the vertical edges by a freehand pseudo-Kufic design (see fig. 1) like those found in many of Giotto's works, including *Saint Stephen*, *Saint Lawrence*, and *Saint John the Evangelist*. Giotto used a similar, but more graphic, pseudo-Kufic design for the mordant-gilded borders on the Madonna's garments. Inner and outer lines of the halos of the Holy Mother and the Christ Child appear to have been inscribed using a compass, although no compass point holes were found. A double row of punched dots follows a pair of lines at the inner and outer periphery of the Madonna's halo. Between these compass lines and punches is a design incised freehand. It is a series of endless knots; the first two on the left are composed of intricate, interlaced chords, while the rest of the knots are a simplified basket-weave pattern without interlaced cords and were executed with less assured draftsmanship. The change in the design is curious and suggests a disruption in the decoration of the gilded halo, perhaps indicating so much as a different hand at work. In what appears to be a sophistication, lines were inscribed into the gold leaf in the space behind the Madonna's head and the interior border of her halo. By disrupting the reflectivity of the surface, they subtly produce a sense of space.

Figure 3
Paint cross section from the gilded background (paint layers are numbered beginning with the lowest layer): (1) white gesso preparatory layer; (2) green bole; (3) red bole; (4) gold leaf.

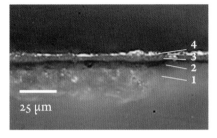

3

Painting the Flesh

Cennini provided detailed descriptions of how to paint flesh colors, which he claimed were the methods Giotto used.[23] They included the use of underpainting with washes and a *verdaccio* for shading. They were followed, in a general manner, by many painters, including sometimes, but not always, Giotto. Although variations in practice from those described by Cennini are well documented,[24] there is not yet complete knowledge of the variations used by Giotto, and careful examination to document how he worked will support understanding of the development and range of his painting practices.

In the Goldman Madonna, the Holy Mother's face and hands and the Christ Child's body were completely underpainted by laying in a green earth – containing wash using relatively broad, long, fluid strokes. The way the wash was laid in is in accord with Cennini's description of how to start painting flesh tones: "Take a little terre-verte in another dish, well thinned out: and with a bristle brush, half squeezed out between the thumb and forefinger of your left hand, start shading under the chin, and mostly on the side where the face is to be darkest; and go on by shaping up the under side of the mouth."[25] A false-color hyperspectral infrared reflectogram (fig. 4) reveals the washes of green earth as broad pink strokes.[26] Another wash, which contained carbon and so appears dark gray in the false-color hyperspectral infrared reflectogram, was applied using a similarly sized brush to locate shadows in the figures in order to suggest form. This laying out of

Figure 4
False-color infrared reflectogram (RGB channels assigned to three wavelength bands: blue centered at 1000 nm, green at 1200 nm, red at 1600 nm). The wash that contains green earth appears pink in this rendition. It was applied in long, even, broad strokes, and is present under all the flesh tones.

4

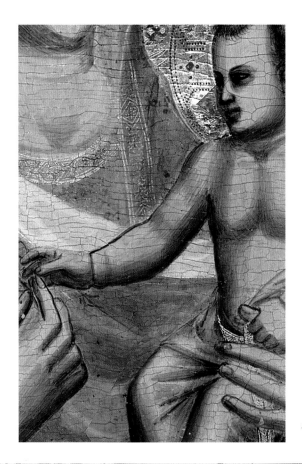

5

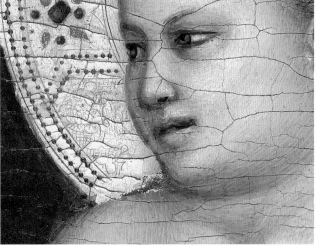

6

Figure 5
Detail of false-color infrared reflectogram
(fig. 4). The wash that contains carbon
appears dark gray in this rendition. It was
used to lay out the shaded parts of the fig-
ure and create form. Long, broad strokes
can be seen defining, for example, the
Christ Child's eye socket, torso, and limbs,
and the Madonna's fingers.

Figure 6
Detail (fig. 1), showing strokes of *verdaccio*
visible in the shadowed areas.

the positions of shaded areas in a highly graphical manner can be seen, for
example, in the shadowed edges of the Madonna's fingers, in the underside
of the Christ Child's forearm and the modeling of the torso, and in the
heads, where the broad strokes were used to form the shadows around the
eyes and the unlit sides of the faces (fig. 5). Its use and appearance are con-
sistent with the diluted ink wash described by Cennini for placing shadows
on figures.[27] These two washes were followed by more discrete, finer, short
strokes laid down to build form by adding a deep tone to shadowed parts.[28]
These strokes are dark gray in the false-color infrared reflectogram because
they were painted using *verdaccio*, a mixture that contains a carbon-based
black pigment in addition to earths and lead white. Giotto used *verdaccio*

to define the features and create volume in the faces and the Christ Child's torso using fine, parallel hatch marks (fig. 6). A cross section obtained next to a small loss in the Christ Child's forearm shows the layering for painting flesh (fig. 7).[29] The green wash — a mere 3–4 micrometers thick — lies directly on the gesso ground. Unlike the green earth bole used under the gilding, this wash has white pigments mixed with it. The backscatter electron image coupled with elemental maps indicated that both lead white and bone white (inferred from the presence of calcium and phosphorus in the same place) were mixed with the green earth. So far as we know, bone white has not been identified in the wash used in other panels by Giotto. The same cross section (see fig. 7) shows that the *verdaccio* paint layer, used here to create the rounded form of the underside of the Christ Child's forearm, contains red and yellow iron earths, lead white, and black.[30] The pink-hued flesh was painted in egg tempera using a mixture of lead white, vermilion, and red lake, which are visible on the surface using OM.

Figure 7
Paint cross section from the lower part of the Christ Child's forearm (paint layers are numbered beginning with the lowest layer): (1) gesso preparatory layer; (2) green wash (c. 4 µm thick): green earth, lead white, and bone white; (3) *verdaccio*: red and yellow iron earths, lead white, and a black pigment; (4) flesh-toned paint: lead white, vermilion, and a red lake. (This image has been modified using Image J 64 and the stack focusing plug-in.)

Figure 8
Photomacrograph, showing strokes of *verdaccio* that were left uncovered to create shadows around and in the Madonna's eye socket.

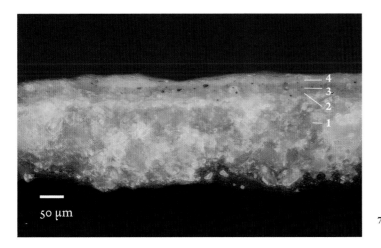

50 µm

7

Giotto used a combination of narrow, parallel strokes and broader strokes for the flesh-colored paint that he blended over the *verdaccio* and the washes, sometimes applying it thinly, allowing it to remain translucent so the *verdaccio* would show through, and at other times applying it more thickly, obscuring the green layers. The application of thin, narrow strokes of paint is characteristic of the egg tempera paint medium. FORS in the near-infrared found evidence characteristic of egg yolk tempera.[31] In the deepest shadows in the flesh, Giotto did not apply the pink paint but left the *verdaccio* uncovered to create the shadows and thus give form to limbs and facial features. This technique can be seen clearly around the Madonna's eyes, where the pink paint was brought up to the orbital socket (fig. 8). In the Christ Child's body, strokes of a lively yellow-colored paint appear in folds and junctions, giving the impression of lightness.[32]

A thin green wash used to block in the areas where flesh tones were to be painted has been found in other works by Giotto. For example, the *verdaccio* flesh tones in *Saint John the Evangelist* were underpainted with a green wash.[33] The green wash found in *Madonna and Child* is similar in color but understandably not as thick as that found in the Santa Maria Novella crucifix, Basilica of Santa Maria Novella, Florence, because there it is being used to depict the livid color of Christ's dead body.[34] Giotto used the technique

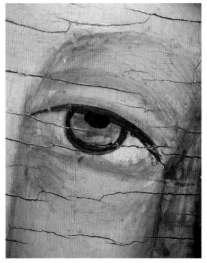

8

of allowing the green underpaint to create the shadows in a very similar way to depict faces in the *Saint Lawrence* and *Saint John the Evangelist* panels[35] as well as in the *Saint Francis* and *Saint John the Baptist* panels from the Peruzzi altarpiece. In contrast, in *The Virgin* and the *Saint John the Evangelist* and *Christ* panels from the Peruzzi altarpiece, the gray shadows were created by applying scumbles of paint over the undermodeling.[36] In *The Pentecost*, a small panel from a predella or *dossal*,[37] there is no green underpaint, just possibly some rudimentary sketching in brown; the darker tones and shadows were formed using brown or black paints applied over a pink layer.[38] However, any comparison between the pale skin of the Madonna and the Christ Child with that of the swarthy complexion of aged saints or the livid flesh of the dead Christ is inappropriate, because different effects were intended.

The Pigments

Several studies in the past have identified the pigments Giotto used, and although we will not go into great depth here on the entire palette, we have selected some findings that are novel and interesting and of value for comparison with previous results in order to study the oeuvre of Giotto and increase knowledge of the relationships of works within it.

The Madonna's blue robe and mantle were painted using azurite. A close visual examination using a stereomicroscope showed the particle size ranges widely to provide some color variation. It also showed that there are few red particles of red lake added to the blue,[39] which would barely add warmth to the greenish cast of azurite's blue hue. EDX analysis of the azurite indicates it is extraordinarily pure compared with many samples of azurite from paintings examined at the National Gallery of Art. The analysis of a cross section shows that, in addition to the particles of azurite, there are also a few smaller greenish particles (fig. 9). One or two of these might be malachite, but the EDX spectrum of a deep turquoise blue particle that appears to be a hexagonal prism (see fig. 9c) shows it is a ternary copper-bismuth-arsenic oxide; the composition suggests it could be mixite. This is a rare mineral, and its origins are still only vaguely known. Generally, this type of mineral forms from oxidation of copper-arsenic ores.[40] There is little information on the trade in artists' materials in Giotto's time,[41] and it is unclear whether the ternary oxide mineral was an impurity in the azurite blue or purchased as a separate pigment. Finding this mineral in the Goldman Madonna may help identify one source of azurite for Trecento Florentine artists. If found in other panels, its presence may also help to relate them to the Goldman Madonna and to other works in Giotto's oeuvre. The presence of bismuth suggests a Tyrolean or Germanic origin.

Giotto did not use ultramarine in the Goldman Madonna, although he employed this pigment in many other works and it was widely used also by other Florentine artists.[42] While the absence of this most expensive pigment might suggest that there was some economic restraint on the commission or perhaps some difficulty in obtaining the pigment, the presence of mixite in the azurite indicates that the greenish-blue color of the robe in this panel was a conscious choice. The depth of hue and variation of tones throughout the blues and greens were accomplished using mixtures of azurite, yellows, and this rare green-blue mineral. In several other works in tempera and

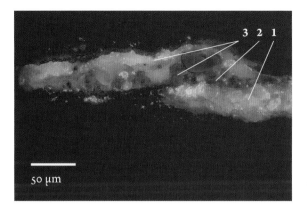

50 μm

9a

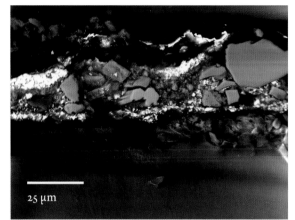

25 μm

9b

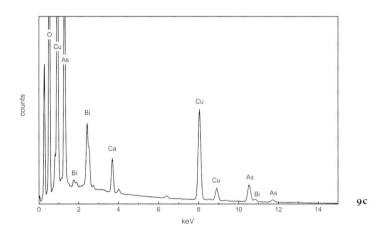

9c

Figure 9
Paint cross section from the Madonna's blue mantle with yellow and green highlights.

(a) Visible light (paint layers are numbered beginning with the lowest layer): (1) gesso preparatory layer; (2) a thin dark layer; (3) intermixed yellow and blue layers: azurite (large, deep blue particles), lead-tin yellow, lead white, and a black or deep blue pigment. These layers also include additions of binary or ternary copper oxides: most contain copper and arsenic, and some also contain bismuth or silicon. (This image has been modified using Image J 64 and the stack focusing plug-in.)

(b) Backscatter electron image of part of figure 9. The large dark gray particle is azurite, and the bright white particles are lead-tin yellow and lead white. Mid-toned hexagonal particles of mixite are in the center.

(c) EDX spectrum of a single turquoise blue particle in the paint showing the presence of copper (Cu), bismuth(Bi), and arsenic (As). The elemental profile, in combination with the crystal habit, strongly suggests that the pigment is the mineral mixite.

fresco Giotto mixed orpiment with indigo to make greens,[43] but it does not seem that he used that mixture in the *Madonna and Child*. No tabular yellow particles typical of orpiment pigment were observed using surface microscopic examination. The trace of arsenic in the XRF spectra of the brighter blue parts of the Madonna's drapery is likely due to the ternary oxide noted above, and not to the presence of orpiment. Two yellow pigments were used with azurite in the green lining of the mantle. One is a splendid, warm yellow iron earth; the other, swirled into the same paint mixture or layered very thinly, has a clear light yellow tone. SEM-EDX showed that lead-tin yellow was used.[44] The particular brilliant yellow found here has the appearance in the backscatter image of a frit rather than a glass,[45] accounting for the intensity of the hue.

The Rose

The presence of a rose in Giotto's depiction of the Holy Mother is among the earliest known in painting or even liturgical ornamentation. The rose has a long and rich tradition of symbolic and metaphoric meaning. It has been associated with martyred saints and Christ since the writings of Saint Ambrose in the fourth century. In the twelfth century, Saint Bernard compared the Virgin to a rose. Julian Gardner has noted in regard to the Giotto *Madonna and Child* panel that the rose (usually red) is a symbol of the Passion.[46] In *Paradiso*, Dante Alighieri (1265–1321) augmented, enriched, and made the symbolism of the rose more nuanced. While unproven, tradition has it that Dante and Giotto were acquainted,[47] and therefore the depiction of the rose in this painting is of interest. Dante envisaged a giant white rose on which the company of saints was enthroned and on which God's light shone. A passage that may be relevant to the imagery in the Goldman Madonna is, "Why are you so enamored of my face that you do not turn your gaze to the beautiful garden which blossoms under the radiance of Christ? There is the rose, in which the divine word became flesh; here are the lilies whose perfume guides you in the right ways."[48]

The newness of this symbol in painting prompted examination of how Giotto worked to place and paint it. He sketched freehand the outline of the blossom, stem, and five leaflets of the rose sprig using a brush loaded with a dark fluid medium that absorbs in the infrared (fig. 10).[49] He also indicated the turned leaf and the layers of petals in the blossom at this stage. The blue mantle was painted over the sketch; then Giotto painted in the sprig at about the place he had indicated at the beginning of the process. At this moment he changed the position of one the leaf stalks. For the leaves, Giotto made ovals in dark brownish green, filled in the shape with a slightly lighter green,

Figure 10
Detail of the rose.

(a) Visible light.

(b) False-color infrared reflectogram. The position of the rose as sketched in outline was moved in the final painting to be closer to the Christ Child's hand.

10a

10b

and used hatches of the same across the dark oval outline to depict the serrated margins of the leaflets, thus giving a naturalistic sense to the symbolic motif of the rose. He used indigo mixed with lead-tin yellow to obtain the green color in the stems and leaves of the rose.[50]

The change in the position of the rose is one of the most significant in the painting. It places the rose within the grasp of the Christ Child, making it an attribute shared between Him and the Holy Mother.

Conclusion

The materials and painting techniques used by Trecento and Quattrocento artists are often usefully studied in the context of *Il Libro dell'Arte*. Cennini's book described a range of protocols. Examination of numerous works has shown, however, that there is, as Cennini himself noted (sometimes pejoratively), variation in practice. This study of a Giotto's *Madonna and Child* panel has augmented knowledge of the similarities and variation of practice within Giotto's workshop production. Comparison of the materials found here with those employed for other works attributed to Giotto will be useful for exploring the relationships of the works to one another. The use of a double green and red bole for the gilding offers strong evidence that the Goldman Madonna is related to *Saint Lawrence* and *Saint John the Evangelist* in the Musée Jacquemart-André and *Saint Stephen* in the Museo Horne. It is significant that ultramarine was not used in the Goldman Madonna, as Giotto usually employed this costly pigment at least for final glazes. However, the discovery that he used bone white, a yellow frit, and azurite with a rare green-blue mineral suggests that the early Trecento palette, at least Giotto's palette, contained a larger range of materials and subtlety than we previously knew and offers insight into Giotto's choices of color, which are often strikingly bold.

B.H.B. and J.R.D. wrote the essay with J.K.D. B.H.B. sampled the panel and performed OM and SEM-EDX analyses and their interpretation. J.K.D. undertook FORS and hyperspectral imaging and their interpretation. L.D.G. performed XRF and its interpretation.

We are grateful to colleagues who shared insights and observations with us: David Alan Brown, William Brown, Cecilia Frosinini, Julian Gardner, Dr. Barry Daly, Gretchen Hirschauer, Cinzia Pasquale, Elisabeth Ravaud, Mark Sandona, Dominique Thiébaut, and Elisabeth Walmsley.

1 For a review of the provenance and literature on the painting, see National Gallery of Art, The Collection, s.v. "Giotto, *Madonna and Child*," http://www.nga.gov/content/ngaweb/Collection/art-object-page.397.html (accessed January 8, 2014). Known as the Goldman Madonna, the painting was owned by Henry Goldman from 1917 to 1937.

2 For example, the copresence of lead and tin indicates the use of lead-tin yellow, and potassium, silicon, and iron in green indicate the use of green earth.

3 Organic materials identified using FORS include paint mediums and pigments such as indigo and organic red colorants. Reflectance

spectra were acquired using a fiber optic spectrometer, ASD FS3 (ASD Corp., Boulder, CO). Unless stated otherwise, conclusions presented in the text were made based on results integrated from the various analytical techniques as generally described here.

4 Julian Gardner, "Giotto in America (and Elsewhere)," in *Italian Panel Paintings of the Duecento and Trecento,* ed. Victor M. Schmidt, Studies in the History of Art 61 (Washington, 2002), 160 – 181.

5 For a discussion of the churches that may have housed this polyptych, see Miklós Boskovits, *Italian Paintings of the Thirteenth and Fourteenth Centuries*, National Gallery of Art Systematic Catalogue (Washington, 2015).

6 Michael Palmer, analysis report for Giotto, *Madonna and Child* (NGA 1939.1.256), January 11, 1989, NGA scientific research department.

7 The CT scan, 950 images at 50mA, 140 kV, was performed by Barry Daly, MD, FRCR, chief of Abdominal Imaging and vice chair for research, Department of Diagnostic Radiology, University of Maryland Medical Center, Baltimore. In addition to connecting the panels in an altarpiece, battens provided stability and helped to prevent warping. Jill Dunkerton, Susan

Foister, Dillian Gordon, and Nicholas Penny, *Giotto to Dürer: Early Renaissance Painting in the National Gallery* (New Haven, 1991), 152; Ciro Castelli, "The Construction of Wooden Supports of Late-Medieval Altarpieces," in *Sassetta: The Borgo San Sepolcro Altarpiece*, ed. Machtelt Israëls (Leiden, 2009), 1:321.

8 Castelli 2009, 1:319 – 335.

9 The x-radiograph is preserved in the collection of the NGA paintings conservation department. A thread count could not be determined because a large enough area was not visible, but the cloth appeared to be fine weight.

10 Many of Giotto's paintings have a fine weight fabric under the gesso, as was typical of Trecento Florentine paintings. Examples of other works by Giotto in which such fabric has been found are the Santa Maria Novella crucifix (Paola Bracco and Ottavio Ciappi, "Technique of Execution, State of Conservation and Restoration of the Crucifix in Relation to Other Works by Giotto: The Painted Surface," in *Giotto: The Crucifix in Santa Maria Novella*, ed. Marco Ciatti and Max Seidel [Florence, 2001], 273 – 274) and the Peruzzi altarpiece (David Findley, William Brown, Barbara Wojcik, and Molly March, examination report for Giotto, Peruzzi altarpiece [North Carolina Museum of Art, GL.60.17.7], n.d.). We thank William Brown, chief conservator, North Carolina Museum of Art, for discussing the Peruzzi altarpiece with us and for sharing the report. *Saint John the Evangelist* in the Musée Jacquemart-André also has fine weight fabric under the gesso. Elisabeth Ravaud, "Saint Jean l'Évangéliste; Saint Laurent," in *Giotto e compagni*, ed. Dominique Thiébaut (Musée du Louvre, Paris, 2013), 133.

11 FORS and the hyperspectral near-infrared imaging map show the hydroxyl (-O — H) groups of the gypsum that make up the gesso ground layer over the entire panel, including places where gold is under azurite but over the gesso.

12 It is possible from the backscatter electron images to see that the particle shape and size of the gesso are the same throughout the depth of the priming and appropriate for gypsum.

13 XRF analysis was performed using an ArtTax (Roentec, Berlin [now Bruker]) μXRF spectrometer with a rhodium tube and 60 μm polycapillary focusing optics. The x-ray tube voltage was 50 kV, and the current was 200 μA. Analysis live time was 200 seconds. For SEM-EDX analysis, a Hitachi S3400-N scanning electron microscope equipped with an Oxford Aztec energy dispersive spectrometer and an Oxford X-Max x-ray detector (80 mm^2) were employed. Samples were examined without a conductive coating at pressures of 20 – 30 Pa. For SEM and EDX analysis the accelerating voltage was generally 20 kV.

14 We thank Cinzia Pasquale for bringing the green earth layer in this painting to our attention.

15 Minerals from the celadonite group $(K(Mg, Fe^{2+})(Fe^{3+}, Al)[Si_4O_{10}](OH)_2)$ were the typical colorant in Italian green earth. See Carol Grissom, "Green Earth," in *Artists' Pigments:*

A Handbook of Their History and Characteristics, vol. 1, ed. Robert L. Feller (Washington, 1986), 141 – 167.

16 Cennino Cennini, *The Craftsman's Handbook*, trans. Daniel V. Thompson Jr. (New Haven, 1933), 73.

17 Cennini 1933, 80; Thea Burns, "Cennino Cennini's *Il Libro Dell'Arte:* A Historiographical Review," *Studies in Conservation* 56, no. 1 (2011): 1 – 13.

18 Theophilus (fl. c. 1070 – 1125) described applying metal leaf with either glue or egg white. Theophilus, *On Divers Arts: The Foremost Medieval Treatise on Painting, Glassmaking, and Metalwork / Theophilus*, trans. and ed. John G. Hawthorne and Cyril Stanley Smith (New York, 1979), 31 – 32. Green bole has been detected in two other fourteenth-century Italian panels as well as two northern European panels. Cecilia Frosinini, "Saint Stephen," in Thiébaut 2013, 139; Jilleen Nadolny, "All That's Burnished Isn't Bole: Reflections on Medieval Water Gilding, Part 1, Early Medieval to 1300," in *Medieval Painting in Northern Europe — Techniques, Analysis, Art History: Studies in Commemoration of the 70th Birthday of Unn Plahter*, ed. Jilleen Nadolny with Kaja Kallandsrud, Marie Louise Sauerberg, and Tine Foysaker (London, 2006), 148 – 162; Miklós Boskovits, *Early Italian Painting, 1290 – 1470: The Thyssen Bornemisza Collection* (London, 1990), 138, 152.

19 Findley et al., examination report, n.d.

20 Dunkerton et al. 1991, 174. Green earth bole was also found on the other panels associated with *The Pentecost: The Epiphany, The Entombment*, and *The Descent into Limbo*. Dillian Gordon, "A Dossal by Giotto and His Workshop: Some Problems of Attribution, Provenance and Patronage," *Burlington Magazine* 131 (August 1989): 524.

21 Ravaud 2013, 133, 136, 139. We thank Dominique Thiébaut, Elisabeth Ravaud, and Cecilia Frosinini for discussing these three paintings with us in depth.

22 Frosinini 2013, 139.

23 Cennini 1933, 46. Cennini noted that Taddeo Gaddi was Giotto's pupil and Cennini was the pupil of Taddeo's son Agnolo. Because his teachers came in a direct line from Giotto, Cennini claimed to know the exact methods Giotto followed.

24 Various techniques for painting flesh and complexions have been noted. See Franco R. Pesenti, "'Del modo di colorire le incarnazioni e i vestiri,' in Giotto, dopo alcuni restauri," in *Scritti e immagini in onore di Corrado Maltese*, ed. Stefano Marconi with Marisa Dalai Emiliani (Rome, 1997), 149 – 157; Roberto Bellucci and Cecilia Frosinini, "Working Together: Technique and Innovation in Masolino's and Masaccio's Panel Paintings," in *The Panel Paintings of Masolino and Masaccio*, ed. Carl Brandon Strehlke and Cecilia Frosinini (Milan, 2002), 32 – 40. Variations in the techniques for painting flesh in fresco are also described in Bruno Zanardi, "Giotto and the St. Francis Cycle at Assisi," in *The Cambridge Companion to Giotto*, ed. Anne Derbes and Mark Sandona (New York, 2004), 32 – 75.

25 Cennini 1933, 45.

26 The false-color infrared image was captured using a modified 720 Surface Optics Corp. NIR hyperspectral camera. The focal plane has been replaced by a high-sensitivity InGaAs camera (Sensor Unlimited). The camera collects images from 970 to 1680 nm with a spectral resolution of 3.4 nm. The images are calibrated to reflectance. False-color images were made using three bands (centered at 1000 nm for the blue, 1200 nm for the green, and 1600 nm for the red) to better show features of interest described in the text. In the false-color image in figure 4 the green wash appears pink because green earth upon the highly reflective gesso ground has decreased absorption at the wavelength chosen for the red display channel (1600 nm). The dark gray color in the false color infrared image of the wash used to create form by locating shadows indicates it absorbs radiation throughout the visible and infrared spectrum and implies this wash contains a carbon-based pigment.

27 A wash for shading was described by Cennini (1933, 45–47): "Put a few drops of ink into a glass half full of water, and with a pointed minever brush mark over the outline of your design. Then with the feather part of the pen, brush away the charcoal. With some more of the ink, and a flat-pointed minever [sic] brush, shade any fold and any shaded part of the face, and you will have made an agreeable design, which will cause all men to fall in love with your works." A similar wash was found in the Ognissanti Maestà, the Peruzzi altarpiece (Maria C. Galassi and Elizabeth Walmsley, "Painting Technique in the Late Works of Giotto: Infrared Examination of Seven Panels from Altarpieces Painted for Santa Croce," in The Quest for the Original, ed. C. Janssens de Bistohaven and Hélène Verougstraete [Leuven, Belgium, 2009], 117–122), and the Madonna di San Giorgio alla Costa and the Ognissanti crucifix (Bracco and Ciappi 2001, 347–349).

28 Cennini 1933, 45, 75; Galassi and Walmsley 2009, 118; Roberto Bellucci and Cecilia Frosinini, "Reading Underdrawing in Early Italian Panel Paintings," in Strehlke and Frosinini 2002, 57.

29 The loss was in the lower shadowed area of the arm. The sample was mounted in Bioplastic resin, cut perpendicular to the paint surface, and polished on silicon carbide wet-dry papers. Paint cross sections were analyzed using reflected and polarized light microscopy up to 1600×.

30 Phosphorus is present in a very low amount (likely from the binder) and is not associated with the black particles. Based on this observation and their shape, they are charcoal or vine black.

31 FORS spectra contain absorbance features at 2309 nm due to lipids or fatty acids indicative of egg yolk. See Manuela Vagnini, Costanza Miliani, Laura Cartechini, Paola Rocchi, Brunetto G. Brunetti, and Antonio Sgamellotti, "FT-NIR Spectroscopy for Non-Invasive Identification of Natural Polymers and Resins in Easel Painting," Analytical and Bioanalytical Chemistry 395 (2009): 2107–2118.

32 A yellow-brown glaze was found in Sassetta's Borgo San Sepolcro altarpiece, but this appears to be different from the yellow paint strokes found in the Christ Child in the Goldman Madonna. See Roberto Bellucci and Cecilia Frosinini, "Art in the Making: Sassetta and the Borgo San Sepolcro Altarpiece," in Israëls 2009, 1:383–396.

33 Bracco and Ciappi 2001, 292. For the description of how the flesh was painted in Saint John the Evangelist, see Thiébaut 2013, 134, cat. 13. Giotto did not use a green layer in the flesh paint in The Pentecost. See David Bomford, Jill Dunkerton, Dillian Gordon, and Ashok Roy, with contributions from Jo Kirby, Art in the Making: Italian Painting before 1400 (National Gallery, London, 1989), 71. A green underpaint, described as an ébauche, was found in several large crucifixes and appeared to contain green earth and lead white. See Daphné de Luca, "L'enterprise de Giotto," CeROArt: Conservation, Exposition, Restauration d'Objets d'Art 7 (2011): 1–25. In a different context from painting flesh, Cennini (chap. 57) notes that to make "sage green" one should mix lead white, green earth, and bianco di san Giovanni. Cennini 1933, 33.

34 Bracco and Ciappi 2001, 292. Roberto Bellucci and Cecilia Frosinini propose that varying the thickness of the green layer was Giotto's deliberate choice of methods to depict different complexions. Roberto Bellucci and Cecilia Frosinini, "'Di greco in latino': Considerazioni sull'underdrawing di Giotto come modello mentale," in L'officina di Giotto: Il restauro della Croce di Ognissanti, ed. Marco Ciatti (Florence, 2010), 167–177.

35 Thiébaut 2013, 134, cat. 13.

36 Galassi and Walmsley 2009, 119.

37 Bomford et al. 1989, 68.

38 Dunkerton et al. 1991, 71. It should be noted, however, that these are smaller panels from a predella or dossal, and the painting techniques used for these sometimes involved less workmanship.

39 The addition of red lake to blue pigments (particularly to azurite) was common in the painting technique of the time and has been found in works by Giotto, Duccio, and other contemporaries. For information on azurite and its use, see Bomford et al. 1989, 36–37.

40 The precise formula of the mineral has not yet been determined. At the Earth's surface oxidation of mixed copper-iron-arsenic ores can lead to formation of green copper arsenates that have been mistaken for malachite. The compounds formed from copper-arsenic ores have appealing and interesting colors. R. A. Ixer and R.A.D. Pattrick, "Copper-Arsenic Ores and Bronze Age Mining and Metallurgy with Special Reference to the British Isles," http://goodprovenance.com/fahlerz.htm (accessed November 21, 2013). Spherulitic malachite has been recognized as forming naturally as mine water flows over ores, and in Germany in the sixteenth century a specific green pigment was noted as being produced from ores. Gunnar Heydenreich et al., "Malachite Pigment of Spherical Particle Form," ICOM Committee for Conservation, 14th Triennial Meeting

ICOM *Committee for Conservation, the Hague, 12 – 16 September 2005, Preprints,* ed. Isabelle Sourbès-Verger (the Hague, 2005), 480 – 488; Gunnar Heydenreich, "A Note on Schifergrün," *Studies in Conservation* 48, no. 4 (2003): 227 – 236.

41 The papers of the Pratese merchant Francesco di Marco Datini provide some of the earliest information on trade in pigments, although that formed only a small part of his business. The bills of lading show that various grades and sorts of colorants were distinguished, including four varieties of brazilwood and five of indigo. Julia A. DeLancey, "Shipping Colour: *Valute*, Pigments, Trade and Francesco Di Marco Datini," in *Trade in Artists' Materials: Markets and Commerce in Europe to 1700,* ed. Jo Kirby, Susie Nash, and Joanna Cannon (London, 2010), 74 – 85.

42 In *The Pentecost* at National Gallery, London, a thin glaze of ultramarine covers azurite glazes and paint in blue robes. Bomford et al. 1989, 71. Ultramarine was used in the Santa Maria Novella crucifix (Bracco and Ciappi 2001, 295 – 298) as well as the Badia polyptych (Kaori Fukunaga, Costanza Cucci, Cristina Montagner, Marcello Picollo, Susanna Bracci, Donata Magrini, and Oscar Chiantore, "Diagnostic and Analytical Study of the Badia Polyptych with Non-Invasive and Micro-Invasive Techniques," in *Giotto: The Restoration of the Badia Polyptych*, ed. Angelo Tartuferi [Florence, 2012], 152 – 175), the Madonna of San Giorgio alla Costa (Paola Bracco, "La Tavola di San Giorgio alla Costa: Costruzione, Tecnica Artistica, Stato di Conservazione e Restauro," in *La Madonna di San Giorgio alla Costa di Giotto: Studi e Restauro; Catologo della Mostra*, ed. Marco Ciatti and Cecilia Frosinini [Florence, 1995], 67 – 80), and other works.

43 A mixture of an arsenical yellow such as orpiment with indigo was used to prepare mixed greens in the Santa Maria Novella crucifix and in the Madonna of San Giorgio alla Costa. Pietro Moioli and Claudio Seccaroni, "X-ray Fluorescence (XRF) for Analysis of Pigments," in Ciatti and Seidel 2001, 375 – 380.

44 In SEM-EDX cubes of lead-tin oxide are surrounded by a lighter atomic number matrix that contains silicon, calcium, lead, and tin. Lead-tin yellow was identified in a panel from Giotto's workshop, *The Last Supper* (Bayerische Staatsgemäldesammlungen, Munich), dated to c. 1306. Hermann Kühn, "Lead-Tin Yellow," in *Artists' Pigments*, vol. 2, ed. Ashok Roy (Washington, 1993), 83 – 112.

45 Martin Heck, Thilo Rehren, and Peter Hoffmann, "The Production of Lead-Tin Yellow at Merovingian Schleitheim (Switzerland)," *Archaeometry* 45, no. 1 (2003): 33 – 44.

46 Gardner 2002, 173.

47 Dante's work was well known, and he and Giotto were in Padua around the same time. Peter Murray, "Notes on Some Early Giotto Sources," *Journal of the Warburg and Courtauld Institutes* 16, nos. 1 – 2 (1953): 58 – 180.

48 Dante Alighieri, *Paradisio*, trans. Charles S. Singleton (Princeton, 1977), 23, 71 – 75.

49 In the infrared images the gray level of the first outline of the rose is very similar to that of the first drawing of the Christ Child's ear, suggesting they were made using the same medium.

50 The relative transparency of indigo in the 700 – 950 nm region of the infrared spectrum, the shape of the peak in the green region of the visible spectrum, and the lack of elements such as silicon or aluminum in the XRF spectra allow it to be distinguished from azurite and ultramarine.

References

BELLUCCI AND FROSININI 2002A Bellucci, Roberto, and Cecilia Frosinini. "Reading Underdrawing in Early Italian Panel Paintings." In Strehlke and Frosinini, 56 – 66.

BELLUCCI AND FROSININI 2002B Bellucci, Roberto, and Cecilia Frosinini. "Working Together: Technique and Innovation in Masolino's and Masaccio's Panel Paintings." In Strehlke and Frosinini, 29 – 67.

BELLUCCI AND FROSININI 2009 Bellucci, Roberto, and Cecilia Frosinini. "Art in the Making: Sassetta and the Borgo San Sepolcro Altarpiece." In Israëls 2009, 383 – 396.

BELLUCCI AND FROSININI 2010 Bellucci, Roberto, and Cecilia Frosinini. "'Di greco in latino': Considerazioni sull'underdrawing di Giotto come modello mentale." In *L'officina di Giotto: Il restauro della Croce di Ognissanti*, edited by Marco Ciatti, 167 – 177. Florence, 2010.

BOMFORD ET AL. 1989 Bomford, David, Jill Dunkerton, Dillian Gordon, and Ashok Roy, with contributions from Jo Kirby. *Art in the Making: Italian Painting before 1400.* National Gallery, London, 1989.

BOSKOVITS 1990 Boskovits, Miklós. *Early Italian Painting, 1290 – 1470: The Thyssen Bornemisza Collection.* London, 1990.

BOSKOVITS 2015 Boskovits, Miklós. *Italian Paintings of the Thirteenth and Fourteenth Centuries.* National Gallery of Art Systematic Catalogue. Washington, 2015.

BRACCO 1995 Bracco, Paola. "La Tavola di San Giorgio alla Costa: Costruzione, Tecnica Artistica, Stato di Conservazione e Restauro." In *La Madonna di San Giorgio alla Costa di Giotto: Studi e Restauro; Catologo della Mostra*, edited by Marco Ciatti and Cecilia Frosinini, 273 – 274. Florence, 1995.

BRACCO AND CIAPPI 2001 Bracco, Paola, and Ottavio Ciappi. "Technique of Execution, State of Conservation and Restoration of the Crucifix in Relation to Other Works by Giotto: The Painted Surface." In Ciatti and Seidel, 273 – 359.

BURNS 2011 Burns, Thea. "Cennino Cennini's *Il Libro Dell'Arte*: A Historiographical Review." *Studies in Conservation* 56, no. 1 (2011): 1 – 13.

CASTELLI 2009 Castelli, Ciro. "The Construction of Wooden Supports of Late-Medieval Altarpieces." In Israëls 2009, 319–335.

CENNINI 1933 Cennini, Cennino. *The Craftsman's Handbook*, translated by Daniel V. Thompson Jr. New Haven, 1933.

CIATTI AND SEIDEL 2001 Ciatti, Marco, and Max Seidel, eds. *Giotto: The Crucifix in Santa Maria Novella*. Florence, 2001.

DANTE ALIGHIERI 1977 Dante Alighieri. *Paradiso*, translated by Charles S. Singleton. Princeton, 1977.

DELANCEY 2010 DeLancey, Julia A. "Shipping Colour: *Valute*, Pigments, Trade and Francesco Di Marco Datini." In *Trade in Artists' Materials: Markets and Commerce in Europe to 1700*, edited by Jo Kirby, Susie Nash, and Joanna Cannon, 74–85. London, 2010.

DE LUCA 2011 de Luca, Daphné. "L'enterprise de Giotto." *CeROArt: Conservation, Exposition, Restauration d'Objets d'Art* 7 (2011): 1–25.

DUNKERTON ET AL. 1991 Dunkerton, Jill, Susan Foister, Dillian Gordon, and Nicholas Penny. *Giotto to Dürer: Early Renaissance Painting in the National Gallery*. New Haven, 1991.

FROSININI 2013 Frosinini, Cecilia. "Saint Stephen." In Thiébaut 2013, 139–140.

FUKUNAGA ET AL. 2012 Kaori Fukunaga, Costanza Cucci, Cristina Montagner, Marcello Picollo, Susanna Bracci, Donata Magrini, and Oscar Chiantore. "Diagnostic and Analytical Study of the Badia Polyptych with Non-Invasive and Micro-Invasive Techniques." In *Giotto: The Restoration of the Polyptych*, edited by Angelo Tartuferi, 152–175. Florence, 2012.

GALASSI AND WALMSLEY 2009 Galassi, Maria C., and Elizabeth Walmsley. "Painting Technique in the Late Works of Giotto: Infrared Examination of Seven Panels from Altarpieces Painted for Santa Croce." In *The Quest for the Original*, edited by C. Janssens de Bistohaven and Hélène Verougstraete, 116–122. Leuven, Belgium, 2009.

GARDNER 2002 Gardner, Julian. "Giotto in America (and Elsewhere)." In *Italian Panel Paintings of the Duecento and Trecento*, edited by Victor M. Schmidt, 160–181. Studies in the History of Art 61. Washington, 2002.

GORDON 1989 Gordon, Dillian. "A Dossal by Giotto and His Workshop: Some Problems of Attribution, Provenance and Patronage." *Burlington Magazine* 131 (August 1989): 524–531.

GRISSOM 1986 Grissom, Carol. "Green Earth." In *Artists' Pigments: A Handbook of Their History and Characteristics*, vol. 1, edited by Robert L. Feller, 141–167. Washington, 1986.

HECK ET AL. 2003 Heck, Martin, Thilo Rehren, and Peter Hoffmann. "The Production of Lead-Tin Yellow at Merovingian Schleitheim (Switzerland)." *Archaeometry* 45, no. 1 (2003): 33–44.

HEYDENREICH 2003 Heydenreich, Gunnar, "A Note on Schifergrün." *Studies in Conservation* 48, no. 4 (2003): 227–236.

HEYDENREICH ET AL. 2005 Heydenreich, Gunnar, Marika Spring, Martina Stillhammerove, and Carlos M. Pina. "Malachite Pigment of Spherical Particle Form." *ICOM Committee for Conservation, 14th Triennial Meeting ICOM Committee for Conservation, the Hague, 12–16 September 2005, Preprints*, edited by Isabelle Sourbès-Verger, 480–488. The Hague, 2005.

ISRAËLS 2009 Israëls, Machtelt, ed. *Sassetta: The Borgo San Sepolcro Altarpiece*. Leiden, 2009.

KÜHN 1993 Kühn, Hermann. "Lead-Tin Yellow." In *Artists' Pigments*, vol. 2, edited by Ashok Roy, 83–112. Washington, 1993.

MOIOLI AND SECCARONI 2001 Moioli, Pietro, and Claudio Seccaroni. "X-ray Fluorescence (XRF) for Analysis of Pigments." In Ciatti and Seidel 2001, 375–380.

MURRAY 1953 Murray, Peter. "Notes on Some Early Giotto Sources." *Journal of the Warburg and Courtauld Institutes* 16, nos. 1–2 (1953): 58–180.

NADOLNY 2006 Nadolny, Jilleen. "All That's Burnished Isn't Bole: Reflections on Medieval Water Gilding, Part 1, Early Medieval to 1300." In *Medieval Painting in Northern Europe — Techniques, Analysis, Art History: Studies in Commemoration of the 70th Birthday of Unn Plahter*, edited by Jilleen Nadolny with Kaja Kallandsrud, Marie Louise Sauerberg, and Tine Foysaker, 148–162. London, 2006.

PESENTI 1997 Pesenti, Franco R. "'Del modo di colorire le incarnazioni e i vestiri,' in Giotto, dopo alcuni restauri." In *Scritti e immagini in onore di Corrado Maltese*, edited by Stefano Marconi with Marisa Dalai Emiliani, 149–157. Rome, 1997.

RAVAUD 2013 Elisabeth Ravaud. "Saint Jean l'Évangéliste; Saint Laurent." In Thiébaut 2013, 133–134.

STREHLKE AND FROSININI 2002 Strehlke, Carl Brandon, and Cecilia Frosinini, eds. *The Panel Paintings of Masolino and Masaccio*. Milan, 2002.

THEOPHILUS 1979 Theophilus. *On Divers Arts: The Foremost Medieval Treatise on Painting, Glassmaking, and Metalwork / Theophilus*, translated and edited by John G. Hawthorne and Cyril Stanley Smith. New York, 1979.

THIÉBAUT 2013 Thiébaut, Dominique, ed. *Giotto e compagni*. Musée du Louvre, Paris, 2013.

VAGNINI ET AL. 2009 Vagnini, Manuela, Costanza Miliani, Laura Cartechini, Paola Rocchi, Brunetto G. Brunetti, and Antonio Sgamellotti. "FT-NIR Spectroscopy for Non-invasive Identification of Natural Polymers and Resins in Easel Painting." *Analytical and Bioanalytical Chemistry* 395 (2009): 2017–2118.

ZANARDI 2004 Zanardi, Bruno. "Giotto and the St. Francis Cycle at Assisi." In *The Cambridge Companion to Giotto*, edited by Anne Derbes and Mark Sandona, 32–75. New York, 2004.

Riccio in Relief: Documented Sculpture as a Technical Context for *The Entombment*

Dylan Smith

In 1957, the National Gallery of Art, Washington, received a large bronze relief depicting *The Entombment* by the Renaissance sculptor Andrea Briosco (1470 – 1532), nicknamed "Riccio" for his curly hair (fig. 1).[1] *The Entombment* is an exceptional record of his art and, like his other bronzes, visually expresses the fascination of his humanist patrons with the art and literature of classical antiquity.[2] The National Gallery's relief is the only major sculpture that was inscribed by the artist; however, its date and original setting are not known.[3] To establish a technical context in which to consider *The Entombment*, an investigation was carried out of Riccio's other large reliefs, many of which are documented. The results of this study point toward a possible date for *The Entombment* and constitute a fundamental reference for the materials and methods of this Renaissance master.

Riccio's talents were celebrated in his lifetime, and his bronzes were thought to match or surpass the achievements of antiquity.[4] He represented the third generation of a Paduan bronze tradition, having worked as a young artist with Bartolomeo Bellano (c. 1437 – c. 1496/1497), who had served as an assistant to Donatello (c. 1386 – 1466).[5] Riccio's bronzes may be divided into four general types — large reliefs, small plaquettes, statuettes, and decorative objects — each with its own mode of expression and specific technical demands.[6] His large reliefs range in size from roughly 16 × 51 centimeters to 65 × 85 centimeters (table 1, pages 46 – 47). They were created primarily as commissions for prominent religious settings and appear in period contracts and descriptions that establish an outline of his career.

Riccio appears to have been intimately involved with every aspect of production of his bronzes.[7] He was praised specifically for his skills in this medium by Pomponius Gauricus.[8] Although Riccio's artistic persona dominates his bronze sculpture, it is reasonable to assume that his brothers, also trained as goldsmiths in their father's workshop, may have assisted in various projects.[9] For certain large commissions, other artists may have been present, as is suggested by the many small bronzes in Riccio's style that appeared in Padua during the first half of the sixteenth century.[10]

Although documentary evidence provides an outline of Riccio's career, it offers little insight into his methods, leaving the sculptures themselves

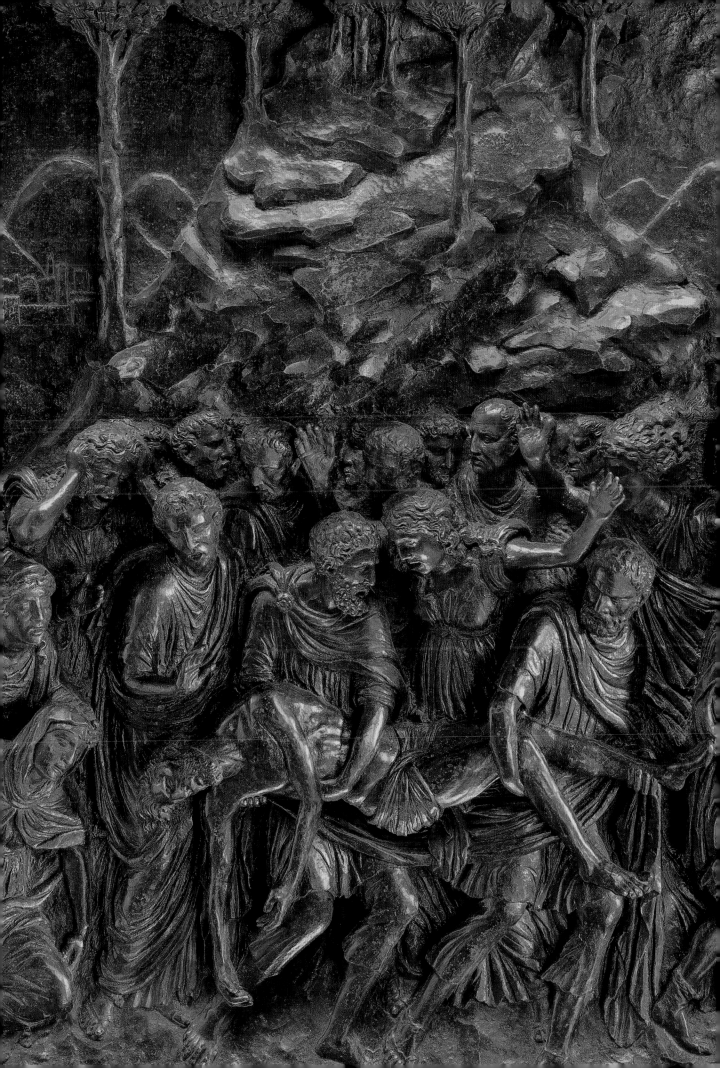

Figure 1
Andrea Briosco, known as Riccio,
The Entombment, 1516/1520s (here dated
1507–1513), bronze, overall: 50.4 × 75.5 cm,
gross weight 53.071 kg, National Gallery
of Art, Samuel H. Kress Collection.

Figure 2
Back of *The Entombment* (fig. 1). The image
has been reversed for ease of comparison
to the front.

Figure 3
X-radiograph.

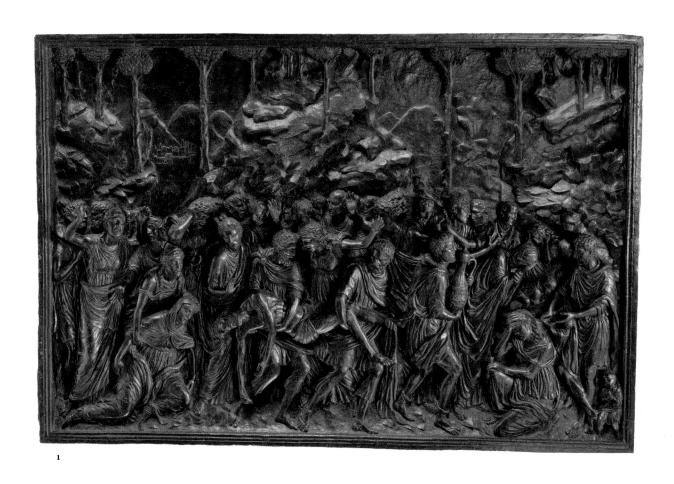

1

2

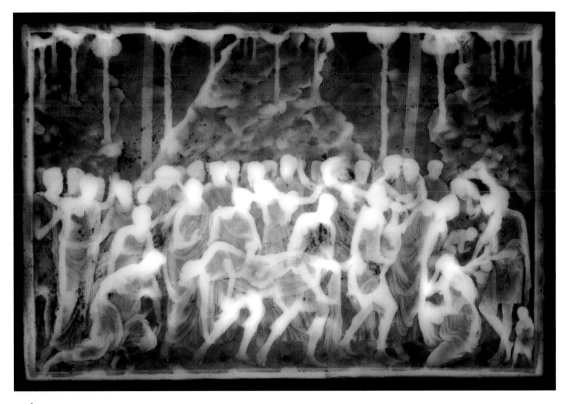

3

to serve as the primary source of information. To date, technical study of his large reliefs has been limited.[11] In 1989, *The Entombment* was included in a study that focused primarily on alloy analysis of undocumented plaquettes.[12] In 2008, an essay presenting an overview of Riccio's methods that focused mostly on statuettes included discussion of one group of reliefs.[13] In 2009, the first technical examination of documented reliefs by the artist was undertaken by conservators and curators from the National Gallery of Art at the Basilica of San Antonio, Padua, known as the Santo.[14]

For the present study, thirty-six large reliefs by Riccio were examined, including thirty-two with an established provenance and date.[15] These include six from the altar of the True Cross, now at the Ca' d'Oro, Venice; two installed in the choir and sixteen from the paschal candlestick that remain in situ at the Santo; and eight from the Della Torre monument, now at the Musée du Louvre, Paris. In addition to *The Entombment*, three other undocumented reliefs were examined: *Saint Martin and the Beggar*, at the Ca' d'Oro; and *The Descent into Limbo* and *The Resurrection*, at the Louvre. Observations on the fabrication of the reliefs were based on visual examination that included the backs when accessible (fig. 2). X-radiography of *The Entombment* provided further insight into Riccio's casting technique (fig. 3).[16] Alloy analysis was performed on all of the reliefs using x-ray fluorescence spectrometry (XRF), a nondestructive technique that has been used extensively for the study of Renaissance bronzes.[17] The alloys and casting techniques observed on the documented examples provide a chronological context for considering the possible date and provenance of *The Entombment* and the other undocumented reliefs.

The Entombment

Riccio considered the subject of Christ's entombment in several documented large reliefs over the course of his career and apparently also in a number of small plaquettes attributed to him.[18] The representation in the National Gallery's example is unique, capturing a transitional moment between Christ's deposition and his entombment (see fig. 1).[19] Thirty-nine figures, classically garbed and of various ages, form a solemn procession that moves toward a cave at the right. Among them is a stoic figure holding an urn inscribed "AERDNA," Riccio's first name in reverse (fig. 4).[20] Rocky outcroppings punctuated by trees rise in the middle ground and, in the distance, mountains and a walled city. The scene is surrounded by an integrally cast articulated frame. Riccio's representation drew upon the antiquarian style of Andrea Mantegna (c. 1431–1506) and the emotional intensity of Donatello, his most prominent predecessors in Renaissance Padua.[21] The composition was also influenced directly by ancient sarcophagi, notably depictions of the death of the hero Meleager.[22] Riccio avoided any overt Christian symbolism, leaving the subject open to interpretation as a *thiasos* or pagan funerary rite.[23]

The Entombment was first recorded in Paris in 1865 while in the Janzé Collection and even then attributed to Riccio.[24] The relief passed from the sculptor Charles Timbal (1821–1880) to the important collector Gustave Dreyfus (1837–1914), whose collection was purchased by Charles Duveen in 1930.[25] In 1945, Duveen sold *The Entombment* to the Samuel H. Kress

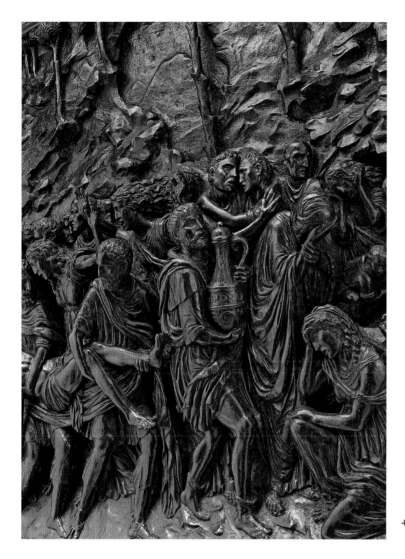

Figure 4
Detail showing the inscription "AERDNA"
on the urn carried by figure at center.

4

Foundation, and in 1957 it was part of a major donation from the foundation
to the National Gallery of Art.[26] Since its arrival in Washington, scholarly
discussion of the relief has been rather limited, perhaps in part due to its
lack of a documented provenance or date.[27] Renewed interest was prompted
by its inclusion in two exhibitions focused on Riccio in 2008 held at the
Castello del Buonconsiglio in Trento and the Frick Collection in New
York.[28] Recent scholarship has placed execution of the relief between 1516
and 1520, although various dates were given previously.[29] A possible original
setting for the relief was also recently proposed, in the Maffei Chapel at
Sant'Eufemia in Verona.[30]

The Entombment is 50.4 × 75.5 centimeters, a scale typical for Riccio's
large reliefs, and weighs approximately 53 kilograms (117 pounds). The relief
was cast in bronze, an alloy formed by the deliberate combination of copper
with a significant amount of tin (12.0%) (see table 1).[31] Lead is present, but
the relatively low level (2.2%) probably indicates accidental introduction
with the copper and tin rather than a deliberate addition.[32] Trace levels (<1%)
of zinc, iron, nickel, arsenic, silver, and antimony were also detected. These
elements were all likely introduced as impurities in the raw materials and
are commonly found in Renaissance copper alloys.[33] Bronze was known to
be the preferred alloy in antiquity for statuary, an association that would

have had a special resonance for Riccio and his humanist clients.[34] The choice of bronze follows in the tradition of important Renaissance sculpture commissions and was the alloy recommended for this purpose by Riccio's Paduan contemporary Pomponius Gauricus.[35]

During Riccio's career, the bronze statuette as a Renaissance art form was rapidly developing in northern Italy, as were the techniques used for their production.[36] In the last decade of the fifteenth century, indirect casting had been introduced in Mantua by Pier Jacopo Alari-Bonacolsi (c. 1455 – 1528), known as Antico.[37] In the indirect method, a model of the desired bronze was prepared and used to form a plaster piece-mold in which wax copies of the design could be made. These copies could then be invested in clay and used to cast any number of bronzes. Indirect casting was known in Padua, and this technique has been identified in certain statuettes attributed to Riccio.[38]

Figure 5
Diagram of the preparation of the wax model, investment, and casting process of *The Entombment* (partial section). Starting with a board (A), a thick base layer of wax was applied (B). The integral frame was then added (C). The landscape was applied to the background (D). Trees were modeled separately and added, along with an underlying wax support (E). The group of three women, including Mary, was applied in layers (F). The bearers were assembled on either side the body of Christ (G). The side supports were removed, and sprues were added (H). The temporary wax supports for the trees were removed (I). After the front was invested in clay (J), the board was removed to expose the reverse (K). The back of the wax model was then partially hollowed out (L), and the back edges along the top and sides were reduced (M). Fine iron pins were inserted through the wax (N). The back was also covered in clay, and the complete investment was heated to melt out the wax and harden the clay (O). Molten bronze was poured in through the sprues to fill the investment (P). The investment was broken away, the sprues were cut off, and the iron wires were cut off or extracted (Q).

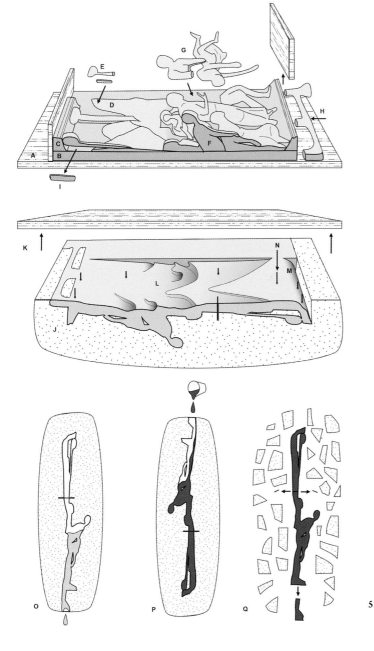

However, reproducing the model in rigid plaster molds would have placed limitations on the complex undercutting of Riccio's designs, especially the densely crowded figures in *The Entombment*.[39] Flexible mold materials commonly employed today were not known in the Renaissance.[40] For his purposes, Riccio chose the direct lost-wax method for most of his sculptures, and this is the technique used for *The Entombment*.[41] A single wax model was prepared and destroyed in the process of casting this unique bronze, and, without the necessity of an intervening piece-mold, this technique allowed much greater freedom of expression than indirect casting. Although this method is often described as riskier than the indirect method, Riccio and other artists were skilled at obtaining good casts and also at mending faults.[42]

Riccio may have prepared drawings or a small *modello* in consultation with his patron before creating the full-scale wax of *The Entombment*.[43] See figure 5 for a diagram of the preparation of the wax model; each step is identified by a capital letter and described below. Riccio began his model on a board or other rigid support (A), probably with smaller boards to reinforce the edges, and applied a relatively thick layer of wax (B).[44] Wax to form the frame was probably added at this stage as a point of reference for the depth of relief (C). The landscape appears to have been modeled in wax directly on the background, varying the thickness to create the three more prominent rocky outcroppings or the shallow relief of the distant mountains (D). The deep recess of the cave opening was created by carving into the base layer of wax. In the x-radiograph of the bronze, these variations appear as brighter, thicker areas and darker, thinner areas (see fig. 3). To complete the landscape, Riccio added trees that were separately modeled and attached to the background only at the foot and crown (E) (fig. 6). A temporary wax support was included behind the delicate trunks to avoid damage as the model was being prepared. Although these were removed before casting (I), remnants of this wax, now translated into bronze, remain visible behind one of the trees (see fig. 6). In the x-radiograph of the bronze, these solid, nearly freestanding trees are notably whiter (see fig. 3).

Riccio created the funerary procession on *The Entombment* with a more complex application of wax. His figures were assembled from separately formed elements to produce pierced and undercut layers that generate a remarkable visual depth (see fig. 4). In the group of three women toward the left side of the relief, a figure usually identified as Mary collapses into the arms of a woman behind her, and over their shoulders another mourner stands with arms outstretched. The foreground figure was probably applied first, then the next inserted behind, and finally the third was attached, emerging from the background, her body and arms applied separately (F). Working in the direct method with solid wax figures, Riccio was free to assemble his figures using different approaches. For example, the upper and lower bodies of the central figures appear to have been attached on either side of the horizontal figure of Christ, contributing to their rather elongated torsos (G).

The foreground mourners were sculpted with heads that are fully three-dimensional, but bodies that taper downward until their feet are in very low relief (see fig. 4). As a result, the figures project dramatically at the center of

Figure 6
Detail showing freestanding tree, with repair indicated by arrow.

6

the panel while remaining bound by the frame at the bottom. In the x-radio-graph (see fig. 3), the projecting heads and limbs appear bright white, indi-cating areas originally modeled in solid wax that were not hollowed from the back prior to casting (see discussion below). In addition to the more fully modeled foreground figures, Riccio also inserted numerous mourners in the background rendered only as heads. These fill the remaining spaces in the foreground and produce a sculptural composition that cannot be taken in from a single vantage point. The wall of figures in the procession also eliminated the need for pictorial perspective in the lower half of the relief, where Riccio relied on physical layering as the primary indicator of space.

With the model complete, Riccio added rods of wax, which would serve as sprues — channels to distribute the metal throughout the design that included an opening for the bronze to enter the finished mold (H). The appli-cation of an external network of sprues has been observed on reliefs by other artists, notably Lorenzo Ghiberti (1378 – 1455).[45] Such a network typically leaves indications of channels or points of entry on the unfinished reverse. No such evidence was present, however, on *The Entombment*. Instead, thicker areas of bronze visible in the x-radiograph (see fig. 3) indicate pos-sible positions for the sprues along the bottom edge, suggesting that the relief was cast vertically and upside down (P). Without an external network of sprues, the molten metal could travel only through channels created by the model itself. For this reason, Riccio may have left the background plane of the relief rather thick so that it could feed bronze to all parts of the design. He also filled in behind some of the projecting parts with wax to allow the molten metal to flow more easily into these areas (fig. 7). Furthermore, Riccio interconnected the limbs and bodies of adjacent figures to provide additional paths for the metal, a practice that has been noted in his statu-ettes.[46] Although the freestanding trees bear a resemblance to sprues, these narrow channels would not have offered an effective path for the metal to flow, and not all of the trees were successfully cast.[47] It is unclear if any vents were added to help gases escape from the mold as the metal was poured in; if the molding material was sufficiently porous, these may not have been necessary.[48]

Figure 7
Detail showing top view of central group of figures.

7

With the model complete, Riccio applied a layer of clay over the front of the wax; this clay formed part of the investment — the heat-resistant mold in which the bronze would be cast (J). Traces of clay that remain on *The Entombment* are fine and uniform, as would be expected because the investment would ideally capture every detail of the model's surface.[49] The relief could then be inverted and the board removed to expose the back of the model (K). Additional wax was applied to thin areas, indicated by brush-strokes, and small repairs were made. In parts of the model where the design was rendered in high relief, the thicker wax was partially removed (L). Riccio may have used a drawing of the design to help guide this process or simply relied on his memory of the depth of relief. The variations in thickness are visible on the back of the bronze and evident in the x-radiograph, where the thinned areas appear darker within a brighter, thicker outline (see figs. 2, 3).[50] Riccio hollowed the wax to reduce the amount of metal required and to even out the thickness to avoid casting defects that can occur in thick-walled bronzes by differences in cooling and contraction. On *The Entombment*, the removal of wax was rather shallow and only generally conformed to the design, suggesting concern about accidentally damaging the carefully rendered surface (see figs. 1, 2). Riccio also trimmed the top and sides of the frame, leaving only the front surface (M); the bottom flat edge was preserved to provide an attachment point for the sprues and an even surface for the bronze to rest upon when later installed.

Riccio inserted fine iron pins through the wax, which were sparingly placed within the design but more regularly spaced along the frame (N).[51] He used similar fine wires in his statuettes to fix the internal clay cores in place during casting. Such cores, and the pins to support them, are necessary only to cast a hollow form and therefore were not required for a relief such as *The Entombment*.[52] The pins may have helped maintain the spacing inside the investment after the wax was melted out.[53] They may also have prevented fragments of clay from breaking loose and floating inside the investment, where they could disrupt the flow of bronze and cause lacunae in the cast.

To complete the investment, Riccio applied clay to cover the back of the wax model. The assembly was then heated to melt out the wax model and fire the clay (O). Copper and tin were melted together to form molten bronze. Riccio may have chosen a high tin content for *The Entombment* to increase the fluidity of the metal and allow it to more easily fill the particularly thick-walled and complex high relief.[54] The amount of bronze required to cast the sculpture would have been calculated using the weight of the wax needed to create his model and sprues.[55] Molten metal was poured into the investment through the sprues, traveling through and filling the form of the relief (P). The resulting cast was slightly convex, possibly due to distortion as the thick bronze cooled. Riccio then broke away the investment, removed the sprues and other excess metal, and cut off or extracted the iron pins (Q).

The surface of *The Entombment* does not appear to have been extensively worked after casting, and the fine peening found on many of the statuettes attributed to Riccio is not present (see fig. 6).[56] Some crisp lines of the drapery may have been refined by chasing — using a tool with a rounded tip to displace and compress the metal. Coarse hammering was used to close any open bubbles at the surface caused by trapped gases. Bubbles can be a

particular problem with thick-walled casts, and significant porosity is visible in the x-radiograph of *The Entombment* (see fig. 3). Cracks remain in the integral frame that formed as the bronze cooled; the acceptance of certain types of casting flaws has been noted in other Riccio bronzes.[57] Greater effort was made to repair faults in the main part of the composition. Voids in several tree trunks were repaired by "casting-in" additional metal in a secondary pour. Some of these "cast-in" repairs had slots cut in them and were mechanically fixed in place with bridges made of the same alloy (see fig. 6).[58] This approach has some similarities to lap joints observed on certain small bronzes attributed to Riccio.[59] Much later restoration was carried out on two of the wailing women, whose damaged arms were replaced with a distinct brass alloy with a high zinc content and a chemical patination.[60]

When Riccio completed his repairs, *The Entombment* was covered with a thin black coating that unified its appearance and concealed minor imperfections. To a Renaissance eye, the black color may have also evoked the appearance of ancient bronzes.[61] Although the surfaces of many Renaissance bronzes have been altered over time, the black layer on *The Entombment* conforms closely to the modeled surface and is present even in deeply recessed areas, suggesting that this application was original. Similar "applied patinas," composed of drying oils and lampblack, have been identified on Riccio's statuettes and are typical for northern Italian bronzes of this period.[62]

The considerable weight and unfinished sides of *The Entombment* suggest placement in a permanent architectural setting. Its heavy casting stands in sharp contrast to the more thinly cast and portable roundels by Riccio's contemporary Antico.[63] The large iron hangers on the back of the relief have a corrosion layer that is consistent with age and were made using historically appropriate forging methods (see fig. 2). However, no provision was made on the relief to accommodate the hangers, and the holes that secure them appear to have been drilled after original manufacture.[64] Visual examination and x-radiography identified other holes and iron pins that suggest the mounting of the relief was changed over time. The plaster on the reverse appears intended to conceal the unfinished edges and was applied sometime after the iron loops while the relief was hanging (see fig. 2).[65]

The heavy cast and limited finish of *The Entombment* are surprising given that Riccio trained as a goldsmith.[66] Craftsmen working in precious metals take great care to minimize the metal required, and thin-walled casts are typical. The free handling and lively surfaces of Riccio's bronzes sharply contrast with the careful treatment expected from a goldsmith, such as the refined statuettes of Antico. The solid masses, layered construction, and hollowing from the back used to form *The Entombment* emphasize modeling and express an affinity with the processes of terracotta, the medium of Riccio's other known sculptures.[67]

Riccio's Documented Commissions

Riccio's documented reliefs provide the context necessary to consider the date and origin of *The Entombment*. These bronzes from four major commissions span two decades of the artist's career, with the earliest begun around 1498 and the latest completed around 1521. Alloy analysis found that Riccio's materials remained remarkably consistent over time, but some

variations are observed in the alloys present in the different commissions. More notably, Riccio's figures developed over time in their depth of modeling and increasing size, prompting certain changes in his casting technique. These changes also demanded changes in his presentation of perspective as he worked to resolve a visual problem unique to relief sculpture — integrating forms that extend into three-dimensional space within a two-dimensional framework.

The altar of the True Cross

Riccio's earliest reliefs adorned an altar dedicated to the True Cross in Santa Maria dei Servi, Venice, commissioned to house an elaborate reliquary cross previously donated to the church.[68] These were deinstalled in 1814 and are now at the Ca' d'Oro. The group of six reliefs includes a pair of tabernacle doors and four narrative scenes depicting *The Vision of Constantine, The Discovery of the True Cross, The Victory of Constantine* (figs. 8, 9), and *The Proof of the True Cross*. Riccio's authorship is confirmed by self-portraits in two of the reliefs: he appears in classical garb but is readily recognized by his curly hair. The bronzes must have been executed sometime after construction of the altar in 1498 and before the completed installation was first mentioned in 1509.[69] Commitments to other projects suggest that Riccio completed the True Cross bronzes by the end of 1505, and a date around 1500 has been convincingly argued.[70]

Both altar doors and the four reliefs were cast from similar bronze alloys with 4.4 percent to 7.8 percent tin (see table 1).[71] These alloys are consistent with Riccio's other reliefs, suggesting that he cast all six himself rather than making use of Venetian foundries.[72] Levels of zinc (0.4 – 1.8%) are lower than would represent a deliberate addition to the alloy but slightly higher than found in his other commissions. As these are his earliest reliefs, and probably his earliest independent bronzes of any sort, the suggestion of slightly different raw materials or less rigorous preparation is perhaps not surprising.

The surfaces of all six True Cross reliefs are mostly covered by a later dark coating; however, in recessed areas underlying bright metal was noted as well as traces of a natural patina — the oxidation layer developed slowly from exposure to the atmosphere.[73] Visual examination and XRF analysis identified gilding on various details of all six bronzes (fig. 10).[74] The absence of mercury and the presence of flaking in the gold are consistent with mordant gilding, presumably applied with a drying oil, and the layer appears intimately associated with the metal surface.[75] The True Cross bronzes are the only known instances of mordant gilding in Riccio's oeuvre, an exceptional practice that again might be associated with their early date. Only three other bronzes, including two reliefs (discussed below), have gilding, and on those a mercury amalgam technique was used. The presence of gilding may have been prompted by descriptions of the episodes in the *Legende aurea* (The Golden Legend, c. 1260) by Jacobus de Voragine: in one version, after receiving his vision, Constantine "changed the military standards into Crosses and held the golden Cross upright in this hand."[76]

The bronzes for the True Cross altar were directly cast, as indicated by their thickness and the fact that the hollowing on the reverse does not

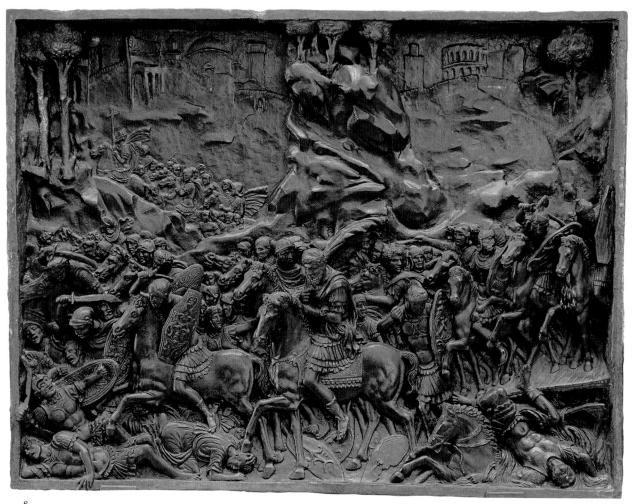

8

9

Figure 8
Riccio, *The Victory of Constantine*, 1498 –
1505, bronze, 38.8 × 51.2 cm, Ca' d'Oro,
Venice.

Figure 9
Back of *The Victory of Constantine* (fig. 8).
The image has been reversed for ease of
comparison to the front.

Figure 10
Detail of Riccio, *The Discovery of the True
Cross*, 1498 – 1505, bronze, 38.6 × 50.6 cm,
Ca' d'Oro, Venice, showing foreground
figures with mordant gilding on crosses.

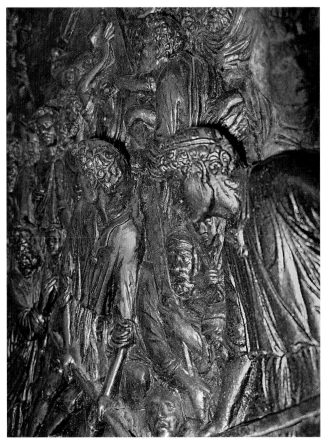

10

conform at all to the finished surface of the front (see fig. 9). Despite the tendency of such thick-walled bronzes to trap gases and crack due to uneven cooling, Riccio achieved a successful cast, a testament to his skill at that early date and his training as a goldsmith and with Bellano.[77] The casting techniques and alloys are similar to those found in Riccio's other reliefs and support the conclusion that he cast the sculpture himself, although the commission was for a church in Venice.[78] A professional Venetian founder would likely have cast the reliefs more thinly to avoid casting defects and economize on metal, aims that would be more readily achieved using the indirect technique.[79]

The modeling and figural composition vary considerably among the six True Cross bronzes, suggesting an artist still defining his methods and visual vocabulary. The tabernacle doors were executed in low relief and in a rather conservative style. They were probably the first part of the commission executed, since they were necessary to secure the reliquary; on one door is Riccio's earliest documented *Entombment*.[80] *The Discovery of the True Cross* and *The Proof of the True Cross* are primarily in low relief, with select details rendered in greater depth, such as foreground heads and background trees (see fig. 10). Here the figures are generally more elongated, more medieval in appearance, and crowded into triangles of stacked heads to create a sense of perspective. Figures become more individualized and classicizing in *The Vision of Constantine* and *The Victory of Constantine*; several figures draw on ancient prototypes such as the equestrian monument of Marcus Aurelius (see fig. 8).[81] These scenes include additional details modeled in depth, such as the floating Cross or the rider dramatically tumbling from the bridge. The perspectival space of these early reliefs remains problematic, with tiny figures roaming the mountains and cities in the distance that seem to float above the scene (see fig. 8).

The Santo reliefs

On August 6, 1506, Riccio received a prestigious commission for two reliefs at the Santo.[82] *The Story of Judith* (fig. 11) and *David and the Transport of the Ark of the Covenant* (fig. 12) were completed on March 22, 1507, and installed at the entrances to the choir two months later.[83] In later configurations of the choir, these independent bronzes were added to ten reliefs depicting other Old Testament subjects executed by Bellano two decades earlier.[84] In each panel Riccio included a self-portrait dressed in contemporaneous garb different from the other classically dressed figures. He appears again with his characteristic curly hair but now wearing a distinctive cap (see fig. 11, at the far right).

The alloy of *The Story of Judith* contains 4.0 percent tin and 4.0 percent lead (see table 1), both likely deliberate additions.[85] The alloy of the David relief is slightly different, with 6.3 percent tin and 2.5 percent lead, indicating that the two reliefs were cast at different times.[86] Gilding is present on select details in both scenes, including architectural elements in the Judith panel and, in the David relief, on the ark and the inscribed block at the lower right. The use of gold emphasizes Riccio's departure from Bellano's unadorned panels and speaks instead to Donatello's gilded reliefs on the Santo's main altar. XRF analysis detected mercury on the gilding of Riccio's reliefs,

Figure 11
Riccio, *The Story of Judith*, 1506 – 1507, bronze, 65 × 85 cm, choir of the Basilica of San Antonio, Padua.

Figure 12
Detail of Riccio, *David and the Transport of the Ark of the Covenant*, 1506 – 1507, bronze, 65 × 85 cm, choir of the Basilica of San Antonio, Padua, showing shepherd and goat with amalgam gilded inscription panel.

11

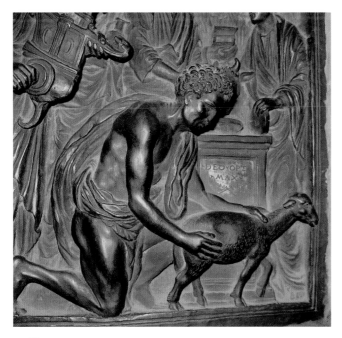

12

indicating his use of the amalgam technique that is found on only one other bronze in his oeuvre.[87]

The Santo choir reliefs remain in situ, and their backs are not accessible to help determine the casting technique. However, the depth of modeling is similar to that of the Constantine panels from the True Cross altar, having relatively few foreground figures in higher relief, and the Santo reliefs were probably also rather thick walled (see fig. 12). The arrangement of the figures is somewhat different, being placed in a background where a central triangle of space recedes into the distance more effectively than seen in the True Cross reliefs.

The paschal candlestick

The choir reliefs must have been well received, because in 1507 Riccio was commissioned to create a monumental paschal candlestick to be placed in front of the altar in the Santo (fig. 13).[88] The candlestick was not installed until January 9, 1516, after considerable delays caused by the War of the League of Cambrai (1508–1516).[89] This massive bronze stands nearly 4 meters high and is a testament to the breadth of Riccio's artistic genius, integrating elements of ornament, relief, and figures in the round. Its symbolism is rooted in sixteenth-century Paduan humanism and utilizes pagan imagery to express a Christian thematic program.[90] Among the decoration is another *Entombment*, where Riccio again depicted himself in his cap, marking his role in this important public monument.

The originality of the decoration of the candlestick is matched by its technical ingenuity. Prior examination by conservators and curators from the National Gallery of Art identified that Riccio's sculpture was not created in massive sections but assembled from forty-five separately cast parts.[91] The four lower registers are comprised of sixteen reliefs joined at the sides that depict (from bottom up) a mythological marine procession, Christological narratives scenes, cartouches held by centaurs, and standing female figures (see fig. 13).[92] The surface of the candlestick appears to have been finished with coarse peening to close surface porosity. No traces of an original applied coating were observed, and the metal appears to have been left to develop a natural patina.

Thirteen of the sixteen reliefs from the lower registers have been analyzed by XRF and found to be bronze with a tin content ranging from 6.5 percent to 10.2 percent (see table 1), slightly higher than the earlier reliefs.[93] The significant variation in the tin suggests batches of metal that were cast over time, a process that might be expected for such a large undertaking and is supported by the sequence of documented payments.[94] The low levels of lead, 0.4 percent to 3.2 percent, probably represent accidental introduction, and the zinc content was particularly low, less than 0.2 percent. Documents from the Santo record the purchase of gold specifically for the monumental bronze on March 4, 1516, although the amount and intended use were not indicated.[95] No gilding was identified visually or by XRF analysis, the latter being particularly sensitive to any traces of gold that might remain on the surface.

The interior of the paschal candlestick could not be directly examined, but the finished surfaces demonstrate a variety of compositions

Figure 13
Detail of the four lower registers of Riccio, paschal candlestick, 1507–1516, bronze, height 3.92 m, Basilica of San Antonio, Padua, showing (1) marine scenes, (2) Christological narratives, (3) cartouches held by centaurs, and (4) standing female figures.

13

and modeling. The first and third registers, depicting marine scenes and cartouches held by centaurs, were rendered largely in low relief and would not have required techniques any more sophisticated than Riccio's earlier panels. However, in the Christological scenes, the largest of the four registers, the artist presented compositions rather different from in his earlier reliefs. Among them is another interpretation of *The Entombment*. In each, a small group of more statuesque figures fills the lower two-thirds of the relief (fig. 14). These are rendered in greater depth than in Riccio's earlier documented reliefs, and likely reflect a shift in technique. The figures are positioned in a stagelike foreground, and modeling, rather than perspective, is the primary means of establishing spatial relationships. The three-dimensional trees that dotted the background hills of the earlier reliefs appear only in *The Adoration of the Magi*, where they were greatly enlarged and serve to bracket the scene.

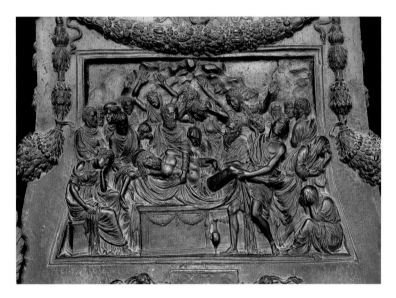

14

The fourth register of reliefs has a strikingly different figural composition, with a single standing female against a flat, ornamental background (see fig. 13). These figures are almost fully three-dimensional and stand on small pedestals that project from the frame. The sculptural character of this register is thought to reflect a development in Riccio's style over the years of production for the candlestick, and technical changes appear to have occurred as well.[96] To cast the female figures successfully, he would have needed a technique that reduced the thickness more effectively than could be achieved by simply hollowing from the reverse.

Riccio may have used the method observed on another of his bronze reliefs, the undocumented *Saint Martin and the Beggar*, where the back could be examined (figs. 15, 16). Well-defined deep openings correspond to the highest relief of the two large figures, one on horseback and one seated, which are depicted nearly fully in the round and placed on an integrally cast shelf. Visual examination suggests that each figure was modeled separately in wax over a clay core and then inserted into openings in the flat background.[97] Evidence of assembly of the wax model is found on the front of the relief where the sculptural figures were attached to the background

Figure 14
Detail of Christological narratives, second register of the paschal candlestick (fig. 13), showing *The Entombment*.

Figure 15
Riccio, *Saint Martin and the Beggar*, c. 1513–1520, bronze, 74.6 × 54 cm, Ca' d'Oro, Venice.

Figure 16
Back of *Saint Martin and the Beggar* (fig. 15). The image has been reversed for ease of comparison to the front.

15

16

(fig. 17); similar indications are found on the female figures on the candle-stick (fig. 18). This technique would produce a thinner, more even cast and avoid the risk of excavating a mass of wax from the back. *Saint Martin* was part of another altar in Santa Maria dei Servi and, like the True Cross bronzes, came to the Ca' d'Oro.[98] The attribution of the relief to Riccio is widely accepted, and it has generally been dated to 1513 – 1520, around the time the similar candlestick reliefs were produced or a little later.[99] The alloy of *Saint Martin* is bronze, very similar in content to Riccio's other reliefs (see table 1).[100]

Figure 17
Detail of *Saint Martin and the Beggar* (fig. 15), showing probable wax join between the back edge of the horse and the background.

Figure 18
Detail of standing female figure, fourth register of the paschal candlestick (fig. 13), showing probable wax join along edge between figure and background.

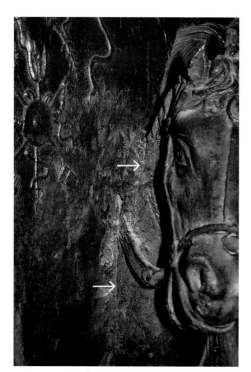

17

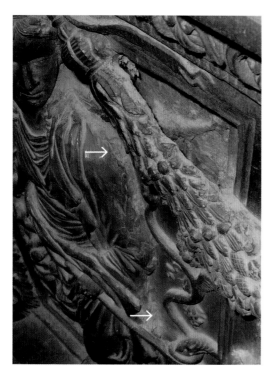

18

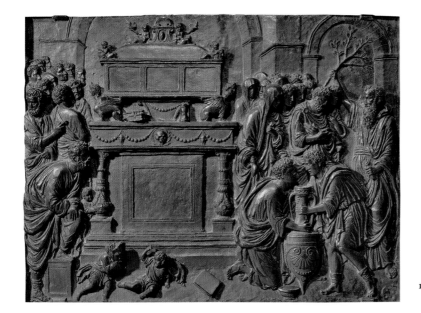

Figure 19
Riccio, *Funeral*, from the Della Torre monument, 1516 – 1521, bronze, 37 × 49 cm, Musée du Louvre, Paris. A representation of the Della Torre monument itself is included in the scene.

Figure 20
Back of *Funeral* (fig. 19). The image has been reversed for ease of comparison to the front. Note that hollowed areas on the reverse correspond to the front of the design, even for relatively low relief elements such as the monument.

19

20

The Della Torre monument

Riccio's last documented bronze reliefs decorated a funerary monument dedicated to Girolamo (1444 – 1506) and Marcantonio della Torre (1478 – 1511) at San Fermo Maggiore in Verona (fig. 19). Riccio's responsibility for this project was recorded in a proposed inscription for the artist's tomb.[101] Although the date of the commission was not documented, prior scholarship argues convincingly for the period between 1516 and 1521, after the completion of the paschal candlestick but before the start of the funerary monument for Antonio Trombetta (1436 – 1517).[102] The design of the tomb and its symbolic program are exceptional in their use of purely pagan imagery that only symbolically, and rather obscurely, represents underlying Christian concepts.[103] Eight reliefs encircle the marble casket elevated on a pedestal, with inscriptions to the entombed on either side.[104] Riccio applied a rigorous *all'antica* vocabulary in these bronzes to depict a narrative of the

life, death, and afterlife of a scholar. The reliefs were removed in 1797 by Napoleon's troops and are now in the collection of the Louvre.[105] The tomb included other bronze elements: a double-portrait, putti, and sphinxes.[106]

The eight Della Torre reliefs are bronze alloys similar to Riccio's other reliefs, except that the average lead content is slightly higher, 3.3 – 5.2 percent (see table 1).[107] Given the tight control over alloy content and the low lead contents observed in Riccio's reliefs in general, this amount likely represents a deliberate addition. This change could be associated with their production later in Riccio's career, but may reflect no more than the materials obtained for this particular commission.[108] The surfaces of the reliefs were left somewhat rough overall, although certain areas of flesh show indications of peening. No evidence of an applied coating was noted; rather, the patina appears to have formed by natural oxidation of the metal surface. Results of the alloy analysis of the reliefs and a reconsideration of the subjects of certain scenes suggest a possible change in the interpretation of their original order on the tomb.[109]

The compositions of the Della Torre reliefs build upon the changes noted in the Christological scenes on the paschal candlestick. The figures stand about two-thirds the height of the panel, are limited in number, and establish the foreground as the primary visual space. Like the Christological scenes, views into the far distance are absent from many of the scenes, and, where they are present, as in *Funeral* (see fig. 19), details are softly defined, suggesting distance through atmospheric effects. Compared with the paschal candlestick figures, those on the Della Torre monument are in lower relief and their modeling is more integrated into the background. This visual change has a corresponding change in technique. Because the figures were rendered with less depth, their forms could be more readily hollowed out on the reverse; indeed, greater conformation is observed on the back (fig. 20). Even the trees are attached to the background, a placement that allowed them also to be partially hollowed out. The overall reduction of modeled depth in the Della Torre reliefs coincides with Riccio's decision to abandon the integral frames that had been included on all of his earlier commissions. Although the lack of frames reduced the surface area available for attachment, the absence of any evidence of sprues on the back suggests that they still entered at the edge. The necessarily smaller diameter of the sprues would have limited the influx of molten metal, compensated for by the overall reduction in thickness of the panels.

The Entombment in context

The examination of Riccio's documented reliefs from these four commissions provides new information to address a hypothesis concerning the origin of *The Entombment* on the altar of the Maffei family in Sant'Euphemia in Verona.[110] It has been argued that the National Gallery relief was displayed in Verona with two other undocumented bronzes attributed to Riccio now at the Louvre, *The Descent into Limbo* (fig. 21) and *The Resurrection*.[111] Documents from 1796 and 1803 – 1804 attest that the altar had at least two bronze reliefs that were considered to be by Riccio at that time.[112] The altar also has three openings in its decorative marble facade that approximate the dimensions of the reliefs.[113]

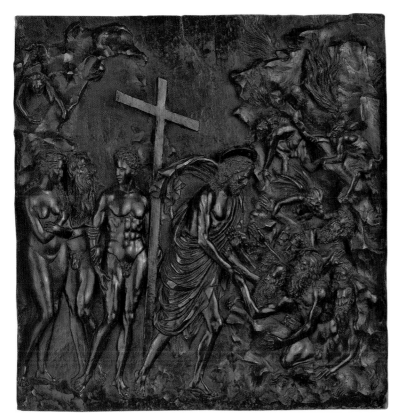

Figure 21
Attributed to Riccio, *The Descent into Limbo*,
c. 1520–1530, bronze, 41 × 39.8 cm, Musée
du Louvre, Paris.

21

However, the technical characteristics of the three reliefs do not support their original association. Within Riccio's documented commissions, the alloys of individual reliefs are very similar, with the greatest variation in the paschal candlestick due to it being cast in a great number of parts over time (see table 1). *The Entombment,* however, was found to contain more than twice the amount of tin present in the two other reliefs.[114] Furthermore, *The Descent into Limbo* has a higher arsenic and antimony content than any of Riccio's reliefs, including *The Entombment* and *The Resurrection,* although it is still within the range of alloys found in his sculpture.[115] *The Descent into Limbo* (see fig. 21) and *The Resurrection* have larger figures modeled in moderate relief and lack integral frames. Although heavy marble frames prevent examination of the back, their casting technique is probably similar to the Della Torre bronzes, and distinct from the high relief and thick-walled cast of *The Entombment.*[116] Despite its greater depth and integral frame, the opening in the Maffei altar in which *The Entombment* was supposed to have been placed appears shallower, being set back by a marble frame absent from the openings for the other reliefs.[117] Notable differences in detail between the Louvre reliefs and *The Entombment* make it seem unlikely that these three formed a coherent group. Christ has a halo in both *The Descent into Limbo* and *The Resurrection* but not in *The Entombment.* The presence of a halo in the Christological scenes of the paschal candlestick might suggest that the undocumented Louvre reliefs were also once presented in a similar public and sacred setting. Without the association with *The Entombment,* and with technical characteristics that appear similar to or later than the Della Torre reliefs, the Louvre reliefs can be dated around 1520–1530, as has previously been proposed.[118]

The absence of Christ's halo on *The Entombment* could indicate its possible original location. Halos were not included on the plaquettes of this subject attributed to Riccio, and like those small bronzes, the National Gallery relief may have been intended for private contemplation. A more personal connection between artist and patron is suggested by the absence of a self-portrait and the inclusion of Riccio's first name.[119] The presence of a number of figures that appear to be portraits could also indicate a bronze intended for such a private setting.[120] The black patina applied to *The Entombment* distinguishes it from Riccio's documented reliefs and may suggest that it was displayed in a scholar's private collection, possibly alongside patinated statuettes, rather than in a public religious setting. Although the composition of the scene does not allow all of the figures in *The Entombment* to be seen from any single position, the sculpture does appear to have been designed with a preferred angle from the viewer's right to left.[121] This distinction from Riccio's documented reliefs, which were originally presented in large religious spaces and all appear designed to be viewed frontally, again suggests that *The Entombment* was intended for a more intimate setting.

Figure 22
Comparison of male figure groups.

(a) Detail of *The Entombment* (fig. 1).

(b) Detail of Riccio, *Death,* from the Della Torre monument, 1516 – 1521, bronze, 37 × 49 cm, Musée du Louvre, Paris.

22a

22b

In addition to arguing against its origin in the Maffei altar, the evidence of Riccio's documented reliefs provides additional guidance as to the probable date of the National Gallery's *Entombment*. Comparison with the Della Torre reliefs has been used to argue that *The Entombment* was created in the same general period, 1516 – 1520. During the present examination it was noted that the same pair of embracing male figures appears in *The Entombment* and in *Death* from the Della Torre monument (fig. 22).[122] The more

careful modeling and greater relief of *The Entombment* figures strongly suggest that this motif originated in that relief and that the sketchier and less three-dimensional version on the Della Torre tomb reflects a later reinterpretation. The more thinly cast and conformal Della Torre bronzes appear to have been created well after the thick-walled *Entombment*, which more closely resembles the rather solidly cast True Cross reliefs. The shift in technique that separates *The Entombment* from the Della Torre panels is likely the result of Riccio's intensive efforts on the intervening project, the paschal candlestick, which contains nearly half of his large reliefs among its many separately cast parts.

 The Entombment would then appear to have been cast during the candlestick project and probably in its early stages. The sequence of payments to Riccio suggests that little of the candlestick was completed between 1507 and 1510; the substantial payments that began in 1513 likely correspond with the completion of major sections of the candlestick.[123] This interpretation correlates with the fact that Padua was under siege in 1509, during which time Riccio was forced to relocate parts of the candlestick.[124] Although the casting sequence needs to be explored in greater detail, the assembled construction almost certainly required the lowest register of the marine scenes to be completed first to serve as a basis for the preparation of the upper registers.[125] If so, the upper registers would likely have been cast between 1513 and 1516. In this context, the similarity of the higher tin alloy of *The Entombment* to the marine reliefs may be significant, suggesting that the National Gallery relief was also created between 1507 and 1513. *The Entombment* may represent a smaller scale commission taken up by Riccio during the significant delays in work on the candlestick. Riccio is thought to have begun fabricating statuettes at this time, including the only dated example, *Moses/ Zeus Ammon* from 1513.[126]

Conclusion

 The technical examination of Riccio's reliefs indicates that his primary emphasis was on the aesthetic qualities of his sculptures, visible and invisible. He consistently chose bronze for its antiquarian significance, and the very limited range of alloys identified speaks to a skilled founder's tight control over his materials. Consequently it is not possible to make a strong association between the alloys present in the documented works and their date. Variations were noted in tin content, likely reflecting different batches of metal prepared for different commissions. The slightly increased zinc content in the True Cross altar reliefs might be associated with their early date, while the slightly higher lead content in the Della Torre reliefs might reflect later production. The high tin content of *The Entombment*, which is less typical of Riccio's practice, more convincingly suggests an association with relief elements probably cast in the early stages of the paschal candlestick project. The consistency of Riccio's alloys is a valuable basis for the evaluation of unattributed reliefs and potentially other forms of sculpture.[127]

 The casting methods observed in Riccio's documented bronze reliefs present more recognizable changes over the course of his career and provide greater insight into the possible date of *The Entombment*. Throughout, Riccio used the direct lost-wax technique for the freedom it offered in modeling.

His application of complex layers of solid wax figures resulted in fairly thick models, and the successful casting of these bronzes is a testament to his skill. Although all of Riccio's reliefs are rather thick walled, a significant change occurred between those created for the True Cross altar around 1500 and the Della Torre monument two decades later. The method used for *The Entombment* falls between the techniques of these commissions but is more similar to the early reliefs. The thinner, more conformal casting of the Della Torre reliefs likely reflects developments in Riccio's approach made during the creation of the paschal candlestick, developments that are not generally reflected in *The Entombment*. Placing *The Entombment* in the period between 1507 and 1513 would help resolve the significant stylistic and technical gap between Riccio's Santo choir reliefs and the paschal candlestick. Questions remain about the casting techniques of the Santo choir reliefs and the candlestick because their backs were not accessible for examination. Future investigation of those sculptures will reveal more fully the evolution of Riccio's techniques during that period and, it is hoped, confirm this proposed dating of *The Entombment*.

The author is grateful to Clarice Smith, Michele Smith, and the Robert H. Smith Family Foundation for generously supporting his research.

1 Essential references are Denise Allen, cat. 27, in *Andrea Riccio: Renaissance Master of Bronze*, ed. Denise Allen (Frick Collection, New York, 2008), 264 – 271; Davide Gasparotto, cat. 19, in *Rinascimento e passione per l'antico: Andrea Riccio e il suo tempo*, ed. Andrea Bacchi and Luciana Giacomelli (Castello del Buonconsiglio, Trento, 2008), 280 – 81; Debra Pincus, "Andrea Briosco, detto Andrea Riccio (Rizzo, Crispus)," in *Dizionario Biografico degli Italiani* (Rome, 1972), 14:327 – 32; John Pope-Hennessy, cat. 203, in John Pope-Hennessy, *Renaissance Bronzes from the Samuel H. Kress Collection* (London, 1965), 60 – 61; Seymour de Ricci, *The Gustave Dreyfus Collection*, 2 vols. (Oxford, 1931); Leo Planiscig, *Andrea Riccio* (Vienna, 1927), 225 – 227.

2 For Riccio's biography, see Bacchi and Giacomelli 2008; Davide Banzato, *Andrea Briosco detto il Riccio — Mito pagano e cristianesimo nel Rinascimento: Il candelabro pasquale del Santo a Padova* (Milan, 2009).

3 Plaquettes attributed to Riccio bear various inscriptions; however, they were frequently reproduced and none are documented. See Shelley Sturman and Barbara Berrie, "Technical Examination of Riccio Plaquettes," in *Italian Plaquettes*, ed. Alison Luchs, Studies in the History of Art 22 (Washington, 1989), 175 – 188.

4 See Allen 2008, xi.

5 Pomponio Gaurico, *De Sculptura* (1504), ed. Paolo Cutolo (Naples, 1999) , 255; Volker Krahn, "Riccio's Formation and Early Career," in *Andrea Riccio: Renaissance Master of Bronze*, ed. Denise Allen and Peta Motture (New York, 2008), 5 – 7.

6 Riccio's monumental paschal candlestick can be considered a combination of reliefs and statuettes. See below and Shelley Sturman, Simona Cristanetti, Debra Pincus, Karen Serres, and Dylan Smith, "'Beautiful in Form and Execution': The Design and Construction of Andrea Riccio's Paschal Candlestick," *Burlington Magazine* 1279, no. 151 (October 2009): 666 – 672.

7 Richard Stone has suggested that three bronzes in Riccio's oeuvre may have been cast by others. Richard Stone, "Riccio's Technology and Connoisseurship," in Allen 2008, 93 – 96. *Shepherd with a Goat* and *Boy with a Goose* are indirectly cast, unlike the majority of Riccio's bronzes. *Shepherd with a Goat* has recently been found to have a chemical patination characteristic of Antico's bronzes and was almost certainly cast in Mantua. Dylan Smith and Shelley Sturman, "The Art and Innovation of Antico's Bronzes: A Technical Investigation," in *Antico: The Golden Age of the Renaissance Bronze,* ed. Eleonora Luciano (National Gallery of Art, Washington, 2011), 174. *Boy with a Goose* shares many stylistic features with the *Shepherd with a Goat*, and responsibility for its production is a subject for future debate. The paschal candlestick had not been technically examined at the time of Stone's publication and has proven to be executed in a manner that suggests Riccio cast it himself. Sturman et al. 2009.

8 Gaurico (1504) 1999, 255.

9 Antonio Sartori, *Documenti per la Storia dell'Arte a Padova*, ed. Clemente Fillarini (Vicenza, 1976), 248 – 253.

10 Planiscig 1927, an exhaustive monograph, includes many examples of these derivative works alongside Riccio's autograph works. See also Anthony Radcliffe, "Ricciana," *Burlington Magazine* 124, no. 952 (July 1982): 412 – 424.

11 Riccio's statuettes were first considered in an overview of the techniques of northern Italian bronzes in Richard Stone, "Antico and the Development of Bronze Casting in Italy at the End of the Quattrocento," *Metropolitan Museum Journal* 16 (1981): 111 – 113.

12 Sturman and Berrie 1989, 177.

13 Stone 2008, 79 – 94.

14 Sturman et al. 2009.

15　The total number of large reliefs produced by Riccio may change depending on how the assembled components of the paschal candlestick are counted. See discussion below.

16　Film x-radiography of *The Entombment* performed by the author at the National Gallery of Art. Exposures were made at 260 kV, 5 minutes, 5 mA, TFD 39 inches, with a 0.01 lead filter on the tube, and 0.005 and 0.01 lead screens on the front and back of the film respectively. The films were scanned and assembled to produce an overall image.

17　Most reliefs were analyzed with a Bruker Tracer III-V portable handheld spectrometer with a rhodium anode run at 40 kV, 1.8 µA and a 25.4 µm titanium/304.8 µm aluminum beam filter for 60 seconds of actual time and a 4.5 mm² spot size. Certain reliefs were analyzed with a Bruker Tracer III-SD, run at the same settings except at 14.1 µA. Quantification of elemental content was performed using PXRF software applying an empirical method using a custom calibration based on a set of thirty-two copper alloy reference standards that cover a broad range of major and minor elements typically found in historic alloys. The values reported reflect requantification in 2013 of prior results using updated calibrations for historic copper alloys. Multiple spots were analyzed on each relief to obtain a representative average. For overview and bibliography, see Dylan Smith, "Handheld Portable X-ray Fluorescence Analysis of Renaissance Bronzes: Practical Approaches to Quantification and Acquisition," in *Practical Handheld X-Ray Fluorescence for Art Conservation and Archaeology*, ed. Aaron Shugar and Jennifer Mass, Studies in Archaeological Sciences 3 (Leuven, Belgium, 2012), 37–74.

18　Six plaquettes of *The Entombment* are in the collection of the National Gallery of Art (1942.9.268, 1957.14.251, 1957.14.252, 1957.14.253, 1957.14.250, 1942.9.269). Four are presented in Sturman and Berrie 1989, which includes alloy analysis. No documented Riccio plaquettes are known, and the problems surrounding their attribution remain to be fully addressed. These include examples attributed to Ulocrino, which is now thought to be a pseudonym for Riccio. For this argument, see Bertrand Jestaz, "Riccio et Ulocrino," in Luchs 1989, 191–205. See also Davide Gasparotto, "Andrea Riccio a Venezia: Sui rilievi con le *Storie della Vera Croce* per l'altare Donà già in Santa Maria dei Servi," in *Tullio Lombardo: Scultore e Architetto nella Venezia del Rinascimento*, ed. Matteo Ceriana (Venice, 2007), 399.

19　Gasparotto, cat. 19, in Bacchi and Giacomelli 2008, 280–281.

20　Paul Mantz, "Musée retrospectif," *Gazette des Beaux-Arts* 19 (1865): 462. For mirror writing, see Allen 2008, 269.

21　Allen 2008, 267–268; for Mantegna, see Bacchi and Giacomelli 2008, 274–275; for Donatello, see Allen 2008, 275–276.

22　Meleager was recommended by Leon Battista Alberti (1404–1472) for depicting transport of a body. Pope-Hennessey 1965, 60–61.

23　Allen 2008, 267–268.

24　Mantz 1865, 462. For history, see Allen, cat. 27, in Allen 2008, 264; Gasparotto, cat. 19, in Bacchi and Giacomelli 2008, 280–281.

25　In 1878 *The Entombment* was displayed with Dreyfus bronzes in Paris. Eugène Piot, "La sculpture à L'Exposition Rétrospective du Trocadéro," *Gazette des Beaux-Arts* 43, no. 2 (1878): 588–590, repro. 821; "The International Exhibition: The Historic Galleries," *Athenæum: A Journal of Literature, Science, the Fine Arts, Music, and the Drama* 2, no. 2645 (July 6, 1878): 22. For photograph of installation, see Allen 2008, 267.

26　*Sculpture and Medals of the Renaissance from the Dreyfus Collection* (Fogg Art Museum, Cambridge, MA, 1932); Pope-Hennessy 1965, cat. 203, 60–61.

27　Overviews of the artist's career are included in Francesco Cessi, *Andrea Briosco detto il Riccio: Scultore, 1470–1532*, Collana Artisti Trentini 45 (Trento, 1965); John Pope-Hennessy, *Italian Renaissance Sculpture* (London, 1986), 2:332–334; Charles Avery, "Andrea Riccio," in *Grove Dictionary of Art*, ed. Jane Turner (New York, 2000), 2:1338–1342; Charles Avery, "Andrea Briosco detto il Riccio," in *Donatello e il suo tempo* (Musei Civici, Padua, Milan, 2001), 93–101; Mary Levkoff, "Riccio (Andrea Briosco)," in *The Encyclopedia of Sculpture*, ed. Antonia Bostrom (New York, 2004), 3:1423–1427.

28　Gasparotto, cat. 19, in Bacchi and Giacomelli 2008, 280–281; Allen, cat. 27, in Allen 2008, 264–271.

29　For recent dating, see Gasparotto, cat. 19, in Bacchi and Giacomelli 2008, 280–281; Allen, cat. 27, in Allen 2008, 264–271; Banzato 2009, 24; Davide Gasparotto and Luciana Giacomelli, "L'Altare Maffei in Sant'Eufemia a Verona, Giulio Della Torre e Andrea Riccio," *Nuovi Studi* 15 (2010): 120. For prior dating, Planiscig (1927, 225–227), Ricci (1931, 1:2), and Pincus (1972, 14:327–332) associated the relief with the early part of Riccio's career, 1501–1509. Pope-Hennessey (1965, 60–61) placed it in the mature period represented by the Santo reliefs and the paschal candlestick.

30　Gasparotto and Giacomelli 2010.

31　"Bronze" is generally used to describe any copper-based alloy. Here the technical definition is used: copper combined primarily with tin. Dylan Smith, analysis report for Andrea Briosco, called Riccio, *The Entombment* (NGA 1957.14.11), September 9, 2013, NGA object conservation department. Certain areas of the surface had higher tin (up to 13.9%), possibly due to segregation of the tin-rich phase in the alloy. Results with high tin that also had a slight enhancement of antimony, suggesting filtering by a surface tin-rich layer, were eliminated from the average.

Prior analyses by other XRF instruments produced nearly identical results with slight variation, mainly in tin content: Tracer III-V XRF with 2012 quantification, 11.1% tin, examination by Dylan Smith, Shelley Sturman, and Simona Cristanetti, in Dylan Smith, analysis report for Andrea Briosco, called Riccio, *The Entombment* (NGA 1957.14.11), July 16, 2009, NGA object conservation department; Kevex XRF, 12.3% tin, 4.4%

TABLE 1

Alloys of Riccio's reliefs determined by XRF analysis. (Elements are reported in wt%.)

RELIEF	DATE	COPPER	TIN	LEAD	ZINC
THE ENTOMBMENT	1507 – 1513	84.1	12.0	2.2	0.3

Documented (arranged chronologically)

RELIEF	DATE	COPPER	TIN	LEAD	ZINC
ALTAR OF THE TRUE CROSS					
Tabernacle door (right)	1498 – 1505	89.8	7.2	1.2	0.5
Tabernacle door (left)	1498 – 1505	89.6	7.2	1.4	0.5
The Vision of Constantine	1498 – 1505	89.9	5.6	1.4	1.3
The Discovery of the True Cross	1498 – 1505	90.1	7.0	1.2	0.4
The Victory of Constantine	1498 – 1505	88.7	7.8	1.1	0.8
The Proof of the True Cross	1498 – 1505	89.5	4.4	2.1	1.8
	avg	89.6	6.5	1.4	0.9
	2sd	0.9	2.6	0.7	1.1
SANTO CHOIR					
The Story of Judith	1506 – 1507	90.4	4.0	4.0	0.0
David and the Transport of the Ark of the Covenant	1506 – 1507	89.3	6.3	2.5	0.1
	avg	89.9	5.2	3.3	0.1
	2sd	1.5	3.4	2.2	0.1
PASCHAL CANDLESTICK*					
Marine procession (front)	1507 – 1513	87.4	10.2	1.0	0.1
Marine procession (altar)	1507 – 1513	87.8	8.7	2.1	0.1
Marine procession (choir)	1507 – 1513	87.8	9.3	1.6	0.1
Marine procession (balcony)	1507 – 1513	89.2	8.3	1.5	0.1
The Sacrifice to Risen Christ (front)	1513 – 1516	89.7	8.6	0.4	0.1
The Adoration of the Magi (altar)	1513 – 1516	90.9	6.7	1.0	0.1
The Entombment (choir)	1513 – 1516	90.3	7.7	1.0	0.1
The Descent into Limbo (balcony)	1513 – 1516	91.0	7.4	0.8	0.1
Centaurs (choir)	1513 – 1516	90.1	6.5	2.7	0.1
Centaurs (front)	1513 – 1516	91.2	7.3	0.8	0.1
Centaurs (altar)	1513 – 1516	90.4	7.7	1.2	0.1
Standing female figures (front)	1513 – 1516	90.3	6.6	1.9	0.2
Standing female figures (choir)	1513 – 1516	88.7	7.2	3.2	0.1
	avg	89.6	7.9	1.5	0.1
	2sd	2.6	2.3	1.6	0.1
DELLA TORRE MONUMENT					
Triumph of Humanist Virtue	1516 – 1521	87.2	6.1	4.0	0.7
Lecturing Scholar	1516 – 1521	87.9	5.2	4.4	0.5
Illness	1516 – 1521	87.7	6.7	3.6	0.3
Death	1516 – 1521	87.9	5.7	3.9	0.7
Funeral	1516 – 1521	85.4	7.5	5.2	0.2
Sacrifice to Asclepius	1516 – 1521	90.2	5.2	3.3	0.1
Underworld	1516 – 1521	87.7	6.8	4.0	0.1
Paradise	1516 – 1521	90.2	4.4	4.0	0.1
	avg	88.0	6.0	4.0	0.3
	2sd	3.2	2.1	1.2	0.5

Undocumented

RELIEF	DATE	COPPER	TIN	LEAD	ZINC
Saint Martin and the Beggar	c. 1513 – 1520	90.2	7.8	0.6	0.1
The Descent into Limbo	c. 1520 – 1530	90.1	3.8	2.4	0.6
The Resurrection	c. 1520 – 1530	87.7	6.1	3.7	0.3

Note: The result for each relief represents the average of three or more analyzed spots.
pr = present, below 0.1%; avg = group average; 2sd = 2 standard deviations for group
*Three reliefs have not been analyzed: centaurs (balcony), standing female figures (altar), and standing female figures (balcony).

IRON	NICKEL	SILVER	ARSENIC	ANTIMONY	SIZE (CM)	GILDING
0.7	pr	0.1	0.2	0.5	50.4 × 75.5	
0.2	0.1	0.2	0.3	0.4	89 × 23	mordant
0.3	0.1	0.2	0.4	0.5	89 × 23	mordant
0.3	0.1	0.2	0.5	0.6	38.9 × 50.5	mordant
0.2	0.1	0.2	0.3	0.5	38.6 × 50.6	mordant
0.4	0.1	0.2	0.4	0.5	38.8 × 51.2	mordant
0.6	0.2	0.2	0.6	0.7	39.8 × 50.8	mordant
0.3	0.1	0.2	0.4	0.5		
0.3	0.1	0.0	0.2	0.2		
0.4	pr	0.2	0.4	0.5	65 × 85	amalgam
0.6	0.1	0.2	0.4	0.5	65 × 85	amalgam
0.5	0.1	0.2	0.4	0.5		
0.3	—	0.0	0.0	0.1		
0.3	pr	0.3	0.2	0.4	~ 24 × 85	
0.3	pr	0.3	0.2	0.5	~ 24 × 85	
0.5	pr	0.3	0.1	0.3	~ 24 × 85	
0.3	pr	0.3	0.1	0.3	~ 24 × 85	
0.4	pr	0.2	0.3	0.3	~ 60 × 80	
0.5	pr	0.2	0.2	0.4	~ 60 × 80	
0.3	pr	0.2	0.2	0.2	~ 60 × 80	
0.3	pr	0.2	0.1	0.2	~ 60 × 80	
0.2	pr	0.2	0.1	0.3	~ 16 × 51	
0.1	pr	0.2	0.1	0.2	~ 16 × 51	
0.1	pr	0.2	0.2	0.1	~ 16 × 51	
0.4	pr	0.2	0.2	0.2	~ 57 × 39	
0.2	pr	0.2	0.2	0.3	~ 57 × 39	
0.3	pr	0.2	0.2	0.3		
0.3	—	0.1	0.1	0.2		
0.5	0.2	0.2	0.6	0.7	37 × 49	
0.4	0.1	0.2	0.5	0.9	37 × 49	
0.2	0.1	0.2	0.5	0.7	37 × 49	
0.3	0.1	0.2	0.5	0.7	37 × 49	
0.3	0.1	0.2	0.4	0.6	37 × 49	
0.2	0.1	0.2	0.4	0.4	37 × 49	
0.4	0.1	0.2	0.3	0.4	37 × 49	
0.3	0.1	0.2	0.4	0.5	37 × 49	
0.3	0.1	0.2	0.4	0.6		
0.2	0.1	0.1	0.2	0.3		
0.4	pr	0.1	0.3	0.4	74.6 × 54	
0.6	0.2	0.2	0.9	1.3	41 × 39.8	
0.7	0.1	0.1	0.7	0.7	41.5 × 39.5	

lead, 0.7% zinc, and similar trace elements, Carol Batchelder, analysis report for Andrea Briosco, called Riccio, *The Entombment* (NGA 1957.14.11), October 22, 1997, NGA scientific research department; Tracor XRF, 15% tin, 5% lead, only major elements were quantified manually, Sturman and Berrie 1989, 177.

32 The elemental levels generally considered indicative of deliberate alloying are zinc >2%, tin >2%, and lead >4%. These are based on published data on Renaissance medals as well as extensive data on Renaissance copper alloys collected by the National Gallery of Art. For the medals, see Lisha Glinsman and Lee-Ann Hayek, "A Multivariate Analysis of Renaissance Portrait Medals: An Expanded Nomenclature for Defining Alloy Composition," *Archaeometry* 35 (1993): 49–67. A companion study on Renaissance statuettes is planned.

In addition to these general levels, elemental content must also be evaluated based on the distribution found within each artist's production. Across Riccio's reliefs, no object has more than 2% zinc, and none has less than 3% tin. Lead content forms two slightly overlapping groups, one representing accidental inclusion containing about 0–2.5% (slightly lower than the general standard) and a deliberate group around 2.5–5.5%.

33 For discussion of trace elements in Renaissance alloys, see Smith 2012, 44–51; Glinsman and Hayek 1993, 49–67; Lisha Glinsman, "Renaissance Portrait Medals by Matteo de' Pasti: A Study of Their Casting Materials," in *Conservation Research*, Studies in the History of Art 57 (Washington, 1997), 97–99.

34 The use of bronze in antiquity was known notably from Pliny the Elder, *Natural History*, trans. J. Bostock and H. T. Riley (London, 1893).

35 The notable exception is Lorenzo Ghiberti, whose sculptures were in brass. For statuary, Gauricus indicated 12 parts tin to 100 parts of copper, and for reliefs, 10 parts tin were added. For bells, he recommended 30 parts tin, and for medals, he recommended reused copper combined with equal brass, adding small amounts of tin or calamine (zinc oxide). Gaurico (1504) 1999, 228–229.

36 For an introduction, see Stone 1981, 87–116.

37 Stone 1981, 87–116; Smith and Sturman 2011, 157–177. For a recent overview of early Renaissance replica casts, see Claudia Kryza-Gersch, "The Production of Multiple Small Bronzes in the Italian Renaissance: When, Where and Why (I)," *Ricce Minere* 1 (2014): 20–41.

38 For indirect casting by Riccio's contemporary Severo da Ravenna, see Dylan Smith, "Reconstructing the Casting Technique of Severo da Ravenna's *Neptune*," *Facture* 1 (2013): 167–181. For Riccio's statuettes, see Stone 2008, 89–90.

39 For a discussion of direct and indirect methods to cast high relief, see Francesca Bewer, Richard Stone, and Shelley Sturman, "Reconstructing the Casting Technique of Lorenzo Ghiberti's Gates of Paradise," in *The Gates of Paradise: Lorenzo Ghiberti's Renaissance Masterpiece*, ed. Gary Radke (High Museum of Art, Atlanta, 2007), 159–160.

40 These include latex and silicone rubber. Stone 2008, 85. The limitations of even modern flexible molding materials for casting in high relief are demonstrated by the reconstruction of Ghiberti's method using the indirect technique. Salvatore Siano, Piero Bertelli, Ferdinando Marinelli, and Marcello Miccio, "Casting the Panels of the Gates of Paradise" in Radke 2007, 140–155. Vannoccio Biringuccio, writing in 1540 after Riccio's career, discussed the indirect method, including the use of a mixture of glue to create flexible molds. Vannoccio Biringuccio, *De la Pirotechnia* (1540), trans. Cyril Stanley Smith and Martha Teach Gnudi (New York, 1959), 232. Even if this method may have been available earlier, glue molds could not have captured a design as complex and undercut as *The Entombment*.

41 For further discussion of the significance of Riccio's technique, see Peta Motture, "Riccio and the Small Bronze as Art Form," in Allen 2008, 67–68.

42 The author has observed that the tendency in the Renaissance is to repair rather than recast. Even in the case of indirect casting, the cost of fuel to re-melt the metal would have been an important consideration.

43 Period documents from the Santo record that a drawing was prepared for the paschal candlestick as well as a model of wood (and presumably wax?), but the design phase may have been more intensive because of its prominence and scale. Giovanni Luisetto, ed., *Archivio Sartori: Documenti di Storia e Arte Francescana* (Padua, 1983), 1:284–285. Much of this documentation is also given in association with Riccio's life. Sartori 1976, 198–203. See Sturman et al. 2009, 666.

44 The method suggested here draws upon ideas presented by Richard Stone for the Della Torre reliefs. Stone 2008, 86.

45 Compare to Ghiberti's reliefs in Bewer et al. 2007, 156–182, esp. 162–163.

46 Motture 2008, 68, 75; Andrew Lacey, "Experimenting with Riccio's Casting Method," paper presented at "The State of Play in Bronzes Research," Robert H. Smith Renaissance Sculpture Programme, Victoria and Albert Museum, October 6–7, 2011, online at Andrew Lacey, www.andrewlacey.com/andrewlacey.com/research_Riccio.html (accessed July 16, 2012).

47 The resemblance of the trees to sprues has been noted by Motture 2008, 68.

48 Robert van Langh, *Technical Studies of Renaissance Statuettes*, Technische Universiteit Delft (Wildert, Belgium, 2012), 105–125, esp. 113.

49 Traces of clay are preserved on the reverse. Coarse clay cores that included chopped straw have been found in the interior of Riccio's hollow-cast statuettes, where a fine texture was not necessary to achieve a finished surface. See Stone 2008, 91; Sturman et al. 2009, 670. Biringuccio (1540) 1959, 228–299, suggests mixing cloth clippings into the core while building up thinner layers of clay that are finely sifted on the outer surface.

50 This technique is markedly different from the modeling technique used by Ghiberti for the *Gates of Paradise*. Bewer et al. 2007, 162–163.

51 During examination of *The Entombment*, the iron pins were detected with a rare earth magnet or, where extracted, indicated in the x-radiograph by small dark spots, just visible in figure 3.

52 Stone 2008, 89–92.

53 In Ghiberti's reliefs, a single large central rod was used to brace the mold and allow straps to be attached around the outside. Bewer et al. 2007, 167, also 162–163.

54 A high tin content is recommended in Biringuccio (1540) 1959, 210: "From twelve [parts of tin] upwards is used for all other works that need it, either for hardness or to give them fluidity in casting by surpassing the degree of bronze."

55 Pomponius Gauricus' treatise included conversion equivalents for various modeling materials to bronze, including wax. Gaurico (1504) 1999, 230–231.

56 Motture 2008, 70.

57 Motture 2008, 68.

58 XRF analysis of the bridges also identified platinum, most likely associated with repatination of the surface of the repairs at a later date. For XRF method, see note 17. Platinum chloride as a patinating constituent began to be used in the early nineteenth century. David Scott, *Copper and Bronze in Art* (Los Angeles, 2002), 21.

59 Lap joints were found on the tail of the *Shouting Horseman*, a tendril of the Frick Collection oil lamp, and the strigil of the *Strigil Bearer*. Stone 2008, 88.

60 These restored limbs contain about 30% zinc, but 1% arsenic, suggesting the repair used copper that was not electrolytically refined. Platinum was found on these restorations as well, suggesting that the repatination of the bridge repairs occurred at the same time.

61 For discussion of black color, see Denise Allen, "Gold, Silver, and the Colors of Bronze," in Luciano 2011, 139–156; Richard Stone, "Understanding Antico's Patinas," in Luciano 2011, 181.

62 Václav Pitthard, Sabine Stanek, Martina Griesser, Helene Hanzer, and Claudia Kryza-Gersch, "Comprehensive Investigation of the 'Organic Patina' on Renaissance and Baroque Indoor Bronze Sculptures from the Collection of the Kunsthistorisches Museum, Vienna," in *Conservation Science*, ed. Joyce Townsend, Luciano Toniolo, and Francesca Cappitelli (Milan, 2008), 49–55. See also Richard Stone, "Organic Patinas on Small Bronzes of the Italian Renaissance," *Metropolitan Museum Journal* 45 (2010): 107–124; Richard Stone, Raymond White, and Norman Indictor, "Surface Composition of Some Italian Bronzes," in ICOM Committee for Conservation and Getty Conservation Institute, *Preprints of the 9th Triennial Meeting, Dresden*, ed. Kirsten Grimstad (Los Angeles, 1990), 2:568–573.

63 Smith and Sturman 2011, 157–158, and app. 1. Antico's reliefs can be lifted by a single person, and the presence of hangers on most of them indicates that they were not placed in a permanent setting.

64 Venetian door knockers, for example, have the iron striking surface cast into the bronze.

65 The application of the plaster while the relief was mounted is suggested by the presence of plaster around the outside of the back but not in the center.

66 Gaurico (1504) 1999, 255.

67 It is interesting to note that hollowing out from the back is a common practice in terracottas to reduce the thickness before firing.

68 An inscription records the donation of the altar and the Cross. Gasparotto 2007, 395; Adriana Augusti, "La Vittoria di Constantino su Massenzio," in *Donatello* 2001, 106–107, cat. 13.

69 Gasparatto 2007, 394–398.

70 A date of around 1500 is presented in Gasparatto 2007, 394–398, followed by Denise Allen in Allen 2008, 33, and argued on an iconological basis by Eveline Baseggio Omiccioli, "Andrea Riccio's Reliefs for the Altar of the True Cross in Santa Maria dei Servi, Venice: A Political Statement within the Sacred Walls," *Explorations in Renaissance Culture* 38 (2012): 101–121. Pope-Hennessy suggests soon after 1492. John Pope-Hennessy, "Italian Bronze Statuettes, 1," *Burlington Magazine* 105, no. 718 (January 1963): 18.

71 Dylan Smith, analysis report for two doors and four reliefs, the altar of the True Cross, April 14, 2008, NGA object conservation department, examination with Shelley Sturman; Dylan Smith, analysis report for two doors and four reliefs, the altar of the True Cross, May 31, 2012, NGA object conservation department.

72 In the past, it has been proposed that the tabernacle doors might not be by Riccio. Pope-Hennessy 1963, 18. Although bronze alloys like those identified in the True Cross reliefs may be present in Venetian sculptures, many documented works of the sixteenth century have quaternary alloys that contain several percent of zinc and lead as well as significant traces of arsenic and antimony. For examples, see Shelley Sturman and Dylan Smith, "Italian Renaissance Bronzes: Alloy Analysis, Artist and Interpretation," in *Carvings, Casts and Collectors: The Art of Renaissance Sculpture*, ed. Peta Motture, Emma Jones, and Dimitrios Zikos (London, 2013), 160–175. Quaternary alloys have also been identified in many undocumented Venetian objects. See Peta Motture, "The Production of Firedogs in Renaissance Venice," in *Large Bronzes in the Renaissance*, ed. Peta Motture, Studies in the History of Art 64 (Washington, 2003), 300–301.

73 These works are currently undergoing treatment to remove the later dark layers. Thanks to Serena Bidorini, conservator, and Claudia Cremonini, director, of the Ca' d'Oro, for allowing me access to *The Discovery of the True Cross* relief during treatment and sharing information regarding its condition. Natural patinas are primarily of a layer of cuprite. Scott 2002, 82, 329.

74 The gilding is mentioned only in Sybille Ebert-Schifferer, ed., *Natur und Antike in der Renaissance* (Frankfurt, 1986), 361–363.

75 Serena Bidorini, personal communication, February 28, 2013.

76 Transcribed and translated in Baseggio Omiccioli 2012, 113 – 114.

77 Future study of Bellano's techniques would define the relationship between his methods and those of Riccio's early career.

78 A further question is whether Riccio would have executed the works in Venice. They are not very large and could have been executed in Padua and then transported for installation.

79 For instance, Jacopo Sansovino's sacristy door reliefs (1546 – 1571) in San Marco, Venice, were indirectly cast. Shelley Sturman and Dylan Smith, "Examining Jacopo Sansovino's *Sacristy Door*: Preliminary Results," in *L'Industria Artistica del Bronzo del Rinascimento a Venezia e Nell'Italia Settentrionale*, ed. Matteo Ceriana and Victoria Avery (Venice, 2009), 447 – 458. The indirect technique would also preserve the original model, which is more critical as a reference for finishing when casting is executed by someone other than the artist.

80 Levkoff 2004, 1424.

81 Ebert-Schifferer 1986, 361 – 363.

82 Luisetto 1983, 1:284 – 285. Much of this documentation is also given in association with Riccio's life. Sartori 1976, 198 – 203.

83 Luisetto 1983, 1:284 – 285.

84 Riccio's panels are often interpreted as completing the earlier project, encouraged by the fact that Riccio had completed other commissions by Bellano, bronzes for the monument to Pietro Roccabonella in San Francesco, Padua, and terracotta figures for San Canziano, Padua. See Allen 2008, 7; Avery 2000, 2:1342.

85 Dylan Smith, analysis report, November 7, 2008, NGA object conservation department, examination with Shelley Sturman, Simona Cristanetti, Debra Pincus, and Karen Serres. Based on Renaissance sculptures examined by the author and others at the National Gallery of Art, the general level of lead considered a deliberate addition in Renaissance works is likely around 4%, although this amount is dependent on the particular practices of each artist. See Glinsman and Hayek 1993 for consideration of lead levels in medals.

86 The tin content is of greater significance because it represents deliberate alloying. Some variation in lead levels within the individual reliefs was observed, but the average levels are distinct.

87 This is *Shepherd with a Goat*, determined by XRF analysis, which also identified an Antico-type chemical patination. Smith and Sturman 2011, 174. This statuette is also an exception as an indirect cast. Stone 2008, 93 – 95.

88 Luisetto 1983, 1:284 – 286. The candlestick was later relocated to the side of the altar and also rotated. Sturman et al. 2009, 666 – 667. Davide Banzato, "Riccio and the Paschal Candlestick" in Allen 2008, 43; Banzato 2009, 48.

89 A lost lead inscription stated that Riccio would have finished in three years but for the war. Transcribed in Giannantonio Moschini, *Guida per la Città di Padova* (Venice, 1817), 57. See Banzato 2008, 42 – 43.

90 For interpretation, see Banzato 2008, 41 – 63.

91 Sturman et al. 2009, 667. Previously Stone had proposed that the candlestick "must have been cast in what were for Riccio massive sections," which was why he suggested that the artist would have needed the assistance of professional founders. Stone 2008, 95.

92 For the remaining registers, see Sturman et al. 2009, 667.

93 For a description of the alloys in the rest of the candlestick, see Sturman et al. 2009, 669. One of the centaur panels and two of the standing female figure panels were not accessible for analysis.

94 Sturman et al. 2009. For documents, see Luisetto 1983, 1:284 – 286.

95 Luisetto 1983, 1:284 – 286.

96 Anthony Radcliffe, "A Forgotten Masterpiece in Terracotta by Riccio," *Apollo* 118 (1983): 44.

97 A cast-in inscription was noted on the reverse of the Saint Martin relief during deinstallation of the exhibition *Andrea Riccio: Renaissance Master of Bronze* at the Frick Collection in 2008. It appears to be only four letters and not easily legible. For the exhibition, see Allen 2008.

98 Denise Allen, cat. 9, in Allen 2008, 152 – 157.

99 The original attribution by Planiscig (1927, 234 – 239) has not been questioned. For overview of dating, see Allen, cat. 9, in Allen 2008, 152n4.

100 Smith, analysis report, April 14, 2008; Dylan Smith, analysis report for *Saint Martin and the Beggar*, July 13, 2009, NGA object conservation department, examination with Shelley Sturman and Simona Cristanetti; Smith, analysis report, May 31, 2012.

101 Luciana Giacomelli and Andrea Tomezzali, "La lezione di medicina," cat. 94, in Bacchi and Giacomelli 2008, 442. The inscription ultimately used mentions only the paschal candlestick.

102 Rebekah Carson, *Andrea Riccio's Della Torre Tomb Monument: Humanism and Antiquarianism in Padua and Verona* (Toronto, 2010), 14; Giacomelli and Tomezzali, cat. 94, in Bacchi and Giacomelli 2008, 442; Anthony Radcliffe, "The Illness of the Professor/The Soul of the Professor in the Fortunate Woods," in *The Genius of Venice, 1500 – 1600*, ed. Jane Martineau and Charles Hope (London, 1983), 372 – 374; Radcliffe 1983a, 45. For the monument to Antonio Trombetta in the Santo, see Planiscig 1927, 408 – 410. Prior to 1516, Verona was still occupied by hostile forces. John Norwich, *A History of Venice* (New York, 1982), 390 – 433.

103 Rebekah Carson, "The Triumph of the Humanist Virtue," in Allen 2008, 285 – 286.

104 Carson 2010, 16 – 17.

105 Giacomelli and Tomezzali 2008, 442.

106 The portraits and sphinxes appear to remain in place; the putti are lost. See Caterina Brenzoni, "Il mausoleo della famiglia della Torre," in *I Santi Fermo e Rustico: Un Culto e una Chiesa in Verona* (Verona, 2004), 281 – 288.

107 Dylan Smith, analysis report, July 13, 2009, NGA object conservation department.

108 Future examination of the late Trombetta monument could help to confirm an association of this change with the date of these reliefs.

109 A more detailed exploration of the order of the Della Torre reliefs is planned for future publication.

110 Gasparatto and Giacomelli 2010, 115 – 127.

111 Gasparatto and Giacomelli 2010, 117; Luciana Giacomelli, "Resurrezione e Dicesa al limbo," cat. 98, in Bacchi and Giacomelli 2008, 458 – 461; cats. RF 1704, RF 1705, *Les Sculptures Européennes du Musée du Louvre* (Paris, 2006), 188. These reliefs were not discussed in the Frick catalog, Allen 2008. See also Timothy Knox, "Edward Cheney of Badger Hall: A Forgotten Collector of Italian Sculpture," *Sculpture Journal* 16, no. 1 (2007): 16.

112 Gasparatto and Giacomelli 2010, 118.

113 In the published reconstruction, a gap remains around *The Entombment*. Gasparatto and Giacomelli 2010, fig. 154. A different panel had been proposed previously. Giacomelli, cat. 98, in Bacchi and Giacomelli 2008, 458 – 461.

114 Smith, analysis report, July 13, 2009.

115 Notably, certain corner figures from the paschal candlestick contain similar levels of arsenic and antimony. Sturman et al. 2009, 669.

116 These marble frames were already in place in the early twentieth century, visible in a photograph published in Knox 2007, 13, fig. 9.

117 For an illustration of the altar, see Gasparatto and Giacomelli 2010, fig. 150.

118 Giacomelli 2008, 461. At least one late relief (1560) is known in Riccio's style executed by a follower. See Allen 2008, 116 – 121.

119 Allen 2008, 269.

120 Allen 2008, 269.

121 This point was observed by Denise Allen and incorporated into *The Entombment*'s display during the exhibition at the Frick Collection.

122 A similar motif with two women appears in *Paradise* from the Della Torre monument.

123 Radcliffe 1983a, 44. A sense of Riccio's progress is given by payments, if one assumes that these reflect the work completed. Documentation of the Santo choir reliefs provides a possible pay scale. Luisetto 1983, 1:284 – 286.

124 Norwich 1982, 390 – 433; Luisetto 1983, 1:284 – 286.

125 For more discussion, see Sturman et al. 2009.

126 Alexander Nagel, cat. 7, in Allen 2008, 134 – 143, and app., 317 – 320.

127 There is evidence, however, that Riccio selected different alloys depending on the form of his sculpture, and therefore a relief, a statuette, and a lamp may not be directly comparable.

References

ALLEN 2008 Allen, Denise, ed. *Andrea Riccio: Renaissance Master of Bronze*. Frick Collection, New York, 2008.

ALLEN 2011 Allen, Denise. "Gold, Silver, and the Colors of Bronze." In Luciano 2011, 139 – 156.

AUGUSTI 2001 Augusti, Adriana. "La Vittoria di Constantino su Massenzio." In *Donatello* 2001, 106 – 107.

AVERY 2000 Avery, Charles. "Andrea Riccio." In *Grove Dictionary of Art,* edited by Jane Turner (New York, 2000), 2:1338 – 1342.

AVERY 2001 Avery, Charles. "Andrea Briosco detto il Riccio." In *Donatello* 2001, 93 – 101.

BACCHI AND GIACOMELLI 2008 Bacchi, Andrea, and Luciana Giacomelli, eds. *Rinascimento e passione per l'antico: Andrea Riccio e il suo tempo*. Castello del Buonconsiglio, Trento, 2008.

BANZATO 2008 Banzato, Davide. "Riccio and the Paschal Candlestick." In Allen 2008, 41 – 63.

BANZATO 2009 Banzato, Davide. *Andrea Briosco detto il Riccio — Mito pagano e cristianesimo nel Rinascimento: Il candelabro pasquale del Santo a Padova*. Milan, 2009.

BASEGGIO OMICCIOLI 2012 Baseggio Omiccioli, Eveline. "Andrea Riccio's Reliefs for the Altar of the True Cross in Santa Maria dei Servi, Venice: A Political Statement within the Sacred Walls." *Explorations in Renaissance Culture* 38 (2012): 101 – 121.

BEWER ET AL. 2007 Bewer, Francesca, Richard Stone, and Shelley Sturman. "Reconstructing the Casting Technique of Lorenzo Ghiberti's Gates of Paradise." In Radke 2007, 156 – 182.

BIRINGUCCIO (1540) 1959 Biringuccio, Vannoccio. *De la Pirotechnia* (1540), translated by Cyril Stanley Smith and Martha Teach Gnudi. New York, 1959.

BRENZONI 2004 Brenzoni, Caterina. "Il mausoleo della famiglia della Torre." In *I Santi Fermo e Rustico: Un Culto e una Chiesa in Verona*, 281 – 288. Verona, 2004.

CARSON 2008 Carson, Rebekah. "The Triumph of Humanist Virtue." In Allen 2008, 285 – 289.

CARSON 2010 Carson, Rebekah. *Andrea Riccio's Della Torre Tomb Monument: Humanism and Antiquarianism in Padua and Verona*. Toronto, 2010.

CESSI 1965 Cessi, Francesco. *Andrea Briosco detto il Riccio: Scultore, 1470 – 1532*. Collana Artisti Trentini 45. Trento, 1965.

DONATELLO 2001 *Donatello e il suo tempo*. Musei Civici, Padua, Milan, 2001.

EBERT-SCHIFFERER 1986 Ebert-Schifferer, Sybille, ed. *Natur und Antike in der Renaissance*. Frankfurt, 1986.

GASPAROTTO 2007 Gasparotto, Davide. "Andrea Riccio a Venezia: Sui rilievi con le *Storie della Vera Croce* per l'altare Donà già in Santa Maria dei Servi." In *Tullio Lombardo: Scultore e Architetto nella Venezia del*

Rinascimento, edited by Matteo Ceriana, 389 – 410. Venice, 2007.

GASPAROTTO AND GIACOMELLI 2010 Gasparotto, Davide, and Luciana Giacomelli. "L'Altare Maffei in Sant'Eufemia a Verona, Giulio Della Torre e Andrea Riccio." *Nuovi Studi* 15 (2010): 115 – 127.

GAURICO (1504) 1999 Gaurico, Pomponio. *De Sculptura* (1504), edited by Paolo Cutolo. Naples, 1999.

GIACOMELLI 2008 Giacomelli, Luciana. "Resurrezione e Dicesa al limbo." In Bacchi and Giacomelli 2008, 458 – 461.

GIACOMELLI AND TOMEZZALI 2008 Giacomelli, Luciana, and Andrea Tomezzali. "La lezione di medicina." In Bacchi and Giacomelli 2008, 442 – 451.

GLINSMAN 1997 Glinsman, Lisha. "Renaissance Portrait Medals by Matteo de' Pasti: A Study of Their Casting Materials." In *Conservation Research*, 92 – 107. Studies in the History of Art 57. Washington, 1997.

GLINSMAN AND HAYEK 1993 Glinsman, Lisha, and Lee-Ann Hayek. "A Multivariate Analysis of Renaissance Portrait Medals: An Expanded Nomenclature for Defining Alloy Composition." *Archaeometry* 35 (1993): 49 – 67.

"INTERNATIONAL EXHIBITION" 1878 "The International Exhibition: The Historic Galleries." *Athenæum: A Journal of Literature, Science, the Fine Arts, Music, and the Drama* 2, no. 2645 (July 6, 1878): 21 – 24.

JESTAZ 1989 Jestaz, Bertrand. "Riccio et Ulocrino." In Luchs 1989, 191 – 205.

KNOX 2007 Knox, Timothy. "Edward Cheney of Badger Hall: A Forgotten Collector of Italian Sculpture." *Sculpture Journal* 16, no. 1 (2007): 5 – 20.

KRAHN 2008 Krahn, Volker. "Riccio's Formation and Early Career." In *Andrea Riccio: Renaissance Master of Bronze*, edited by Denise Allen and Peta Motture, 3 – 14. New York, 2008.

KRYZA-GERSCH 2014 Kryza-Gersch, Claudia. "The Production of Multiple Small Bronzes in the Italian Renaissance: When, Where and Why (I)." *Ricce Minere* 1 (2014): 20 – 41.

LANGH 2012 Langh, Robert van. *Technical Studies of Renaissance Statuettes*. Technische Universiteit Delft. Wildert, Belgium, 2012.

LEVKOFF 2004 Levkoff, Mary. "Riccio (Andrea Briosco)." In *The Encyclopedia of Sculpture*, edited by Antonia Bostrom, 3:1423 – 1427. New York, 2004.

LUCHS 1989 Luchs, Alison, ed. *Italian Plaquettes*. Studies in the History of Art 22. Washington, 1989.

LUCIANO 2011 Luciano, Eleanora, ed. *Antico: The Golden Age of the Renaissance Bronze*. National Gallery of Art, Washington, 2011.

LUISETTO 1983 Luisetto, Giovanni, ed. *Archivio Sartori: Documenti di Storia e Arte Francescana*. Vol. 1. Padua, 1983.

MANTZ 1865 Mantz, Paul. "Musée retrospectif." *Gazette des Beaux-Arts* 19 (1865): 462.

MOSCHINI 1817 Moschini, Giannantonio. *Guida per la Città di Padova*. Venice, 1817.

MOTTURE 2003 Motture, Peta. "The Production of Firedogs in Renaissance Venice." In *Large Bronzes in the Renaissance*, edited by Peta Motture, 277 – 308. Studies in the History of Art 64. Washington, 2003.

MOTTURE 2008 Motture, Peta. "Riccio and the Small Bronze as Art Form." In Allen 2008, 64 – 80.

NORWICH 1982 Norwich, John. *A History of Venice*. New York, 1982.

PINCUS 1972 Pincus, Debra. "Andrea Briosco, detto Andrea Riccio (Rizzo, Crispus)." In *Dizionario Biografico degli Italiani*, 14:327 – 32. Rome, 1972.

PIOT 1878 Piot, Eugène. "La sculpture à L'Exposition Rétrospective du Trocadéro." *Gazette des Beaux-Arts* 43, no. 2 (1878): 588 – 590.

PITTHARD ET AL. 2008 Pitthard, Václav, Sabine Stanek, Martina Griesser, Helene Hanzer, and Claudia Kryza-Gersch. "Comprehensive Investigation of the 'Organic Patina' on Renaissance and Baroque Indoor Bronze Sculptures from the Collection of the Kunsthistorisches Museum, Vienna." In *Conservation Science*, edited by Joyce Townsend, Luciano Toniolo, and Francesca Cappitelli, 49 – 55. Milan, 2008.

PLANISCIG 1927 Planiscig, Leo. *Andrea Riccio*. Vienna, 1927.

PLINY 1893 Pliny the Elder. *Natural History*, translated by J. Bostock and H. T. Riley. London, 1893.

POPE-HENNESSY 1963 Pope-Hennessy, John. "Italian Bronze Statuettes, 1." *Burlington Magazine* 105, no. 718 (January 1963): 14 – 23.

POPE-HENNESSY 1965 Pope-Hennessy, John. *Renaissance Bronzes from the Samuel H. Kress Collection*. London, 1965.

POPE-HENNESSY 1986 Pope-Hennessy, John. *Italian Renaissance Sculpture*. London, 1986.

RADCLIFFE 1982 Radcliffe, Anthony. "Ricciana." *Burlington Magazine* 124, no. 952 (July 1982): 412 – 424.

RADCLIFFE 1983A Radcliffe, Anthony. "A Forgotten Masterpiece in Terracotta by Riccio." *Apollo* 118 (1983): 40 – 48.

RADCLIFFE 1983B Radcliffe, Anthony. "The Illness of the Professor/The Soul of the Professor in the Fortunate Woods." In *The Genius of Venice, 1500 – 1600*, edited by Jane Martineau and Charles Hope, 372 – 374. London, 1983.

RADKE 2007 Radke, Gary, ed. *The Gates of Paradise: Lorenzo Ghiberti's Renaissance Masterpiece*. High Museum of Art, Atlanta, 2007.

RICCI 1931 Ricci, Seymour de. *The Gustave Dreyfus Collection*. 2 vols. Oxford, 1931.

SARTORI 1976 Sartori, Antonio. *Documenti per la Storia dell'Arte a Padova*, edited by Clemente Fillarini. Vicenza, 1976.

SCOTT 2002 Scott, David. *Copper and Bronze in Art*. Los Angeles, 2002.

SCULPTURE AND MEDALS 1932 *Sculpture and Medals of the Renaissance from the Dreyfus Collection.* Fogg Art Museum, Cambridge, MA, 1932.

SCULPTURES EUROPÉENNES 2006 *Les Sculptures Européennes du Musée du Louvre.* Paris, 2006.

SIANO ET AL. 2007 Siano, Salvatore, Piero Bertelli, Ferdinando Marinelli, and Marcello Miccio. "Casting the Panels of the Gates of Paradise." In Radke 2007, 140–155.

SMITH 2012 Smith, Dylan. "Handheld Portable X-ray Fluorescence Analysis of Renaissance Bronzes: Practical Approaches to Quantification and Acquisition." In *Practical Handheld X-Ray Fluorescence for Art Conservation and Archaeology*, edited by Aaron Shugar and Jennifer Mass, 37–74. Studies in Archaeological Sciences 3. Leuven, Belgium, 2012.

SMITH 2013 Smith, Dylan. "Reconstructing the Casting Technique of Severo da Ravenna's *Neptune.*" *Facture* 1 (2013): 167–181.

SMITH AND STURMAN 2011 Smith, Dylan, and Shelley Sturman. "The Art and Innovation of Antico's Bronzes: A Technical Investigation." In Luciano 2011, 157–177.

STONE 1981 Stone, Richard. "Antico and the Development of Bronze Casting in Italy at the End of the Quattrocento." *Metropolitan Museum Journal* 16 (1981): 87–116.

STONE 2008 Stone, Richard. "Riccio's Technology and Connoisseurship." In Allen 2008, 79–94.

STONE 2010 Stone, Richard. "Organic Patinas on Small Bronzes of the Italian Renaissance." *Metropolitan Museum Journal* 45 (2010): 107–124.

STONE 2011 Stone, Richard. "Understanding Antico's Patinas." In Luciano 2011, 178–182.

STONE ET AL. 1990 Stone, Richard, Raymond White, and Norman Indictor. "Surface Composition of Some Italian Bronzes." In ICOM Committee for Conservation and Getty Conservation Institute, *Preprints of the 9th Triennial Meeting, Dresden*, edited by Kirsten Grimstad, 2:568–573. Los Angeles, 1990.

STURMAN AND BERRIE 1989 Sturman, Shelley, and Barbara Berrie. "Technical Examination of Riccio Plaquettes." In Luchs 1989, 175–188.

STURMAN AND SMITH 2009 Sturman, Shelley, and Dylan Smith. "Examining Jacopo Sansovino's *Sacristy Door*: Preliminary Results." In *L'Industria Artistica del Bronzo del Rinascimento a Venezia e Nell'Italia Settentrionale*, edited by Matteo Ceriana and Victoria Avery, 447–458. Venice, 2009.

STURMAN AND SMITH 2013 Sturman, Shelley, and Dylan Smith. "Italian Renaissance Bronzes: Alloy Analysis, Artist and Interpretation." In *Carvings, Casts and Collectors: The Art of Renaissance Sculpture*, ed. Peta Motture, Emma Jones, and Dimitrios Zikos, 160–175. London, 2013.

STURMAN ET AL. 2009 Sturman, Shelley, Simona Cristanetti, Debra Pincus, Karen Serres, and Dylan Smith. "'Beautiful in Form and Execution': The Design and Construction of Andrea Riccio's Paschal Candlestick." *Burlington Magazine* 1279, no. 151 (October 2009): 666–672.

Auguste Rodin's Lifetime Bronze Sculptures in the Simpson Collection

Daphne Barbour and Lisha Deming Glinsman

Perhaps the greatest and most prolific sculptor of his time, Auguste Rodin (1840 – 1917) profited from technological advances in late nineteenth-century bronze-casting practices to serialize his sculpture. In 1916, he willed his art as well as the legal rights to reproduce his sculpture to the French government.[1] In doing so, he promoted his own legacy and authorized the continued production of his works after his death. Yet bronzes cast during Rodin's lifetime define his intrinsic aesthetic. The National Gallery of Art owns ten lifetime bronzes by Rodin,[2] seven gifted by his patron and friend Mrs. John Simpson (née Kate Seney). As "one of the few private collections anywhere that was assembled during Rodin's lifetime, with his participation, and that remains intact,"[3] the Simpson Collection in Washington provides a rare opportunity to study the artist's working methods firsthand.[4] Furthermore, the history of these bronzes, from Rodin to his patrons to the National Gallery, offers works whose provenance is impeccable and whose conditions are untainted by later alterations. Using the Simpson bronzes as a primary source, the present study examines the casting process, the metallurgical composition, and surface patination of these lifetime casts in the context of the sculptures' technical histories, with a special focus on the craftsmen who helped create them.

Historical Background

François Auguste René Rodin was born in Paris on November 12, 1840, the second child of Jean-Baptiste and Marie Rodin. Although of modest means, his father did not appear to object to his son's desire to become a sculptor. His mother, however, cautioned him: "Art, my son, rarely brings generous returns to its followers."[5] At fourteen, after a stint in a boarding school run by his uncle, Rodin enrolled in a school that introduced him to modeling and drawing from plaster casts as well as antiquities at the Musée du Louvre, Paris.[6] His true desire, however, remained to gain admission to the prestigious École des Beaux-Arts, for which he competed and failed three times.[7] His attempts to have his sculptures accepted into the official Salons fared equally poorly. Not until Rodin was thirty-five did his first work appear in the Paris Salon.[8] By 1879 his submissions were more favorably received, one earning an Honorable Mention.[9] A year later, the French government commissioned Rodin to design a sculptural portal, *The Gates*

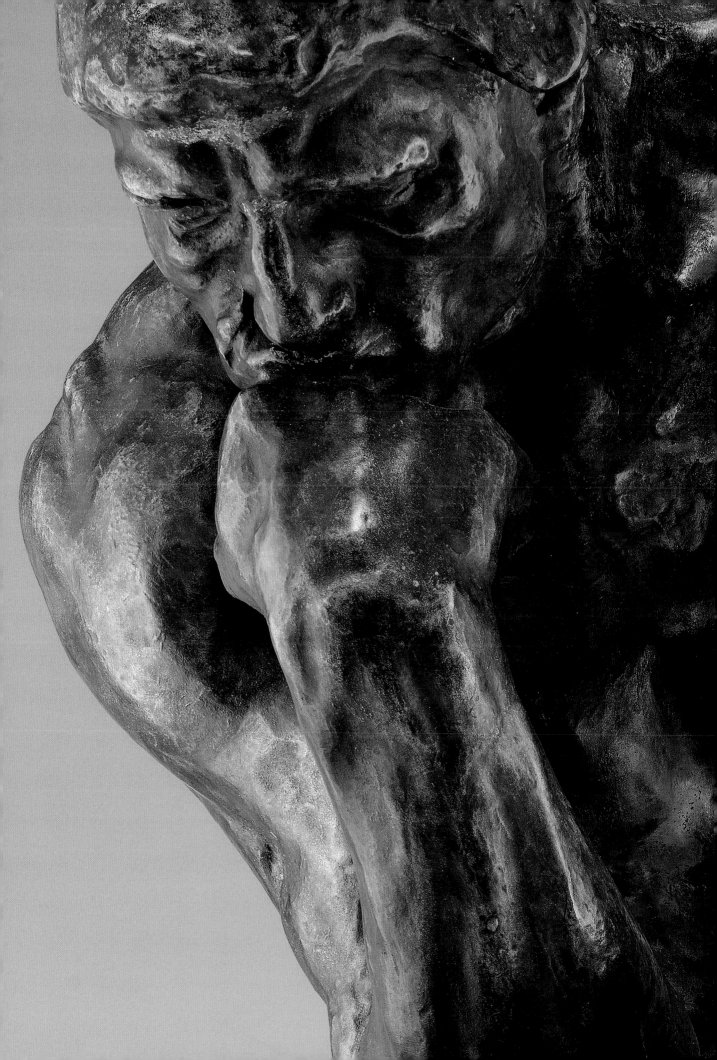

of Hell, for a new Museum of Decorative Arts. Although the museum was never built and the doors never cast into bronze during Rodin's lifetime, *The Gates of Hell,* an interpretation of Dante Alighieri's (1265 – 1321) *The Inferno,* provided him a means to create some of the most iconic works of late nineteenth-century sculpture, including two represented in the Simpson Collection, *The Thinker* and *The Kiss.*

Rodin was already a well-established artist when he met Mr. and Mrs. John W. Simpson in August 1902, introduced by the Parisian dealer Samuel Bing. Their meeting resulted in the commission of Kate Simpson's portrait in marble (fig. 1), an outcome Ruth Butler describes as "daring": no American woman had been so bold as to approach the world's most famous sculptor for a portrait.[10] Bing, for his role in the commission, received 5,000 francs, a percentage of the price the Simpsons paid for the bust.[11] But the fee for providing new patrons paled with the friendship and benefaction that ensued. Kate Simpson promoted Rodin's sculpture in the United States and played an important role in encouraging potential purchases, particularly by American museums. Their correspondence lasted until Rodin's death in 1917. When Kate Simpson closed her New York City home in the early 1940s, she chose to give her collection to the National Gallery because it would be kept together.[12] Her gift, including *The Thinker, Head of Balzac, The Walking Man, The Age of Bronze, La France, The Kiss,* and *A Burgher of Calais,* forms the core of the National Gallery collection of Rodin's sculpture today.

1

The Simpson bronzes
The first three bronzes purchased by the Simpsons — *The Thinker, Head of Balzac,* and *The Walking Man* (fig. 2) — were shipped to New York together with the marble portrait. "My dear M. Rodin, The four pieces arrived without accident," confirmed John Simpson in December 1903.[13] Illustrious and notorious, these first bronze sculptures represent pivotal moments in Rodin's career. *The Walking Man,* for example, was considered

Figure 1
Kate Simpson and Auguste Rodin in his
studio, 1903.

Figure 2
Auguste Rodin, *The Walking Man*
(L'Homme qui marche), model 1878 – 1900,
cast probably 1903, copper alloy, 85.1 cm
height, National Gallery of Art, Washing-
ton, Gift of Mrs. John W. Simpson.

2

by Rodin to be one of his best.[14] Assembled from a torso and legs that he had
modeled more than twenty years earlier for *Saint John the Baptist,* the sculp-
ture remained a fragment in its final form. It is Rodin who is credited with
exalting the fragment into a finished work, and *The Walking Man,* infused
with sheer movement absent context, even limbs that might reinforce the
expressive quality, is powerfully complete.

 The Thinker and *Head of Balzac,* two of Rodin's most famous works, both
derive from public commissions. Originally perched on the tympanum
of *The Gates of Hell, The Thinker* draws from Michelangelo's (1475 – 1564)
Il Penseroso (1520 – 1534) seated at the top of the tomb for Lorenzo, Duke of
Urbino, in the Medici Chapel, Florence. Clad in armor, the seated Lorenzo
rests his face on his left hand in a contemplative gesture. This notion of
contemplation is emphasized in Rodin's *Thinker,* whose brooding intensity
permeates every element of his being, from the furrowed brow, pursed lips
and gripping toes, to the rippling muscles of his nude body. *The Thinker* had
become a freestanding sculpture separate from *The Gates of Hell* almost
twenty years before its purchase by the Simpsons. Yet Rodin's interpreta-
tion of the subject of *The Gates of Hell,* Dante's *Inferno,* resonates within the
isolated figure. "The subject of Rodin's *Gates,*" notes Mary Levkoff, "became
the alienated, ambiguous nature of the human condition and humanity's
hopeless regret over mistakes or sins that could not be made right through
acknowledgement and repentance."[15] The importance of *The Thinker* to
Kate Simpson cannot be underestimated. Her scrapbook, also part of the

National Gallery collections, is full of newspaper clippings from that time that chronicle the growing popularity of *The Thinker*.[16]

Head of Balzac, on the other hand, is not symbolic but a portrait of the great novelist (fig. 3). Rodin never met Honoré Balzac, who had died forty years before his commemorative commission from the Société des Gens de Lettres in 1891. To compensate, Rodin immersed himself completely into learning as much as possible about Balzac, studying daguerreotypes for likenesses, reading his works, and interviewing family members.[17] The commission was fraught with controversy and delays. When the finished plaster sculpture was ultimately exhibited in 1898, the Société criticized the likeness, rescinded the coveted commission, and gave it to Alexandre Falguière (1831–1900) instead. History has judged Rodin's *Balzac* more favorably, and it ranks among his most widely recognized works. Many iterations of Rodin's *Balzac* exist. It is represented in the Simpson Collection as a head considered to be the final study complete with bulbous lips, deep-set eyes, and thick tufts of hair.[18]

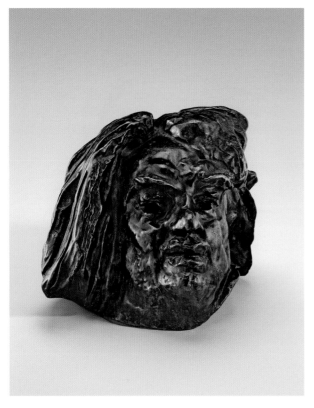

3

The Age of Bronze, as it is now titled, was likely the fourth bronze purchased by the Simpsons.[19] Like its predecessors, *The Age of Bronze* is central to Rodin's oeuvre. It was one of his first major works to have been accepted into a Paris Salon, exhibited in a larger scale (180 cm) in 1877.[20] According to the sculptor Truman Bartlett (1835–1922), who wrote a series of articles on Rodin in 1889, Rodin's aim was simply to "make a good piece of sculpture."[21] Yet the result, like so many of his works that push the boundaries of previously accepted artistic norms, brought Rodin fame and notoriety. The sculpture was conceived as an homage to the suffering endured by the French people during the Franco-Prussian War. Rodin eschewed the decorative

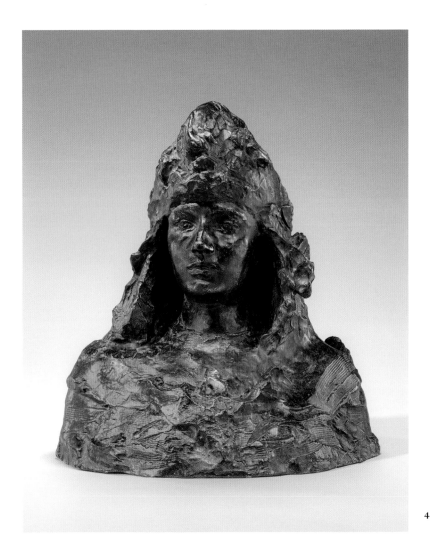

Figure 3
Auguste Rodin, *Head of Balzac,* model 1897,
cast by 1903, copper alloy, 16.5 cm height,
National Gallery of Art, Washington, Gift
of Mrs. John W. Simpson.

Figure 4
Auguste Rodin, *La France*, 1904, copper
alloy, 49.5 cm height, National Gallery
of Art, Washington, Gift of Mrs. John W.
Simpson.

4

qualities characteristic of art in the Second Empire, however, and in its *con-
trapposto* and anatomical precision the sculpture recalls Italian Renaissance
sculpture and the influence of Michelangelo.[22] Purity of form prevails to a
fault, and one critic erroneously denounced *The Age of Bronze* as "cast from
life."[23] By 1880, however, Rodin's sculpture was recognized for its technical
prowess and was purchased by the French government.

A less publicly acclaimed sculpture purchased by the Simpsons one
year later was *La France* (fig. 4). It is a portrait of the young sculptor Camille
Claudel (1864 – 1943), Rodin's lover throughout much of the 1880s, whose
youthful beauty is transformed into an allegory of France by the addition of
a helmet. Antoinette Le Normand-Romain has proposed that the Simpson
sculpture may have been the first bust of this subject cast into bronze.
The detail preserved as well as the depth of the recesses, she further notes,
suggest *La France* may have been created from the first plaster taken directly
from the mold of the clay model.[24]

In addition to *The Age of Bronze*, two other sculptures in the Simpson
Collection, *The Kiss* and *A Burgher of Calais,* are represented in a diminu-
tive scale — or reduced from larger, monumental sculpture.[25] The two are
likely gifts from Rodin. In fact *The Kiss* bears an inscription expressing
his friendship: "HOMAGE À MADAME KATE SIMPSON EN SOUVENIR DES
HEURES D'ATELIER SEPT 1902" (figs. 5, 6). Originally conceived as part of

5

6

The Gates of Hell, *The Kiss* was inspired by the tale of Paolo and Francesca from the fifth canto of Dante's *Inferno*. Paolo and Francesca, betrothed to Paolo's deformed brother, allegedly fell in love as they sat reading. (The book included on the back of the base of the sculpture is the only true reference to their tale.) Upon discovering the lovers, the enraged brother stabbed them to death, whereupon, according to Dante, they were condemned forever to the second circle of hell. Rodin separated *The Kiss* from *The Gates of Hell*, perhaps because the blissful lovers appeared incompatible with its implicit theme of "the tragedy of modern life."[26] The sculpture was first exhibited as an individual work in 1887, where one critic dubbed it *The Kiss*.[27]

The second reduction cast, *A Burgher of Calais*, is also derived from a public commission (fig. 7). Awarded the commission by the city of Calais for a monument to honor the six burghers who sacrificed their lives to spare the city in 1347, Rodin worked on this monumental sculpture throughout the 1880s. His conception included all six burghers, "heads and feet bare, with halters around their necks, and with the keys of the town and castle in their hands."[28] In 1895 Rodin had two of the six from the monumental sculpture reduced. No purchase or transport record of the Simpson *Burgher* is known, although it is documented to have been in their collection by 1905.[29]

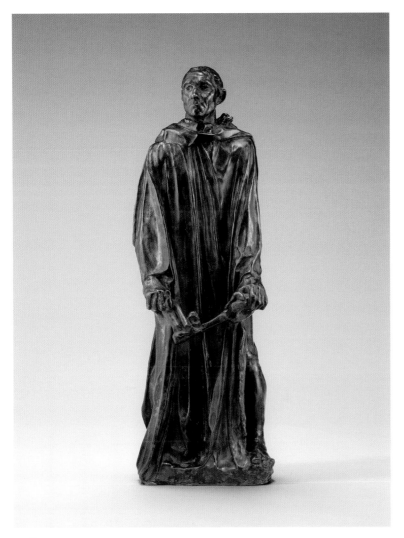

7

Figure 5
Auguste Rodin, *The Kiss (Le Baiser)*, model
1880 – 1887, cast 1898/1902, copper alloy,
24.7 cm height, National Gallery of Art,
Washington, Gift of Mrs. John W. Simpson.

Figure 6
Detail of *The Kiss (Le Baiser)* (fig. 5),
showing Auguste Rodin's inscription
and Collas inset below.

Figure 7
Auguste Rodin, *A Burgher of Calais
(Jean d'Aire)*, 1884 – 1889, reduction cast
probably 1895, copper alloy, 47 cm height,
National Gallery of Art, Washington,
Gift of Mrs. John W. Simpson.

Figure 8
Eugène Rudier beside an enlarged version
of *The Thinker (Le Penseur)*.

8

Practitioners of the Simpson bronzes

Study of Rodin's working methods for the Simpson bronzes leads
naturally to consideration of the practitioners to whom he entrusted the
casting of his sculpture into bronze. As his popularity increased, so, too,
did offers from founders who sought the prestige of working with him.
In fact, Rodin is documented to have worked with almost thirty different
foundries over the course of his career.[30] Extolling the virtues of lost-wax
casting, Rodin once wrote that it was the only method to reproduce his
sculpture.[31] Lost wax, the method employed in antiquity and throughout the
Renaissance, was considered by some to be more noble, less industrial than
sand-casting. A sculpture cast using the lost-wax method, they believed,
was more faithful to its original as it could generally be created in one pour,
eliminating the need to cut the sculpture into multiple sections required
of sand-casting. Ultimately, however, Rodin turned to sand-casting and to
Eugène Rudier (1878 – 1952), who specialized in this method (fig. 8). From
1902 on, coincidentally the same year Rodin first met the Simpsons, Rudier
became Rodin's primary founder, casting nearly five hundred bronzes in
Rodin's lifetime.[32]

Eugène Rudier, founder

After his father's death in 1897, Eugène Rudier assumed the operation of the family foundry together with his mother. They maintained Alexis Rudier's name, and although his foundry mark appears on many of Rodin's bronzes (but not the Simpsons' bronzes), Alexis Rudier never cast any sculptures for Rodin.[33] It was his son, Eugène Rudier, who became one of Rodin's trusted collaborators. Years after they had established a close relationship, Rudier reminisced that the artist was "not particularly friendly" at their first meeting. Rather than entrust Rudier with one of his own sculptures, Rodin initially assessed the founder's skill by giving him the work of another sculptor to cast into bronze. "When I returned with the finished product, Rodin looked at it for a long time and caressed it with his fingers. All he said was 'excellent.'"[34] Touted for his ability to cast bronze sculptures in one pour using the sand-cast method, Rudier further elevated his stature as a founder, comparable, even superior, to those using lost-wax casting. It is true that "the single casting" of an early bronze *Thinker* is recorded in a contemporary account.[35] Occasional invoices also indicate that select works by Rodin were cast in a single pour,[36] and recent research on *The Thinker* by Tonny Beentjes further supports the notion that many were cast in one piece.[37] Yet a definitive conclusion that Rudier cast all his bronze sculpture in one pour awaits research beyond the scope of this study. Technical examination in the course of this study, however (discussed below), indicates that the Simpson bronzes thought to have been cast by Rudier were, in fact, cast in one piece, although in a few examples the bases were cast separately and attached after casting.

9

None of the Simpson bronzes thought to have been cast by Rudier bears a foundry mark. Three — *The Age of Bronze*, *The Thinker,* and *La France* — have been identified as Rudier casts through archival evidence.[38] In addition, the cachet "A. Rodin" that Rudier was known to have used is affixed to the interior of these three sculptures (fig. 9) as well to the interior of as *The Walking Man*.[39] The preponderance of evidence suggests, therefore, that four Simpson bronzes were cast by Rudier despite the absence of foundry marks.

Ferdinand Barbedienne, founder

Rodin's arrangement with Rudier did not preclude work with other foundries. In fact, the only Simpson bronze to bear a foundry mark, *The Kiss,* is inscribed "F. Barbedienne, Fondeur." Perhaps the most famous Parisian foundry at that time, Barbedienne was known especially for its bronze reductions. Established by Ferdinand Barbedienne (1810 – 1892), the foundry employed Achille Collas, who invented and maintained the rights to a reducing machine. "Exploiting the Collas process after 1839," explains Jacques de Caso, "Barbedienne becomes the living example of serial sculpture."[40] The National Gallery bronze, for example, is one of sixty-nine casts in the 25 centimeter height size.[41] That it is a Collas reduction is clearly marked in a circular inset noting, "reduction mecanique A. Collas brevete" (see fig. 6).[42] Rodin himself apparently claimed, "I am not taken with these little casts in various sizes."[43] Yet the bronze was presented as a gift to Kate Simpson and bears an inscription to her.

Jean Limet, patinator

The final stage in bronze production was the application of a surface treatment known as a patina applied by specialist patinators (*patineurs*). For Rodin, this ultimate finish was frequently entrusted to Jean François Germain Limet (1855–1941), his premier patinator. From 1900 on, Limet worked with Rodin as both a patinator and photographer (fig. 10).[44] From surviving correspondence, Limet is known to have patinated some of the Simpson bronzes. "My dear master," wrote Limet to Rodin in July 1903, "I am responding to your letter of the 12th. I prefer to return to Paris to do the patinas for your American client. I will be in Paris Thursday evening and I hope that The Thinker will be ready" (fig. 11).[45] The American client to whom he referred was Kate Simpson, whose *Thinker* was shipped to New York in September of that same year,[46] together with *Head of Balzac*

Figure 9
Interior of *The Thinker* (*Le Penseur*) (see fig. 16), revealing cachet associated with the Rudier foundry.

Figure 10
Jean Limet and his son, Jean Limet, in their Paris studio, 1938.

Figure 11
Letter from Jean Limet to Auguste Rodin, July 13, 1903, on patinating the Simpson *Thinker* (see fig. 16).

10

11

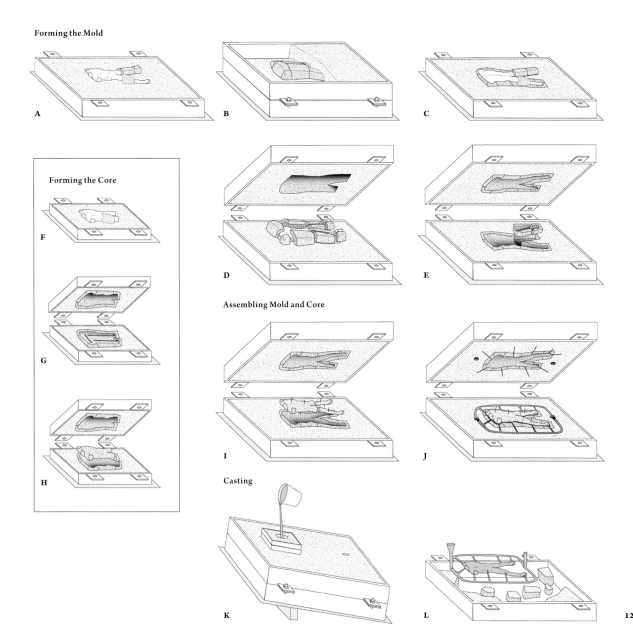

Forming the Mold

A

B

C

Forming the Core

F

G

H

D

E

Assembling Mold and Core

I

J

Casting

K

L

12

and *The Walking Man*, also patinated by Limet. Archival evidence indicates that *La France*, which was not purchased by the Simpsons until several years later, was sent to Limet for patinating as well.[47]

Trained as a landscape painter but unable to support a wife and two children by painting, Limet had turned to patinating bronze sculpture as his primary profession. He also practiced photography, photographing Rodin's sculpture for catalogs and other purposes.[48] Hélène Pinet has suggested it was his studio neighbor the sculptor Jean-Joseph Carriès (1855–1894) who may have encouraged Limet to become a patinator.[49] Carriès himself had experimented with colorful bronze patinas in conjunction with the founder Pierre Bingen (1842–after 1903), who had worked for Rodin in the 1880s. Through Carriès, Limet met Bingen, with whom he worked briefly and formulated patination recipes.[50] It is also purported that Carriès introduced Limet to Rodin.[51] Carriès embraced the notion shared by his contemporaries that the color of sculpture was not so much polychromy but a play of color

values, exemplars of the artist's ability to bring monochromatic materials such as bronze or marble to life.[52] Limet's patinas realize the same ideal.

Another young artist who studied with Carriès, worked with Bingen until he owned his own foundry, and created his own recipes for bronze patinas was the American Paul Wayland Bartlett (1865–1925). Bartlett, known to Rodin originally through his father, the sculptor Truman Bartlett, experimented with new formulations for patinas and documented his findings in a notebook that was ultimately published.[53] Today young Bartlett's recipes are invaluable, as neither Limet nor Bingen's formulas for patinas are known.[54] There are, however, a few recipes recorded in correspondence or notes preserved in the files of the Musée Rodin that have provided additional insight into Limet's preferred ingredients.[55]

Examination and Technical Study

Technical analyses of the Rodin bronzes in the National Gallery collections were first undertaken for the National Gallery of Art Systematic Catalogue in the 1990s. At that time, the bronzes were examined using x-radiography to reveal their internal structures and x-ray fluorescence analysis (XRF) to determine their alloy compositions.[56] Patinas were sampled and analyzed using x-ray diffraction analysis (XRD).[57] The scope of the original study was broadened here to address new questions posed in subsequent publications and archival records, including contemporaneous correspondence that addressed technical issues. To this end, additional analyses were undertaken including XRF with updated equipment, polarized light microscopy (PLM), scanning electron microscopy with energy dispersive x-ray analysis (SEM-EDX), and Fourier transform infrared spectroscopy (FTIR).[58]

Sand-casting

Technical examination established that all the bronzes in the Simpson Collection were sand-cast.[59] (See figure 12 for a schematic diagram of the sand-casting process, each step identified by a capital letter and described below.) In traditional sand-casting, the founder began with a model, generally a plaster version of the original sculpture. The model, dusted with a separator such as charcoal powder, was then placed into an open flask, or drag, and partially filled with a special sand-clay mixture. Carefully molded sand pieces (false cores or keys) were packed around the contours of the model to compensate for undercut areas (A). A second open flask, the cope, was placed onto the drag, and the two flasks were fastened together. Sand was then packed around the remaining half of the model (B). Once filled, the mold was turned over, and the same process of packing sand and creating keys around the model was repeated on the back (C). The drag was removed and inverted, revealing a cavity created by the keys. They were then lifted carefully off the model (D). The two flasks together constitute the mold (E).[60] To facilitate sand-casting a large or complex sculpture, founders commonly cast the sculpture in several pieces that were later joined. Each separate piece required its own mold, although, depending on the size, several might be placed in the same flask.

If the cast sculpture was to be hollow, a sand core was needed, which generally required a second, separate manufacture. According to Rodin's

Figure 12
Diagram of sand-casting. A plaster model of the original sculpture was pressed into sand packed in the lower flask (drag); sand keys were packed around exposed areas of the model (A). A second open flask (cope) was placed on top of the drag, and sand was packed around the model and its keys (B). Once filled, the mold was inverted, and the same keying and packing of sand was done to the other side of the model (C). The drag was removed, and the sand keys were carefully lifted off (D). The two flasks together constituted the mold (E). In different flasks, a plaster piece of the sculpture was molded to create the core (F) in a manner similar to steps A–D. The cores were formed over metal armatures (G). The cores were removed (H) and returned to the mold of entire sculpture in preparation for casting the bronze sculpture (I). Channels for gates and vents for molten metal during bronze-casting were carved directly into sand mold (J). The flasks were clamped together, and molten metal was poured into the mold from a crucible (K). The bronze sculpture was removed from mold, showing remnants of the casting process that would be removed during the finishing process (L).

student, Malvina Hoffman, the sand core was formed directly in the mold prepared for the bronze.[61] Alternatively, to avoid disrupting the surrounding sand mixture and damaging the mold when making a core in situ, cores could have their own molding system. One method simply repeated the steps to make the mold described above by placing the plaster model into a separate flask partially filled with sand and then packing sand into the rest of the flask (F–H). However, Beentjes' research suggests that Rudier created his own sand-casting method.[62] He essentially modified the process, from creating individual molds for the different pieces of the sculpture to be cast in bronze, to creating individual molds for different sections of the sand core. In this scenario, the plaster model was placed into the flasks and packed with sand to create the mold as described above. Then the model was cut into pieces, and each piece was molded. Those individual molds were used to create sand cores (often formed over metal armatures) (see F–H). Using Rudier's approach, the founder then returned the sand core sections to the cavity of the mold for the entire sculpture, in anticipation of casting it into bronze in one piece (I). Core sections were then shaved back so that they were slightly smaller than the cavity, the difference in size ultimately determining the thickness of the bronze sculpture when cast. When complete, cores were secured using small iron pins. Channels for the molten metal (gates) and vents to allow gases to escape while the metal cooled were carved directly into the sand within the mold (J). An opening through which the molten metal could be poured and linked to the gating and venting system was also created. The mold and core were then heated to eliminate any moisture within the sand and to bind the sand mixture. Finally cope and drag were clamped together, and molten metal poured from a crucible into the mold (K).

After the molten metal cooled, the bronze casting was extracted from the mold (L). Core material was generally removed, and the bronze was cleansed, often with acid (pickling). The surface was then chased by a specialist, the *ciseleur*, to remove remnants or imperfections from the casting process.

Rudier was not the first founder to sand-cast bronze sculpture in one piece.[63] He was the first, however, to adapt the technique to accommodate larger works. Casting a bronze sculpture in one piece eliminated the laborious process of mechanical assembly after casting. In addition, the seamless bronze was aesthetically more pleasing as joins were not visible on the exterior.

Casting *The Age of Bronze*

The National Gallery's *Age of Bronze* (fig. 13) is one of three cast in the 104 centimeter height scale during Rodin's lifetime. An understanding of its fabrication along with the facture of other Simpson bronzes was determined by visual, microscopic, and x-radiographic examination. Visual examination revealed that *The Age of Bronze* was cast in two sections, the figure and its base. Radiography confirmed that the figure was cast in one piece. It also provided a glimpse into the casting process, for the skilled founders left little trace on the exterior (fig. 14). Jagged white lines present in the radiograph in the middle of both shins, at the bicep and wrist of the right arm, and above

Figure 13
Auguste Rodin, *The Age of Bronze (L'Age d'Airain)*, model 1875–1876, cast 1903–1904, copper alloy, 104.1 cm height, National Gallery of Art, Washington, Gift of Mrs. John W. Simpson.

Figure 14
X-radiograph of *The Age of Bronze (L'Age d'Airain)* (fig. 13), showing core-to-core joins present as jagged lines in the shins, bicep and wrist of the right arm, and above the elbow in the left arm.

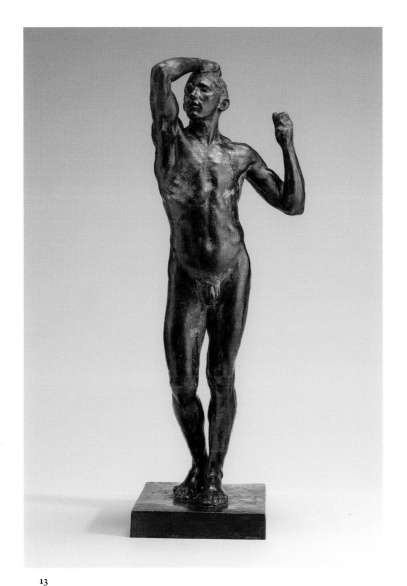

13

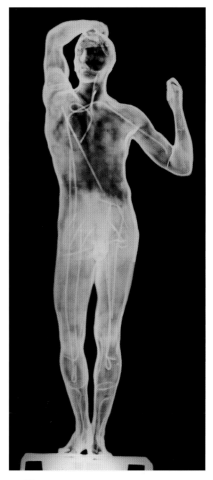

14

the elbow on the left arm identify the juncture of sand core pieces where molten metal seeped between the sections inside the sculpture. A section in the form of a U was cut from the back of the head to provide access to the interior of the sculpture so that the sand core could be removed after casting. Sand was not removed from the bottom half of the sculpture, however, but left as a counterweight for the top-heavy sculpture. Other remnants of the casting process include slender iron core pins intended to secure the sand core during casting. In the radiograph they are visible in the torso as thin white lines. Metal tubes and rods of the armature, wrapped with wire, are evident throughout the interior. Wrapping the armature enhanced the adhesion of the core sand to the internal metal support. The armatures conform to the length of the individual sand core sections. They are visible, for example, in the rods bent within the calves and were clearly inserted for the core alone rather than to provide internal support to the finished sculpture. Channels (veins) carved into the core on both side of the groin anticipate the need for extra support to the sculpture in those areas, as the channels accumulate additional bronze when poured. Three parallel lines on the right and two on the left reveal the thick metal veins added to reinforce the legs (see fig. 14).

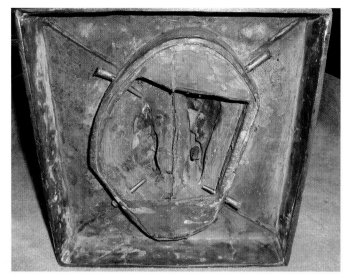

15

After casting and chasing, the figure and base were joined using mechanical joins (fig. 15). Cast metal extensions that protrude from the underside of the feet were hammered into the oval sleeves of the separately cast base. The sections were firmly secured using four pins hammered through pre-drilled holes. On the exterior of the base, this join appears as the solitary hairline seam on an otherwise seamless sculpture. Beautifully integrated, the imperceptible seam remains a testament to the superior quality of workmanship in Rudier's foundry.

Casting *The Thinker*

Like *The Age of Bronze* (excluding the base), the Simpson *Thinker* (fig. 16) was cast in one piece. Le Normand-Romain has identified it with the one described as "acq. 1903: this bronze with no foundry mark, probably corresponds to the first *Thinker* cast by Alexis Rudier, 'in one piece,' delivered to Rodin in 1903 just before the small *Walking Man*."[64] Technical evidence supports this assertion. As revealed in the radiograph (fig. 17), jagged lines (core-to-core joins) delineating separately molded sand core sections are present on both thighs and the left shoulder. Examination of the interior further reveals lines of excess metal that seeped into the juncture of separate core sections seen, for example, at the intersection of the right leg and thigh (fig. 18). C-shaped bronze brackets, integral to the cast and created by excavating the core in those areas (like the veins identified in the groin of *The Age of Bronze* [see fig. 14] that follow the juncture of the support and the seated figure), provide reinforcement to that central area. Similar but cropped brackets that appear as truncated pins are also present at the connection of the right foot and base. In contrast to the sand core left as ballast within *The Age of Bronze*, *The Thinker* contains a lead block poured directly into its interior as a counterweight to the forward cant of the seated figure. Here the core was removed from within the sculpture overall. However, core armatures similar to those seen inside *The Age of Bronze* undulate down both legs and extend along both arms.

The Thinker in the scale of the Simpson version (71.5 cm height) was cast almost thirty times by Rudier between 1902 and 1930. Other founders,

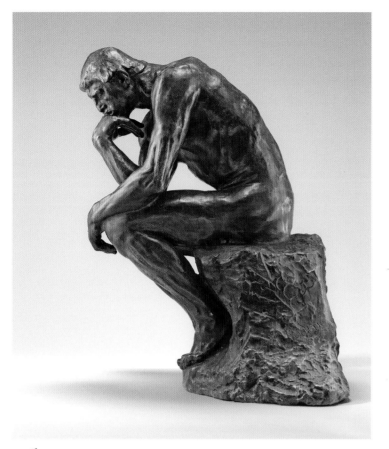

16

17

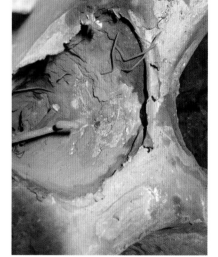

18

Figure 15
Underside of *The Age of Bronze (L'Age d'Airain)* (fig. 13), showing mechanical joins — sleeve joins reinforced using pins — that attach the figure to its base.

Figure 16
Auguste Rodin, *The Thinker (Le Penseur)*, model 1880, cast by 1903, copper alloy, 71.5 cm height, National Gallery of Art, Washington, Gift of Mrs. John W. Simpson.

Figure 17
X-radiograph of *The Thinker (Le Penseur)* (fig. 16), showing core-to-core joins present as white lines around the thigh and the lead counterweight undersupport.

Figure 18
Interior of *The Thinker (Le Penseur)* (fig. 16), showing the juncture of two separate core sections inside the right thigh identified by excess metal along the juncture.

including Eugène Rudier's uncle François Rudier, cast three bronze *Thinker*s of a similar scale one year earlier.[65] The notion of multiples was not always appealing to Rodin's clients, however, and caused Kate Simpson to fret, "An artist asked me if you had patented your "Thinker" because he told me that one can buy it in smaller dimensions in stores of the type of the Bon Marché, etc."[66]

Metallurgical analyses of the Simpson bronzes

To determine the metallurgical composition of the Simpson bronzes, analyses of the elemental surface composition were undertaken using XRF. Results derived from many readings of each sculpture taken from areas without patina, unless otherwise noted, are reported in table 1. Elemental analyses also indicate that the sculptures can be categorized as true bronzes (an alloy consisting of mainly copper and tin) or brasses (an alloy consisting of mainly copper and zinc), although all have been referred to as "bronzes" in a generic sense. Notably, the sculptures identified as cast by Rudier, through archival documentation as well the presence of the cachet "A. RODIN" associated with that foundry, are additionally linked by their classification as low tin bronzes (see table 1). The alloys of *The Thinker*, *The Walking Man*, *The Age of Bronze*, and *La France* are similar (approximately 94% copper with 4% tin). At the time that these four Simpson bronzes were cast by Rudier, there were six hundred foundries operating in Paris, and Rudier was certainly not the only one to use traditional bronze alloys. However, the compositional similarities of these four sculptures support their association with each other and a single foundry. Furthermore, other bronzes cast by Rudier and analyzed separately also have compositions similar to those of the four noted above.[67] The three diminutive sculptures not cast by Rudier were identified as brasses, a metal less expensive than bronze. *The Kiss* and *Head of Balzac* (approximately 88% and 84% copper, 8.4% and 9.7% zinc, with 3% and 6% tin, respectively) contain less zinc and more tin than *A Burgher of Calais* (approximately 84% copper, 13.5% zinc, with a small amount — 3% — of tin present).

TABLE 1

Alloy composition of Auguste Rodin's Simpson bronzes at the National Gallery of Art, determined by XRF analysis. (Elements are reported in wt%.)

SCULPTURE	COPPER	TIN	ZINC	LEAD	ARSENIC	NICKEL	SILVER	ANTIMONY	IRON
The Thinker	94.7	4.0	1.2	0.1	0.2	bdl	bdl	bdl	0.1
The Walking Man	94.1	4.1	0.8	0.3	0.2	bdl	bdl	bdl	*
The Age of Bronze	93.7	5.0	0.7	0.1	0.1	bdl	bdl	bdl	*
La France	93.4	4.9	1.0	0.1	0.1	bdl	bdl	bdl	*
The Kiss	87.7	3.1	8.4	0.4	0.2	bdl	bdl	bdl	0.3
Head of Balzac	84.3	5.7	9.7	0.6	0.2	bdl	bdl	bdl	0.2
A Burgher of Calais	83.4	2.6	13.4	0.6	0.2	bdl	bdl	bdl	0.1

bdl = below detection limits (200 ppm)
* denotes patinated areas

Surface patination

Once in a condition deemed ready for patination, the newly cast and chased sculpture was colored using carefully crafted solutions of dilute acid and metal salts that reacted with the surface of the bronze to form a layer of colored corrosion products, the patina (figs. 19, 20). Paul Wayland Bartlett wrote in his handbook on patination: "The patina may be briefly described as the skin of the bronze, having a texture and a beauty of its own. It is a permanent alteration or corrosion of the surface of the metal. It may be produced by the slow action of ages; thus the lovely green patina which spreads, like a varying film of delicate undressed kid, over antique bronzes, is in reality time-honored rust."[68]

Rodin, as previously noted, often entrusted this vital process to the patinator, Jean Limet. The former director of the Musée Rodin, Monique Laurent, observed, "The importance of the role played by this patinator for the sculptor merits a pause here, for his correspondence shows that a climate of great confidence, hardly the rule for Rodin, whose several collaborators deplored his distrust and changeable humor, reigned constantly between the two men."[69] The degree to which Limet or Rodin ultimately selected the palette of the patina for Rodin's sculpture apparently varied. Pinet has proposed that the photographer Limet attempted to bring the same tonalities achieved with his photographic processes to the palette of his bronze patinas.[70] It is fair to assume that when Limet was working at his studio in Cayeux-sur-Mer, several hundred miles from Paris, he relied on his own judgment for his patinas. In the case of the three Simpson bronzes shipped to New York in the fall of 1903, however, Limet evidently worked in his Paris studio, as his letter of July 1903 suggests.[71] There he would have been subject to Rodin's approval. Correspondence preserved in the Musée Rodin Archives suggests both sculptor and patinator offered opinions in the course of their long collaboration. "My Dear Limet, absolutely do not touch the torso,"[72] warned Rodin on one occasion. On another he instructed, "The red of the hand in bronze is admirable. Would you be so kind as to collect at the rue de Varenne the one that you patinated black and do it the same way."[73]

The patina of The Walking Man

The surface of *The Walking Man* appears to have been created through the layering of chemicals that collectively impart dark overtones ranging from black on the right thigh, mossy brown on the left thigh, to bright green on the left hip and buttock. Subtle hues in the patina were achieved through strategic abrasion of the dark outer layer to reveal lighter or brighter shades of green below, creating a play of color values that brought the monochrome bronze to life. Preliminary analyses of the light green layer using XRF and XRD indicate it was created using a copper nitrate solution. These results are substantiated by supplies such as copper and ferric nitrates listed among the items purchased by Limet from Poulenc Frères, a local artist supply store that provided quality chemicals to scientists, artists, and photographers (fig. 21). Further evaluation of the analyses identified two different forms of copper nitrate hydroxide hydrates — orthorhombic gerhardtite and monoclinic rouaite. The latter, formed only at high temperatures, indicates that a torch was used to apply the patina.[74] Color was gradually built up by

Detail of *La France* (fig. 4), showing variation in patina.

Figure 20
Detail of *The Age of Bronze* (fig. 13), showing variation in patina.

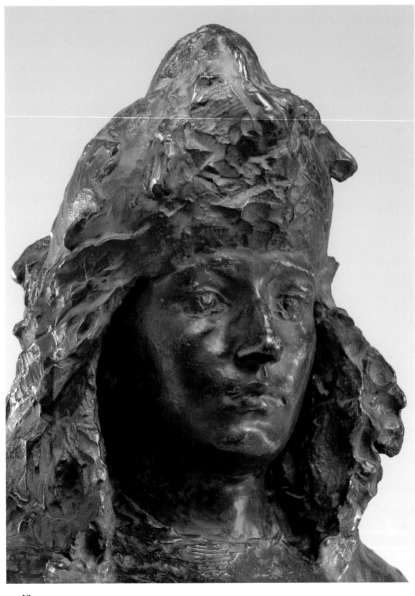

19

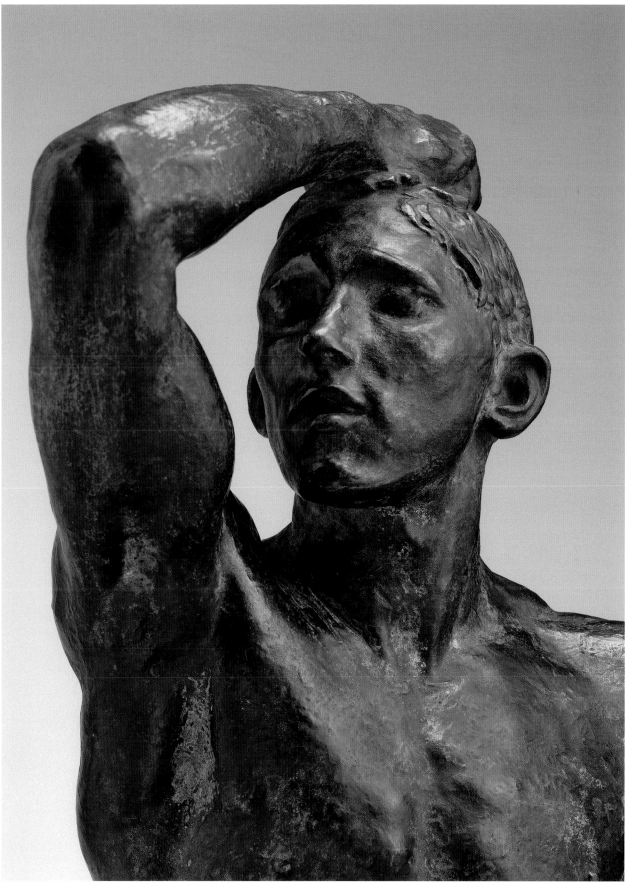

20

locally heating the bronze with an oxidizing flame while alternately brushing on dilute acidic salt solutions. This technique created multiple layers of artificially induced colored corrosion products, creating richness and depth through layering translucent and opaque colors on the surface.

The final layer of the patina consists of ferric nitrate, which created dark reddish brown interspersed with black, likely present as gold chloride. Although gold is not visible to the naked eye, it was detected using XRF. In his handbook, Bartlett explains that black patinas can be achieved using a combination of gold III chloride and tin nitrate.[75] In fact, Limet complained to Rodin about the difficulty of obtaining an acceptable black patina: "that black is not varied enough, or the metal does not lend itself to that color. You'll have to send it in green and gold. If that's not acceptable to you, we'll look for another color."[76] The gold to which Limet referred may well be Bartlett's gold III chloride. It is a light-sensitive compound historically used for gold toning in the creation of photographic chrysotype prints,[77] and in "Tricks of the Trade," Bartlett notes that gold and silver can be recovered from photographic baths.[78] It is entirely plausible that Limet efficiently salvaged these materials and transformed them into chemical patinas. Selenium, a photographic toner, was also found in the black patina on the base of *The Walking Man*.[79] Given the challenge of achieving an acceptable black surface, Limet likely drew on his experience as a photographer and used photosensitive chemicals.

The patina of *La France*

Certainly the most colorful of all Rodin's bronzes in the Simpson collection is *La France* (see fig. 19). Results from XRF and XRD analyses revealed that the patina on *La France* was applied using a hot torch in a manner similar to that used on *The Walking Man*. The presence of gold, again most likely in the form of gold chloride, on the chest as a black patina is also comparable. Mercury and chloride were also detected in the black passages on *La France*, possibly from mercuric chloride, a sensitizer and developer used in photography at that time. Bartlett wrote that dissolving mercuric chloride in vinegar and brushing it on the sculpture achieved a black patina.[80]

Like *The Walking Man*, the ferric nitrate patina of *La France* was strategically rubbed off the raised areas of the helmet, shoulders, chest, neck, and left side of the face to reveal the underlying light green copper nitrate layer. The surface was further enhanced with matte reddish brown present in the interstices of the headdress, and matte blue-gray in areas of the face and headdress (fig. 22). The same materials were applied to other sculptures, including *The Thinker*.

Figure 21
Receipt from Poulenc Fréres, listing the purchase by Jean Limet of patination chemicals, including copper nitrate, ferric nitrate, and turpentine.

Figure 22
Detail of *La France* (fig. 4), showing Prussian blue around the eyes.

22

XRD and PLM revealed that both the reddish-brown and blue-gray areas of the patina contained the pigment Prussian blue, iron ferric cyanide.[81] Even though the addition of pigments to artificial patinas was *en vogue* during the late nineteenth century, Rodin disdained their use in patinating solutions used on his sculpture.[82] His assertion that he did not add pigments may not be dishonest. Bartlett described several recipes for producing a blue-green color using potassium cyanide, iron sulfate, water, and nitric acid that formed Prussian blue as a result of the patinating process without the intentional addition of commercial pigments to the solution.[83] He even warned about the dangers of this process: "Note: Adding potassium cyanide to an acidic solution yields hydrogen cyanide, a deadly gas. Try this process only with extreme caution."[84] Modern-day patinators also dissolve potassium cyanide into copper nitrate and add small amounts of iron nitrate to create a partially miscible patinating solution with two distinct colors: blue-gray and reddish brown. The top layer, rich in Prussian blue, is used to create the blue-gray, while the underlying liquid imparts a matte reddish brown to the surface.[85] Technical evidence suggests that Limet was using such a process as well. Prussian blue was also used by photographers to create cyanotypes, a process of photographic contact-printing. Here again Limet appears to have used chemicals from photography and bronze patinations interchangeably.[86]

The patina of *The Thinker*

Like *The Walking Man* and *La France*, the surface of *The Thinker* was created using similar patinating constituents that include copper and iron nitrates, and Prussian blue. Darker external areas of higher relief were rubbed to reveal the lighter green below, as with the patinas of the other

Figure 23
Detail of *The Thinker (Le Penseur)* (fig. 16),
showing dark brown patination streaks on
the legs.

23

sculptures. Yet the patina of *The Thinker* is distinctive for its application.
Dark brown streaks that drip down the legs of the figure give the impression
of sloppy workmanship (fig. 23). However, Limet patinated *The Thinker* in
Paris, presumably under the watchful eye of the master and for a particular
patron. Hence the drips, perhaps created by accident, were intentionally
preserved as an element of the patina's aesthetic. "Catch the accidents and
convert them into science," Rodin counseled his students.[87] The notion of
the accident or beauty derived from imperfection inspired by Japanese art
and introduced to many Parisian artists at the 1878 Exposition Universelle
was embraced by Limet and Rodin. Rodin's interest in *Japonisme* is well
documented.[88] The drips on the Simpson *Thinker* are subtle but would have
been understood by his contemporaries. Though seemingly in contrast to
the high quality of the cast, these brown drips are perhaps intentional adap-
tations to the surface that embrace a contemporaneous ideal.

The patina of *A Burgher of Calais*

Neither the patinator nor the founder of *A Burgher of Calais* is known,
but technical analysis coupled with archival research offers a hypothesis.
Like the other Simpson bronzes discussed, the surface of the *Burgher* bears
a copper nitrate patina, although some of it has abraded over time. Whether
the *Burgher*'s patina was never properly applied is a question raised by cor-
respondence between Rodin and Limet in which Limet comments on a
newly cast, chased bronze of a different figure from *The Burghers of Calais*:
"My dear master, I brought you the small Burgher of Calais today to the rue
de l'Univeristé.... Forgive me if I made you wait a long time for the small
Burger but the cast was not good and the founder had submerged it entirely
in acid. Unfortunately I was unable to prevent the formation of effluores-
cences and blanching."[89] Although this letter refers to a small version of
Pierre de Wissant, and the Simpson bronze is of *Jean d'Aire*, the latter exhibits
problems with its patina that may be related (see fig. 7). Passages on the
sculpture, particularly those in higher relief, including the right side of the
robe, the key, and the left foot, have lost patina, and bare metal is exposed.
Green paint identified using PLM and XRD, intended to integrate the bare
metal with the surrounding patina, was found to contain lampblack and

yellow earth.[90] Although it is unclear who inpainted the losses to the patina, it is intriguing to consider the problematic surface in the context of the correspondence above. One wonders whether François Rudier, uncle of Eugène Rudier and founder for *Pierre de Wissant*,[91] also cast the Simpson *Burgher of Calais*. The foundry that fabricated the Simpson *Burgher* is unknown, yet as previously noted, the alloy composition of this sculpture, in fact a brass, is different from the composition of Simpson bronzes associated with the Alexis Rudier foundry (see table 1). Analyses undertaken on three Rodin bronzes cast by François Rudier in the collection of the Ny Carlsberg Glyptotek, Copenhagen, also identified them as brasses whose alloy compositions are similar to that of the small Simpson *Burgher*.[92] François Rudier is known to have cast reductions of the same version as the Simpson *Jean d'Aire* in 1901, 1903, and 1904, dates that are compatible with the Simpson *Burgher*.[93] Perhaps the technician in François Rudier's foundry who carelessly overpickled the small *Pierre de Wissant* also contributed to the poor adhesion of the patina on the Simpson *Burgher*. If so, one can understand why Rodin came to rely on Eugène Rudier and the workmanship of the Alexis Rudier foundry.

Conclusion

Technical study of the National Gallery of Art's Simpson Collection bronzes offers a mere glimpse into the prolific production of Rodin's lifetime bronzes. Yet this small but important group provides insight into questions surrounding production. The sculptures were all sand-cast, and those by Eugène Rudier in one piece. At least four were documented to have been cast by Rudier and patinated by Jean Limet. Limet not only created colorful patinas that embraced contemporaneous aesthetics but did so in a manner that borrowed from his concurrent profession as a photographer. Even within the context of the serialization of bronze sculpture, the Simpson bronzes encapsulate the individuality of the artist realized by his trusted craftsmen. They represent a cross-fertilization of disciplines tailored by Rodin at a moment in history. Eugène Rudier, tasked with reproducing the work of the master, and Jean Limet, charged with bestowing color, integrated their skills to realize Rodin's artistic vision. *The Thinker, The Walking Man,* and *The Age of Bronze* may be familiar subjects, but they are inimitable sculptures. Process and product coalesce to record the sculpture of a great artist and the collection of his special patron.

D.B. and L.D.G. together coordinated, carried out the examinations of the Simpson bronzes, and jointly wrote the paper. D.B. provided the translations from French. L.D.G performed the XRF analyses.

1 Auguste Rodin made three gifts to the French State — April 1, September 13, and October 25, 1916 — to transfer his collection. The Musée Rodin, Paris, later limited the edition to twelve casts per sculpture. Monique Laurent, "Observations on Rodin and His Founders," in *Rodin Rediscovered*, ed. Albert E. Elsen (National Gallery of Art, Washington, 1981), 286. For a discussion of the legal aspects of casting authorized posthumous bronzes by Rodin, see Régis Cusinberche, "Original Editions in Bronze by the Musée Rodin Reproductions of Rodin's Works: A Legal Perspective," in Antoinette Le Normand-Romain, *The Bronzes of Rodin: Catalogue of Works in the Rodin Museum*, 2 vols. (Paris, 2007), 1:65 – 77.

2 Another bronze, *The Rape of Hippodamia*, is attributed to Albert-Ernest Carrier-Belleuse and Rodin by Mary Levkoff, former curator of sculpture and decorative arts, National Gallery of Art.

3 Ruth Butler, "Auguste Rodin and Kate Simpson: Artist and Patron — A Perfect Match," in Ruth Butler and Suzanne Glover Lindsay, with Alison Luchs et al., *European Sculpture of the Nineteenth Century*, National Gallery of Art Systematic Catalogue (Washington, 2000), 409 – 412.

4 The Simpson Collection of Rodin's work includes twenty-eight sculptures and eight drawings. For a discussion of collectors during Rodin's lifetime, see Anna Tahinci, "The Collector of Rodin's Sculpture in His Lifetime" (PhD diss., University of Paris, Panthéon-Sorbonne, 2002).

5 Quoted in Truman H. Bartlett, "Auguste Rodin, Sculptor," *American Architect and Building News*, January 19, 1889, 28.

6 Bartlett January 19, 1889, 28 – 29. La Petit École, Bartlett notes, included Jean-Baptiste Carpeaux (1827 – 1875) and Jules Dalou (1838 – 1902) among its faculty.

7 Bartlett (January 19, 1889, 28) writes that Rodin was accepted in drawing but did not enroll.

8 Ruth Butler, "Rodin and the Paris Salon," in Elsen 1981, 19.

9 Butler 1981, 40.

10 Butler and Lindsay 2000, 374. See also Butler 2000.

11 Butler and Lindsay 2000, 374. The marble portrait of Kate Simpson was given to the National Gallery as part of the Simpson Collection gift in 1942.

12 Butler 2000, 412.

13 John Simpson to Auguste Rodin, December 5, 1903, in Butler and Lindsay 2000, 414 – 415.

14 Le Normand-Romain 2007, 2:423.

15 Mary L. Levkoff, *Rodin in His Time: The Cantor Gifts to the Los Angeles County Museum of Art* (New York, 1994), 56.

16 Kate Simpson's Rodin scrapbook, compiled by Miss Jean Simpson, Gift of the Cantor Foundation, National Gallery of Art, Washington, D.C., Gallery Archives.

17 Butler and Lindsay 2000, 362.

18 Le Normand-Romain 2007, 1:177.

19 John Simpson to Auguste Rodin, November 6, 1905, in Butler and Lindsay 2000, 416, enclosing the payment for the "Age d'Airain" (*The Age of Bronze*).

20 *The Age of Bronze* in plaster was shown at the Paris Salon in May 1877. See Le Normand-Romain 2007, 1:127; Butler 1981, 23; Frederick V. Grunfeld, *Rodin: A Biography* (New York, 1987), 101 – 107.

21 Bartlett June 1, 1889, 263.

22 Butler 1981, 24.

23 *The Age of Bronze* was first exhibited in Brussels in 1877, where it was described as "odd" and "cast from life." Several months later it suffered a similar critical response at the Paris Salon. Butler and Lindsay 2000, 312 – 313.

24 Le Normand-Romain 2007, 1:373.

25 *The Kiss* was reduced by the Barbedienne Foundry and edited directly by the foundry in four different sizes with Rodin's formal agreement but not under his direct control. In contrast, *A Burgher of Calais* was reduced by Victor-Henri Lebossé, *reducteur* (practitioner engaged in enlarging or reducing works of art) but overseen by Rodin.

26 Albert E. Elsen, "The Gates of Hell: What They Are About, and Something of Their History," in Elsen 1981b, 63.

27 Le Normand-Romain 2007, 1:162; Butler and Lindsay 2000, 329; Antoinette Le Normand-Romain, *Le Baiser de Rodin* (Musée Rodin, Paris, 1995), 244 – 319.

28 Butler and Lindsay 2000, 342.

29 Butler and Lindsay 2000, 348.

30 Le Normand-Romain 2007, 1:18 – 19. Le Normand-Romain's essay on "The Bronzes of Rodin" is a superb record of the many foundries with which Rodin had some affiliation, but she cautions, "Although numerous invoices from founders are in the Musée Rodin's possession, the descriptions are frequently very vague: 'groups…figures…busts.'" The Musée Rodin Archives holds Rodin's personal archives as well as the largest collection of letters to Rodin and from Rodin. These primary sources are frequently used to provide dates for bronze casts.

31 Quoted in Le Normand-Romain 2007, 1:21.

32 For a discussion of the Alexis Rudier foundry, see Élisabeth Lebon, *Dictionnaire des Fondeurs de Bronze d'Art: France, 1890 – 1950* (Perth, Australia, 2003), 219 – 223.

33 Laurent 1981, 290.

34 Quoted in "Art: The Last Master," *Time*, May 5, 1952, 1.

35 Le Normand-Romain 2007, 1:30.

36 See, for example, Le Normand-Romain 2007, 1:29, fig. 48.

37 Tonny Beentjes, "Rodin's *The Thinker*: Investigation of Bronze Casting Technology and the Development of New Conservation Strategies" (PhD diss., University of Amsterdam, forthcoming 2015).

38 Butler and Lindsay 2000, 315, 321, 325n7, 381n5.

39 Lebon 2003, 220; Le Normand-Romain 2007, 1:33; Laurent 1981, 290. It was originally believed that these cachets were only used after a 1919 trial regarding illegal casts. Two other lifetime bronzes in the National Gallery collections by Rodin that bear the Rudier foundry mark, *Thomas Fortune Ryan* and *Gustave Mahler,* also have the same cachet affixed to their interiors; *The Walking Man* and *The Age of Bronze* have two cachets.

40 Jacques de Caso, "Serial Sculpture in Nineteenth-Century France," in *Metamorphoses in Nineteenth-Century Sculpture*, ed. Jean L. Wasserman (Fogg Art Museum, Harvard University, Cambridge, MA, 1987), 8. See also Catherine Chevillot, "Les stands industriels d'édition de sculptures à l'Exposition Univierselle de 1889: L'exemple de Barbedienne," *Revue de l'art*, no. 95 (1992): 61 – 67.

41 Barbedienne was given exclusive casting rights for the reduction of *The Kiss* by Rodin in 1898. The foundry cast it 329 times in four different sizes before the contract expired and the rights transferred to the Musée Rodin. See Isabelle Vassalo, "Barbedienne et Rodin: L'histoire d'un success," *Rodin sculpteur: Oeuvres méconnues* (Musée Rodin, Paris, 1992), 189; Laurent 1981, 289. The National Gallery *Kiss* is reduced to a 24.7 centimeter height from a plaster cast of the original 184 centimeter marble. Le Normand-Romain 2007, 1:159 – 161; François

Blanchetière, personal communication, February 2014.

42 Vassalo 1992, 189. Using the Collas method, *The Kiss* was reduced by system of points traced from the surface of the original and marked onto a plaster block using a stylus. Both the tracing and marking features are attached to the same arm angled to accommodate the diminishing scale.

43 Quoted in Butler and Lindsay 2000, 330.

44 Le Normand-Romain 2007, 1:31; Hélène Pinet, "À la recherche de la couleur Jean Limet," in *Rodin et la Photographie* (Museé Rodin, Paris, 2007), 176 – 177.

45 Jean Limet to Rodin, July 13, 1903, Musée Rodin Archives.

46 Rodin to Mr. and Mrs. Simpson, September 1, 1903, in Butler and Lindsay 2000, 414 – 415.

47 Le Normand-Romain 2007, 1:31.

48 Pinet 2007, 177.

49 Pinet 2007, 176.

50 Lebon 2003, 114.

51 Lebon (2003, 114) claims Carriès introduced Rodin and Limet. Grunfeld (1987, 559) states that Limet was a childhood friend. Pinet (2007, 176) speculates that the introduction could have come from any one of many shared acquaintances, including Carriès and the critic Arsène Alexandre.

52 Édouard Papet, "Une autre polychromie: Plâtres patinés, bronzes et sculptures céramiques de Jean-Joseph Carriès," *48/14 La Revue du Musée d'Orsay*, no. 18 (Spring 2004): 73.

53 Carol P. Adil and Henry A. DePhillips Jr., *Paul Wayland Bartlett and the Art of Patination* (Wethersfield, CT, 1991). Paul Bartlett was born in the United States and raised in Paris. He attended the École des Beaux-Arts and studied with Emanuel Fremiet and Jean-Joseph Carriès before establishing his own Paris foundry around 1890.

54 Pinet (2007, 179) discusses a photograph album in the collection of Foundation Nationale des Arts Graphiques et Plastiques, recently discovered by its director, Gérard Allaux. The album includes a series of test photographs that enabled her to identify Limet's photographic processes and helped the authors identify some of his patinating constituents.

55 See, for example, the handwritten recipe for "Patine verte sur bronze" on a loose piece of paper attributed to Limet between July 1910 and February 1912, Musée Rodin Archives; see also Le Normand-Romain 2007, 1:31.

56 Results were published in the technical notes for each entry in Butler and Lindsay, 2000. X-radiographs were taken by Kelly McHugh and Helen Spande, July 1995 – March 1996, 300 kV, 5.0 mA, 150 inches TFD, 8 – 12 minutes, tube filter: 0.010 lead front and back screens. The sculptures were analyzed with a Kevex 0750A XRF spectrometer equipped with a Rhodium anode x-ray tube, operating at 60 kV, 0.4 mA with a $BaCl_2$ secondary target, collected for 200 seconds live time; quantification using Kevex Exact software.

57 XRD was performed on paint samples each mounted on a glass fiber and placed in a Gandolphi Camera that used a copper anode with a nickel filter and was operated at 40 kV and 20 mA. D-spacings were measured using a calibrated rule.

58 XRF was performed using a Bruker Tracer III-SD handheld spectrometer equipped with a Rhodium anode x-ray tube, operating at 40 kV, 1.8 μA, with a 25.4 μm titanium/304.8 μm aluminum excitation beam filter, collected for 100 seconds of live time; quantification using Bruker PXRF software with a custom empirical calibration. Dispersed paint samples were analyzed by PLM using reflected and transmitted light at magnifications of up to 1600×, and comparisons were made with reference materials. Uncoated samples were analyzed using a Hitachi SEM-EDX equipped with an Oxford detector under variable pressure, 20 kV, and a working distance of 10 mm. Additional samples were analyzed using FTIR by Suzanne Quillen Lomax using a Nicolet (Thermo) Nexus 670 Spectrometer equipped with a Continuum Microscope. The samples were compressed between two windows of a Diamond cell (Spectratech); 256 scans were collected at 4 cm⁻¹ resolution. The data were processed with Omnic software.

59 For a discussion on the sand-casting technique, see Lebon 2003, 14 – 18; Michael Shapiro, *Bronze Casting and American Sculpture, 1850 – 1900* (Cranbury, NJ, 1985), 16 – 23.

60 Molds for larger bronze sculptures sometimes required a series of multiple stacked flasks. For a discussion of sand-cast, enlarged versions of *The Thinker*, see Beentjes 2015.

61 Malvina Hoffman, *Sculpture Inside and Out* (New York, 1939), 296 – 300.

62 Andrew Lins, personal communication, February 2014; Beentjes 2015.

63 Pierre Griffoul is also known to have sand-cast small bronze sculptures in one piece. We are grateful to Tonny Beentjes for bringing this fact to our attention. Rodin ceased to send sculpture to Griffoul after 1903, when a bronze *Saint John* was poorly chased. Lebon 2003, 174.

64 Le Normand-Romain 2007, 2:586.

65 Le Normand-Romain 2007, 2:586. Additional versions cast before 1902 include two in 1896 and a third unique type wearing a cap cast in 1884. François Blanchetière, personal communication, February 2014.

66 Kate Simpson to Auguste Rodin, November 29, 1915, in Butler and Lindsay 2000, 430 – 431.

67 Analyses of sixty-two modern bronze sculptures undertaken in a collaborative study at the Art Institute of Chicago, Northwestern University, and the Philadelphia Museum of Art further support the notion that Rudier cast *The Thinker, The Walking Man, The Age of Bronze,* and *La France.* Four bronzes cast by Rudier from the Philadelphia Museum and three others in the Art Institute reported in the study have compositions similar to those in the four NGA works noted above. See Marcus L. Young, Suzanne Schnepp, Francesca Cassadio, Andrew Lins, et al., "Matisse to Picasso: A Compositional

Study of Modern Bronze Sculpture," *Analytical and Bioanalytical Chemistry* 395, no. 1 (2009): 182. We are grateful to Andrew Lins for sharing this article with us. Analyses undertaken by the authors of lifetime Rodin bronzes cast by Rudier in the collections of the Metropolitan Museum of Art, New York, and the Ny Carlsberg Glyptotek, Copenhagen, are also compositionally akin to the four NGA bronzes thought to be cast by Rudier. We are grateful to Flemming Friborg, Line Clausen Pedersen, and Rebecca Hirst at the Ny Carlsberg Glyptotek for kindly allowing us to examine and perform XRF analyses of Rodin's bronze sculpture, April 28 – May 1, 2014, and to Linda Borsch, Larry Becker, Jim Draper, and Luke Syson at the Metropolitan Museum of Art for kindly arranging for us to examine the museum's sculptures.

68 Quoted in Adil and DePhillips 1991, iii. For additional contemporary patination recipes, see, for example, Arthur H. Hiorns, *Metal-Colouring and Bronzing* (London, 1902).

69 Laurent 1981, 292.

70 Pinet 2007, 179; Cucinella Briant, personal communication, September 2013.

71 Jean Limet to Rodin, July 13, 1903, Musée Rodin Archives.

72 Rodin to Limet, n.d., Musée Rodin Archives: "Mon Cher Limet, Ne touchez pas au torse absolument." See also Le Normand-Romain 2007, 1:31.

73 Rodin to Limet, August 1, 1914, Musée Rodin Archives: "Mon cher Limet, La patine rouge de la main en bronze est admirable. Veuillez vous je vous prie faire prendre au rue de Varenne celle que vous avez patinée noire et la [illegible word inserted above] faire pareille." See also Le Normand-Romain 2007, 1:31.

74 Polonca Ropret and Tadeja Kosec, "Raman Investigation of Artificial Patinas on Recent Bronze, Part 1: Climatic Chamber Exposure," *Journal of Raman Spectroscopy* 43 (2012): 1582. For additional analyses on copper nitrate patinas, see Valerie Hayez, Triana Segato, Annick Hubin, and Herman Terryn, "Study of Copper Nitrate-Based Patinas," *Journal of Raman Spectroscopy* 37 (2006): 1211 – 1220. Jeff Davis, materials research engineer, Microanalysis Research Group, National Institute for Standards and Technology, analyzed the patina samples using a Bruker Micro XRD-D8 to examine individual grains with Gadds software and Jade search routine to identify the gerhardtite and the rouaite. Reported in an e-mail communication, April 29, 2013.

75 Adil and DePhillips 1991, 10.

76 Limet to Rodin, January 18, 1910, Musée Rodin Archives, quoted in Le Normand-Romain 2007, 1:33: "soit que le noir ne soit pas assez varié, soit que le métal ne se prête pas à cette couleur. Vous le'enverrai vert et or. Si cela ne vous convient pas, nous chercherons une autre couleur."

77 Mike Ware, *Gold in Photography: The History and Art of Chrysotype* (Brighton, UK, 2006), 102 – 103, 110 – 111. Also noteworthy is a preparation of colloidal gold and tin hydroxide,

called purple of Cassius, that was used as a colorant for decorating glazed ceramics, a technique that might have been of interest to Carriès, who ultimately worked only in ceramics.

78 Adil and DePhillips 1991, 69.

79 To date selenium has been detected only in the patina of *The Walking Man*. Lisha Deming Glinsman (analysis report, June 3, 2014, NGA scientific research department) confirmed the presence of selenium in multiple regions of the base and feet using XRF.

80 Adil and DePhillips 1991, 10.

81 The NGA *Thomas Fortune Ryan* and the Metropolitan Museum of Art's *Walking Man* patinas also contained Prussian blue. Samples were analyzed using XRD, and results matched with JCPDS 1-239, iron ferric cyanide. FTIR showed a broad nitrile stretch for Prussian Blue at 2085 cm^{-1}, copper nitrate at 1419 cm^{-1}, 1330 cm^{-1} due to the ONO_2.

82 Rodin to Carl Jacobsen, August 9, 1903, *Correspondance de Rodin*, vol. 2, *1900 – 1907*, ed. Alain Beausire and Florence Cadouot (Paris, 1986), 91. We are grateful to Andrew Lins for bringing this letter to our attention.

83 Adil and DePhillips 1991, 4, 7.

84 Adil and DePhillips 1991, 4.

85 Andrew Baxter, patinator, personal communication, September 3, 2014.

86 Mike Ware, *Cyanotype: The History, Science and Art of Photographic Printing in Prussian Blue* (London, 1999).

87 Quoted in Hoffman 1939, 302.

88 For an archival image of *Crying Woman* whose face bears drips in the patina, see François Blanchetière, "Un Créateur Libre et Curieux," in *Rodin: Les Arts Décoratifs* (Musée Rodin, Paris, 2009), 250, fig. 144. See also Pinet 2007, 178; Papet 2004, 76. Carriès was influenced by Japanese masks and stoneware characterized by *wabi-sabi*, a Japanese aesthetic that identified beauty in imperfection. Adil and DePhillips (1991, 20 – 22) records Bartlett's recipes that attempt to reproduce Japanese patinas for bronze sculpture.

89 Limet to Rodin, February 24, 1903, Musée Rodin Archives: "Mon cher maitre, je vous ai porté le petit Bourgeois de Calais aujourd'hui rue de l'Université…. Vous me'excusez si je vous ai fait longtemps attendre pour le petit Bourgeois mai la fonte n'était pas bonne et le fondeur l'avait entierrment [missing word] dans l'acide sans retirer le noyoux et mal-gré (tous mes) efforts je ne pouvais l'empêcher d'avoir des efflorescences de blanchés. Je n'ai pas volu vous la porter."

90 Examination with PLM found that the olive-green paint was composed of very fine, spherical black particles of lampblack and yellow, fine-grained particles of yellow earth.

91 Le Normand-Romain (2007, 1:31) identifies *Pierre de Wissant* as cast by François Rudier.

92 Le Normand-Romain (2007, 2:433, 620, 586) identifies Copenhagen's *Victor Hugo*, *Puvis de Chavanne*, and *The Thinker* (73.5 cm) as cast by François Rudier.

93 Le Normand-Romain 2007, 1:220.

References

ADIL AND DEPHILLIPS 1991 Adil, Carol P., and
 Henry A. DePhillips Jr. *Paul Wayland
 Bartlett and the Art of Patination.* Wethers-
 field, CT, 1991.

"ART" 1952 "Art: The Last Master." *Time*, May 5,
 1952, 1.

BARTLETT 1889 Bartlett, Truman H. "Auguste
 Rodin, Sculptor." *American Architect and
 Building News* 25, no. 682 (January 19, 1889):
 27 – 29; no. 683 (January 26, 1889): 44 – 45;
 no. 685 (February 9, 1889): 65 – 66; no. 688
 (March 2, 1889): 99 – 101; no. 689 (March
 9, 1889): 112 – 114; no. 696 (April 27, 1889):
 198 – 200; no. 698 (May 11, 1889): 223 – 225;
 no. 700 (May 25, 1889): 249 – 251; no. 701
 (June 1, 1889): 260 – 263; no. 703 (June 15,
 1889): 263 – 28.

BLANCHETIÈRE 2009 Blanchetière, François.
 "Un Créateur Libre et Curieux." In *Rodin:
 Les Arts Décoratifs*, 82 – 87. Musée Rodin,
 Paris, 2009.

BUTLER 1981 Butler, Ruth. "Rodin and the
 Paris Salon." In Elsen 1981, 19 – 49.

BUTLER 2000 Butler, Ruth. "Auguste Rodin
 and Kate Simpson: Artist and Patron —
 A Perfect Match." In Butler and Lindsay
 2000, 409 – 412.

BUTLER AND LINDSAY 2000 Butler, Ruth, and
 Suzanne Glover Lindsay, with Alison
 Luchs et al. *European Sculpture of the
 Nineteenth Century.* National Gallery of Art
 Systematic Catalogue. Washington, 2000.

CHEVILLOT 1992 Chevillot, Catherine. "Les
 stands industriels d'édition de sculptures
 à l'Exposition Univierselle de 1889:
 L'exemple de Barbedienne." *Revue de l'art*,
 no. 95 (1992): 61 – 67.

CUSINBERCHE 2007 Cusinberche, Régis.
 "Original Editions in Bronze by the Musée
 Rodin Reproductions of Rodin's Works:
 A Legal Perspective." In Le Normand-
 Romain 2007, 1:65 – 77.

DE CASO 1987 de Caso, Jacques. "Serial
 Sculpture in Nineteenth-Century France."
 In *Metamorphoses in Nineteenth-Century
 Sculpture*, edited by Jean L. Wasserman,
 1 – 27. Fogg Art Museum, Harvard Univer-
 sity, Cambridge, MA, 1987.

ELSEN 1981A Elsen, Albert E. "The Gates of
 Hell: What They Are About, and Some-
 thing of Their History." In Elsen 1981b,
 63 – 79.

ELSEN 1981B Elsen, Albert E., ed. *Rodin
 Rediscovered.* National Gallery of Art,
 Washington, 1981.

GRUNFELD 1987 Grunfeld, Frederick V. *Rodin:
 A Biography.* New York, 1987.

HAYEZ ET AL. 2006 Hayez, Valerie, Triana
 Segato, Annick Hubin, and Herman

Terryn. "Study of Copper Nitrate-Based
 Patinas." *Journal of Raman Spectroscopy* 37
 (2006): 1211 – 1220.

HIORNS 1902 Hiorns, Arthur H. *Metal-Colour-
 ing and Bronzing.* London, 1902.

HOFFMAN 1939 Hoffman, Malvina. *Sculpture
 Inside and Out.* New York, 1939.

LAURENT 1981 Laurent, Monique. "Observa-
 tions on Rodin and His Founders." In Elsen
 1981b, 285 – 293.

LEBON 2003 Lebon, Élisabeth. *Dictionnaire des
 Fondeurs de Bronze d'Art: France, 1890 – 1950.*
 Perth, Australia, 2003.

LE NORMAND-ROMAIN 1995 Le Normand-
 Romain, Antoinette. *Le Baiser de Rodin.*
 Musée Rodin, Paris, 1995.

LE NORMAND-ROMAIN 2007 Le Normand-
 Romain, Antoinette. *The Bronzes of Rodin:
 Catalogue of Works in the Rodin Museum.*
 2 vols. Paris, 2007.

LEVKOFF 1994 Levkoff, Mary L. *Rodin in His
 Time: The Cantor Gifts to the Los Angeles
 County Museum of Art.* New York, 1994.

PAPET 2004 Papet, Édouard. "Une autre
 polychromie: Plâtres patinés, bronzes et
 sculptures céramiques de Jean-Joseph
 Carriès." *48/14 La Revue du Musée d'Orsay*,
 no. 18 (Spring 2004): 72 – 83.

PINET 2007 Pinet, Hélène. "À la recherche de la
 couleur Jean Limet." In *Rodin et la Photog-
 raphie*, 176 – 189. Museé Rodin, Paris, 2007.

RODIN 1986 Rodin, Auguste. *Correspondance
 de Rodin*, vol. 2, *1900 – 1907*, edited by Alain
 Beausire and Florence Cadouot. Paris, 1986.

ROPRET AND KOSEC 2012 Ropret, Polonca, and
 Tadeja Kosec. "Raman Investigation of
 Artificial Patinas on Recent Bronze, Part 1:
 Climatic Chamber Exposure." *Journal of
 Raman Spectroscopy* 43 (2012): 1578 – 1586.

SHAPIRO 1985 Shapiro, Michael. *Bronze Cast-
 ing and American Sculpture, 1850 – 1900.*
 Cranbury, NJ, 1985.

VASSALO 1992 Vassalo, Isabelle. "Barbedienne
 et Rodin: L'histoire d'un success." In *Rodin
 sculpteur: Oeuvres méconnues*, 187 – 190.
 Musée Rodin, Paris, 1992.

WARE 1999 Ware, Mike. *Cyanotype: The History,
 Science and Art of Photographic Printing in
 Prussian Blue.* London, 1999.

WARE 2006 Ware, Mike. *Gold in Photography:
 The History and Art of Chrysotype.* Brigh-
 ton, UK, 2006.

YOUNG ET AL. 2009 Young, Marcus L.,
 Suzanne Schnepp, Francesca Cassadio,
 Andrew Lins, et al. "Matisse to Picasso:
 A Compositional Study of Modern Bronze
 Sculpture." *Analytical and Bioanalytical
 Chemistry* 395, no. 1 (2009): 171 – 184.

Movements in Paint: The Development of John Marin's Watercolor Palette, 1892 – 1927

Cyntia Karnes, Lisha Deming Glinsman, and John K. Delaney

Using paint as paint is different from using paint to paint a picture. I'm calling my pictures this year "Movements in Paint" and not movements of boat, sea, or sky, because in these new paintings, although I use objects, I am representing paint first of all.
JOHN MARIN

On February 17, 1913, New York's 69th Regiment Armory opened its doors for the International Exhibition of Modern Art, soon to pass into history as the Armory Show. At last, the European vanguard was presented on a grand scale to an eager American audience. While organizers heralded the exhibition as "The New Spirit," one American artist had already staked his claim to the spirit of the modern age with his dizzying depictions of New York's first skyscraper, the Woolworth Building, and other city landmarks. Just one day earlier, on February 16, the *New York World* reproduced six watercolors by John Marin (1870 – 1953) in a two-page color spread titled "The Futurist's New York" (fig. 1); on that same day, the *New York American* heralded Marin as "One of the Leaders in the New Movement to Revitalize Art," printing an extensive essay by the artist, including his earliest and most direct statement on the use of color: "In our efforts to express through the medium of painting the inner life and meaning of things, we most truly need every means at our disposal, colors most of all.... I am peculiarly impressed with the important part which colors play in the painter's expression of natural objects when I attempt to visualize something which does not exist."[1]

Marin's essay, no doubt masterfully timed for maximum impact by his art dealer and advocate Alfred Stieglitz (1864 – 1946), established him as the native-born inheritor of the radical French style on display at the Armory Show and as an exemplar of a new and autonomous American avant-garde. Initially controversial, Marin would soon be one of the country's most respected artists.[2] Just as important, his words established — at this critical early stage in his career — his impassioned thinking about the potential of

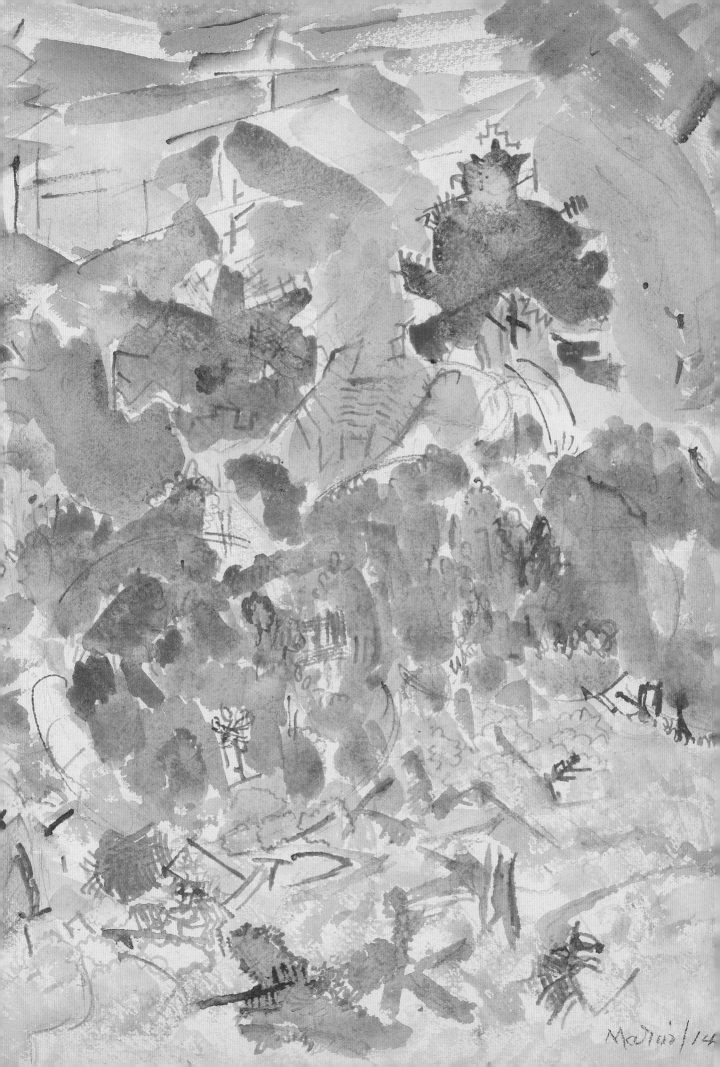

Figure 1
"The Futurist's New York," February 16,
1913, *New York World*, 12 – 13.

color to express impalpable sensation. Throughout his career, perceptive
observers praised Marin's instinct for color, yet his pigment selections and
manipulation of color have not received much attention in subsequent stud-
ies of his work.

This article explores the evolution of Marin's palette over the first half of
his long artistic practice. It considers both his pigment choices and his delib-
erate organization of color to evoke a sense of kinetic energy, so characteris-
tic of his work after 1912. Technical analysis of the artist's watercolors in the
collection of the National Gallery of Art, Washington, indicates that Marin
limited himself to a narrow palette of pigments in only primary colors, with
distinct additions and substitutions of pigments at important junctures
in his career (table 1, page 103).[3] Particularly noteworthy is his preference
for using only red, yellow, and blue pigments before 1912; after this date, he
consistently relied on a four-color palette by incorporating a commercially
prepared green pigment. These findings are examined in the context of color
theories discussed in watercolor manuals of the period and of aesthetic
theories published regularly in Stieglitz's influential journal *Camera Work*,
as well as in other writings by contemporaries. Marin's own prolific writings
and published interviews reveal the artist's knowledge of these theories and
his burgeoning interest in using color to evoke "movements in paint" — an
analogy for the viewer's experience of the subject and of the process of
painting itself.

Methodology
The National Gallery of Art possesses one of the largest public holdings
of works by John Marin, including 153 watercolors on 148 sheets, approxi-
mately 122 of which are dated within the period of study, 1892 – 1927.[4] Of
these, sixteen works are discussed here, randomly chosen for analysis from
groupings representing key subjects and locales.

In this study Marin's pigments were characterized without sampling, using both highly magnified visual examination and in situ analytical methods.[5] Pigments were visually characterized through close examination under high magnification using a stereomicroscope.[6] Works were further examined under short- and long-wave ultraviolet (UV) illumination to determine absorption or luminescence characteristics. All works were analyzed at multiple sites. Elemental data were collected from all works using x-ray fluorescence spectroscopy (XRF).[7] Six works were also analyzed by collecting electronic and vibrational information related to molecular structure reflectance spectra generated across the ultraviolet and near-infrared using fiber optic reflectance spectroscopy (FORS).[8] In addition to the methods described above, which give information on the pigments used at specific points on the works examined, multispectral imaging spectroscopy (MSI) was used to distinguish and map the use of several pigments in three works.[9]

Conclusions about specific pigments discussed in the text are based on results integrated from these various analytical techniques, and the findings are summarized in table 1.[10] Only those pigments found in sufficient abundance to be considered intentional by the artist are described in the text.

Marin's Tonal Color: Early Watercolors, 1892–1900

Long before Marin became famous for the free handling of color in his *Woolworth* watercolors, his earliest extant sketches of rural scenes reveal a controlled and deft hand at using line and shade to create form. In 1887, his father directed him toward a practical education in mechanical engineering at the Stevens Institute of Technology, Hoboken, New Jersey.[11] An indifferent student, Marin dropped out after only one semester, but he went on to gain considerable experience in draftsmanship over the next five years, working for several architecture firms and in his own practice.

Analysis of some of Marin's earliest watercolors suggests that he used a triad palette recommended in mechanical and architectural drawing manuals of the period, consisting of red, yellow, and blue pigments. In the 1886 edition of *A Textbook of Geometrical Drawing*, the author explains the inspiration for a limited palette: "When we survey with attention, the beautiful coloring of the works of nature; we cannot fail to perceive the almost infinite variety of tints and hues.... All are composed of three primary colors: YELLOW, RED, AND BLUE."[12] Marin would later express this same idea in similar language, saying: "The three primary hues... Nature has given them to us."[13]

As a mechanical engineering student at the Stevens Institute, Marin may well have consulted the closest reference available to him for his watercolor studies — *Practical Hints for Draughtsmen*, a popular manual authored by Charles William MacCord, a professor of mechanical drawing at the Stevens Institute during Marin's brief attendance there. MacCord advised his students that they "cannot do better than to use the cakes of water colors furnished for artists. Preference should be given to those which are most soluble, such as Prussian Blue, Carmine, Scarlet Lake, Indian Yellow, etc."[14]

These colorants were known for their high tinting strength and fluid wash characteristics, properties also suited to the atmospheric effects Marin aimed to capture in his earliest watercolors. In *White Lake* (fig. 2), inscribed

Figure 2
John Marin, *White Lake*, 1888 (redated
c. 1892 based on watermark), watercolor
and graphite, 28.2 × 39.2 cm, National Gal-
lery of Art, Gift of John Marin Jr.

Figure 3
John Marin, *Landscape,* c. 1895 – 1900,
watercolor and graphite, 18.4 × 25.5 cm,
National Gallery of Art, Gift of John
Marin Jr.

2

3

1888 but believed to have been created around 1892, Marin stained his paper
with watery infusions of Prussian blue, cobalt blue, yellow earth (iron oxide),
organic yellow (probably a yellow lake), and a red lake (visually typical of
carmine) to evoke an opalescent sky reflected in the lake's rising mists.[15] In
a departure from his carefully rendered sketches of the same period, Marin
demonstrated a clear understanding of watercolor's potential for capturing
atmosphere. His biographer MacKinley Helm notes the influence of J.M.W.
Turner (1775 – 1851), relating how Marin "used the technique of saturating
the whole paper with water" — not unlike the British master — after seeing
reproductions of English watercolors that "played with tonalities."[16] Turner
was well known for using only red, yellow, and blue pigments in his water-
colors to capture the evanescent conditions of light and weather.[17]

For *Landscape* (fig. 3), c. 1895 – 1900, Marin selected Prussian blue and organic yellow to create the verdant green tree canopy and expanse of meadow.[18] Dense bone black pigment in the tree trunks contrasts with touches of red lake, vermilion, and organic yellow, representing clusters of summer blooms. The clear sky is faintly washed in Prussian blue and zinc white, occasionally interrupted by a clear, shiny film not dissimilar to gum water — suggestive of a beginner's technique recommended in several watercolor manuals for laying down and correcting aerial tints.[19]

Marin's use of red, yellow, and blue pigments in these early works, which he mixed to create a wider color range of secondary and tertiary colors, had long been a fundamental lesson of painting. The concept was refined over a century to include explanations for the optical effects of color interaction, most notably by the French chemist Michel Eugène Chevreul.[20] This triad of primitive colors was challenged in 1856 by German physicist Hermann von Helmholtz, who proposed a series of "optical" or "light" primaries, consisting of red, green, and blue-violet.[21] Elaborating on earlier research by the English naturalist Thomas Young, Helmholtz demonstrated that mixtures of red, yellow, and blue pigment created black, whereas mixtures of red, green, and blue-violet light produced white. Most important, he proved that color was not a material, objective property of pigment; rather, it was generated by the physiological response of the human visual system to wavelengths of light.

Artists and theorists tried to assimilate these scientific concepts for practical application to painting, but a confusing array of proposals nevertheless confronted students of art (fig. 4). Most nineteenth-century manuals were loyal to academic tradition, exemplified by the author of *The Artists' Manual of Pigments*, from 1886: "I cannot here enter into the question of which colours should be considered as true primaries, but from my own knowledge of colour science I remain steadfast to the old original theory of red, yellow, and blue being the three primaries."[22] As late as 1908, the author of *The Colorist* felt compelled to insist that "the old theory of primary colors does not fit the scientific facts as ascertained in modern times."[23] Modern color theory was most notably espoused by Ogden Rood, a professor of physics at Columbia University and an accomplished watercolorist in his own right who conducted research on color. His book *Modern Chromatics…with Applications to Art and Industry* was enormously influential from the time of its first publication in 1879, both in the United States and in Europe.[24]

In 1899, Marin decided to leave architecture and enrolled at the Pennsylvania Academy of the Fine Arts in Philadelphia. While there, he may have been exposed to color theory by his instructors, Thomas P. Anshutz and Hugh Breckenridge. Both men were keenly interested in the subject; Breckenridge owned books by both Rood and Chevreul and was recommending that students read works by Chevreul and the British chemist Sir Arthur H. Church, an advocate of modern color theory, around the time of Marin's arrival.[25] However, Marin ceased his studies at the academy in his second year, before he would have undertaken formal instruction in painting and color theory. If he learned about the optical primaries of light prior to his departure, his watercolor technique at the time does not seem

Figure 4
Diagram illustrating the position of primaries in six major color theories (note the three-and four-ray theories of Ewald Hering, Michel Eugène Chevreul, and Hermann von Helmholtz) from Joseph W. Lovibond, *An Introduction to the Study of Colour Phenomena, Explaining a New Theory of Colour Based Entirely on Experimental Facts with Applications to Scientific and Industrial Investigations* (New York, 1905), 31, pl. VII.

4

to reflect it.[26] Analysis indicates that more than a decade would pass before Marin incorporated a commercially prepared green pigment into his palette. By the end of 1902, a year after his premature departure from the academy, Marin resumed his fragmented education, briefly studying at New York's Art Students League before setting his sights abroad.

Marin's Color Awakening: Paris, 1905 – 1910

In September 1905, Marin's restless spirit led him to Paris, where lessons in art and color were all around him. Living in Montparnasse, just five minutes from the famous Café du Dôme, he was ensconced with an international group of artists. Marin typically spent time with his fellow Americans, mostly former classmates from the academy and the Art Students League. Perhaps for this reason, works from his early years in Paris show little influence of the bold color techniques used by the modern French painters. Rather, they reveal the strong influence of James Abbott McNeill Whistler (1834 – 1903), whose aesthetic held sway over many among that generation of American expatriate artists.

By 1907, Marin tentatively began to introduce new and bright pigments while still working within his standard triad of red, yellow, and blue pigments. In the watercolor *Notre Dame* (fig. 5), c. 1907, he rendered the cathedral in somber tones set against a luminous half-light.[27] The Gothic silhouette is washed in cobalt blue and red lake, augmented with additions of pulverized charcoal and clear gum to add depth to the shadows along the buttressed wall. The blue-violet contrasts with the warm glow of the sky, painted in a vivid pigment known as lemon yellow, and red lake, here possibly madder as well as carmine. The strontium-chromate formulation of lemon yellow used here, also detected in *The Seine after the Storm* (fig. 6),

Figure 5
John Marin, *Notre Dame*, c. 1907, watercolor, graphite, and charcoal, 39 × 28.4 cm, National Gallery of Art, Gift of John Marin Jr.

5

Figure 6
John Marin, *The Seine after the Storm*, 1908,
watercolor, 36.4 × 42.3 cm, National Gal-
lery of Art, Gift of John Marin Jr.

1908, is less chemically stable than the alternative formulation, barium
chromate.[28] The strontium formula appears to have been popular in France
despite its tendency to discolor: as one U.S. critic noted, "It is to the use of
bright and new tints with which the French color-makers tempt our artists
that much of the evil complained of is due, and moreover the adulteration
practiced abroad, but rarely in this country, has added to it."[29]

Marin's adoption of this bright, modern pigment in 1907 coincides
with several turning points in his career. For the first time, his work was
displayed with that of the French avant-garde, both in the Salon des Artistes
Indépendants in the spring and, later that same year, the Salon d'Automne.
That summer, the artist Arthur B. Carles (1882 – 1952) settled in Paris and
reconnected with his former academy classmate. After listening to Marin's
frustrations about working in oil, Carles encouraged his friend to commit
his energies to watercolor.[30] Equally important, he introduced Marin to the
painter and photographer Edward Steichen (1879 – 1973), likely in the fall of
1907.[31] Steichen was searching for works representing the current expressive
ideals of art to exhibit at Alfred Stieglitz's Little Galleries of the Photo Seces-
sion in New York, also known as 291. He encouraged Marin to continue his
experiments in watercolor and brought his work to Stieglitz's attention that
same year. Shortly after they met, Steichen supplied the palette that would
push the reticent artist to the fore of modern art. In a later memory, Steichen
recalled:

> When I met Marin I was deeply interested in the whole modern
> movement in Paris.... I tried to get him to take an interest in the
> rich, vivid color of Matisse. It didn't mean anything to him. He had
> pallet, peon's grey, yellow ochre, neutral tint, all dull colors —
> all what i have to refer to again as Whistlerian colors. I had him
> out... at my place in the country for a week, and I slipped some
> crude or brilliant prismatic colors into his pallet box and he started

playing around with vermeer rose, rose madder and cadmium yellows for the first time. He got drunk with them at once. Now, I think that's the only influence that modern art had on Marin. Just simply the matter of the pigments. It would be hard — Cézanne interested him. I don't think Matisse interested him at all, not at that time at any rate.[32]

Perhaps looking to Paul Cézanne (1839 – 1906), Marin created *French Landscape* (fig. 7) in 1909. Marin would have encountered Cézanne's watercolors in the 1907 Salon des Indépendants, which included his own work near a memorial display honoring the recently deceased artist. Like Cézanne, he composed his scene with flattened planes of warm and cool hues, intersected by white paper. Marin failed, however, to achieve the luminous effects of the French master, who juxtaposed pure washes of highly saturated, transparent pigments dominated by reds, greens, and blues — a simulacrum of the primaries of light.[33] In contrast, Marin relied on his traditional triad, applying mixtures of cobalt blue, cadmium yellow, and red lake. The result is a loss of vibrancy, compounded by the opacity of the cadmium pigment, which obscures the reflective surface of the white paper support.

Figure 7
John Marin, *French Landscape*, 1909, water-color, 31.6 × 37.9 cm, National Gallery of Art, Gift of John Marin Jr.

Figure 8
John Marin, *Tyrol Series*, 1910, watercolor and charcoal, 46.6 × 39.1 cm, National Gallery of Art, Gift of John Marin Jr.

7

Following a five-month visit to New York to prepare his first solo exhibition at 291, Marin traveled to Austria's Tyrolean Alps, depicted by generations of artists before him. Clearly energized by his visit with Stieglitz and his fellow artists, Marin infused his watercolors of the Tyrol with more vivid colors than he had ever used before, made more brilliant by wide-open passages of white paper. In *Tyrol Series* (fig. 8), 1910, Marin captured a fleeting glimpse of a mountain peak amid parting clouds, using cerulean blue, ultramarine blue, and possibly a madder-based red lake. A bright streak of light suspended among the clouds is composed primarily of cadmium

8

yellow.[34] A combination of these pigments, with pulverized charcoal, is used to create the blue-gray silhouette of pine trees against rivulets of two different cadmium yellows.[35]

Beginning with the *Tyrol Series*, Marin seems to have selected more chemically stable pigments with greater lightfastness than he had used in earlier watercolors. In analysis of his later watercolors from the 1920s and 1930s, no Prussian blue, strontium formula of lemon yellow, or organic yellow was observed at all. Marin also seems to have slowly adopted more madder-based red lakes, recommended over carmine lakes in artists' manuals for their superior light resistance.[36] The widely published Russell and Abney *Report on the Action of Light on Water Colours* (1886) proved that certain watercolor pigments could be significantly altered by exposure to excessive light or polluted air.[37] One wonders why it took Marin so long to heed these warnings: trade catalogs of the period confirm that the chemically stable pigments were no more expensive than his earlier choices. Perhaps it was the influence of the artists at 291, and the prospect of earning a stable income from the sale of his watercolors, that caused him to consider their longevity.[38] Marin's close friend Paul B. Haviland, another Stieglitz associate, asserted the value of color permanence in a 1911 issue of *Camera Work*, not long after Marin had captured the transient light effects of the Tyrol:

> Last but not least comes the question of permanency, a question to which artists have often given but too little thought. What fair-minded man will claim that the purchase he acquires…on the assumption that he becomes the possessor of a "thing of beauty" which will be "a joy forever," is treated honorably when…he receives an article which in a short period of time will have lost, through deterioration, much of its exchange value, as well as its power to give esthetic pleasure?[39]

"Movements in Paint": The Stieglitz Circle, 1910 – 1923

In 1910, after nearly five years abroad, Marin returned to New York. He could now count on the promise of financial support from Stieglitz, who would henceforth promote his work in yearly exhibitions, and on the friendship of a close-knit circle of artists. Together they formed the vanguard of modern art in America. The exuberance of this period in Marin's life and the energy of the metropolis and its inhabitants galvanized him to explore new modes of expression through expansive use of color.

Marin embarked on an ambitious series of watercolors capturing the engineering marvels of New York, including the construction of the massive Woolworth Building, a powerful symbol of American achievement. These watercolors, first displayed at Stieglitz's gallery in January 1913 and a month later at the Armory Show, generated significant critical outcry for their distorted, ephemeral representation of the city's newest edifice. Marin's expressive use of color, however, was singled out for praise by many. Of the *Woolworth Series* one critic remarked: "No matter how annoyed the conservative may be at finding the strongest steel structures of New York wavering to fit the ideas of movement…only the prejudiced can fail to become conscious of Mr. Marin's infallible instinct for color."[40]

Figure 9
John Marin, *Woolworth Building No. 28,* 1912, watercolor and graphite, 47 × 39.6 cm National Gallery of Art, Gift of Eugene and Agnes E. Meyer.

9

In *Woolworth Building No. 28* (fig. 9), 1912, Marin used the optical effects of color interaction, contrasting opaque and transparent washes to enervate — that is, to excite to the point of fatigue — the eye and undermine conventional perspective. The watercolor reveals a wider palette, now composed of four primaries. A green pigment, viridian, is incorporated into washes of cerulean, cobalt, and ultramarine blue; red earth (iron oxide) and red lake (based on madder); and cadmium yellow. Sheer passages of color in the sky mimic rays of light glinting off the exterior, dematerializing the great building to suggest a vibrating, universal energy. Surrounding buildings rendered in heavier strokes of watercolor delineate a foundation for the visionary structure; above, Marin weighted the top of the tower with opaque red iron earth pigment flowing into transparent red lake (fig. 10), establishing a precarious tension between the structure and the thick application of red lake in the street below.

Figure 10
Marin, *Woolworth Building No. 28* (fig. 9), detail of the top of the tower showing Marin's use of two red pigments: red earth (left) and red lake (right).

Figure 11
Macrophotographs of red pigments used in the top of the tower (fig. 10) of Marin, *Woolworth Building No. 28* (fig. 9).

(a) Opaque particles of red earth used in the tower.

(b) Transparent red lake used in the foreground.

10

11a

11b

Marin's use of both red earth and red lake pigments in *Woolworth Building No. 28* can be visually discerned through the microscope. Figure 11a shows opaque red earth particles used in the tower, and figure 11b shows a deep, transparent area of red lake in the foreground (perhaps enriched with added gum). These two pigments can also be seen in the MSI map of the red pigments (fig. 12),[41] which localizes Marin's use of two distinct red pigments as well as areas where he used the two together.[42] MSI was also used to create a false-color luminescence image, in which madder-based red lake stands out as the most strongly luminescent areas (fig. 13).[43]

In the *New York American* article published on the occasion of the Armory Show's opening, Marin wrote of color's mystical, symbolic associations, calling to mind the concepts of the abstract painter Wassily Kandinsky (1866 – 1944).[44] The same year Marin painted his *Woolworth Series,* Stieglitz translated an excerpt from Kandinsky's *On the Spiritual in Art* for *Camera Work,* publishing it for the first time in America.[45] Although Marin's color symbolism vaguely resonated with the Russian artist's ideas, Kandinsky's recognition of color's "psychic effect" might have had greater influence on

Figure 12
False-color MSI image of Marin, *Woolworth Building No. 28* (fig. 9). The false-color MSI map visually separates the red pigments: red false color represents areas rich in madder, blue represents red iron oxide, and green areas represent a mixture or layering of the two.

Figure 13
False-color luminescence image of Marin, *Woolworth Building No. 28* (fig. 9). Luminescent areas, typical of madder, coincide with the red false-color areas in the MSI image (fig. 12).

Marin's watercolors. This concept — that color causes a psycho-physical response — had been influenced by recent studies in experimental psychology that investigated how stimuli from the optic nerve are reduced to fundamental opponent color signals in the brain. These "psychological primaries" were red and green, blue and yellow, and black and white.[46]

As the Armory Show drew record crowds, Stieglitz published *A Study of the Modern Evolution of Plastic Expression,* written by Marius de Zayas and Paul B. Haviland, which explored the ways in which modern art "is trying to make form a vehicle for psychology and metaphysics" (fig. 14).[47] The authors refer to Marin at length as an exemplar of this intention, quoting the introductory statement from his recent exhibition at 291: "It is this 'moving of me' that I try to express, so that I may recall the spell I have been under and behold the expression of the different emotions which have been called into being."[48]

The following summer, Marin turned his attention to the coastal woodlands of Maine, a subject he would revisit for the rest of his life. In *West Point, Maine* (fig. 15), 1914, Marin relied on opponent colors, heightened by reserves of white paper, to enliven and subvert pictorial perspective. He arranged warm and cool hues created from cerulean blue, viridian green, red lake (probably based on madder), red earth, and cadmium yellow in contrasting pairs along a diagonal to create an eddy of motion, contracting toward a red splotch set against a mass of green. The complementary pairing intensifies both green and red, creating a central focal point around which the fields of color seem to pivot. The painting's energy is further enhanced by the obvious vigor with which Marin applied the watercolor medium: he used the bottom of his palm and even incised the surface with a fingernail or the back end of a brush to encourage the pooling of color into bruised paper.[49]

14

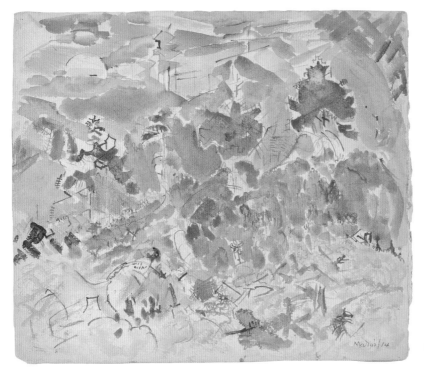

15

16

Figure 14
Alfred Stieglitz, photo of John Marin holding *The Modern Evolution of Plastic Expression*, printed 1963 by Todd Webb from slashed plate negative. Alfred Stieglitz/ Georgia O'Keeffe Archive, Yale Collection of American Literature, Beinecke Rare Book and Manuscript Library.

Figure 15
John Marin, *West Point, Maine*, 1914, watercolor and graphite, 42.1 × 49.5 cm, National Gallery of Art, Gift of John Marin Jr.

Figure 16
John Marin, *Abstraction*, 1917, watercolor and graphite, 41.4 × 48.9 cm, National Gallery of Art, Gift of John Marin Jr.

In 1917, Marin produced a series of nonobjective watercolors, each titled *Abstraction* or *Movement*, in which he formally explored the interaction of flattened masses of color. In *Abstraction* (fig. 16) he used cobalt blue, viridian, madder-based red lake, cadmium yellow, and an unknown yellow. Like others in the series, *Abstraction* embodies Marin's fundamentally experimental nature — his habit of restlessly investigating compositional logic, color harmonies, pictorial space, and the relationship of parts to the whole. Perhaps Marin was inspired by recent exhibitions of works by the synchromist painters Morgan Russell (1886 – 1953) and Stanton Macdonald-Wright (1890 – 1973), who sought a "pure language of color" to convey rhythm through the advance or recession of different hues and the spatial interaction of color forms.[50]

"Color Fights with Line": Maine, 1923 – 1927

Marin's struggle to invoke metaphysical sensation became more fully resolved in his watercolors of the 1920s as he introduced bold lines around concentrated points of color to convey movement. An undated note in his archive at the National Gallery of Art reveals his private search for a graphic vocabulary: "When color fights with line what then! Then mass becomes more important than direction Isn't mass intensified direction? Direction pushing mass aside [Let the whole thing be based on the great sound movement]" (fig. 17).[51] These notes, and others in the archive, synthesize key psychological concepts that describe how fleeting, unconscious eye movements — momentarily held by strong contrasts of brightness, color, or shape — allow visual apprehension of a scene. In *Deer Isle, Maine* (fig. 18), c. 1923,[52] Marin used saturated blocks of color, intersected and framed by black lines, to draw the eye into and across the image. His chosen pigments — cerulean blue, viridian, madder-based red lake, cadmium yellow, and charcoal — were scrubbed into the paper so vigorously that brush hairs remain embedded in the paint layer, indicating the artist's intense effort to capture the vision before him.

17

Figure 17
Note in Marin's hand.

Figure 18
John Marin, *Deer Isle, Maine*, c. 1923,
watercolor, charcoal, and crayon, 34.9 ×
44.1 cm, National Gallery of Art, Gift of
John Marin Jr.

In *Echo Lake, Franconia Range, White Mountain Country*, painted in 1927
(fig. 19), Marin seems to emulate the dynamic activity of seeing itself, imbu-
ing a placid mountain scene with vital energy. Black diagonal lines lead the
eye to a central focal point of madder-based red lake; the hazy visual periph-
ery is suggested by washes of cerulean and ultramarine blue, viridian, red
earth, and barium yellow, wiped away to reveal white paper. Cognitive scien-
tists understood that illusions of movement are keenly sensed in peripheral
vision, especially when held by "points of fixation," or, as Marin called them,
"spots of eye arrest." In 1928, the artist explained in his characteristically
idiosyncratic style how he evoked movement through line and color:

> The worker in parts to create a whole must have his parts arrange his
> parts his parts separate his parts so placed that they are mobile (and
> though they don't interchange you must be made to feel that they can)
> have his lines of connection his life arteries of connection and there
> will be focussing points focussing on — well spots of eye arrest and
> these spots sort of framed within themselves Yes there will be big parts
> and small parts and they will all work together they will all have the
> feel that of possible motion. There will be the big quiet forms there
> will be all sorts of movement and rhythm beats one-two-three two-
> two-three three-one-one — all sorts — all seen and expressed in color
> weights — for color is life the life Sun ashining on our World revealing
> in color light all things.[53]

While Marin's statements can be enigmatic, they clearly indicate his
debt to the discussions of aesthetics and perception he encountered in the
pages of *Camera Work* and in discussions with fellow Stieglitz associates.

18

19

The painter De Hirsh Margules (1899 – 1965), a latecomer to the Stieglitz Circle, later recalled that everything he knew "about color, space, form, line, movement" came from talking to Marin.[54] Margules echoed Marin's words with even greater declarative force, writing:

> Color symbols can produce plastic realities in the consciousness of the observer which appear to be the illusion of motion, like the illusion of depth. If on a two-dimensional plane two sets of lines, colors, designs, aerial or linear perspectives are ingeniously combined in imitation of motion, then empathic movement is created; because the resultant dynamic forces the observer's emotional and sensory responses to pause, follow, or move.[55]

Evaluating Marin's Color Evolution

During the thirty-five-year span examined in this study, artists could choose from a range of 122 to 154 watercolors offered by artist material suppliers.[56] In the watercolors we examined, our survey identified twenty-one distinct pigments that Marin used between 1892 and 1927.[57] Until 1912, his palette was limited to pigments in the three primary colors — red, blue, and yellow — as recommended by mechanical and architectural drawing manuals. Such an approach necessarily required more mixing to create secondary and tertiary colors, which risked creating a dulled palette.

One trend in Marin's use of color, from his muted early works to his adoption of more vivid, saturated colors, can be graphically demonstrated using modern color science. The graphs in figure 20 represent the entire range of colors found in digital images of selected watercolors from Marin's early career and during his years in Paris and in New York with the Stieglitz Circle (plotted as a*, b* color values).[58] The more muted colors of earlier works plot close to the center of figure 20a, while the vivid, saturated colors of his later works plot far from the center in figure 20b (the greater radial distance represents increased chroma). In addition, the graphs suggest that Marin's introduction of the pigment viridian added a more vivid green: many points for the late paintings extend deep into the green section of the graph.

In *The Chemistry of Paints and Painting*, a textbook recommended at the Pennsylvania Academy during Marin's time there as a student, Church alludes to the risk of keeping to a restricted palette: "And although some great masters have done marvelous things with five, four, and even three pigments only, there is no sound argument which can be urged in favour of so severe a restriction. If much mixing of paints be bad, then a reasonable enlargement of the palette will render such mixing unnecessary."[59] While Marin may not have heeded these words, he seems to have amplified his triad of primaries by using transparent and opaque pigments within the same hue. On the next page, Church recommends just this approach, adding "the artist demands, in addition to a chromatic series of opaque pigments, a second series possessed of transparency, or, at least, of translucency."[60]

Marin's adoption of bright pigments, which Steichen introduced to him in 1907, seems to have inspired him to paint with an increasingly saturated palette. By 1912, when Marin painted *Woolworth Building No. 28*, he used more pigments than in any other examined work, expanding his palette

yellow

green ———— red

blue

20a

yellow

green ———— red

blue

20b

Figure 20

Image analysis of Marin's watercolors shows the transformation of the artist's colors. The colors (represented as a* and b* values) are plotted along two axes (horizontal: green-red; vertical: yellow-blue).

(a) Three early works show the colors clustered in a small, tight color range.

purple dots: colors in *White Lake*, c. 1892 (fig. 2)

orange dots: colors in *Landscape*, c. 1895–1900 (fig. 3)

blue dots: colors in *West New York & Vicinity*, c. 1890

(b) Four later works show the colors as widely scattered points.

black dots: colors in *Woolworth Building No. 28*, 1912 (fig. 9)

purple dots: colors in *West Point, Maine*, 1914 (fig. 15)

orange dots: colors in *Deer Isle, Maine*, c. 1923 (fig. 18)

green dots: colors in *Echo Lake, Franconia Range*, 1927 (fig. 19)

beyond his three pigment primaries to include green, specifically viridian. The shift seems to have signaled a move from a traditional, material-based understanding of color mixing to a more sophisticated understanding of color, rooted in psycho-physical laws governing perception and movement. However critical the progress he made in Paris, it seems clear that Marin's use of color as an expressive and activating force in his painting matured with his return to America and his immersion in the Stieglitz Circle.

Color became central to Marin's expression, both as a means for conveying emotional associations and as a force for evoking movement. His selection of pigment and manipulation of color in combination with line ultimately became the manifestation of his impulse to engage the dynamic act of seeing — a sympathetic response to the unseen forces of the material world. Pigment, in fact, became the material to recreate the immaterial. As Marin once wrote: "To the artist it's the way of the telling always that concerns him: the painter his way, the sculptor his. The material used — the way used — of a verity — that's the story."[61]

TABLE 1

Pigments in sixteen watercolor paintings by John Marin in the National Gallery of Art. (Identifications based on: a = magnified examination with visible and UV illumination; b = XRF analysis; c = FORS analysis; d = MSI analysis.)

	West New York & Vicinity, c. 1890 — 1986.54.13	White Lake, c. 1892 — 1986.54.33 (fig. 2)	Landscape, c. 1895–1900 — 1986.54.17 (fig. 3)	Notre Dame, c. 1907 — 1986.54.36	The Seine after the Storm, 1908 — 1986.54.39 (fig. 6)	French Landscape, 1909 — 1986.54.90 (fig. 7)	Tyrol Series, 1910 — 1986.54.45 (fig. 8)	Woolworth Building No. 28, 1912 — 1967.13.8 (figs. 9, 10, 11, 12, 13)	West Point, Maine, 1914 — 1986.54.95 (fig. 15)	Abstraction, 1917 — 1986.54.99 (fig. 16)	Deer Isle (Birch Tree), Maine, 1919 — 1986.54.68	Deer Isle, Maine, 1921 — 1986.54.73	Deer Isle, Maine, c. 1923 — 1986.54.79 (fig. 18)	Movement, New York, 1921/1928 — 1986.54.29	Deer Isle, Maine, 1926 — 1986.54.82	Echo Lake, Franconia Range, 1927 — 1949.2.5 (fig. 19)
PRUSSIAN BLUE	a ?b	a b	a b c		a											
ULTRAMARINE BLUE							a	a c d				a			a	a c
COBALT BLUE	a b	a b			a b	a b	a d	a b c d			a b c	a b		a b		
CERULEAN BLUE							a b	a b c d	a b			a b	a b c		a b	a b c
RED LAKE (CARMINE)	a	a	a c	a	a	a										
RED LAKE (MADDER)				a		?a	a	a b c d	a		a b c	a	a b c		a	a c
VERMILION			a b c													
UNKNOWN RED														a		
RED EARTH (IRON OXIDE)								a b c d	a		?a	a b				a b c
YELLOW EARTH (IRON OXIDE)	a b	a b			a b											
CADMIUM YELLOW						a b d	a b	a b	a b	a b d			a b			
LEMON YELLOW (BARIUM)																a b
LEMON YELLOW (STRONTIUM)				a b	a b											
UNKNOWN YELLOW										a d	a			a		
ORGANIC YELLOW (YELLOW LAKE?)	a	a	a c													
VIRIDIAN								a b c	a b	a b c	a b	a b	a c	a b	a b	a b c
BROWN EARTH (IRON OXIDE)															a b	
BONE BLACK			a b			a b										
CHARCOAL BLACK	a			a		?a	a			a	a		a	a		a
UNKNOWN BLACK					a										a	a
ZINC WHITE			a b													

C.K. carried out historical research and full examinations of sixteen works by microscopy and XRF from 2001 to 2003. L.D.G. reviewed all interpretations of XRF spectra and examined an additional six works with XRF in 2009. J.K.D. and Paola Ricciardi carried out FORS analysis of six works in 2009. J.K.D. prepared the MS-IRR images and CIELAB color values plots, 2009 – 2014. C.K. wrote the essay; J.K.D. and L.D.G. commented on the manuscript.

Cyntia Karnes' work as a postgraduate fellow was funded by the Andrew W. Mellon Foundation at the National Gallery of Art, 2000 – 2003.

The epigraph is quoted from MacKinley Helm, *John Marin* (New York, 1948), 101.

1 John Marin, "The Living Architecture of the Future," *New York American*, February 16, 1913, 4-c E.

2 By the time of his death in 1953, Marin's life had been explored in two biographies and two compilations of his correspondence: E. M. Benson, *John Marin: The Man and His Work* (Washington, 1935); Helm 1948; John Marin, *The Selected Writings of John Marin,* ed. Dorothy Norman (New York, 1949); John Marin, *Letters of John Marin,* ed. Herbert J. Seligmann (New York, 1931).

3 During a postgraduate fellowship funded by the Andrew W. Mellon Foundation at the National Gallery of Art from 2000 to 2003, Cyntia Karnes examined and analyzed twenty-two watercolors in the collection. Of these, only sixteen were analyzed in sufficient depth for inclusion in this article. For the most part, discussions of specific works are limited to the choice of pigments. For a fuller description of Marin's technical handling of watercolor, see Kristi Dahm, "Playing Around with Paint," in Martha Tedeschi with Kristi Dahm et al., *John Marin's Watercolors: A Medium for Modernism* (Art Institute of Chicago, Chicago, 2010), 41 – 57.

4 The NGA department of prints and drawings also includes 18 sketchbooks and 192 drawings in other mediums, which were reviewed but not analyzed as a part of this study. The majority of the collection was acquired directly from the estate of John Marin Jr. Thank you to Carlotta J. Owens, assistant curator of prints and drawings at the National Gallery of Art, for her assistance in tabulating the number of watercolors.

5 "Pigment" is used as a generic term encompassing watercolors composed of inorganic pigments, lakes, resins, and natural or synthetically derived organic dyes. The nature of watercolor technique presents particular challenges to pigment identification due to the presence of extraneous material introduced by rewetting of the artist's brush in standing water. Extraneous pigments may also be introduced after incomplete rinsing of the brush between changes of pigments, and minerals may be introduced from natural water sources used to dilute watercolor paints. Additionally, unexpected colorants may be introduced during manufacture. These unintentional pigments can complicate the interpretation of analytical data by obfuscating features of the primary colorant. Finally, it may be difficult to attribute analytical

results to a single pigment if more than one pigment is present in the target site, whether intentionally applied or not. While some of Marin's watercolors do exhibit fading due to frequent exhibition, observations were made in areas protected from light exposure (by a window mat) or in deeper layers of pigment visible with strong magnification.

6 Cyntia Karnes characterized pigments using a stereomicroscope at 40 – 80× magnification to assess morphology, surface reflectance or transparency of pigment particles, degree of fiber staining and film formation, and the dispersion and settling of pigment mixtures. Visual and XRF analyses were compared with known samples from J. Scott Taylor, *A Descriptive Handbook of Modern Water Colours, Illustrated with Actual Washes of the Pigments on Whatman's Drawing Paper, with an Introductory Essay on the Recent Water-Colour Controversy,* fourteenth thousand (London, c. 1888); J. Scott Taylor, *Modern Water-Colour Pigments* (London, n.d. [c. 1910]); and *Washes of George Rowney & Co's Artists' Water Colours* (London, n.d. [c. early twentieth century]).

7 Between 2001 and 2003, Cyntia Karnes and Lisha Deming Glinsman fully analyzed sixteen watercolors with a Kevex XRF spectrometer using a rhodium tube equipped with a barium chloride secondary target, 50 kV, 1.5 mA, 300 seconds live time and/or molybdenum secondary target, 40 kV, 2 mA, 400 seconds live time. In 2009, six of these works received additional, semiquantitative XRF analysis by Glinsman using an ArtTax XRF spectrometer with a rhodium tube, 50 kV, 200 μA, 200 seconds live time equipped with a 60 μm polycapillary focusing optic and a helium flush. Visual examination was an important complement to XRF analysis. For example, because large sand grains were observed embedded in the paint layers of most of Marin's watercolor paintings, interpretation took into account the possibility that the sand contributed elements such as silica and iron to the XRF spectra.

8 In 2009 John K. Delaney and Paola Ricciardi carried out FORS analysis of six works using a FieldSpec 3 fiber-optic spectroradiometer operating from 350 – 2500 nm with a collection diameter of approximately 3 mm, a collection time for each spectrum of 5 seconds, and with a light intensity of approximately 4000 lux.

9 MSI reflectance and fluorescence imaging spectroscopy were used on *French Landscape* (1909), *Abstraction* (1917), and *Woolworth Building No. 28* (1912). For these techniques, see John K. Delaney, Paola Ricciardi, Lisha Deming Glinsman, Michelle Facini, Mathieu Thoury, Michael Palmer, and E. René de la Rie, "Use of Imaging Spectroscopy, Fiber Optic Reflectance Spectroscopy, and X-ray Fluorescence to Map and Identify Pigments in Illuminated Manuscripts," *Studies in Conservation* 59, no. 2 (2014): 91 – 101. Spectral images were collected every 50 nm (FWHM 40 nm) from 400 – 1000 nm in order to construct a reflectance and fluorescence image cube to map areas of similar reflectance or fluorescence spectral signatures.

10 XRF and FORS were important in identifying the majority of the inorganic pigments. Prussian blue was inferred from an XRF spectral peak for iron and from absorbance in UV (for the purposes of this study, "Prussian blue" is used as a general term to encompass a number of blue pigments created from an iron salt, known by various names). Cobalt blue and cerulean blue were inferred from XRF spectral peaks for cobalt, and cobalt and tin, respectively; vermilion by a peak for mercury; red and yellow earth by iron; cadmium yellow by cadmium and sulfur; lemon yellow by chromium and barium or strontium (depending on the formulation); aureolin by cobalt; viridian by chromium. Brown earth was identified by iron using XRF. FORS identified earth-based pigments by the presence of "Laporte-forbidden" bands in the near-infrared. Zinc white was identified by a peak for zinc in XRF and by luminscence in UV. Some pigments were characterized using XRF by flushing the target area with helium to enable detection of light atomic-weight elements. For example, ultramarine blue was inferred by the presence of aluminum, sulfur, and silica. In addition, black pigments were inferred from the absence of elemental data in XRF and from their physical appearance under stereomicroscopy: irregularly sized, reflective splinters were characterized as charcoal black, while bone black, visually recognizable by a uniformly fine, opaque black particulate, was characterized by the presence of calcium and phosphorus.

Organic yellow pigments were inferred from the lack of elemental data from XRF, from distinctive physical features visible with a stereomicroscope, and from the presence of UV excited luminescence. The presence of red lake pigments (organic dyestuffs bonded to a transparent substrate) was determined through visual characterization in visible and UV illumination in comparison with known samples and from XRF results consistent with a potassium aluminum hydroxide substrate. FORS, when available, was able to identify plant-based red lakes such as madder based on spectral features $(n -> \pi^*)$ and the presence of absorption bands at 514 (\pm2) nm and 546 (\pm1) nm; identification of insect-based red lakes such as carmine was based on absorption bands at 520 (\pm4) nm and 557 (\pm5) nm. Christina Bisulca, Marcello Picollo, Mauro Bacci, and Diane Kunzelman, "UV-Vis-NIR Reflectance Spectroscopy of Red Lakes in Paintings," in *9th International Conference, Art 2008: Non-Destructive Investigations and Microanalysis for the Diagnostics and Conservation of Cultural and Environmental Heritage, Jerusalem, Israel, 25 – 30 May 2008*, ed. Amos Notea (Jerusalem, 2008), also available online at www.ndt.net/article/art2008/papers/199Bisulca.pdf (accessed November 7, 2014).

Note that one yellow and one red colorant could not be confidently identified using the existing methodology, although their highly saturated color, magnified physical features, and appearance in UV compared well with twentieth-century synthetic, organic dyestuffs. In addition, Dahm has reported the identification of "tolu-

idine red pigment" in a Marin watercolor from 1922. Dahm 2010, 56.

11 Many details of Marin's life are widely published. Unless noted, biographical information is taken from Ruth Fine's authoritative retrospective exhibition catalog, *John Marin* (National Gallery of Art, Washington, 1990); from his two biographies, Helm 1948 and Benson 1935; and from Sheldon Reich, *John Marin: A Stylistic Analysis and Catalogue Raisonné* (Tucson, 1970). Despite these many sources, the date of Marin's entry into the Stevens Institute is unclear. Reich does not provide a date, but Fine suggests 1886, based in part on a letter from Marin's aunt, written September 26, relating a conversation that day in which his father had decided his son should go to "The Institute." Fine 1990, 23. However, this would mean Marin was only fifteen upon enrollment, as he would not turn sixteen until December 23. Furthermore, September 26 was too late for Marin to enroll at the start of the school year. Marin is listed among the "Class of '90" in the *Stevens Indicator* 67 (1950): 14. According to Fine (1990, 23), the Stevens program is three years, suggesting Marin enrolled in 1887.

12 William Minifie, *A Text Book of Geometrical Drawing: For the Use of Mechanics and Schools* (New York, 1886), 117. This popular manual for engineers and architects is one of the few manuals including any discussion of color and color theory. Page 139 of the 1886 edition suggests a much larger palette than other manuals: gamboge, roman or yellow ocher, Indian yellow, carmine or crimson lake, vermilion, Indian red, cobalt or ultramarine, Prussian blue, indigo, sepia, Vandyke brown or burnt umber, raw sienna, and India ink or neutral tint.

13 Quoted (n.d.) in John Marin, *John Marin by John Marin*, ed. Cleve Gray (New York, 1970), 102, also paraphrased in Helm 1948, 97.

14 Charles William MacCord, *Practical Hints for Draughtsmen* (New York, 1888), 85.

15 This watercolor, one of a series made in the White Lake, Sullivan County, region of New York, is signed "MARIN" in vermilion watercolor (a pigment not otherwise used in this painting), above "88" in black in the lower right corner; the paper, however, bears an 1892 Whatman watermark. Reich alludes to dating problems in this series in his catalogue raisonné but still lists them as Marin's earliest extant watercolors, dated 1888: "MacKinley Helm…wrote that the pictures were done the summer of 1887. They were probably not dated when Helm saw them, but when I [Reich] examined them in 1964 they were all signed and dated 1888." Reich 1970, 247.

16 Helm 1948, 6. For a description of Turner's watercolor technique, see Eric Shanes, *Turner's Watercolour Explorations, 1810 – 1842* (Tate Gallery, London, 1997).

17 George Barnard, *The Theory and Practice of Landscape Painting in Water-Colours: Illustrated by a Series of Twenty-Six Drawings and Diagrams in Colours, and Numerous Woodcuts* (London, 1871), 140.

18 Examination with a stereomicroscope indicated manual mixing of Prussian blue and

an unidentified organic yellow, perhaps a yellow lake, rather than the use of a commercially prepared mixture of Prussian blue and gamboge, marketed as Hooker's green or Prussian green. Under magnification, separate blue and yellow washes were observed in layers, and the two colorants were not uniformly homogeneous or intimately combined throughout. The same was true for *West New York & Vicinity*, c. 1890, which exhibits a similar palette. Prussian blue appears as a finely divided particulate, with characteristic "bronzing" in heavy applications. Under magnification, organic yellow is indicated by nonparticulate, transparent yellow washes, often accompanied by yellow spherical droplets, visible in this work throughout the passages of green. It is possible that the droplets are formed when mixed with an excess of gum.

19 The use of gum was deduced through its characteristic appearance as a transparent, shiny film (often exhibiting burst bubbles) and in the context of its widespread, traditional use as a mixing and glazing medium in watercolor painting.

20 Michel Eugène Chevreul, *De la loi du contraste simultané des couleurs et de l'assortiment des objets colorés* (1839), trans. into English by Charles Martel as *The Principles of Harmony and Contrast of Colours* (London, 1854).

21 Hermann Ludwig Ferdinand von Helmholtz, *Handbuch der physiologischen Optik* (Leipzig, 1856 – 1866).

22 H. C. Standage, *The Artists' Manual of Pigments* (Philadelphia, 1886), 10.

23 J. Arthur H. Hatt, *The Colorist: Designed To Correct the Commonly Held Theory That Red, Yellow, and Blue Are the Primary Colors, and To Supply the Much Needed Easy Method To Determine Color Harmony* (New York, 1908), 10.

24 Ogden N. Rood, *Modern Chromatics: Student's Text-Book of Color with Applications to Art and Industry* (1879), facsimile ed. by Faber Birren (New York, 1973).

25 Barbara A. Wolanin, "Hugh Breckenridge," in Peter Morrin, Judith Zilczer, and William C. Agee, *The Advent of Modernism: Post-Impressionism and North American Art, 1900 – 1918* (High Museum of Art, Atlanta, 1986), 69. Breckenridge recommended the 1899 edition of Charles Martel's translation of Chevreul, and Sir Arthur H. Church's *The Chemistry of Paints and Painting* (edition not given, but the 3rd ed., rev. and enlarged, was published in London, 1901) in a one-page handout titled "Making Pastel Sticks." Copy in the Hugh Breckenridge Papers, Archives of American Art, New York, microfilm 1907, frame 481, also printed in Doreen Bolger et al., *American Pastels in the Metropolitan Museum of Art* (Metropolitan Museum of Art, New York, 1989), 311n128. My thanks to Joy Goodwin, archives specialist at the Archives of American Art in New York for locating the document.

26 Excerpts from Marin's published letters and handwritten notes contained in his archive demonstrate his knowledge of color theory, such as Chevreul's principle of simultaneous contrast. See Marin 1970, 102.

27 The watercolor bears no date. Attribution to c. 1907 appears to have been established by Sheldon Reich. The paper's watermark at center left edge — "J WHATMAN/1881" — indicates that Marin painted this piece on an aged sheet.

28 Winsor & Newton heralded its preparation as "the purest barium chromate," contrasting it with "another preparation called 'lemon yellow' often sold to artists, which is far more rich in colour, and consists of chromate of strontium. This extremely beautiful pigment is naturally unfitted for watercolour, as it is slightly soluble in water — a fatal defect for a chromate. It in consequence becomes green with very great rapidity, and should on no account be employed." Winsor & Newton trade catalog, c. 1888, 47 – 48.

29 "Colors in Art," review of *A Handbook for Painters and Art Students on the Character and Use of Colors*, by William J. Muckley, *Littell's Living Age* 146, no. 1882 (September 18, 1880): 763.

30 Barbara Wolanin, *Arthur B. Carles: "Painting with Color"* (Philadelphia, 1983), 42.

31 Steichen and Marin's first meeting has been dated to the 1908 Salon d'Automne (Reich 1970, 251; Fine 1990, 290), but they must have met prior to the February 25, 1908, formation of the New Society of American Artists in Paris at Steichen's apartment, where both artists were reported to have been present. If not during the 1907 Salon d'Automne, the two could have met while preparing for a January 25, 1908, private exhibition of the American Art Association, which included works by both. See "Special Cable to the *Herald*," *New York Herald* (European ed.), January 26, 1908, 6. For the February 25, 1908, meeting of the New Society, see Sarah Greenough, ed., *Modern Art and America: Alfred Stieglitz and His New York Galleries* (Boston, 2001), 558; "American Artists Found New Protective Society," *New York Herald*, February 29, 1908, 6; "New Society for American Artists," *New York Herald* (European ed.), March 29, 1908, Literary and Arts sec., 3.

32 Transcript of a memorial roundtable discussion on John Marin with Edward Steichen, Dorothy Norman, and David Friedenthal, moderated by Roger Lyons, February 10, 1954, Downtown Gallery Records, 1824 – 1974, Artist Files, John Marin, Archives of American Art, Washington, box 24, reel 5550, frames 307 – 308, available online at http://www.aaa.si.edu/collections/container/viewer/Marin-John-2-of-2 — 196925 (accessed November 1, 2013). The transcript is printed here as recorded, without corrections.

33 Faith Zieske, "Paul Cézanne's Watercolors: His Choice of Pigments and Papers," in *The Broad Spectrum: Studies in the Materials, Techniques, and Conservation of Color on Paper*, ed. Harriet K. Stratis and Britt Salvesen (London, 2002), 89 – 100.

34 Martha Tedeschi (2010, 94) noted the introduction of bright yellow in the *Tyrol Series* to emphasize contour.

35 There appear to be two different cadmium yellow pigments: a greenish yellow and a warmer yellow, visually similar to labeled

Winsor & Newton samples of "cadmium lemon hue" and "cadmium yellow deep," respectively. XRF detected significant peaks for cadmium in both. Both pigments are used in the foreground of *Tyrol Series*, but the warmer hue is used in the streak of yellow through the center. Analytical notes are supported by an undated list of watercolors in Marin's hand that lists both "cadmium yellow" and "cadmium pale." John Marin Family Papers, sec. 1: John Marin Papers, pt. 3: Writings by John Marin, folder 1, National Gallery of Art Library, Washington.

36 Taylor, c. 1888, 28 – 29, 68 – 70.

37 William James Russell and William de Wiveleslie Abney, *Report to the Science and Art Department of the Committee of Council on Education on the Action of Light on Water Colours* (London, 1886).

38 On his return to Paris in the summer of 1909, Marin enthusiastically wrote Stieglitz that he sold two watercolors for the impressive sum of $100. Marin to Stieglitz, May 18, 1910, Alfred Stieglitz/Georgia O'Keeffe Archive, Yale Collection of Amercian Literature, YCAL MSS 85, box 34, ser. 1: Correspondence, Beinecke Rare Book and Manuscript Library, Yale University, New Haven.

39 Paul B. Haviland, "Art as a Commodity," *Camera Work*, no. 33 (January 1911): 68 – 69.

40 Forbes Watson, article in the *New York Evening Post*, reprinted in *Camera Work* 42 – 43 (April – July 1913) [published November 1913]: 26.

41 MSI used both reflected and fluorescent light to distinguish, and through mapping to show the location of, Marin's pigments. Images were collected every 50 nm (FWHM 40 nm) from 400 – 1000 nm to construct a reflectance image cube to map areas of similar reflectance signatures.

42 These two red pigments were confirmed by FORS and XRF analysis as a madder-based red lake and a red earth (iron oxide). MSI fluorescence imaging also confirmed the use of madder lake, based on its strong emission under UV excitation.

43 The false-color luminesence image was obtained using three spectral filters (600, 650, and 700 nm), and the multispectral image was obtained as described in note 9 above. The pigments in the watercolor were excited with blue-green light (Kron/Cousins B astronomy filter, 380 to 520 nm in a Kodak Ektragraphic II projector). The images were registered using a feature based image registration algorithm and a 1 pixel median filter applied.

44 Marin 1913, 4-c E: "White, by itself, is expressive of nothing, a blank. Black conveys the idea of darkness, ignorance, chaos, which neutral shades between black and white merely modify.... Blue, space. The sky is blue, yet there is no limit to the space it incloses. Yellow, the color of gold; conveying the idea of things that are precious, light, knowledge. Red, associated with fire, conveys the idea of ruthless force, war, danger, etc. Green, always fresh and youthful in its spirit. Anyone is capable of imagining how the use of these colors and all the tints derived from them, aids the painter in expressing what he sees and feels."

45 Wassily Kandinsky, "Extracts from *On the Spiritual in Art* by Wassily Kandinsky," *Camera Work* 39 (July 1912): 34.

46 Kandinsky's color system was indebted to the work of German physiologist Ewald Hering, who recognized color as a psychological construct produced from visual stimuli according to opponent hues red and green, blue and yellow, and black and white. It is interesting to consider Marin's palette change in 1912 in the context of Hering's theory, although no direct influence was found in Marin's writings. Hering's theory is discussed briefly in Rood (1879) 1973 and in Joseph William Lovibond, *An Introduction to the Study of Colour Phenomena, Explaining a New Theory of Colour Based Entirely on Experimental Facts with Applications to Scientific and Industrial Investigations* (New York, 1905), 30 – 31 (see fig. 4). For a summary of Hering's theories, especially in opposition to Helmholtz, see Rolf G. Kuehni and Andreas Schwarz, *Color Ordered: A Survey of Color Systems from Antiquity to the Present* (Oxford, 2008), 12, 100 – 101. Also see John Gage, *Color and Meaning: Art, Science, and Symbolism* (Berkeley, 1999), 49, 242 – 243.

47 Marius de Zayas and Paul B. Haviland, *A Study of the Modern Evolution of Plastic Expression* (New York, 1913), 19.

48 Quoted in Zayas and Haviland 1913, 14.

49 Marin used "a stick whittled down for the purpose," according to a press release for the Downtown Gallery, December 20, 1953, Downtown Gallery Records, 1824 – 1974, Artist Files, John Marin, box 24, reel 6660, frame 296, available online at http://www.aaa.si.edu/collections/container/viewer/Marin-John-2-of-2 — 196925 (accessed November 1, 2013). Marin's use of a fingernail to scratch into paint is described in Glenn Tucker, "Arts Review: Triumph of the Spirit," *San Antonio Light*, February 9, 1969, 10-E.

50 The 1916 Forum Exhibition of Modern American Painters at New York's Anderson Gallery featured works by Russell and Macdonald-Wright alongside several Stieglitz Circle artists, including Marin, Arthur Dove, Marsden Hartley, Alfred Maurer, and Charles Sheeler. In 1917 Stieglitz exhibited Macdonald-Wright's paintings in a solo show at 291.

51 John Marin, n.d., John Marin Family Papers, sec. 1: John Marin Papers, pt. 3: Writings by John Marin, folder 3.

52 Signed with "MARIN 23" at the lower right and "MARIN 21" at the lower left. The signature at the right is clearly reinforced, although all signatures appear to be in Marin's hand.

53 Marin, statement in *Creative Art* 3, no. 4 (1928), copy in Alfred Stieglitz/Georgia O'Keeffe Archive, box 100, folder 2081, ser. 2, Alfred Stieglitz, Manuscripts, "Writings by Others," Marin, John, also reproduced in Marin 1949, 4. Artist's original spacing retained for publication.

54 Quoted in Harry Salpeter, "The Talking Artist," *Esquire*, April 1946, 174.

55 De Hirsh Margules, "The Empathetic Consideration," typescript, March 15, 1946, 13, Alfred Stieglitz/Georgia O'Keeffe Archive,

box 100, folder 2077, ser. 2: Alfred Stieglitz: Manuscripts, "Writings by Others," Margules, de Hirsh.

56 A count of watercolor samples (plus white) contained in author Cyntia Karnes' copies of Winsor & Newton catalogs from c. 1887 and 1910 indicate that 122 to 154 watercolors were on offer. Another major supplier, George Rowney & Co., offered 103 watercolors in an undated catalog likely published in the late nineteenth or early twentieth century. Marin is thought to have used Winsor & Newton products. See Dahm 2010, 44.

57 An undated list of watercolor pigments in Marin's hand includes Winsor red, rose madder, light red (a red earth pigment), cerulean blue, cobalt green, oxide of chromium, ivory black, sepia, yellow cadmium, cadmium pale, aureolin. John Marin Family Papers, sec. 1: John Marin Papers, pt. 3: Writings by John Marin, folder 1. Marin's palette is also listed in Benson 1935, 111: French ultramarine, cerulean, cobalt, rose madder, light red, spectrum red, aureolin, yellow

ocher, cadmium, viridian, oxide of chromium, Payne's gray, lampblack.

58 High-quality color accurate digital images can be assigned numeric values defining their color in terms of CIELAB (Commission international de l'eclairage [International Commission on Illumination]) color space. Color-corrected images of seven of watercolors were converted to CIELAB color coordinates to explore the ranges of colors Marin used. The graphs plot the colors (represented as a* and b* values) of Marin's watercolors along two axes: the range of colors from green to red is plotted along the horizontal x-axis, and the range from yellow to blue is plotted along the vertical y-axis.

59 Church 1901, 264.

60 Church 1901, 265.

61 John Marin to MacKinley Helm, December 10, 1946, copy, John Marin Family Papers, sec. 1: John Marin Papers, pt. 3: Writings by John Marin, folder 5.

References

"AMERICAN ARTISTS" 1908 "American Artists Found New Protective Society." *New York Herald*, February 29, 1908, 6.

BARNARD 1871 Barnard, George. *The Theory and Practice of Landscape Painting in Water-Colours: Illustrated by a Series of Twenty-Six Drawings and Diagrams in Colours, and Numerous Woodcuts*. London, 1871.

BENSON 1935 Benson, E. M. *John Marin: The Man and His Work*. Washington, 1935.

BISULCA ET AL. 2008 Biscula, Christina, Marcello Picollo, Mauro Bacci, and Diane Kunzelman. "UV-Vis-NIR Reflectance Spectroscopy of Red Lakes in Paintings." In *9th International Conference, Art 2008: Non-Destructive Investigations and Microanalysis for the Diagnostics and Conservation of Cultural and Environmental Heritage, Jerusalem, Israel, 25–30 May 2008*, edited by Amos Notea. Jerusalem, 2008, also available online at www.ndt.net/article/art2008/papers/199Bisulca.pdf (accessed November 7, 2014).

BOLGER ET AL. 1989 Bolger, Doreen, et al. *American Pastels in the Metropolitan Museum of Art*. Metropolitan Museum of Art, New York, 1989.

CHEVREUL (1839) 1854 Chevreul, Michel Eugène. *De la loi du contraste simultané des couleurs et de l'assortiment des objets colorés* (1839), translated into English by Charles Martel as *The Principles of Harmony and Contrast of Colours*. London, 1854.

CHURCH 1901 Church, Arthur H. *The Chemistry of Paints and Painting*. 3rd ed., rev. and enlarged. London, 1901.

"COLORS IN ART" 1880 "Colors in Art." Review of *A Handbook for Painters and Art Students on the Character and Use of Colors* by William J. Muckley. *Littell's Living Age* 146, no. 1882 (September 18, 1880): 763.

DAHM 2010 Dahm, Kristi. "Playing Around with Paint." In Tedeschi et al. 2010, 41–57.

DELANY ET AL. 2014 Delaney, John K., Paola Ricciardi, Lisha Deming Glinsman, Michelle Facini, Mathieu Thoury, Michael Palmer, and E. René de la Rie. "Use of Imaging Spectroscopy, Fiber Optic Reflectance Spectroscopy, and X-ray Fluorescence to Map and Identify Pigments in Illuminated Manuscripts." *Studies in Conservation* 59, no. 2 (2014): 91–101.

FINE 1990 Fine, Ruth. *John Marin*. National Gallery of Art, Washington, 1990.

GAGE 1999 Gage, John. *Color and Meaning: Art, Science, and Symbolism*. Berkeley, 1999.

GEORGE ROWNEY & CO. N.D. *Washes of George Rowney & Co's Artists' Water Colours*. London, n.d.

GREENOUGH 2001 Greenough, Sarah, ed. *Modern Art and America: Alfred Stieglitz and His New York Galleries*. Boston, 2001.

HATT 1908 Hatt, J. Arthur H. *The Colorist: Designed To Correct the Commonly Held Theory That Red, Yellow, and Blue Are the Primary Colors, and To Supply the Much Needed Easy Method To Determine Color Harmony*. New York, 1908.

HAVILAND 1911 Haviland, Paul B. "Art as a Commodity." *Camera Work*, no. 33 (January 1911): 68–69.

HELM 1948 Helm, MacKinley. *John Marin*. New York, 1948.

HELMHOLTZ 1856–1866 Helmholtz, Hermann Ludwig Ferdinand von. *Handbuch der physiologischen Optik*. Leipzig, 1856–1866.

KANDINSKY 1912 Kandinsky, Wassily. "Extracts from *On the Spiritual in Art* by Wassily Kandinsky." *Camera Work* 39 (July 1912): 34.

KUEHNI AND SCHWARZ 2008 Kuehni, Rolf G., and Andreas Schwarz. *Color Ordered: A Survey of Color Systems from Antiquity to the Present*. Oxford, 2008.

LOVIBOND 1905 Lovibond, Joseph. *An Introduction to the Study of Colour Phenomena*,

Explaining a New Theory of Colour Based Entirely on Experimental Facts with Applications to Scientific and Industrial Investigations. New York, 1905.

MACCORD 1888 MacCord, Charles William. *Practical Hints for Draughtsmen.* New York, 1888.

MARIN 1913 Marin, John. "The Living Architecture of the Future." *New York American,* February 16, 1913, 4-c E.

MARIN 1931 Marin, John. *Letters of John Marin,* edited by Herbert J. Seligmann. New York, 1931.

MARIN 1949 Marin, John. *The Selected Writings of John Marin,* edited by Dorothy Norman. New York, 1949.

MARIN 1970 Marin, John. *John Marin by John Marin,* edited by Cleve Gray. New York, 1970.

MINIFIE 1886 Minifie, William. *A Text Book of Geometrical Drawing: For the Use of Mechanics and Schools.* New York, 1886.

"NEW SOCIETY FOR AMERICAN ARTISTS" 1908 "New Society for American Artists." *New York Herald* (European ed.), March 29, 1908, Literary and Art sec., 3.

REICH 1970 Reich, Sheldon. *John Marin: A Stylistic Analysis and Catalogue Raisonné.* Tucson, 1970.

ROOD (1879) 1973 Rood, Ogden N. *Modern Chromatics: Student's Text-Book of Color with Applications to Art and Industry* (1879), facsimile edition by Faber Birren. New York, 1973.

RUSSELL AND ABNEY 1886 Russell, William James, and William de Wiveleslie Abney. *Report to the Science and Art Department of the Committee of Council on Education on the Action of Light on Water Colours.* London, 1886.

SALPETER 1946 Salpeter, Harry. "The Talking Artist." *Esquire,* April 1946, 174.

SHANES 1997 Shanes, Eric. *Turner's Watercolour Explorations. 1810 – 1842.* Tate Gallery, London, 1997.

"SPECIAL CABLE TO THE HERALD" 1908 "Special Cable to the *Herald*." *New York Herald* (European ed.), January 26, 1908, 6.

STANDAGE 1886 Standage, H. C. *The Artists' Manual of Pigments.* Philadelphia, 1886.

TAYLOR C. 1888 Taylor, J. Scott. *A Descriptive Handbook of Modern Water Colours, Illustrated with Actual Washes of the Pigments on Whatman's Drawing Paper, with an Introductory Essay on the Recent Water-Colour Controversy.* London, c. 1888.

TAYLOR C. 1910 Taylor, J. Scott. *Modern Water-Colour Pigments.* London, n.d. [c. 1910].

TEDESCHI ET AL. 2010 Martha Tedeschi with Kristi Dahm et al. *John Marin's Watercolors: A Medium for Modernism.* Art Institute of Chicago, Chicago, 2010.

TUCKER 1969 Tucker, Glenn. "Arts Review: Triumph of the Spirit." *San Antonio Light,* February 9, 1969, 10-E.

WATSON 1913 Watson, Forbes. Article in the *New York Evening Post,* reprinted in *Camera Work* 42 – 43 (April – July 1913) [published November 1913]: 26.

WINSOR & NEWTON DATE VARIES Winsor & Newton trade catalogs, c. 1888 and other dates.

WOLANIN 1983 Wolanin, Barbara. *Arthur B. Carles: "Painting with Color."* Philadelphia, 1983.

WOLANIN 1986 Wolanin, Barbara A. "Hugh Breckenridge." In Peter Morrin, Judith Zilczer, and William C. Agee, *The Advent of Modernism: Post-Impressionism and North American Art, 1900 – 1918,* 69. High Museum of Art, Atlanta, 1986.

ZAYAS AND HAVILAND 1913 Zayas, Marius de, and Paul B. Haviland. *A Study of the Modern Evolution of Plastic Expression.* New York, 1913.

ZIESKE 2002 Zieske, Faith. "Paul Cézanne's Watercolors: His Choice of Pigments and Papers." In *The Broad Spectrum: Studies in the Materials, Techniques, and Conservation of Color on Paper,* edited by Harriet K. Stratis and Britt Salvesen, 89 – 100. London, 2002.

Mark Rothko's Multiforms, 1946 – 1950: Transforming the Painted Surface

Allison Langley and Suzanne Quillen Lomax

1

Mark Rothko (1903 – 1970) was a reclusive painter, rarely allowing anyone to see him at work in his studio (fig. 1) and reticent when questioned about his painting techniques and materials. In a 1958 lecture he declared, "There are some artists who tell all, but I feel it is more shrewd to tell little." He then gave his "Recipe for Art" with the following list of ingredients:

> A clear preoccupation with death. All art deals with intimations of mortality. Sensuality, the basis for being concrete about the world. Tension: conflict or desire, which in art is curbed at the very moment it occurs. Irony: a modern ingredient. (The Greeks didn't need it.) A form of self-effacement and self-examination in which a man can for a moment escape his fate. Wit, humor. A few grams of the ephemeral, a chance. About 10 percent of hope... if you need that sort of thing.

Rothko went on to say that he mixed his ingredients with craft.[1]

Rothko's lifelong reluctance to discuss the materiality of his enigmatic paint surfaces has complicated the study and care of his works. In-depth technical studies of his late mural series have revealed that the artist used unorthodox mixtures of conventional painting materials to achieve nuanced surface effects. The Harvard murals, finished in 1962, were created with

Figure 1
Mark Rothko in his studio, c. 1945.

pigmented glue, oil, and egg layers, with the unfortunate addition of a fugitive red pigment on select canvases.[2] The Rothko Chapel paintings from 1967 were built up with multiple thin paint layers that included a diverse range of materials, including pigmented rabbit skin glue, oil paint, acrylic medium, dry pigments, eggs, turpentine, and dammar resin.[3] The Seagram murals consist of glue-stained canvases with thin paint layers that could include six different binders: oil-modified alkyd, acrylic resin, phenol-formaldehyde resin, dammar, egg, and oil. The same mediums were not used for every painting. That these materials were found in different ratios of constituents (binder, pigments, and extenders) seems to indicate that Rothko either mixed the paint himself or augmented prepared paint.[4]

Rothko's early paintings, by contrast, have not been the focus of a technical study, and little is known about his painting practices and selection of materials during his formative years. The present study examined a group of his paintings dating from 1946 to 1950 to gain insight into his early painting materials and techniques and to broaden the understanding of his evolution as a painter. These abstract paintings, known as multiforms,[5] represent a crucial turning point in Rothko's artistic career. The multiforms emerged at the end of Rothko's surrealist phase, during which his painted compositions featured anthropomorphic forms that represented mythological fables or symbols, positioned in front of flat, colorful, often striated backgrounds. Also called mythomorphic abstractions, the paintings that immediately predate the multiforms had thin matte paint surfaces on which Rothko used gestural brushwork, descriptive lines, and calligraphic marks drawn on or scraped into the paint film to evoke a surrealist atmosphere and suggest a narrative. In contrast, the purely abstract multiforms moved away from recognizable forms and any traditional sense of perspective, and they directly presage Rothko's classic format: large-scale canvases stained with paint, featuring suspended rectangles of bold color. During the multiform period Rothko experimented with the processes of painting and the consistency of his paints to produce a range of abstract, pigment-rich surfaces that vary from thin matte washes to thick, chalky textured peaks.

The multiform paintings are commonly labeled "mixed media" due to the many materials Rothko is known to have used in his later paintings and the unconventional appearances of the paint surfaces, but the materials and techniques of these works have not previously been studied in detail. Our study of Rothko's creative process revealed formerly unrecognized complex experimentation in the materials and techniques of the multiforms that paralleled Rothko's radical stylistic development. In this article we present the findings of extensive technical study that characterized the types of paints Rothko used to create the multiforms through close examination, sampling, and analysis of fifteen paintings in the collection of the National Gallery of Art, Washington (table 1, pages 122 – 125).[6] In 1985 and 1986, the National Gallery of Art received a large body of Rothko's work from The Mark Rothko Foundation, a gift that included 295 paintings and works on paper, including many early paintings from the artist's collection, making the National Gallery of Art a unique study center for Rothko's work.

To identify the types of paints Rothko used on the multiform canvases and to explore the possibility of his early use of mixed mediums, paint

analysis was first carried out with Fourier transform infrared microspec-troscopy (FTIR) on a number of minute, dispersed paint samples taken from each painting.[7] This technique allowed us to characterize a variety of individual paint components in the paint matrix. Vibrational features iden-tified with this technique make it possible to assign the binding mediums to broad classes such as oils, resins, proteins, and carbohydrates and to infer more specific identifications such as shellac (an insect resin) or gum (a car-bohydrate). Further analysis of ground and paint samples was undertaken with gas chromatography – mass spectrometry (GC-MS),[8] which confirmed the identifications of specific oils, resins, and proteins. In addition, paint cross sections were taken from the paintings to examine overall paint consistency and layer structure and to help determine whether Rothko was using primarily manufactured paints or homemade paints, or both, during the late 1940s.[9]

Rothko's painting materials from the late 1940s are largely undocu-mented beyond descriptions from his friends and colleagues in New York and San Francisco, where he taught at the California School of Fine Arts (today the San Francisco Art Institute) for two summers. These individu-als offered varied but contradictory anecdotes about the artist's working methods. Additional insight can be gleaned from contemporaneous reviews of his five one-man shows at the Betty Parsons Gallery in New York City between 1947 and 1951, which chronicled the changing appearance of the multiform canvases on public display, although it is difficult to identify the specific paintings exhibited.[10] At the time, the paintings were designated as untitled or unnamed, or they were assigned a numbered title for exhibi-tion purposes, making it hard to establish the order of creation or accurate dates for the unsigned and undated canvases. David Anfam's 1998 catalogue raisonné of the artist's paintings proposed a chronology for the multiforms based on stylistic groupings and archival evidence, and it is within this framework that National Gallery of Art's paintings were grouped for study and analysis.[11]

Rothko's Background

Rothko had little formal training as an artist. He studied intermit-tently at the Art Students League for two years in the mid-1920s but seems to have had little interest in learning traditional painting techniques. Instead, his artistic education focused on principles of experimentation, adopting his teacher Max Weber's (1881 – 1961) view: "Always it is expres-sion before means. The intensity of the creative urge impels, chooses and invents means."[12] Rothko was also greatly influenced by his friends and colleagues in the art world, with whom he spent considerable time in the 1930s – 1940s — Milton Avery (1885 – 1965), Barnett Newman (1905 – 1970), Adolph Gottlieb (1903 – 1974), and Clyfford Still (1904 – 1980). Between 1936 and 1939 Rothko worked for the Works Progress Administration (WPA) as part of the Treasury Relief Art Project's Easel Painting Division, employed with other artists to produce paintings. This community of artists report-edly shared tips and techniques and used paints made by the paint-maker Leonard Bocour, who supplied them for the project.[13] Bocour, who produced a variety of oils, caseins, watercolors, decorative paints, and his innovative

acrylic resin Magna, provided free paint samples to New York artists in what was known as the "Bocour Breadline." It has been speculated that Rothko could have used Bocour's newly developed acrylic resin paint Magna to create the new surface effects found on the multiforms.[14]

This was also a period of widespread experimentation with egg tempera. The popularity of tempera paints in the 1930s and 1940s can be credited, in part, to Max Doerner and Ralph Mayer, authors of popular artists' handbooks. Doerner's book, *The Materials of the Artist and Their Use in Painting*, has been previously associated with Rothko and the abstract expressionists.[15] Translated from the German in 1934, it was a bestseller for years. Appearing at a time when hand-ground paints were in vogue, it inspired many artists to experiment with paint recipes. Edward Allen Jewell credited Ralph Mayer with the revival of tempera after a series of lectures by Mayer at the Art Students League in the 1930s and the subsequent publication of *The Artist's Handbook* in 1940.[16] Mayer's book repeated many of Doerner's tempera recipes and those of others. During the 1940s the books by Doerner, Mayer, and Frederick Taubes, earlier texts by A. P. Laurie and Hilaire Hiler, in addition to articles on tempera in artists' magazines, extolled the virtues of tempera paints and their use with oils and discussed the relative merits of the different recipes and methods of application.[17] By 1945 Bocour had developed a workshop on "Technics and Media" in which he taught the methods and principles of paint-making, including the preparation of oils, gouache, and tempera.[18]

Friends and associates of Rothko in the 1940s offered conflicting accounts of the paints he used during the multiform period, highlighting the experimental atmosphere of the time as well as the hazards of relying exclusively on contemporary sources for documentation. Joseph Solman recalled that he "ran with a group" whose members prepared and primed their own canvases and read Doerner's book, and he insisted that Rothko did not grind his own paints but always used tubes.[19] This account contrasts with George Okun's memory that Rothko ground his pigments with a mortar and pestle. "He spent hours at it," so that he could save money and create his own colors.[20] Stanley Kunitz had the impression that Rothko "did not use the highest quality of paints, certainly for his grounds" and that "he mixed it all up in a big tub, like a pail."[21] Jacob Kainen said that Clement Greenburg recalled Rothko priming his early canvases with tempera paints, but Kainen disagreed, stating that Rothko did not use traditional tempera but instead a form of glue water mixed with chalk, lead white, and zinc white.[22] Thomas Hess suggested that Rothko used scenery paints cooked over a hot plate for his stainlike colored grounds.[23]

The use of the term "tempera" to describe Rothko's paint links him to his contemporaries in the art world. In the early twentieth century, the term applied broadly to paints that had a matte appearance upon drying and were miscible with water.[24] Manufactured paints such as poster paints, decorative paints, casein, and gouache were labeled "tempera." Artists' handbooks from the time described homemade temperas based on egg, glue, gum, soap, wax, or casein binders mixed in a variety of combinations, with the relative proportions of the ingredients in each recipe varied for specific surface effects and solubility. In a 1952 *ArtNews* article, Dorothy Seckler

recalled that the "successive revivals of tempera, gouache, encaustic in ear-
lier decades of the century led to artists of opposing styles to shell eggs."[25]
The early twentieth-century revival of egg tempera has been associated with
such figurative American artists such as Ben Shahn (1898 – 1969), Thomas
Hart Benton (1889 – 1975), Andrew Wyeth (1917 – 2009),[26] and Jacob Law-
rence (1917 – 2000),[27] but Rothko's close friends Newman and Gottlieb also
used tempera in the 1940s. Hess said of Newman, "He was always drawn to
experimenting with materials and to perfecting his use of traditional ones.
He used egg tempera up to the last year of his life.... Often he alternated
mediums for what he called 'separating coats' of paint — for example egg
tempera on oil on egg tempera on oil."[28] Gottlieb also made and mixed many
of his paints, including gouache, casein, oils, and egg tempera, which he
used in layers to exploit the disparate qualities of the different mediums; he
used oil for the ground and tempera or casein for the matte upper layers.[29]

 Such experimental painting practices may have suited Rothko's creative
impulses aimed at developing a new type of paint surface, but they were
also likely driven by limited funds and resources. Rothko was notoriously
frugal with his materials during his early years as a painter, reusing strainers,
stretching canvases barely large enough to fit the strainer, and occasionally
painting on both sides of a canvas.[30] A few early works were painted on sur-
plus canvas and theatrical black canvas bought from an army-navy store.[31]
The strainers were typically artist-made, off-square, and somewhat rickety.
Joseph Liss recalled that during the summer of 1946 Rothko "painted all day,
and around sunset he would place the paintings one by one in the outdoor
shower and wash them" to erase unsuccessful images from the canvases so
that he could reuse the supports another time.[32]

The Emergence of the Multiforms: Late 1946 – Summer 1947
 In the summer of 1947, the first of two he spent teaching at the Califor-
nia School of Fine Arts, Rothko was not yet painting pure abstractions. "He
was doing a rather feeble biomorphic business, vaguely sort of marine life,
which Bischoff and other people were rather keen about," according to Has-
sel Smith.[33] It was not until the fall of 1947 that Rothko began to immerse
himself fully in the colorful abstractions that defined the multiform period.[34]
 Rothko's abandonment of anthropomorphic forms and mythical
subject matter for his paintings began in late 1946. The earliest multiforms
retained elements of his prior work: centralized biomorphic elements
with a traditional foreground-background relationship (fig. 2). Often the
backgrounds were comprised of a series of colored horizontal bands. As
Rothko moved into the more abstract multiform style, he began to use
white or light-colored paint to modify and obscure the organic forms that
had dominated the surrealist compositions. The paint surfaces were thinly
painted, with limited use of low impasto, and typically matte in appearance
(fig. 3). Rothko experimented with a variety of techniques to deconstruct
the compositions and remove recognizable forms: upper layers of paint
were scraped away to reveal raw underlayers. He used variations of the cal-
ligraphic techniques he had explored in earlier paintings, including sgrafitto
and scraping into the paint surface with palette knives, brush handles, and
other sharp instruments (fig. 4).

2

3

Figure 2
Mark Rothko, *Untitled*, 1947 (1986.43.84),
mixed mediums on canvas, 69.9 × 54.6 cm,
National Gallery of Art, Washington,
Gift of The Mark Rothko Foundation, Inc.

Figure 3
Detail of Mark Rothko, *Untitled*, 1946
(1986.43.64), mixed mediums on canvas,
99.9 × 69.9 cm, National Gallery of Art,
Washington, Gift of The Mark Rothko
Foundation, Inc. The thin washes of paint
on this 1946 multiform retain the gloss and
body suggestive of a dilute oil paint.

Figure 4
Detail of *Untitled*, 1947 (1986.43.84) (fig. 2),
showing inscribed patterns in the paint
surface.

4

The earliest multiforms had barely enough canvas to fold over the strainer edge; the edges were cut unevenly, pulled tightly, and stapled into place prior to preparation and painting. The artist-applied grounds, white or tinted, were covered entirely by the upper layers of paint on the surface plane. The grounds remained visible solely on the tiny tacking edges, the color occasionally spilling onto the exposed edges of the small, narrow strainers. In these early works what appear to be traditional white and grayish-white grounds have the appearance of thick, medium-rich paint; occasionally the ground was sealed with a clear coating layer painted on top (fig. 5). By contrast, the early colored grounds tended to be thinner but did not yet have the stained quality of Rothko's classic works.

Analysis of two paintings from this early multiform period may indicate Rothko was already beginning to select different types of paints to achieve specific effects when layered or mixed. In a canvas dating from 1946 (see fig. 3) that has the surface appearance of a thin, dilute oil paint, medium analysis of a thin pink ground found egg and oil (table 1, no. 1), while the medium of the orange and black painted forms in the center was found to be oil. Samples from other areas — white, red, and yellow — contain mixtures of oil and protein, determined to be egg in the red and yellow samples. The medium of the blue paint was identified as oil and gum (carbohydrate). The paint matrix was found to contain extenders, inorganic substances used by manufacturers and artists to add bulk or body to paints and sometimes to cut cost or tone down strong pigments. The extender particles were observed to be small in size and evenly distributed and appear to be barium sulfate or lithopone based on FTIR. The uniform paint consistency within the cross section layers and the small particle sizes of pigments and extenders suggest the use of manufactured artists' oil paint, and yet the results of analysis of Rothko's mediums indicate that at this early date he already was already experimenting with additives to the paint.

A slightly later canvas from early 1947 (see figs. 2, 4, 5) stylistically in keeping with the earlier multiforms also documents Rothko's experimentation. The medium-rich gray ground was found to have a mixture of oil and

egg, with an egg-based clear coating (table 1, no. 2). It is uncertain whether Rothko added this protein-containing layer for its appearance or as a preservative. This painting exhibits a markedly matte surface, with pigment-rich paint and areas of raised impasto in the white. White, red, and blue samples were characterized as oil and protein by FTIR; the white paint also had the addition of a gum. The yellow, pink, brown, and black paints were found to be predominantly oil. A cross section from this painting shows a traditional-looking ground layer, probably artist-applied. Large silica particles and what appear to be particles of gum were evident exclusively in the white paint layers, suggesting that the artist modified specific paint layers with additions of both organic and inorganic substances to add body to the paint and to impart the matte surface appearance.[35]

The Classic Multiforms Take Shape: Fall 1947–1948

Rothko's exploration of abstraction was fostered by the thriving, experimental environment he found at the California School of Fine Arts, where he worked alongside a staff that included Clyfford Still, David Park, Edward Corbett, Elmer Bischoff, and graduate student Richard Diebenkorn, among others (fig. 6). "Rothko came to San Francisco a surrealist and left an abstractionist. I remember that quite clearly," recalled student Claire Falkenstein.[36] Comments from students at the school reflected the prevailing interest in expression and experimentation over traditional technique that pervaded the atmosphere of the school during Rothko's time there. "There was a feeling that it didn't matter if you didn't size your canvas too well. You didn't have to take pains with your craft. So everybody used that terrible Fuller paint and nobody cared if the painting lasted until tomorrow because now was the important thing," recalled Deborah Remington.[37] The student Ernest Briggs added, "We used industrial paints in a non-painterly manner for the most part and therefore the work did have kind of a definite character."[38]

6

Figure 5
Detail of the tacking edge from *Untitled*, 1947 (1986.43.84) (fig. 2). The ground layer is covered by a clear proteinaceous layer on portions of the canvas edges.

Figure 6
Mark Rothko teaching at the California School of Fine Arts, late 1940s.

Figure 7
Mark Rothko, *No. 22*, 1948 (1986.43.2),
mixed mediums on canvas, 97.8 × 99.7 cm,
National Gallery of Art, Washington,
Gift of The Mark Rothko Foundation, Inc.

7

In late 1947, as Rothko's multiform compositions delved further into pure abstraction, the horizon lines that populated his earlier works disappeared and the painted shapes dissolved into unidentifiable swatches of intense color (fig. 7). Herbert Ferber recalled, "From the time [Rothko] began to leave the surrealist phase he did what he once described to me as avoiding subject matter to the extent that if he saw something in one of his paintings that resembled an object, he would change the shape."[39] The formerly centralized figures and forms evolved into a number of floating shapes moving across the surface, often off the edges of the canvas, as the compositions became busy and chaotic. Amorphous shapes were often juxtaposed with repeated linear and circular brushstrokes. Rothko began to blur traditional spatial relationships, with a continuous fading in and out of colored forms. He concentrated on more expansive, broad, unrestrained brushwork to create areas of design, impart movement, and blur edges. Reviews of Rothko's 1948 Betty Parsons show, in which untitled multiforms were displayed for the first time, described his new work as "art solely of transitions without beginning, middle or end."[40] The paintings appeared "without definition, the colors running into each other with a studied casualness."[41]

In the winter of 1947 – 1948, the magazine *Possibilities* published an extended artist's statement entitled "The Romantics Were Prompted" alongside images of Rothko's earlier paintings. The statement coincided with Rothko's experiments with the multiform format, and it seemed to address the transformations in his work, particularly his search for a new vocabulary of forms:

> On shapes: They are unique elements in a unique situation. They are organisms with volition and a passion for self-assertion. They move with internal freedom, and without the need to conform with or to violate

what is probable in the familiar world. They have no direct association with any particular visual experience, but in them one recognizes the principle and passion of organisms.[42]

The multiform paintings often had no clear orientation, and patterns of drip marks suggest that Rothko was experimenting with the orientation of the paintings while he worked.[43] The easel-size, often square, multiform canvases could be picked up and turned during painting, causing wet paint to drip in a variety of directions, to bend at sharp angles, and even to inspire painted linear elements (fig. 8).[44] The paint on the multiforms became more matte, almost chalky in appearance due to Rothko's increasing use of pigment-rich, underbound paints built up in colorful layers (fig. 9). A reviewer of the artist's 1948 Betty Parsons show noted the "raw life of the pigment" in the seemingly underbound paints.[45] The paint surfaces were described as "worn spots on a stucco house wall."[46] Rothko experimented with the tactile qualities of the paint surface: localized areas of impasto, thick pools of paint dotted with bubble holes, and isolated areas of thin washes of paint were juxtaposed (fig. 10). Rothko also continued to scrape through colors, moving and removing paint with palette knives as the compositions developed.

Figure 8
Detail of Mark Rothko, *Untitled*, 1948 (1986.43.4), mixed mediums on canvas, 126.4 × 111.8 cm, National Gallery of Art, Washington, Gift of The Mark Rothko Foundation, Inc. The bent paint drip suggests that Rothko turned the canvas during painting.

Figure 9
Detail of Mark Rothko, *Untitled*, 1947 (1986.43.15), mixed mediums on canvas, 98.8 × 83.8 cm, National Gallery of Art, Washington, Gift of The Mark Rothko Foundation, Inc. This multiform from 1947 features multiple thin, matte layers of brightly colored paint superimposed on the canvas.

Figure 10
Photomacrograph of Mark Rothko, *Untitled*, 1947 (1986.43.18), mixed mediums on canvas, 98.4 × 70.8 cm, National Gallery of Art, Washington, Gift of The Mark Rothko Foundation, Inc. Areas of paint dotted with bubble holes suggest that Rothko was manipulating his paints with diluents or additions to create distinct surface effects.

8

10

9

TABLE 1

FTIR and GC-MS results for paint and ground samples from fifteen multiforms by Mark Rothko in the National Gallery of Art.

		PAINTING TITLE, DATE, ACCESSION NUMBER, FIGURE NUMBER IF ANY	ANALYTICAL TECHNIQUE	WHITE	RED	BLUE	YELLOW	GREEN
1		*Untitled*, 1946 (1986.43.64) (fig. 3)	FTIR	oil protein	oil protein	oil gum	oil protein [a]	
			GC-MS		oil egg		egg	
2		*Untitled*, 1947 (1986.43.84) (figs. 2, 4, 5)	FTIR	oil protein [a] gum [c]	oil protein	oil protein	oil	oil shellac
			GC-MS	egg	oil egg			
3		*Untitled*, 1947 (1986.43.18) (fig. 10)	FTIR	protein shellac		oil protein		
			GC-MS	egg		oil egg		
4		*Untitled*, 1947 (1986.43.15) (fig. 9)	FTIR	oil protein	oil protein	oil	protein resin	protein resin gum
			GC-MS	oil egg	oil egg			
5		*Untitled*, 1947 (1986.43.1)	FTIR	oil		oil protein gum	*Sample 1:* oil, protein *Sample 2:* shellac	oil
			GC-MS	oil				
6		*Untitled*, 1947 (1986.43.14)	FTIR	protein gum resin	protein resin	oil shellac wax	shellac [c]	resin gum
			GC-MS					
7		*Untitled*, 1947 (1986.43.16)	FTIR	oil protein	oil protein	oil protein gum		oil gum
			GC-MS	oil egg		oil egg		

a. FTIR spectra containing amide stretches of protein and an ester carbonyl can be difficult to interpret. Although the ester carbonyl could be due to a drying oil as well as egg yolk, GC-MS analysis confirmed the presence of egg yolk alone.
b. Large carbonate stretch obscures area of amide stretches of protein.
c. The chromatographic method of analysis for egg and oil does not identify plant gums or natural resins.

PURPLE	ORANGE	PINK	BROWN	GRAY	BLACK	GROUND COLOR	ANALYTICAL TECHNIQUE AND RESULTS
	oil				oil	pink	FTIR: oil [b]
							GC-MS: oil, egg
		oil	oil		oil	gray with clear layer	FTIR ground: oil FTIR clear layer: protein [d]
							GC-MS: egg
		shellac [e]		oil protein	protein	white	FTIR: oil [f]
							GC-MS: oil, egg
	protein resin gum	resin gum		resin		pink	FTIR: protein, gum
							GC-MS: egg
oil gum					oil	white	FTIR: oil, protein
sample decomposed							GC-MS: oil, egg
	protein [f] resin [f] gum [f]	Sample 1: resin Sample 2: resin	oil	resin	protein [f] resin [f] gum [f]	none	
	oil				oil		
						red	FTIR: protein
							GC-MS: egg

d. GC-MS analysis found egg, consistent with the analysis of the coating.
e. The presence of shellac is often based on the presence of a doublet in the carbonyl region from an ester and acid contribution.
f. Very heterogeneous samples. Discrepancies between FTIR and GC-MS results may reflect different areas of the samples examined.
g. Cannot determine if drying oil is present due to absorbances from an azo pigment.

TABLE 1

(cont.)

#		PAINTING TITLE, DATE, ACCESSION NUMBER, FIGURE NUMBER IF ANY	ANALYTICAL TECHNIQUE	WHITE	RED	BLUE	YELLOW	GREEN
8		*No. 2*, 1947 (1986.43.131)	FTIR	protein resin	oil resin gum		gum	
			GC-MS		oil			
9		*Untitled*, 1947 (1986.43.76)	FTIR	resin[f] protein[f]	oil resin gum	gum	resin gum	*Sample 1*: protein, resin, gum *Sample 2*: protein, resin, gum
			GC-MS	oil	oil			
10		*No. 22*, 1948 (1986.43.2) (figs. 7, 11)	FTIR	protein resin		oil protein resin		oil resin
			GC-MS			oil egg		
11		*Untitled*, 1948 (1986.43.4) (fig. 8)	FTIR	oil protein	*Sample 1*: oil *Sample 2*: oil	oil gum	*Sample 1*: oil *Sample 2*: oil	oil protein gum
			GC-MS		oil		oil	
12		*Untitled*, 1948 (1986.43.120)	FTIR					
			GC-MS					
13		*No. 17* [or] *No. 15*, 1949 (1986.43.142)	FTIR		oil gum	protein shellac gum	protein gum	
			GC-MS			egg	egg	
14		*Untitled*, 1949 (1986.43.158) (figs. 15–17)	FTIR		oil gum[g]		oil protein	*Sample 1*: oil *Sample 2*: oil, protein, gum
			GC-MS		egg			oil egg
15		*Untitled*, 1950 (1986.43.159)	FTIR		oil		oil	
			GC-MS				glue egg	

PURPLE	ORANGE	PINK	BROWN	GRAY	BLACK	GROUND COLOR	ANALYTICAL RESULTS
	resin gum	*Sample 1:* oil, gum *Sample 2:* protein, gum	protein resin gum	protein resin	oil protein	pink	FTIR: protein, resin
				egg			GC-MS: egg
		protein resin gum				orange front orange reverse	FTIR front: protein FTIR reverse: protein, resin [f]
							GC-MS front: egg, glue GC-MS reverse: oil
protein			protein	oil protein gum		pink layer gray layer	FTIR pink: protein, resin FTIR gray: protein, resin
				oil egg			GC-MS pink: oil, egg
	oil gum	*Sample 1:* oil *Sample 2:* oil	oil		shellac	yellow	FTIR: oil
							GC-MS: oil
	oil resin	oil [a] protein shellac [e]				orange	FTIR: oil, resin, gum
	oil	egg					GC-MS: oil
						red	FTIR: oil, protein, resin [f]
							GC-MS: oil
			resin gum			red	FITR: protein
							GC-MS: egg
						red	FTIR: oil, protein
			glue egg				GC-MS: egg, glue

Rothko placed more focus on the edges of the classic multiforms, moving the staples from the canvas edges to the reverse. Typically he used thin, dilute, artist-applied grounds in a variety of warm hues such as pink, red, yellow, or orange, with sporadic use of blue or green. Occasionally he experimented with the role of the edges of the unframed works. Sometimes he applied a second colored preparatory layer to the image area, a second ground that remained visible within the composition yet contrasted with the colored edges. In other cases he painted over the tacking edges in contrasting hues (fig. 11).

Figure 11
Detail of the tacking edge from *No. 22*, 1948 (1986.43.2) (fig. 7), showing Rothko's addition of a second color to the tacking edge.

11

Analysis of ten paintings from 1947 and 1948, representing a range of multiform styles, shows intimations of Rothko's later ground preparations (table 1, nos. 3–12). One painting (no. 6) does not have a ground layer, but of the remaining canvases only two have ground layers bound in oil (nos. 11, 12), while the others consist of egg or egg-oil mixtures. One painting in the group (no. 9) is two-sided. In this case the ground of the painting on the reverse — presumably an earlier, discarded composition — is bound in oil (perhaps with resin and protein), but the ground of the front image is bound with glue and egg, an early example of the introduction of a colored, stain-like preparatory layer that Rothko used in many of his later works. These thin grounds retained the tactile quality of the canvas, and the glue-egg binder acted as a more absorbent underlayer that contributed to the final matte surface appearance of the painting.

FTIR analysis also suggests increased experimentation with a variety of paint mediums (table 1, nos. 3–12). Paint samples removed from these paintings revealed a variety of binders, including oil, natural resins, shellac, protein, and carbohydrate (presumed to be gum). When further characterized by GC-MS, the proteinaceous medium was found to be egg. Based on FTIR, natural resins, shellac, and gums were found often, but not in all samples. What we have interpreted as plant gum is found as visible particles within the paint sample. Oil is often present, usually with egg and gum, although it was found alone in some areas of various paintings.

The paint layering observed in the cross sections is complex, often with a number of thick, white, silica-rich paint layers interspersed between thin colored layers (figs. 12, 13).[47] In contrast, the colored layers that alternate

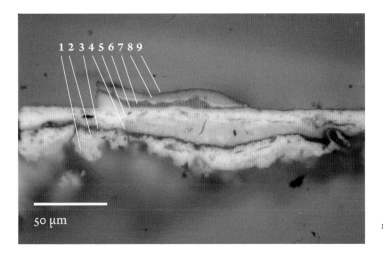

50 μm

12

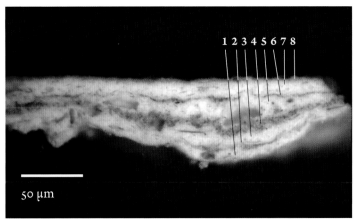

50 μm

13

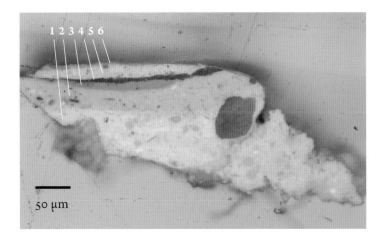

50 μm

14

Figure 12
Cross section from *Untitled*, 1948
(1986.43.4) (fig. 8; see also table 1, no. 11)
(paint layers are numbered beginning with
the lowest layer). Light blue paint of the
final composition (layer 9) lies over a thin
white layer (8), a bright red layer (7), and
another thin white layer (6). These top
layers appear more even and consistent in
pigment and extender distribution than
the layers below. Lower layers, which cor-
respond to earlier versions of the composi-
tion, include two thick white layers (5 and
2) that are visually characteristic of silica-
based fillers (kaolin, mica, or talc); these
layers sandwich two distinct layers of
colored paint: yellow paint with additional
pigment inclusions (4) and a thin, dilute,
dark green (3). Layer 1 is a fragment of the
artist's yellow ground.

Figure 13
Cross section from Mark Rothko,
Untitled, 1948 (1986.43.120), 108.3 ×
111.4 cm, National Gallery of Art, Wash-
ington, Gift of The Mark Rothko Founda-
tion, Inc. (see also table, 1, no. 12) (paint
layers are numbered beginning with the
lowest layer). The thin orange paint layer
of the final composition (layer 8) lies over
thin colored paint layers of blue, gray, and
yellow (6, 4, 2) alternating with thicker
white layers (7, 5, 3, 1) visually character-
istic of silica-based fillers (kaolin, mica, or
talc). The orange ground layer is not visible
in the cross section.

Figure 14
Cross section from *Untitled*, 1948
(1986.43.4) (fig. 8; see also table 1, no. 11),
showing admixtures with which Rothko
modified his paints (paint layers are
numbered beginning with the lowest
layer). Thin orange-red paint correspond-
ing to the final composition (layer 6) lies
above a series of distinctly colored layers
indicating a number of revisions: white
paint tinted with blue and red particles (5);
a thin dark blue layer (4); bright green
paint (3); thick light green paint with red,
yellow, and white particles mixed in (2).
Layer 1 is the artist's thick, yellow ground:
large yellow and white particles with an
added large, dark red agglomerate.

with the thick white layers appear to be thinned paints or colored washes
of dilute pigmented films whose colors often are not reflected in the surface
color, indicating multiple revisions by the artist (fig. 14). It is unclear if the
white layers were used as a re-priming or rethinking of the painting compo-
sition and thus blocked out earlier colors. Rothko had already moved away
from the use of traditional white primings for his canvas, so it seems more
likely that the white layers were added to enhance the thickness, texture,
and appearance of the paint as he alternated between thin and thick paint
layers, and possibly mediums. Typically the paint samples contained large
amounts of extenders. Silica-based fillers (kaolin, mica, or talc) were found

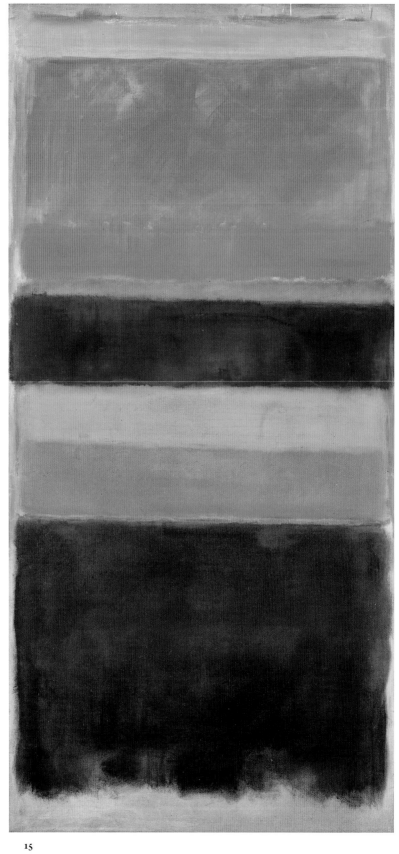

15

to predominate, and increased silica content corresponded to chalkier surface appearances. The consistency of the paints suggests that many were homemade and that, in addition to experimenting with multiple paint binders, Rothko simultaneously modified specific paint layers with additions of select extenders to achieve the desired surface effects.

The Late Multiforms: 1949–1950

The paintings in Rothko's 1949 Betty Parsons show prompted reviewers to note "patches" of color that "float softly up or impetuously punctuate" the surface,[48] and colored areas that "float like clouds or fall like heavy rain."[49]

Following the show, Rothko spent his second summer teaching in San Francisco. He took recent work with him described by Briggs as "big orangey, pink and blue things of beautiful color, [that] created an instantaneous release of pinks and blues and reds and soft edges, that sort of thing."[50] The subtle paint handling and elusive imagery of the multiforms were highly regarded by the students and staff, who were largely engaged in painting nonobjective or abstract paintings as well, and Rothko's presence seems to have inspired further experimentation as he was credited, alongside Jackson Pollock (1912–1956) and Still, as the artists "who killed off the surrealists in this town, upstaged them."[51] In the summer of 1949 Rothko was painting larger, more simplified multiforms (fig. 15), but not yet using the radically reduced paint or forms of the paintings that characterize his classic canvases. "The second summer he was there, he was just beginning to do some things which are like his present work," recalled Briggs.[52]

To create the late multiforms, Rothko moved away from the full-bodied, layered surfaces of the previous years to experiment with thin veils of color and washes of pigment as he moved closer to developing his signature staining technique (fig. 16). The brushwork was restrained: "The artist's control of his latest canvases seems more dubious than a cook's control of a melted cheese sandwich," wrote Belle Krasne. "All solidity disintegrates under his brush. The vaguest of colors nebulously describe the relations between the vaguest of areas."[53]

Figure 15
Mark Rothko, *Untitled*, 1949 (1986.43.158), mixed mediums on canvas, 228.9 × 112 cm, National Gallery of Art, Washington, Gift of The Mark Rothko Foundation, Inc.

Figure 16
Detail in specular light of *Untitled*, 1949 (1986.43.158) (fig. 15), revealing Rothko's careful modulations of surface sheen.

16

The paintings retained localized areas of playful brushwork and design, but generally the compositions became spare, as the colored shapes were simplified, enlarged, and repeated. Rothko painted a number of tall vertical canvases with series of parallel rectangular forms suspended in a mono-chromatic field. Reviewers were taken aback by the artist's "considerable care to avoid even accidental straying into the realms of form, design, line, plasticity, perspective, or, for that matter, texture — save for that which is unavoidably supplied by the thread of the canvas,"[54] as well as his "refusal to exploit the full resources of the oil medium."[55] Rothko's palette was reduced and refined to "pyrotechnic" hues,[56] used in "vibrant, even strident" combinations.[57]

In the late multiforms, as in the classic Rothko paintings to follow, the large, solid areas of pure color often exhibited subtle variations in brushwork and sheen that served as the active elements in otherwise simple compositions. In a review of Rothko's 1950 Betty Parsons show, Hess described the paint surfaces as "flattened pigment [that] takes on the pattern of the absorbent canvas, or occasionally clots in shiny masses over it."[58]

17

The ground became an integral compositional element, and the stained canvas was left exposed throughout the image area. The stained grounds of Rothko's late multiforms were precursors to the thin veils of color he would use to create the classic works that emerged around 1949 (fig. 17). By 1950 Rothko's paintings had "backgrounds [that] seem washed with hues rather than painted."[59] Hess would later remark in Rothko's obituary, "The staining was his own discovery. His stain was a first step in a highly personal methodology, he became a master of the alchemy of colors."[60] As the ground and colored tacking edges changed in appearance and importance, Rothko's strainers also evolved. They grew larger, up to 4 inches (about 10 cm) deep, as Rothko presented increasingly massive square and vertical format paintings. The paintings became an object on the wall that filled the viewer's field of vision, infusing the space with pulsating colors with no recognizable painted forms or narrative.[61] By the 1950 Betty Parsons show Rothko's paintings were called "elephantine" (fig. 18).[62]

Figure 17
Detail of the tacking edge from *Untitled*,
1949 (1986.43.158) (fig. 15). The grounds
of the later multiforms begin to exhibit
a stained appearance.

Figure 18
Mark Rothko at the Betty Parsons Gallery,
New York, 1950.

18

In 1949 Rothko published several multiforms in issue 9 of *Tiger's Eye*
magazine. The four late multiform paintings featured were listed as "new
work" alongside what would be the artist's last published statement. It
expressed the struggle of the multiform years and the move away from his
mythic and surrealist works toward abstraction. Rothko offered a prescient
description of the "clarity" he would ultimately achieve with his classic
paintings:

> The progression of a painter's work, as it travels from point to point,
> will be toward clarity, toward the elimination of all obstacles between
> the painter and the idea, and between the idea and the observer. As
> examples of such obstacles, I give (among others) memory, history, or
> geometry, which are swamps of generalization from which one might
> pull out parodies of ideas (which are ghosts) but never an idea itself.
> To achieve this clarity is, inevitably, to be understood.[63]

Three paintings examined from this time period — two from 1949 and
one from 1950 — offer hints of Rothko's later painting practices. The ground
samples showed a variety of mediums (table 1, nos. 13 – 15): one had glue and
egg (no. 15), one solely egg (no. 14), and one oil (no. 13). The glue-containing
ground was found on the painting dating from 1950, and it is interesting to
note that the medium of the brown and yellow paints from this 1950 painting
are glue-egg mixtures as well (table 1, no. 15). In contrast, the binders found
in the paints dating from 1949 are mixtures of egg and oil (table 1, nos. 13, 14),
in keeping with the samples from the earlier multiforms. It has been specu-
lated that Rothko introduced glue size mixed with powdered pigments for
his grounds during the multiform period.[64] The multiform samples exam-
ined in the present study indicate, however, that although Rothko used thin,
stained grounds in the late multiforms, he may have developed his pure glue
grounds slightly later, when the classic paintings began to emerge. Just two
of the multiforms analyzed used glue in the ground (table 1, nos. 9 front, 15),
in both cases mixed with egg. Rothko's switch to pigmented glue grounds in

his mature works added a new tactile component to the paintings. The pigmented glue ground offered a colored but absorbent preparatory layer that retained the texture of the canvas and allowed for the use of dilute veils of color to be applied in multiple layers. Such layering retained bold coloration but yielded the thin paint surface that was a key component of the classic canvases and the mural series to come.

Cross sections from the late multiform paintings suggest Rothko was close to the refined, controlled painting technique that would become his hallmark. These samples show delicate paint layers with very little extender, appearing almost as pure pigment in very thin layers of medium. The cross sections typically contain few layers with little evidence of revision or reworking (fig. 19).

50 μm

19

Figure 19
Cross section from *Untitled*, 1949 (1986.43.158) (fig. 15; see also table 1, no. 14), showing little evidence of reworking (paint layers are numbered beginning with the lowest layer). The thin green paint (layer 3) corresponds to the final composition. It overlaps a red layer that contains large dark red pigments with smaller white and tiny black particles (2), above a dense white paint with scattered red and blue particles (1). The ground layer is not present in the sample.

Discussion

The presence of egg in the paints and grounds of the multiforms establishes a previously unknown connection between the multiform paintings and Rothko's late paintings and murals, shedding light on the artist's unusual use of egg throughout his career. Rothko's use of egg in his paint continuously from the 1940s onward is all the more remarkable for the variety of paint surfaces he was able to achieve: from the matte, textured paint surfaces of the multiforms to thin veils of varying sheen found on the late Rothko Chapel paintings.

To create the multiforms Rothko was essentially using a type of modern tempera paint made by mixing egg with oil and resin components to make an emulsion. Whether he was manipulating tube oil paints or making his paints entirely from scratch is not clear; he did both for later paintings.[65] It appears that the conflicting stories of his use of tube paints and dry pigments in the 1940s may all be true. The paint samples reveal that Rothko altered and adapted paint mediums and varied the proportions of inorganic components in select layers of the multiforms to obtain distinctly matte paint surfaces. His experiments with tempera prior to the multiform years have been described, particularly as a bridge from watercolor to oil techniques,[66] but his use of egg tempera in the late 1940s has not been well explored.

There is documentary evidence that Rothko had used some type of tempera on paintings created prior to the multiform period. The artist gave clues when he published his statements and images during the late 1940s, in the magazines *Possibilities* and *Tiger's Eye*. In these publications a number of his paintings were listed as "tempera and oil."[67] Additionally, in a letter from around 1947, sent to the California School of Fine Arts prior to his arrival there as a teacher, he listed tempera, oil, and watercolor as his mediums.[68] Publications of Rothko's work after 1948 lack any sort of description of his painting materials; paintings once described as "tempera" or "tempera and oil" in print now commonly have more generic descriptions of "oil" or "mixed mediums." It is conceivable that Rothko's decision to stop titling his paintings, and ultimately speaking about them publicly, prompted him to stop describing his paint mediums as well.

Rothko's studio assistants for the Chapel murals mentioned that "he was always reading these books on how to make paintings more permanent. [He was] very concerned with that."[69] Rothko's paint-making and his choice of materials cannot be tied definitively to the books of Doerner, Mayer, and others, but the popularity of their writings and recipes suggest that he learned to paint in a time of experimentation, when artists were turning away from traditional oil paints and the surfaces they imparted. Making or manipulating egg tempera paints in his studio, Rothko would have been able to create colors with the handling and drying qualities he preferred. After experimenting with chalky paints on a number of multiforms, he seems to have shifted his focus to the production of increasingly dilute but pigment-rich paint layers. His use of the egg tempera medium would have supported his stylistic experimentation. The medium dried quickly, allowing immediate revisions and repeated layering. Tempera materials would have been inexpensive and versatile for an artist yet to gain wide recognition or sales.

The paint recipes for both egg tempera and glue-based tempera published in the artists' handbooks evoke the stories from Rothko's 1960s assistants who made his thin, soupy paints "by the bucketful" after hours of stirring.[70] The descriptions of the stained glue grounds that Rothko's assistants laboriously cooked for hours over the hot plate tally with Hess' account of Rothko's use of scenery paints, which in the early part of the century were glue-based.[71] Expanses of burst bubbles in areas of paint suggest that the artist was agitating and whipping up his paint to some extent, making it thin enough to create his fluid drip marks. Rothko had not, however, fully developed his signature pigmented glue ground in the multiform period, despite his increased use and refinement of the colored stain in the later multiforms. The analysis in the present study indicates that egg and egg-oil mixes rather than glue were used for grounds throughout the period. The presence of glue in both the paint and the ground layers of the 1950 painting examined in the study (table 1, no. 15) may signify the emergence of Rothko's use of thin, colored glue layers that became fundamental to the thin veils of color characteristic of the classic paintings. It is interesting that this study did not find evidence for the use of synthetic mediums or paints, such as Bocour's Magna acrylic resin paint, in Rothko's early mixed-mediums experiments.

The present study reveals the multiform period to be a crucial turning point for Rothko both stylistically and artistically. His experimentation

with abstraction paralleled previously unrecognized experimentation with his painting materials and techniques, as he began to tailor canvases, grounds, and specific paint components layer-by-layer to achieve unique surface effects and, ultimately, his mature artistic vision. The surprising discovery of egg mixed into the multiform paints, a technique Rothko would utilize again for the mural series late in his career, sheds important new light on the artist's lifelong fascination with and manipulation of traditional artists' materials used in new and surprising combinations.

A.L. carried out historical and technical research on Mark Rothko's multiform paintings in the National Gallery of Art's collection between 1999 and 2002. A.L. carried out FTIR analysis of paint samples under the supervision of S.Q.L. S.Q.L. carried out GC-MS examination of paint samples. A.L. and S.Q.L. wrote the essay.

Allison Langley's work was carried out as a William R. Leisher postgraduate fellow funded by the Andrew W. Mellon Foundation at the National Gallery of Art, 1999–2001.

1 Excerpts from notes taken at a lecture given by Mark Rothko at the Pratt Institute, New York, on October 29, 1958, quoted in Bonnie Clearwater, "Selected Statements by Mark Rothko," in *Mark Rothko, 1903–1970* (Tate Gallery, London, 1987), 87.

2 Marjorie B. Cohn, ed., *Mark Rothko's Harvard Murals* (Cambridge, MA, 1988); Jens Stenger et al., "Lithol Red Salts: Characterization and Deterioration," *e-Preservation Science*, http://www.morana-rtd.com/e-preservation-science/2010/Stenger-29-05-2010.pdf (accessed May 12, 2014); Santiago Cuellar et al., "Non-invasive Color Restoration of Faded Paintings Using Light from a Digital Projector," in *ICOM-CC 16th Triennial Conference Preprints (CD-ROM), Lisbon, 19–23 September 2011*, ed. J. Bridgland (Lisbon, 2011), 1–10.

3 Carol Mancusi-Ungaro, "The Rothko Chapel: Treatment of the Black-form Triptychs," in *Cleaning, Retouching, and Coatings*, ed. John S. Mills and Perry Smith (London, 1990), 134–137; Carol Mancusi-Ungaro and Pia Gottschaller, "The Rothko Chapel: Reflectance, Reflection and Restoration," *Zeitschrift for Kunsttechnologie und Konservierung* 16, no. 2 (2002): 215–224.

4 Leslie Carlyle, Jaap Boon, Mary Bustin, and Patricia Smithen, "The Substance of Things," in *Rothko* (Tate Gallery, London, 2008), 75–87.

5 Rothko did not use the term "multiform." It was first used in 1970 in exhibitions held after Rothko's death. David Anfam, "Rothko's Multiforms: The Moment of Transition and Transformation," in *Mark Rothko "Multiforms": Bilder von 1947–1949* (Galerie Daniel Blau, Munich, 1993), 25.

6 Unvarnished and unlined paintings were chosen for analysis. Fewer samples were taken from nos. 12 and 15, which were not available for the full duration of the study.

7 For FTIR analysis samples were compressed between windows of a Diamond Cell and analyzed using a Nicolet Nexus 670 spectrometer and Continuum microscope.

8 Samples were hydrolyzed (6N HCL) and silylated (MTBSTFA/TBDCMS in pyridine) for analysis by GC-MS. The analyses were carried out a Varian Saturn 2000 GC-MS.

9 Procedure for paint cross sections: microscopic paint cross sections and dispersed paint samples were analyzed using reflected and polarized light microscopy at up to 1600×. Microscopic samples were examined by UV-visible excited luminescence (using an excitation band-pass filter at 355–425 nm and a long-pass suppression filter at 460 nm) and grouped according to luminescence behavior. The paint consistency within the cross sections was noted (particle size, pigment distribution, layer thickness, layer order, and color order) to aid characterization of manufactured paints vs. artist mixed paints, with the assumption that paint layers with more inclusions and variability likely indicated some artist manipulation of the paint.

10 David Anfam has reconstructed Rothko's shows at the Betty Parsons Gallery. David Anfam, *Mark Rothko, The Works on Canvas: A Catalogue Raisonné* (New Haven, 1998), 54–62. Anfam's reconstruction differs from that in James E. B. Breslin, *Mark Rothko: A Biography* (Chicago, 1993), 232–233, 246–248.

11 Anfam 1998. Most of the multiform paintings currently bear dates bestowed twenty years after their creation, during Rothko's 1968–1969 inventory of his work, at which time he grouped paintings loosely by year and signed the reverse of many without regard to orientation. Anfam 1998, 17, 19–21.

12 Quoted in Dore Ashton, *About Rothko* (New York, 1983), 16. See also Breslin 1993; Anfam 1998.

13 For a discussion of the WPA artists and their painting materials, see Jan Lee Ann Marontate, "Synthetic Media and Modern Painting: A Case Study in the Sociology of Innovation" (PhD diss., Université de Montreal, 1996).

14 Dana Cranmer, "Painting Materials and Techniques of Mark Rothko: Consequences of an Unorthodox Approach," in *Mark Rothko 1987*, 196.

15 Max Doerner, *The Materials of the Artist and Their Use in Painting, with Notes on the Techniques of the Old Masters*, trans. Eugen Neuhaus (New York, 1934). Rothko's connection with Doerner's book is mentioned repeatedly: Cranmer 1987, 187; Anfam 1998, 28; Joseph Solman, interview by Avis Berman, May 6–8, 1981, 24, transcript, Archives of American Art, Washington; Marontate 1996, 267. John Gage offers

a detailed discussion of Doerner's influence on Rothko. John Gage, "Rothko: Color as Subject," in Jeffrey S. Weiss, *Mark Rothko* (National Gallery of Art, Washington, 1998), 249–252.

16 Ralph Mayer, *The Artist's Handbook* (New York, 1940). See Hilton Brown, "On the Material Side: Ralph Mayer's Contribution to Our Understanding of the Technology of Art, part 1," in *American Institute for Conservation of Historic and Artistic Works: Preprints of Papers Presented at the 11th Annual Meeting, Baltimore, Md.* (Washington, 1983), 13.

17 Frederick Taubes, *The Technique of Oil Painting* (New York, 1941); A. P. Laurie, *The Painter's Methods and Materials* (Philadelphia, 1926); Hilaire Hiler, *Notes on the Technique of Painting* (London, 1935); Hilaire Hiler, *The Painter's Pocket Book of Methods and Materials* (Los Angeles, 1945). Taubes' book was found in Pollock's studio. Carol Mancusi-Ungaro, "Jackson Pollock: Response as Dialogue," in *Jackson Pollock: New Approaches*, ed. Kirk Varnedoe and Pepe Karmel (New York, 1999), 146.

18 Marontate 1996, 139–140.

19 Solman interview 1981, 24.

20 Quoted in Breslin 1993, 245.

21 Stanley Kunitz, interview by Avis Berman, December 8, 1983, part 1, 25, transcript, Archives of American Art.

22 Jacob Kainen, interview by Avis Berman, August 10 and September 22, 1982, 28, transcript, Archives of American Art.

23 Thomas Hess, "Editorial: Mark Rothko, 1903–1970," *ArtNews* 69 (April 1970): 67.

24 Several publications discuss the terminology and ingredients for early twentieth-century tempera paints, both manufactured and artist made. Lance Mayer and Gay Myers, "Old Master Recipes in the 1920s, 1930s, and 1940s: Curry, Marsh, Doerner and Maroger," *Journal of the American Institute for Conservation* 4, no. 1 (2002): 21–42; Elizabeth Steele, "The Materials and Techniques of Jacob Lawrence," in *Over the Line: The Art and Life of Jacob Lawrence*, ed. Peter T. Nesbett and Michelle DuBois (Seattle, 2000), 247–265; Hilton Brown, "On the Technical Side," in *Milk and Eggs: The American Revival of Tempera Painting* (Brandywine River Museum, Chadds Ford, PA, 2002), 96–101.

25 Dorothy Seckler, "Changing Means to New Ends," *ArtNews* 50 (Summer 1952): 67–69.

26 Joyce Hill Stoner, "The Medium Is the Message," in *Rethinking Andrew Wyeth*, ed. David Cateforis (Berkeley, 2014), 86–99.

27 Steele 2000. See also Elizabeth Steele and Susana M. Halpine, "Precision and Spontaneity: Jacob Lawrence's Materials and Techniques," in *Jacob Lawrence: The Migration Series*, ed. Elizabeth Hutton Turner (Washington, 1993), 155–159.

28 Thomas Hess, *Barnett Newman* (Museum of Modern Art, New York, 1971), 53.

29 Linda Kunheim Kramer, "The Graphic Sources of Gottlieb's Pictographs," in *The Pictographs of Adolph Gottlieb* (New York, 1994), 54.

30 When Rothko painted on both sides of a canvas he often used different styles. See *Untitled*, 1947 (1986.43.76) (table 1, no. 9) and

also *Fantasy at Dawn* [front], 1946 (1986.43.5.a) and *Fantasy at Dawn* [reverse], 1947 (1986.43.5.b). He does not seem to have been in the practice of painting over completed paintings.

31 Anfam 1998, 42.

32 Joseph Liss, "Willem de Kooning Remembers Rothko: 'His House Had Many Mansions,'" *ArtNews* 78, no. 1 (January 1979): 41. Rothko also washed canvases later in his career. William Scharf recalled that Rothko "wanted one canvas painted and scrubbed off to see how it behaved and if it could be used again." Quoted in Breslin 1993, 468.

33 Quoted in Susan Landauer, *The San Francisco School of Abstract Expressionism* (Berkeley, 1996), 33.

34 Anfam 1998, 58.

35 The particles inferred to be gum were irregularly shaped, clear particles that were easily compressed with the Diamond Cell used for FTIR analysis. They had an infrared spectrum consistent with a carbohydrate and were therefore inferred to be a plant gum.

36 Quoted in Landauer 1996, 232.

37 Quoted in Landauer 1996, 11. Remington refers to W. P. Fuller & Co. industrial paints, which were produced in San Francisco and other West Coast cities in the early twentieth century.

38 Quoted in Mary Fuller McChesney, *A Period of Exploration: San Francisco, 1945–1950* (Oakland Museum, Oakland, CA, 1973), 77.

39 Quoted in Breslin 1993, 237.

40 Sam Hunter, "Diverse Modernism," *New York Times*, March 14, 1948, sec. 2, 8.

41 Emily Genauer, "Indefinite Ideas," *New York World Telegram*, March 16, 1948, 25.

42 Mark Rothko, "The Romantics Were Prompted," *Possibilities* 1 (Winter 1947–1948): 84. Rothko's statements are reprinted in Clearwater 1987, 67–75.

43 Rothko's drip marks have been discussed in Carol Mancusi-Ungaro, "Material and Immaterial Surface: The Paintings of Rothko," in Weiss 1998, 286–288; Anfam 1998, 60.

44 The white vertical drips in the upper right corner of *Untitled*, 1948 (1986.43.4) appear to have inspired a series of painted white lines that begin at the drip edges.

45 Hunter 1948, 8.

46 PVB, "Art Exhibition Notes: Formless and Tenuous," *New York Herald Tribune*, March 9, 1948, 23.

47 Gage (1998, 248–263) suggested that Rothko consistently added white to his paints from the 1930s onward, and analysis found supporting evidence for this practice.

48 Stuart Preston, "Diverse New Shows," *New York Times*, April 3, 1949, sec. 2, 8.

49 T[homas] B H[ess], "Reviews and Previews," *ArtNews* 48 (April 1949): 48–49.

50 Quoted in Landauer 1996, 33.

51 McChesney 1973, 78.

52 Quoted in Landauer 1996, 33.

53 Belle Krasne, "Mark of Rothko," *Arts Digest*, January 15, 1950, 17.

54 PVB 1948, 23.

55 H[ess] 1949, 48–49.

56 Howard Devree, "In New Directions," *New York Times*, January 8, 1950, sec. 2, 10.

57 Krasne 1950, 17.

58 T[homas] B H[ess], "Reviews and Previews," *ArtNews* 49 (February 1950): 46.

59 H[ess] 1950, 46.

60 Hess 1970, 67.

61 The deeper stretchers seem to be a temporary response to Rothko's experiments with large-scale canvases, as the artist returned to traditional stretcher depths later in his career, evident in the mural series from the 1960s.

62 Krasne 1950, 17.

63 Mark Rothko, "Statement on His Attitude toward Painting," *Tiger's Eye*, no. 9 (October 1949): 114.

64 Cranmer 1987, 189–197.

65 Mancusi-Ungaro 1990.

66 Gage 1998, 249; Anfam 1998, 28; David Anfam, "The Art of Mark Rothko: Simplifying the Complex Thought," in *Mark Rothko* (Kawamura Memorial Museum of Art, Tokyo, 1995), 207.

67 In the winter of 1947 seven works painted before the multiforms were published without titles in the magazine *Possibilities*, although the paintings had early titles by which they are currently known. Three paintings were listed as tempera and oil: *Birth of Cephalopods*, *Rites of Lillith*, and *Votive Figure*. Similarly, in *Tiger's Eye*, no. 1, published in December 1947, *The Source* was listed as oil and tempera. In *Tiger's Eye*, no. 3, published in March 1948, *Sacrificial Moment*, was listed as "oil and tempra [sic]." For more on Rothko's contributions to the *Tiger's Eye* publications, see Pamela Franks, *The Tiger's Eye: The Art of a Magazine* (New Haven, 2002).

68 Mark Rothko to Douglas MacAgy, n.d., California School of Fine Arts (San Francisco Art Institute) Archives, San Francisco.

69 Roy Edwards and Ralph Pomeroy, "Working with Rothko," *New American Review* 12 (1971): 108–121.

70 Edwards and Pomeroy 1971, 113.

71 Hess 1970, 67; Brown 2002, 96–101.

References

ANFAM 1993 Anfam, David. "Rothko's Multiforms: The Moment of Transition and Transformation." In *Mark Rothko "Multiforms": Bilder von 1947–1949*, 17–31. Galerie Daniel Blau, Munich, 1993.

ANFAM 1995 Anfam, David. "The Art of Mark Rothko: Simplifying the Complex Thought." In *Mark Rothko*, 204–209. Kawamura Memorial Museum of Art, Tokyo, 1995.

ANFAM 1998 Anfam, David. *Mark Rothko, The Works on Canvas: A Catalogue Raisonné.* New Haven, 1998.

ASHTON 1983 Ashton, Dore. *About Rothko.* New York, 1983.

BRESLIN 1993 Breslin, James E. B. *Mark Rothko: A Biography.* Chicago, 1993.

BROWN 1993 Brown, Hilton. "On the Material Side: Ralph Mayer's Contribution to Our Understanding of the Technology of Art, part 1." In *American Institute for Conservation of Historic and Artistic Works: Preprints of Papers Presented at the 11th Annual Meeting, Baltimore, Md.,* 8–17. Washington, 1983.

BROWN 2002 Brown, Hilton. "On the Technical Side." In *Milk and Eggs: The American Revival of Tempera Painting,* 96–101. Brandywine River Museum, Chadds Ford, PA, 2002.

CARLYLE ET AL. 2008 Carlyle, Leslie, Jaap Boon, Mary Bustin, and Patricia Smithen. "The Substance of Things." In *Rothko,* 75–87. Tate Gallery, London, 2008.

CLEARWATER 1987 Clearwater, Bonnie. "Selected Statements by Mark Rothko." In *Mark Rothko* 1987, 67–75.

COHN 1988 Cohn, Marjorie B., ed. *Mark Rothko's Harvard Murals.* Cambridge, MA, 1988.

CRANMER 1987 Cranmer, Dana. "Painting Materials and Techniques of Mark Rothko: Consequences of an Unorthodox Approach." In *Mark Rothko* 1987, 189–197.

CUELLAR ET AL. 2011 Cuellar, Santiago, et al. "Non-invasive Color Restoration of Faded Paintings Using Light from a Digital Projector." In *ICOM-CC 16th Triennial Conference Preprints (CD-ROM), Lisbon, 19–23 September 2011,* edited by J. Bridgland, 1–9. Lisbon, 2011.

DEVREE 1950 Devree, Howard. "In New Directions." *New York Times,* January 8, 1950, sec. 2, 10.

DOERNER 1934 Doerner, Max. *The Materials of the Artist and Their Use in Painting, with Notes on the Techniques of the Old Masters,* translated by Eugen Neuhaus. New York, 1934.

EDWARDS AND POMEROY 1971 Edwards, Roy, and Ralph Pomeroy. "Working with Rothko." *New American Review* 12 (1971): 109–121.

FRANKS 2002 Franks, Pamela. *The Tiger's Eye: The Art of a Magazine.* New Haven, 2002.

GAGE 1998 Gage, John. "Rothko: Color as Subject." In *Weiss* 1998, 246–263.

GENAUER 1948 Genauer, Emily. "Indefinite Ideas." *New York World Telegram,* March 16, 1948, 25.

H[ESS] 1949 H[ess], T[homas] B. "Reviews and Previews." *ArtNews* 48 (April 1949): 48–49.

H[ESS] 1950 H[ess], T[homas] B. "Reviews and Previews." *ArtNews* 49 (February 1950): 46.

HESS 1970 Hess, Thomas. "Editorial: Mark Rothko, 1903–1970." *ArtNews* 69 (April 1970): 67.

HESS 1971 Hess, Thomas. *Barnett Newman.* Museum of Modern Art, New York, 1971.

HILER 1935 Hiler, Hilaire. *Notes on the Technique of Painting.* London, 1935.

HILER 1945 Hiler, Hilaire. *The Painter's Pocket Book of Methods and Materials.* Los Angeles, 1945.

HUNTER 1948 Hunter, Sam. "Diverse Modernism." *New York Times*, March 14, 1948, sec. 2, 8.

KRAMER 1994 Kramer, Linda Kunheim. "The Graphic Sources of Gottlieb's Pictographs." In *The Pictographs of Adolph Gottlieb*, 46–57. New York, 1994.

KRASNE 1950 Krasne, Belle. "Mark of Rothko." *Arts Digest*, January 15, 1950, 17.

LANDAUER 1996 Landauer, Susan. *The San Francisco School of Abstract Expressionism*. Berkeley, 1996.

LAURIE 1926 Laurie, A. P. *The Painter's Methods and Materials*. Philadelphia, 1926.

LISS 1979 Liss, Joseph. "Willem de Kooning Remembers Rothko: 'His House Had Many Mansions.'" *ArtNews* 78, no. 1 (January 1979): 41–44.

MANCUSI-UNGARO 1990 Mancusi-Ungaro, Carol. "The Rothko Chapel: Treatment of the Black-form Triptychs." In *Cleaning, Retouching, and Coatings*, edited by John S. Mills and Perry Smith, 134–127. London, 1990.

MANCUSI-UNGARO 1998 Mancusi-Ungaro, Carol. "Material and Immaterial Surface: The Paintings of Rothko." In Weiss 1998, 282–300.

MANCUSI-UNGARO 1999 Mancusi-Ungaro, Carol. "Jackson Pollock: Response as Dialogue." In *Jackson Pollock: New Approaches*, edited by Kirk Varnedoe and Pepe Karmel, 117–153. New York, 1999.

MANCUSI-UNGARO AND GOTTSCHALLER 2002 Mancusi-Ungaro, Carol, and Pia Gottschaller. "The Rothko Chapel: Reflectance, Reflection and Restoration." *Zeitschrift for Kunsttechnologie und Konservierung* 16, no. 2 (2002): 215–224.

MCCHESNEY 1973 McChesney, Mary Fuller. *A Period of Exploration: San Francisco, 1945–1950*. Oakland Museum, Oakland, CA, 1973.

MARK ROTHKO 1987 *Mark Rothko, 1903–1970*. Tate Gallery, London, 1987.

MAYER 1940 Mayer, Ralph. *The Artist's Handbook*. New York, 1940.

MAYER AND MYERS 2002 Mayer, Lance, and Gay Myers. "Old Master Recipes in the 1920s, 1930s, and 1940s: Curry, Marsh, Doerner and Maroger." *Journal of the American Institute for Conservation* 4, no. 1 (2002): 21–42.

PRESTON 1949 Preston, Stuart. "Diverse New Shows." *New York Times*, April 3, 1949, sec. 2, 8.

PVB 1948 PVB. "Art Exhibition Notes: Formless and Tenuous." *New York Herald Tribune*, March 9, 1948, 23.

ROTHKO 1947–1948 Rothko, Mark. "The Romantics Were Prompted." *Possibilities* 1 (Winter 1947–1948): 84.

ROTHKO 1949 Rothko, Mark. "Statement on His Attitude toward Painting." *Tiger's Eye*, no. 9 (October 1949): 114.

SECKLER 1952 Seckler, Dorothy. "Changing Means to New Ends." *ArtNews* 50 (Summer 1952): 67–69.

STEELE 2000 Steele, Elizabeth. "The Materials and Techniques of Jacob Lawrence." In *Over the Line: The Art and Life of Jacob Lawrence*, edited by Peter T. Nesbett and Michelle DuBois, 247–265. Seattle, 2000.

STEELE AND HALPINE 1993 Steele, Elizabeth, and Susana M. Halpine. "Precision and Spontaneity: Jacob Lawrence's Materials and Techniques." In *Jacob Lawrence: The Migration Series*, edited by Elizabeth Hutton Turner, 155–159. Washington, 1993.

STONER 2014 Stoner, Joyce Hill. "The Medium Is the Message." In *Rethinking Andrew Wyeth*, edited by David Cateforis, 86–99. Berkeley, 2014.

TAUBES 1941 Taubes, Frederick. *The Technique of Oil Painting*. New York, 1941.

WEISS 1998 Weiss, Jeffrey S. *Mark Rothko*. National Gallery of Art, Washington, 1998.

IN FOCUS

Sfumato and Sheen: Bernardino Luini's Lady in Black

Michael Swicklik, Barbara H. Berrie, and Gretchen Hirschauer

Bernardino Luini (c. 1480 – 1532) arrived in Milan around 1500, where he came into the orbit of Leonardo da Vinci (1452 – 1519). The near-contemporary critic Giovanni Battista Lomazzo, writing of Luini in *Trattato dell'arte della pittura* (Treatise on the Art of Painting, 1584) does not associate him with Leonardo or indicate that he was a pupil.[1] Nevertheless, Luini was in possession of a cartoon by Leonardo at the time of his death, suggesting a connection.[2] Moreover, Luini's *Portrait of a Lady* in the National Gallery of Art exhibits Leonardo's profound impact on this painter's style and technique. It is the only known surviving independent portrayal of a female sitter by the artist (fig. 1).[3] The identity of the sitter has never been ascertained, and, given the painting's high quality and rarity, that is surprising.[4] The panel was purchased by Andrew W. Mellon in 1928, and there are no records of it being treated after it entered the National Gallery's collection until examination and treatment were undertaken in 2013. This project has prompted our focus on the mimetic intention of the artist.

Leonardo was in Milan in 1506 and again 1508 – 1513, and the techniques with which Luini depicted the soft transitions in form in his portrait certainly derive from observations of the master's and his pupils' works. With the slight smile and *sfumato* (from the Italian *fumo*, or "smoke") — the pervading softness of light and shadow in the nearly imperceptible blending of colors and tones in the face — *Portrait of a Lady* appears to owe a particular debt to Leonardo's *Mona Lisa*, 1503 – 1507, an observation that often appears in the literature.[5] The translucent treatment of the sitter's diaphanous hat and bodice also seem to gather insights from Leonardo's practice. Although some comparisons to Leonardo's painting will be brought to bear in the following discussion, it is our intention to concentrate on Luini's painting technique as it relates to the depiction of this refined figure, and particularly to her elaborate costume, the condition of the painting, the conservation treatment, and the inpainting of the damaged black dress.

The Costume of the Lady in Black

Luini's lady in black is elegant but subtle and understated in her dress and accessories. She wears a long-sleeved white linen smock shirt, or *camicia,* embellished by

Figure 1
Bernardino Luini, *Portrait of a Lady*,
1520/1525, oil on panel, 77 × 57.5 cm,
National Gallery of Art, Washing-
ton, Andrew W. Mellon Collection,
after treatment.

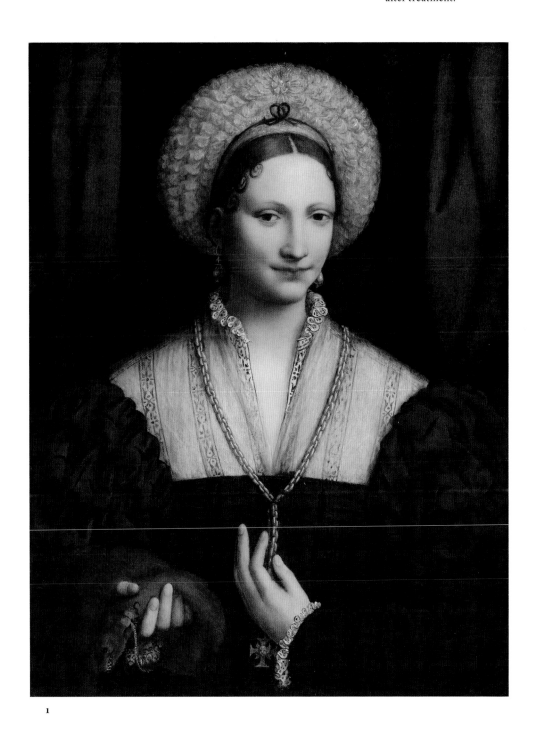

1

a blackwork-embroidered ruffled collar with a pattern that repeats at her sleeve cuff. Blackwork is a counted-thread embroidery technique using black silk thread on a plain weave white or off-white fabric to create patterns that are traditionally geometric or floral.[6] Her collar is covered by a partlet tucked inside her dress, probably made of nearly transparent ecru linen or silk. During the years when Luini's portrait was likely painted, 1520/1525, these partlets became increasingly elaborate items of individual taste, with delicate pleats that had to be reworked often to maintain their form.[7] However, Luini's sitter chose a simple example that allowed the high-collared embroidered *camicia* to show through. Her large, round headpiece, called a *capigliara* or *balzo*, fashioned over a thin wood or wicker form, also demonstrates relative restraint. The *capigliara* was made popular by Isabella d'Este (1474 – 1539), marchioness of Mantua, an educated collector and patron of the arts, and these headpieces were often excessively ornamented with lace, bows, jewels, pearls, embroidery, and even woven human hair.[8] But again, Luini's sitter wears a relatively subdued silken shirred version that would likely have originally been a shimmering gold color. It is decorated with a simple black bow and subtle flower instead of an expensive jewel. She holds a marten or weasel pelt (few distinctions were made between these animals at this time) called a *zibellino,* which is attached to her dress or belt by a gold chain. These fur accessories have been described as charms used to ward off evil spirits[9] or a means to attract fleas away from the sitter.[10] In fact, because of the notion that these animals gave birth miraculously, the

pelt was not only a fashionable accessory but also a talisman believed to aid fertility and safe childbirth.[11]

In the absence of other female portraits from the artist's hand, Luini's portrait is often discussed in connection with Lorenzo Lotto's *Lucina Brembati*, circa 1518, in the Accademia Carrara, Bergamo (fig. 2).[12] Both sitters wear a *capigliara* and a linen partlet, and carry a *zibellino*, but comparison between the two works reveals great differences in their sitters' outward appearance. Lucina Brembati wears an opulent headpiece, a gold-edged chemise, two necklaces, and many rings, all of which stand in contrast to the understated, demure image and personality suggested by Luini's sitter, whose gold chain, cross, and pearl earrings are reserved by comparison. The cross is unusual, with what appears to be an infant head at the center. It could provide

Figure 2
Lorenzo Lotto, *Lucina Brembati*, c. 1518, oil on panel, 52.6 × 44.8 cm, Accademia Carrara di Belle Arti, Bergamo.

2

some insight into the sitter or her circumstance, but its origin and significance remain elusive. The earrings are large but simple in design and not ostentatious in their setting. Pearls were highly valued not only for their cost but also for their association with chastity, good health, and marriage.[13]

Again, while the shape of the sitter's square, low-necked silk taffeta gown appears simple, its structure and design are complex and difficult to decipher. The bodice and lower sleeves of the dress appear to have been created by complicated rounded, vertical and horizontal folds and pleats, probably considered at the time to be both refined and stylish (fig. 3). These folds must have been as difficult to maintain as they were to execute, requiring

sustained labor for upkeep. The oversize upper sleeves and shoulders were of a different construction, consisting of large, slashed puffs called *baragoni* (fig. 4).[14] Slashing or defacing of expensive fabric, considered a commodity or luxury item, was periodically banned by sumptuary laws, although such decrees were often ignored.

The choice of the color black for the sitter's garment is also revealing. This noble color first became popular at the Burgundian court of Philip the Good (r. 1419 – 1467), who adopted it as a symbol of virtue and nobility, suffering, and filial devotion, after the murder of his father in 1419.[15] The trend for black clothing spread to the northern Italian courts, and black was praised as a pleasing color by Baldassare Castiglione

Figure 3
Detail of *Portrait of a Lady* (fig. 1), showing bodice and lower sleeve.

Figure 4
Detail of upper sleeve and shoulder.

3

4

in *The Book of the Courtier* (1528).[16] However, black fabric dye, a mix of tannins and iron,[17] was very corrosive. The darker the color, the more perishable the fabric, and it would have also faded quickly. Black garments simply did not last.[18] In choosing to be portrayed in black, Luini's sitter was asserting her elevated rank as one who could afford a complex and refined fabric and was not concerned with durability. In her choice of accessories and expensive but ephemeral dress, Luini's sitter presents herself as elegant and of high status, but in an understated and subtle way.

Luini's Painting Techniques

To understand how Luini painted this portrait, a critical surface examination aided by stereomicroscopy was augmented by examination of cross section samples and infrared and x-ray imaging.[19] The samples were analyzed using optical microscopy (OM) and scanning electron microscopy with energy dispersive x-ray analysis (SEM-EDX).[20] The combination of these methods allowed the painting method and materials to be identified.

The painting was executed on a wooden panel support characterized by a tight grain, suggesting it is poplar or a similar wood. The support consists of three boards that have been joined together with the grain oriented vertically. A wooden cradle was attached to the original support in modern times, with seven vertical fixed members and seven horizontal transverse members. The cradle was painted with opaque, thick green paint. The green paint probably contains lead white, as it is dense to x-rays and obscures the painted image in its radiograph (fig. 5).

Although Luini's portrait does suffer from severe cracking, it does not suffer from the defect of wrinkling, which occurs in many Milanese school paintings from this period. This condition in some cases affects the entire painting, and in others it is localized, often to specific colors in the composition.[21] The wrinkling might be a consequence of the use of walnut oil, which dries rather poorly, or of a lightly pigmented oil laid directly on the gesso.[22] The wooden panel support for Luini's portrait was prepared with gesso covered by a sealing layer, which preliminary analysis suggests is glue rather than the pigmented oil more typical of Leonardesque painters,[23] and it is likely that this glue prevented the drying defect. It is also possible that the thinness of the paint films Luini used in this panel helped prevent wrinkling.

Figure 5
X-radiograph with overlay in blue of the outline of the figure. The gold chain and white cuffs, which contain lead white, can be seen, but the hands and face appear dark because they were not underpainted with lead white.

5

Luini painted the portrait using a spare technique, employing thin films of paint applied in only a few — sometimes only two — layers. For example, the flesh tones are built up thinly from light to dark. Luini augmented the brightness of the ground with the thinnest of warm glazes to accomplish the brightest and warmest highlights. Shadows were glazed over the brighter, warmer tones, progressing from warm red tones at the edges of the bright highlights to darker, cooler glazes in the deeper shadows. Although they are not visible from a simple examination of the paint surface, numerous layers of thin glazes would have been necessary to achieve the deepest shadows. If Luini had used lead white underpaint it would have appeared in the radiograph (see fig. 5) as bright white shapes in the flesh areas. However, the overall lack of density in the area of the face corroborates that Luini did not put down a layer of white or pale pink for the sitter's head but used the ground for a light tone and thin, glazed paint to heighten the highlight areas on her face, forehead, cheeks, and chin. In this respect Luini's mode of painting is similar to that of Leonardo in his late works, as x-radiography has demonstrated that Leonardo did not use lead white underpaint in faces after 1500, although he had done so before that date.[24]

The *capigliara* was painted using thin, swirling strokes of glazes, mingling yellow paints with green. It is interesting that warmhued lead antimonate, also called Naples yellow, was mixed with the

Figure 6
Paint cross section from highlight at the top of the sitter's *capigliara* (paint layers are numbered beginning with the lowest layer).

(a) Visible light image (bright field, crossed polarizing filters). The lightest highlight (5) is painted using lead-tin yellow that has degraded (the extent of deterioration is seen in figure 6b by the distribution of light gray in the top layer). This pale yellow paint lies over a layer (4) of lead antimonate (Naples yellow) mingled with a copper green (which has discolored somewhat and appears dark in the cross section). Underneath is a thin layer (3) of yellow ocher. A translucent layer (2) lies between the paint layers and the preparatory gesso (1).

(b) Backscatter electron image of area denoted in figure 6a.

(c)–(g) Maps of the elemental distribution, as follows:

(c) Iron (Fe)

(d) Copper (Cu)

(e) Lead (Pb)

(f) Antimony (Sb)

(g) Tin (Sn)

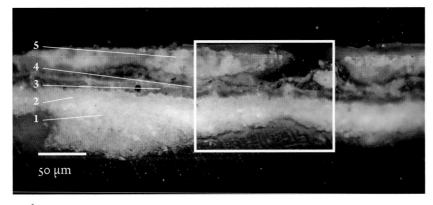

6a

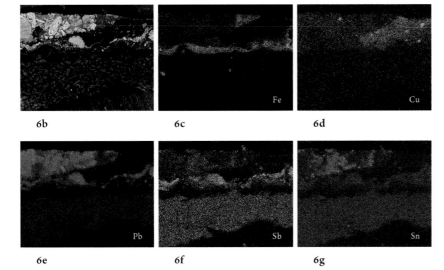

6b 6c 6d

6e 6f 6g

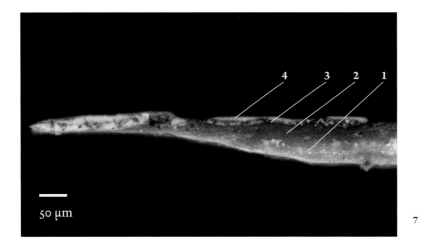

Figure 7
Paint cross section from the edge of the sitter's right sleeve where the paint of the ecru veil covers the dress (paint layers are numbered beginning with the lowest layer). A golden-colored pure ocher glaze (4) was used for the veil. Layer (3), a thin black paint, consists of two adjacent strokes. On the left side of the sample are charcoal and lead white, while on the right side bone black was mixed with lead white, with a small addition of vermilion. Underneath is a translucent layer (2), and then the gesso ground (1).

7

green for the darker tones of the hat (fig. 6) in an early use of this colorant.[25] This mixture of a warm orange-yellow with green yielded a color that was probably more golden than green-yellow and helped make the shadows less brown than they now appear. The lightest highlights of the scrunched fabric in the hat were painted using a small brush in narrow curlicues of lead-tin yellow. This particular formulation, which contains only a small proportion of silicon, was unstable. The degradation of the pigment has resulted in a loss of both color and opacity, softening highlights on the *capigliara* that would otherwise have appeared more silky and reflective. The color would have been more stridently golden yellow when first painted, and the contrast with the golden-hued green mixtures would have created a brighter effect. Despite the diminution of contrast of the color due to these changes, the semblance of opulence, though restrained, remains.

For the sitter's luxurious dress Luini effectively depicted a whole range of blacks — shadowed, lit, matte, and lustrous — with great economy of painting. A cross section from an area of the shoulder where an edge of the black dress is covered by the ecru partlet on top of the white *camicia* demonstrates his method (fig. 7). Over a thick gesso ground a single thin layer of paint mixed from black pigments with lead white was used. The variation of tone was accomplished here in only one layer: at the lighter edge, the stroke of paint mixed from lead white with large black particles blends into darker paint mixed using a smaller proportion of lead white. The higher amounts of calcium and phosphorus in the vicinity of the smaller particles in the darker paint indicate the use of bone black. In contrast, the black particles in the paler paint have the splintered edges typical of charcoal, and only a barely detectable trace of phosphorus is present, associated with only one particle.

The Florentine Raffaello Borghini (1537 – 1588) noted in *Il Riposo* (The Rest, 1584), that nine black pigments were used by painters.[26] Of these, eight were described as suitable for oil: black earth, black bell earth (*nero di terra di campana*), asphalt, burnt ivory, burnt peach pits, smoke black, charcoal from the viniferous vine, and paper black. Borghini described charcoal as a thin color but very good in oil. He explained that the careful painter would mix black pigments

to achieve the best effect. Charcoal, known for its bluish undertone, is used to advantage in pale layers to give violet-hued colors (especially when red lake is also added). Bone or ivory black is highly regarded for producing a velvety appearance, but it does not have such a blue undertone. By using these two pigments, both black but subtly different, Luini was able to depict the way light might play on what is basically a light-absorbing surface. He mixed these different black pigments with vermilion and lead white to yield an incredibly subtle range of tones from warm to cool black, together with very subtle shifts in the gray layers that create the dress's shimmery highlights. Qualities of luster and shine were highly valued in the sixteenth century.[27] Certainly it was important for Luini to depict the sheen of the silk used in the

sumptuous dress worn by the sitter, an effect he skillfully achieved by making slight modulations in the shades of the blacks he employed and by mixing only minimal additional pigments.

Condition and Treatment
Underdrawing in Luini
The infrared reflectogram image of *Portrait of a Lady* (fig. 8) is most remarkable for its simplicity. With such an elaborately dressed sitter in so detailed a costume, one might expect an equally meticulous drawing to guide the painter through its execution. Instead, the underdrawing in the Luini portrait is rather rudimentary. In the face, just the basic outlines of the shape of the head and neck are indicated, with a little heavier sketching at the bottom of the chin. Only the facial

Figure 8
Infrared reflectogram (1100 – 1400 nm) of detail of *Portrait of a Lady* (fig. 1), revealing a simple underdrawing comprised of basic outlines of the head and neck, with a little heavier sketching at the bottom of the chin. Only the facial features are fully realized.

8

Figure 9
Bernardino Luini, *Portrait of a Young
Woman with a Fan*, c. 1520 – 1525, black, red,
brown, yellow, and white chalk on paper,
41.4× 28.5 cm, Albertina, Vienna.

9

features could be described as fully realized. The shape of the eyes and pupils, the folds around the lids, the shadows beneath the brows, the eyebrows themselves, and the folds and shadows beneath the eyes are all fully depicted. The nose is well formed, particularly the lower part and nostrils. Some sketchy, active lines describe the shadow beneath the nose. The hands were delineated using a style similar to that employed in the face. It might be assumed that an underdrawing for the costume would be as complete as for the face and hands, but it seems this is not the case, and little can be perceived. For example, only the outside contours of the hat appear to be sketched. All the intricate details of the *capigliara* were accomplished in paint with no sign of a guide. Luini produced a detailed drawing of a woman (fig. 9), now in

the Albertina, Vienna, that has been connected to both the National Gallery portrait and to his fresco of *Ginevra Bentivoglio and Saints* in Milan. Perhaps he had the drawing on hand to serve as a model while painting. Both the detailed embroidery of the chemise in the painted portrait and the complexly folded black dress appear devoid of drawing. Curiously, the only area where Luini seemed to employ a detailed underdrawing was for the *zibellino*.

Comparison with the underdrawing of Luini's *The Magdalen* (fig. 10), also in the National Gallery of Art, might lend credence to the notion that there is a more extensive underdrawing in the black dress of *Portrait of a Lady* than can be seen. While the definition and style of the underdrawing of the face in *The Magdalen* are very similar to those of the face in *Portrait of a Lady*,

Figure 10
Composite infrared reflectogram (1100–1400 nm) of Bernardino Luini, *The Magdalen*, c. 1525, oil on panel, 58.8 × 47.8 cm, National Gallery of Art, Washington, Samuel H. Kress Collection.

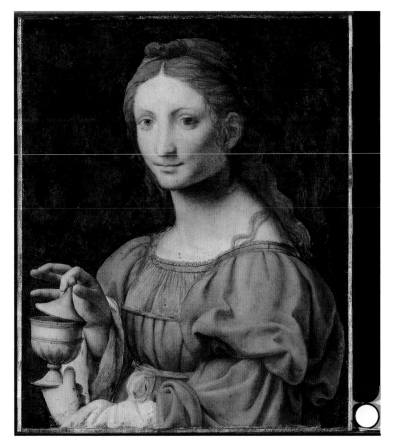

10

the treatment of the two dresses differs. The sitter's green dress in *The Magdalen* has a meticulous underdrawing, but there appears to be no underdrawing for the black dress in *Portrait of a Lady*. Given that the design of the black dress is even more complicated than the green dress, it would seem probable that Luini required an underdrawn guide; perhaps it is present but not visible in infrared because of the carbon-containing paint on top. Another look at the cross section (see fig. 7) taken from the dress at the sitter's shoulder shows scattered fine black pigment in the glue layer directly on top of the ground, suggesting an underdrawing that has been disturbed by the application of a coating over it.[28]

Condition before treatment

Prior to its recent conservation treatment, Luini's *Portrait of a Lady* (fig. 11) was in an aesthetically compromised condition. Its thick coating of natural resin varnish had discolored to a warm coffee color that had turned the soft ocher and yellow tones of the sitter's hat and partlet to an unpleasant caramel brown. The bright warm tones of the flesh colors were stained to a similar color. However, it was not only the change in tones that led to the decision to clean this painting, but also the need to remove the extensive and not particularly meticulous or well-conceived repainting that covered a good part of the original paint. Unfortunately, in past clean-

Figure 11
Portrait of a Lady (fig. 1), before varnish and repaint removal.

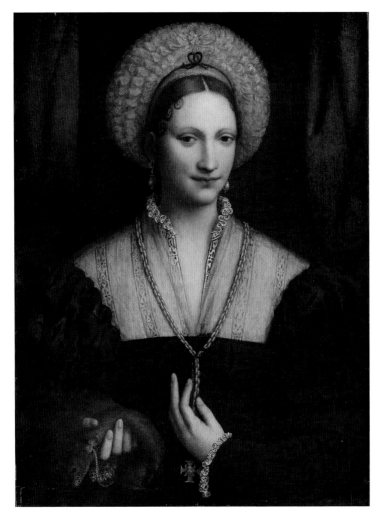

11

ings before the painting arrived at the National Gallery, Luini's portrait had been quite harshly treated. Perhaps while removing a varnish that had been particularly difficult to dissolve, a past restorer resorted to a cleaning solution that was overly active on some areas of the paint layer. In the flesh paint, which was extensively cracked with age, the cleaning solution went into the cracks, severely darkening them by either carrying in the discolored components or by dissolving the white ground and exposing the dark color of the wood support, or perhaps a little of both. In addition to creating a much darker network of cracks, the cleaning agent also widened them by undermining the paint at their edges and causing minute losses on both sides of each crack. It seems that treatment prior to the painting's arrival at the National Gallery had included retouching that covered original paint on each side of the cracks instead of confining the inpainting to cracks and losses. When all the cracks had been retouched in this manner, very little of the original flesh paint remained uncovered. As the retouching had also become cloudy and discolored with age, the look of the face, neck, and hands had become strangely opaque.

The black dress also had been compromised by severe cleaning. One principle of cleaning oil paintings is that dark colors will almost always be more susceptible to damage by cleaning than will light colors because the lead in the white of the light colors catalyzes the drying of the oil paint to create tougher paint films. A solvent that was so strong that it undermined the paint film and caused flaking in the flesh areas would also have caused the extensive damage in the black dress. Examination before conservation treatment showed extensive repainting in the blacks that covered large lacunae where paint had been lost down to the ground or in some places even to the wooden support. Just as in the face, the retouching of these areas had not been expert, leaving the dress undefined in places and poorly imagined in others.

It is never an easy decision to treat a painting that has condition problems, no matter how it looks. While there was no question that removing the discolored varnish was worthwhile, the fact that its removal would also necessarily remove the past retouching that hid more serious preservation flaws gave reason for pause. In the end, recovering the original paint in the flesh tones by removing the repainting, necessitating meticulous inpainting in areas of the cracks, seemed valuable for the appearance of the painting. There was little doubt that treatment would significantly enhance the painting's appearance and allow Luini's achievement to be appreciated.

Inpainting

From the photograph of the painting after the removal of the discolored varnish and the old restorations (figs. 12, 13), it is apparent that considerable retouching was required to reintegrate the damaged areas with those that were still reasonably well preserved. In the face, the most difficult task was to correct the biggest flaw in the previous treatment and apply paint only within the confines of the cracks and their adjacent small losses. Because the cracks were extremely fine and dark, finding a retouching method

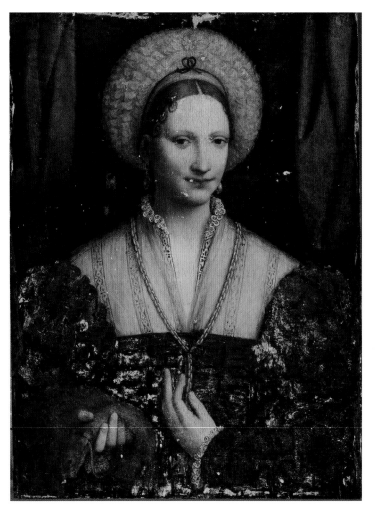

Figure 12
Portrait of a Lady (fig. 1), after removal of varnish and old repainting.

Figure 13
Detail of figure 12, showing face before inpainting.

12

13

that was both opaque and thin enough was a challenge. In the end, dry titanium white pigment mixed only with water, combined with the necessary colored admixtures from cake watercolors, was utilized. The only binding medium was provided by the watercolor paints. This medium gave a very opaque, free-flowing paint. The leanness of the water-based paint allowed the natural bristle brush to maintain its sharpest point, facilitating application of the paint only where it was needed. The retouching was brought to gloss with varnish. In this method, the underbound watercolor goes on as one color, dries as another, and changes again when it is saturated with varnish over the dark cracks. Because of these color changes while the paint was being applied, getting just the right color was difficult.

From the appearance of the black dress after cleaning, its successful retouching seemed daunting. However, given the subtlety in the black paint application already described, the areas that were well preserved served as a guide for the task. Some fortunate circumstances mitigated the difficulty. The existence of the Albertina drawing (see fig. 9) showed how similar sleeves might be constructed. Because some large areas in the painting were missing, especially in the proper left sleeve, the drawing proved crucial in understanding that the pleats were gathered in such a way that three distinct tiers were formed. Recognizing the structure of the pleats permitted a logic in proceeding with the inpainting, as the topography of the folds was better understood. Furthermore, as described above, several fairly large, reasonably well-preserved passages in the dress served as a guide to the tones

required and to the method of shading each individual pleat. The most propitious feature was probably the pigment mixtures that Luini himself employed. As was seen in the analysis of the cross section (see fig. 7), Luini was able to accomplish cool blacks with the use of charcoal, somewhat warmer and more velvety blacks with the use of a phosphorus-containing black such as ivory or bone black, and a range of grays and brownish grays by mixing in small amounts of lead white or vermilion. Retouching black areas can be problematic because of the difficulty in obtaining a rich black, as black has a tendency to move to gray as it is saturated by synthetic varnishes, but Luini's blacks were primarily softer and not so saturated. Mixtures of modern retouching colors such as a substitute for ivory black with a small addition of artificial ultramarine matched Luini's cooler black tones, where he probably employed charcoal, while the warmer blacks could be inpainted with the same ivory black substitute alone or mixed with small additions of orange or brown pigments. Similar mixtures with the addition of titanium white were used for the cooler or warmer tones of gray.[29] Because the shading of the pleats by Luini was subtle, many shades were often essential in a small area, necessitating that the admixtures of other colors to the black be sparing. In the few areas where the blacks needed more richness, Maimeri ivory black mixed with other pigments was employed.[30] By using these techniques and consistently attempting to mimic the well-preserved areas of the dress, as well as attending to the tiered nature of the sleeves, the inpainting proceeded successfully (see fig. 1).

Conclusion

The technical study of the Luini's *Portrait of a Lady* revealed that Luini painted it with great economy in his method but skillfully, using only a few very thin layers of paint. Despite the apparent simplicity of his painting method, some aspects of the painting were probably rather painstaking and slow. The *sfumato* used in the face is an example of this more meticulous execution, and before conservation treatment its excellent implementation was lost under the layers of discolored varnish and overpaint. The conservation treatment has restored the portrait's appearance and confirms that it is among the artist's most accomplished works. Removal of the degraded, yellowed varnish has restored the cooler hues and revealed the wide tonal range in the portrait, reviving the sense of space the sitter occupies. It has given us back the likeness of an attractive woman of elegant mien. Her black dress, though appearing modest, especially prior to the treatment, is, in fact, an expensive outfit opulently fashioned from yards of silk taffeta. The sensitive inpainting that integrated the original black paint allows appreciation of Luini's ability to mimic the luster, slashing, and great volume of the black fabric bodice and sleeves. The dress and the ornaments the sitter wears are not everyday apparel; in fact, her high position in society is much more readily apparent. For this portrait Luini was adept and facile, producing the likeness of a stylish sitter whose identity, for now, eludes us.

M.S. treated the painting. B.H.B. performed the technical analysis of the cross sections. G.H focused on costume. B.H.B., G.H., and M.S. wrote the essay.

We are indebted to Mary Westerman Bulgarella for her observations on the costume and her bibliographic advice, and also to Roberta Orsi Landini. At the National Gallery of Art, we thank Douglas LaChance for obtaining and preparing the infrared reflectograms and David Essex for his assistance.

1 George C. Williamson, *Bernardino Luini* (London, 1907), 18.

2 Eric Harding, Allan Braham, Martin Wyld, and Aviva Burnstock, "The Restoration of the Leonardo Cartoon," *National Gallery Technical Bulletin* 13 (1989): 5–27; Carmen C. Bambach, Rachel Stern, and Alison Manges, eds., *Leonardo da Vinci, Master Draftsman* (Metropolitan Museum of Art, New York, 2003), 18.

3 For a high-resolution image of Luini's *Portrait of a Lady*, see http://www.nga.gov/content/ngaweb/Collection/art-object-page.44.html (accessed January 27, 2015). Until *Portrait of a Gentleman from the House of Porro* came to light in *Bernardino Luini e i suoi figli*, an exhibition at the Palazzo Reale, Milan, in 2014, the National Gallery's image was considered Luini's only known independent portrait. See Giovanni Agosti and Jacopo Stoppa, eds., *Bernardino Luini e i suoi figli* (Palazzo Reale, Milan, 2014), 208–209, cat. 39; see also 210–214, cat. 40, for *Portrait of a Lady*. Donor likenesses do appear in Luini's frescoes, and some figures in his religious works are likely actual people. One example is the kneeling *Ginevra Bentivoglio and Saints*, c. 1523, in San Maurizio al Monastero Maggiore,

Milan. See Maria Teresa Binaghi Olivari, *Bernardino Luini* (Milan, 2007), 34, 47, pl. 30.

4 The sitter was most recently identified as Isabella of Aragon, cousin of Isabella d'Este. Maike Vogt-Lüerssen, *Wer Ist Mona Lisa? Auf der Suche nach iher Identität* (Norderstedt, Germany, 2003), 154.

5 For example, Fern Rusk Shapley, *Catalogue of Italian Paintings*, 2 vols. (National Gallery of Art, Washington, 1979), 1:282.

6 On blackwork, see Elisabeth Geddes and Moyra McNeill, *Blackwork Embroidery* (London, 1965), esp. 11–48, for a historical survey on the technique.

7 Roberta Orsi Landini, "The Individual Garments: Net, Partlet and Smock," in Roberta Orsi Landini and Bruna Niccoli, *Moda a Firenze, 1540–1580: Lo stile di Eleonora di Toledo e la sua influenza* (Florence, 2005), 120.

8 Another example of a *capigliara* can be seen in Titian's *Portrait of Isabella d'Este*, 1534, in the Kunsthistorisches Museum, Vienna. On the role of hats in the politics of fashion, see Evelyn Welch, "Art on the Edge: Hair and Hands in Renaissance Italy," *Renaissance Studies* 23, no. 3 (2009): 241–268.

9 Mauro Lucco, "Lucina Brembati," in David Alan Brown, Peter Humfrey, Mauro Lucco, et al., *Lorenzo Lotto: Rediscovered Master of the Renaissance* (National Gallery of Art, Washington, 1997), 115.

10 The description is corrected by Yvonne Hackenbroch, *Renaissance Jewellery* (New York, 1979), 29–30.

11 Jacqueline Marie Musacchio, *The Art and Ritual of Childbirth in Renaissance Italy* (New Haven, 1999), 136; Jacqueline Marie Musacchio,

"Weasels and Pregnancy in Renaissance Italy," *Renaissance Studies* 15, no. 2 (June 2001): 181–182. The more elaborate gold and jewel-encrusted marten or weasel head accessories evidently came into fashion after the 1520s. Pamela Jones, cat. entry for Bernardino Luini, *Portrait of a Lady* (NGA 1937.1.37), 1987, NGA curatorial records and files department. See also the splendid jewel-encrusted example from the Walters Art Museum in Jacqueline Marie Musacchio, "Conception and Childbirth," in *At Home in Renaissance Italy*, ed. Marta Ajmar-Wollheim and Flora Dennis (Victoria and Albert Museum, London, 2006), 130–132, 352, cat. 7.

12　On *Lucina Brembati*, see Lucco 1997, 114–116.

13　Christina Neilson, *Parmigianino's "Antea": A Beautiful Artifice* (Frick Collection, New York, 2008), 29.

14　See the National Gallery's Agnolo Bronzino, *A Young Woman and Her Little Boy,* c. 1540, for another elaborate dress that features *baragoni*. On *baragoni*, see Orsi Landini 2005, 95, 106–107.

15　Grazietta Butazzi , "The Language of Colours from the Renaissance," in *Silk and Colour,* ed. Chiara Buss (Como, 1997), 14, 17.

16　Baldesar Castiglione, *The Book of the Courtier: The Singleton Translation*, ed. Daniel Javitch (New York, 2002), bk. II, chap. XXVII, 89: "Hence, I think that black is more pleasing in clothing than any other color; and if not black, then at least some color on the dark side." Although Castiglione is writing about male clothing, the passage highlights the vogue for the hue.

17　Sixteenth-century recipes for black dyes for silk are in Giovanventura Rosetti, *The Plictho: Instructions in the Art of the Dyers Which Teaches the Dyeing of Woolen Cloths, Linens, Cottons, and Silk by the Great Art as Well as by the Common* (1540), ed. Sidney M. Edelstein and Hector C. Borghetty (Cambridge, MA, 1969).

18　Chiara Buss, "A Very Fine Black Color," in *Silk, Gold, Crimson: Secrets and Technology at the Visconti and Sforza Courts*, ed. Chiara Buss (Milan, 2009), 110.

19　X-radiography was carried out at 37–39 kV and 50 mA for 6 seconds. Infrared reflectography was carried out with a Santa Barbara Focalplane INSB camera equipped with a "J" filter to work in the IR region from 1100 nm to 1400 nm.

20　Samples were examined using a Leica (Leitz) DMRX polarizing light microscope using NPL 20× and 50× objectives with visible light illumination (bright field with crossed polarizing filters and dark field illumination). UV-visible excited luminescence was carried out with a Leitz D filter cube (excitation band-pass filter at 355–425 nm and long-pass suppression filter at 460 nm) and with a Leitz I3 filter cube (excitation band-pass filter at 450–490 nm and long-pass suppression filter at 415 nm). Samples were examined using the Hitachi S-3400 N scanning electron microscope with an Oxford Aztec energy dispersive spectrometer and an Oxford X-Max SDD (80 mm²) detector.

21　Larry Keith and Ashok Roy, "Giampetrino, Boltraffio, and the Influence of Leonardo," *National Gallery Technical Bulletin* 17 (1996): 4–19; Cornelia Syre, Jan Schmidt, and Heike Stege, eds., *Leonardo Da Vinci: Die Madonna Mit Der Nelke* (Munich, 2006).

22　Jan Schmidt, Heike Stege, Cornelia Syre, Ursula Baumer, Johann Koller, and Christian Nippert, "*The Madonna with a Carnation*: Technological Studies of an Early Painting by Leonardo," in *Leonardo da Vinci's Technical Practice: Paintings, Drawings and Influence*, ed. Michel Menu (Paris, 2014), 40–55; Elizabeth Walmsley, "Leonardo's Portrait of *Ginevra de' Benci: A Reading of the X-Radiographs and Infrared Reflectographs*," in Menu 2014, 56–71.

23　The layer on the gesso has yet to be fully characterized. It is not readily visible in the bright field image of a cross section; however, it emits a light bluish color under UV-violet illumination (cube D). Staining using amido black (neutral) suggested that the layer over the gesso, observed in all the samples (sometimes seen as a continuous layer and in other cases reticulated in an oxbow shape) contains protein. Unusually, in SEM-EDX the electron backscatter image shows small crystals in the translucent layer over the gesso in some of the samples. The EDX spectrum of the layer contains lead, calcium, sulfur, aluminum, potassium, and oxygen. It is possible that calcium and sulfur are present only in the adjacent layers because the spectra were collected at a pressure of 30 torr, which allows a "skirt effect" where x-rays generated in one place appear to come from nearby.

24　Examples can be seen in Menu 2014; "Leonardo da Vinci: Pupil, Painter and Master," *National Gallery Technical Bulletin* 32 (2011): entire volume.

25　Naples yellow has been found in only a few early sixteenth-century works, most usually frescoes. Luini worked in fresco, and if colorant was on his palette in that medium he may well have used a fresco pigment for oil painting. Naples yellow was identified in Raphael's *Loggia of Psyche,* 1517. Ulderico Santamaria, Pietro Moioli, and Claudio Seccaroni, "Some Remarks on Lead-Tin Yellow and Naples Yellow," in *Art et chimie, la couleur: Actes du congrès*, ed. Jacques Goupy and Jean-Pierre Mohen (Paris, 2000), 38–42. It was found in paintings by Lorenzo Lotto. Ashok Roy and Barbara H. Berrie, "A New Lead-Based Yellow in the Seventeenth Century," in International Institute for Conservation of Historic and Artistic Works, *Painting Techniques — History, Materials and Studio Practice: Contributions to the Dublin Congress, 7–11 September 1998,* ed. Ashok Roy and Perry Smith (London, 1998), 160–165; Maria Letizia Amadori, Pietro Baraldi, Sara Barcelli, and Gianluca Poldi, "New Studies on Lorenzo Lotto's Pigments: Non-invasive and Micro-invasive Analyses," https://www.yumpu.com/en/document/view/11493630/new-studies-on-lorenzo-lottos-pigments-lorenzo-lotto-lartista-le-last (accessed October 3, 2014).

26　Lloyd H. Ellis, *Raffaello Borghini's "Il Riposo": A Critical Study and Annotated Translation* (Ann Arbor, MI, 2003), 413–414. Giovanni Battista Armenini wrote similarly about black

pigments in *De' veri precetti della pittura* (The True Precepts of Painting, 1586) (Hildesheim, 1971), 178: *"perfino agli ultimi scuri che sono i neri, dei quali se ne usano di più sorte, perchè oltre il negro di terra, vi sta il carbone di salice, quello di ossa di persico, di carta abbruciata; e quelli che più sono adoperati pei scuri delle carni sono lo spalto, la mumia ed il fumo di pece Greco"* (finally, to the deepest darks, which are the blacks, of which they use the most sorts, because other than black earth, there is charcoal from willow, that of bones of perch, of burnt paper, and those which are adopted most for shadows in flesh are asphalt, mummy and smoke from Greek pitch).

27 Accurate descriptions of color, light, and luster were important not only in the visual arts but also in the literary arts. A notion of the pervasiveness of the sensitivity to these attributes many be presumed from various sources. Writing in 1568, Giorgio Vasari commended the painter Sabastiano del Piombo (c. 1485 – 1547) for his ability to paint black fabrics. Giorgio Vasari, *Lives of the Most Eminent Painters, Sculptors, and Architects* (1550), trans. Gaston Du C. de Vere (London, 1913), 180: "At this same time he also executed a portrait of Messer Pietro Aretino, and

made it such that, besides being a good likeness, it is an astounding piece of painting, for there may be seen in it five or six different kinds of black in the clothes that he is wearing — velvet, satin, ormuzine, damask, and cloth — and, over and above those blacks, a beard of the deepest black, painted in such beautiful detail, that the real beard could not be more natural." The association of specific words to notions of sheen and luster is demonstrated in Antonio Telesio, *Libellus de Coloribus* (Book on Colors, 1529).

28 Another possibility could be that an underpainting executed in brown paint, which would not have shown up in infrared, served as a guide. Giampietrino (act. 1495 – 1549), another painter from the period influenced by Leonardo, was known to have employed this technique. Keith and Roy 1996, 8.

29 The retouching was executed in commercially manufactured Charbonnell retouching colors, which have a methacrylate medium.

30 Maimeri retouching colors are commercially manufactured and have a component of natural resin in the medium that makes them richer and more saturated.

References

AGOSTI AND STOPPA 2014 Agosti, Giovanni, and Jacopo Stoppa, eds. *Bernardino Luini e i suoi figli*. Palazzo Reale, Milan, 2014.

ARMENINI (1586) 1971 Armenini, Giovanni Battista. *De' veri precetti della pittura*. 1586. Hildesheim, 1971.

BAMBACH ET AL. 2003 Bambach, Carmen C., Rachel Stern, and Alison Manges, eds. *Leonardo da Vinci, Master Draftsman*. Metropolitan Museum of Art, New York, 2003.

BINAGHI OLIVARI 2007 Binaghi Olivari, Maria Teresa. *Bernardino Luini*. Milan, 2007.

BUSS 2009 Buss, Chiara. "A Very Fine Black Color." In *Silk, Gold, Crimson: Secrets and Technology at the Visconti and Sforza Courts*, edited by Chiara Buss, 110 – 111. Milan, 2009.

BUTAZZI 1997 Butazzi , Grazietta. "The Language of Colours from the Renaissance." In *Silk and Colour,* edited by Chiara Buss, 13 – 17. Como, 1997.

CASTIGLIONE 2002 Castiglione, Baldesar. *The Book of the Courtier: The Singleton Translation*, edited by Daniel Javitch. New York, 2002.

ELLIS, 2003 Ellis, Lloyd H. *Raffaello Borghini's "Il Riposo": A Critical Study and Annotated Translation*. Ann Arbor, MI, 2003.

GEDDES AND MCNEILL 1965 Geddes, Elisabeth, and Moyra McNeill. *Blackwork Embroidery*. London, 1965.

HACKENBROCH 1979 Hackenbroch, Yvonne. *Renaissance Jewellery*. New York, 1979.

HARDING ET AL. 1989 Harding, Eric, Allan Braham, Martin Wyld, and Aviva Burnstock. "The Restoration of the Leonardo Cartoon." *National Gallery Technical Bulletin* 13 (1989): 5 – 27.

KEITH AND ROY 1996 Keith, Larry, and Ashok Roy. "Giampetrino, Boltraffio, and the Influence of Leonardo." *National Gallery Technical Bulletin* 17 (1996): 4 – 19.

"LEONARDO DA VINCI" 2011 "Leonardo da Vinci: Pupil, Painter and Master." *National Gallery Technical Bulletin* 32 (2011): entire volume.

LUCCO 1997 Lucco, Mauro. "Lucina Brembati." In David Alan Brown, Peter Humfrey, Mauro Lucco, et al. *Lorenzo Lotto: Rediscovered Master of the Renaissance*, 114 – 116. National Gallery of Art, Washington, 1997.

MENU 2014 Menu, Michel, ed. *Leonardo da Vinci's Technical Practice: Paintings, Drawings and Influence*. Paris, 2014.

MUSACCHIO 1999 Musacchio, Jacqueline Marie. *The Art and Ritual of Childbirth in Renaissance Italy*. New Haven, 1999.

MUSACCHIO 2001 Musacchio, Jacqueline Marie. "Weasels and Pregnancy in Renaissance Italy." *Renaissance Studies* 15, no. 2 (June 2001): 172 – 187.

MUSACCHIO 2006 Musacchio, Jacqueline Marie. "Conception and Childbirth." In *At Home in Renaissance Italy*, edited by Marta Ajmar-Wollheim and Flora Dennis, 124 – 135. Victoria and Albert Museum, London, 2006.

NEILSON 2008 Neilson, Christina. *Parmigianino's "Antea": A Beautiful Artifice*. Frick Collection, New York, 2008.

ORSI LANDINI 2005 Orsi Landini, Roberta. "The Individual Garments: Net, Partlet and Smock." In Roberta Orsi Landini and Bruna Niccoli. *Moda a Firenze, 1540 – 1580: Lo stile di Eleonora di Toledo e la sua influenza*, 119 – 130. Florence, 2005.

ROSETTI 1969 Rosetti, Giovanventura. *The Plictho: Instructions in the Art of the Dyers Which Teaches the Dyeing of Woolen Cloths, Linens, Cottons, and Silk by the Great Art as Well as by the Common*, edited by Sidney M. Edelstein and Hector C. Borghetty. Cambridge, MA, 1969.

ROY AND BERRIE 1998 Roy, Ashok, and Barbara H. Berrie. "A New Lead-Based Yellow in the Seventeenth Century." In International Institute for Conservation of Historic and Artistic Works, *Painting Techniques — History, Materials and Studio Practice: Contributions to the Dublin Congress, 7 – 11 September 1998,* edited by Ashok Roy and Perry Smith, 160 – 165. London, 1998.

SANTAMARIA ET AL. 2000 Santamaria, Ulderico, Pietro Moioli, and Claudio Seccaroni. "Some Remarks on Lead-Tin Yellow and Naples Yellow." In *Art et chimie, la couleur: Actes du congrès,* edited by Jacques Goupy and Jean-Pierre Mohen, 38 – 42. Paris, 2000.

SCHMIDT ET AL. 2014 Schmidt, Jan, Heike Stege, Cornelia Syre, Ursula Baumer, Johann Koller, and Christian Nippert. "*The Madonna with a Carnation*: Technological Studies of an Early Painting by Leonardo." In Menu 2014, 40 – 55.

SHAPLEY 1979 Shapley, Fern Rusk. *Catalogue of Italian Paintings.* 2 vols. National Gallery of Art, Washington, 1979.

SYRE ET AL. 2006 Syre, Cornelia, Jan Schmidt, and Heike Stege, eds. *Leonardo Da Vinci: Die Madonna Mit Der Nelke.* Munich, 2006.

TELESIO 1529 Telesio, Antonio. *Libellus de Coloribus.* Venice, 1529.

VASARI (1550) 1913 Vasari, Giorgio. *Lives of the Most Eminent Painters, Sculptors, and Architects* (1550), translated by Gaston Du C. de Vere. London, 1913.

VOGT-LÜERSSEN 2003 Vogt-Lüerssen, Maike. *Wer Ist Mona Lisa? Auf der Suche nach iher Identität.* Norderstedt, Germany, 2003.

WALMSLEY 2014 Walmsley, Elizabeth. "Leonardo's Portrait of *Ginevra de' Benci: A Reading of the X-Radiographs and Infrared Reflectographs.*" In Menu 2014, 56 – 71.

WELCH 2009 Welch, Evelyn. "Art on the Edge: Hair and Hands in Renaissance Italy." *Renaissance Studies* 23, no. 3 (2009): 241 – 268.

WILLIAMSON 1907 Williamson, George C. *Bernardino Luini.* London, 1907.

Andy Warhol's Early Paint Mediums

Molly Donovan, Jay Krueger, Suzanne Quillen Lomax, and Christopher Maines

Andy Warhol's (1928 – 1987) large paintings on canvas from 1961 through the first half of 1962 represent an important and pivotal body of work. From a materials standpoint, they indicate the artist's transition from the aqueous paints commonly used in smaller-scaled works from his commercial art career in the 1950s to the acrylic paints and inks of his signature silk-screened works beginning in 1962 until his death in 1987. Despite their significance, these early hand-painted canvases have not previously been individually analyzed to identify the paint mediums.

The research presented here aims to further understand the mediums of Warhol's early paintings in relationship to the paints he may have used from his days as an illustrator. The opportunity to undertake such a study was provided by the *Warhol: Headlines* exhibition, organized by the National Gallery of Art, where it premiered in September 2011.

Warhol's Early Work

Andy Warhol's images of celebrities and everyday products — from Marilyn Monroe to Campbell's Soup cans — radically opened borders between vernacular and fine art, indelibly linking the two. His aesthetic preoccupations signaled a new style that became known as pop art, and Warhol became its greatest practitioner. Yet the artist did not arrive in New York in the early 1960s crowned "Prince of Pop," as he was known. He enjoyed a successful career as a commercial illustrator in that city throughout the 1950s and was in a strong position from which to convey aspects of the illustration world to the art world. Much has been made of the techniques Warhol carried over from commercial work into his "fine" art practice, among them mechanical reproduction and enlargement strategies.[1] Even more has been made of the stylistic differences between his two careers.

In the world of commercial advertising where Warhol worked full time from 1949 to the early 1960s, his prodigious draftsmanship and overall skill were in full evidence in his signature, refined, "blotted line" ink drawings. As he transitioned to a career in the fine arts, in the late 1950s Warhol began by adopting a more gestural, representational style, "deskilling" the elegantly detailed "line art" of his illustrations. This rougher, hand-wrought style is in full evidence in 1961, when he began using an opaque projector to enlarge his subjects on paper and canvas. In 1962, however,

1

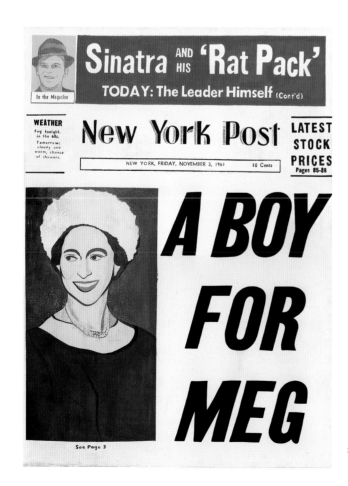

2

Figure 1
Andy Warhol, *A Boy for Meg [1]*, 1961,
168.9 × 133 cm, Collection of Bill Bell.

Figure 2
Andy Warhol, *A Boy for Meg [2]*, 1962,
182.9 × 132.1 cm, National Gallery of Art,
Washington, Gift of Mr. and Mrs. Burton
Tremaine.

signs of Warhol's own mark-making diminished in favor of a seemingly slick mechanically produced image, the style for which he would become best known.

When deciding between these two styles in the spring of 1962, Warhol brought friends and critics to his studio and showed them examples of his two different approaches to painting everyday objects. The often-cited example included two *Coca-Cola* paintings from 1962, one in each style. Later Warhol recounted the reaction of the film-maker Emil ("De") de Antonio who, after studying the two works, said, "Well, look, Andy…One of these is a piece of shit, simply a little bit of everything. The other is remark-able — it's our society, it's who we are, it absolutely beautiful and naked, and you ought to destroy the other."[2] Warhol, in a characteristic act of deferral, credited de Antonio not only with selecting the direction of his style but also with inspiring his transition from a commercial illustrator to an artist with gallery representation.[3] In fact, however, Warhol had taken steps to exhibit art in exhibitions starting in 1952.

For this article, a pair of head-line paintings, *A Boy for Meg [1]*, 1961 (fig. 1), and *A Boy for Meg [2]*, 1962 (fig. 2), stand in for the two stylistic approaches described above. *A Boy for Meg [1]*, the more gestural of the two, is the artist's first use of the newspaper front page as a ready-made composition. This painting would have been made in dramatic, projected light in an otherwise darkened room, with the artist first brushing on the blue and yellow paints, then drawing the head of Frank Sinatra and Princess Margaret with blue and black wax crayons. Warhol left many areas of the painting blank, omitting picto-rial detail (Margaret's dress) and textual data (the word "Meg"). These large open areas and the stray drips are consistent with the style of War-hol's paintings from 1961. *A Boy for Meg [2]* presents a decisive shift in scale and style. Warhol used a taller format, incorporating a majority of the source material and adding Mar-garet's dress and the word "Meg." In this work, Warhol demonstrates a clear intent to faithfully transcribe the photographic halftone, evident in the clean lines, increased con-trast, and grainy texture created by "sponging" the area around the figure's neck. Yet the imperfect let-tering reveals that it, too, was hand-painted. These paintings present two takes on the same subject, one with a stylistic foothold in the wan-ing era of abstract expressionism, and the other a strong stance about that same era's end, signaling a new direction in artistic practice.

Previous Research

The materials artists choose — including paint medium in the case of painters — obviously have a significant effect on the visual qualities of a work of art. As the naked eye cannot often determine the materials, scientific analysis can be crucial to understanding an artist's choices. The traditional composition of a painting includes a three-dimensional structure comprising a range of materials built up in layers, each of which may have a different medium. Typically painting supports (usually wood or canvas) are prepared with a ground or priming layer before the artist applies the paint layers. The ground provides good adhesion of the paint layers to the support and also offers an undertone to the composition.

These grounds can be applied by the artist or, in Warhol's case, commercially prepared.[4] Artists' paints are composed of dry pigments in a binding medium, which might include drying oils, proteinaceous materials, synthetic polymers, and/or plant gums.

Common proteinaceous binders, which include gelatin or animal glue, casein, egg yolk, and egg white, can be distinguished by analyzing for amino acids. Gelatin and animal glue, composed of collagen, contain the amino acid hydroxyproline, making its identification straightforward. Casein, prepared by denaturing milk proteins, contains a high amount of glutamate and proline. The amino acid component of egg is differentiated from casein and animal glue based on the higher serine:glycine ratio and the higher alanine:proline ratio. Egg yolk and white are difficult to distinguish, as both contain an even distribution of essential amino acids.[5]

Despite Warhol's predilection to recount and save everything relating to his career, evident in his abundant archives now at the Andy Warhol Museum in Pittsburgh, information about the paints with which he made these early works is scant.[6] A few art supply store receipts from 1961 and 1962 survive, but if he saved other receipts, they may have been lost in one of his many moves.

The best information thus far on Warhol's materials appeared in *The Andy Warhol Catalogue Raisonné*, volume 1 of which, *Paintings and Sculpture, 1961 – 1963*, was published in 2002. Its appendix 1, "Warhol's Materials," begins to address the question of medium identification in the artist's selection of paints and inks from the early 1960s, the important moment of transition between his graphic arts career and what followed. It states, "Technical analyses of materials, performed in a conservation laboratory, were mostly beyond the scope of the present project and undertaken rarely."[7] In short, for the catalogue raisonné a selection of paintings was carefully examined and medium identifications were made based upon solvent tests rather than chemical analysis; therefore, water solubility might indicate watercolor, gouache, or ink, while paints that were either sensitive to or insoluble in certain organic solvents might suggest the use of oils, alkyds, or protein-containing casein.

It has long been understood that in many of his hand-painted works from 1961 to early 1962 Warhol used the medium casein, described in the catalogue raisonné as a "water-based paint in which color is suspended in a milk emulsion ... marketed under the name Shiva, after Ramon Shiva who developed the paints."[8] A sample of white paint from one 1961 painting was analyzed and found to contain protein, "indicating that it was either casein or egg tempera. Since commercially made tempera is gum or vegetable based, this result suggests that the white paint is casein,"[9] the inference being that commercially prepared tempera would not contain protein. Gum or vegetable-based paints, on the other hand, would point toward materials such as gouache or generic poster paints. However, in the absence of analysis for specific amino acids, discounting egg tempera and concluding that the sample analyzed must be casein are problematic.

This explanation illustrates the confusion resulting from the ubiquitous and almost generic use

of the term "tempera" to indicate an opaque, fast-drying, water-based emulsion paint that produces a matte, nonreflective surface. The term "tempera" had lost much of its relevance by the mid-twentieth century, although good-quality, commercially prepared egg tempera was available at this time and sold in tubes.[10] A revival of interest in painting in egg tempera had started in the 1930s and 1940s, however, and it was used by Ben Shahn (1898 – 1969).[11] Arthur Elias, one of Warhol's classmates at Carnegie Tech. in Pittsburgh, describes Shahn's matte-surfaced works as "casein paintings" made with "a milk board paint. Most of us worked with it at the time — not most of us: a lot of us work with it…flat,"[12] and he asserts they were an important influence on Warhol. Egg tempera was also used by artists Thomas Hart Benton (1889 – 1975), Andrew Wyeth (1917 – 2009),[13] and Jacob Lawrence (1917 – 2000),[14] the latter continuing to paint in tempera into the 1960s.[15] Mark Rothko (1903 – 1970) used egg tempera along with other materials in the construction of his multiform paintings in the 1940s,[16] as did Barnett Newman (1905 – 1970) and Adolph Gottlieb (1903 – 1974). In addition, Rothko was known to have used egg in some paintings throughout the 1950s and 1960s.[17]

Loosely applied to a wide variety of aqueous emulsion paints, those labeled "tempera" might contain casein, gouache, distemper, poster colors, show card colors, designer colors, or egg-oil emulsions. Artists often used them interchangeably, given their similar working characteristics and appearance. Many of these paints were employed in the practice of commercial or graphic arts, and, in light of Warhol's commercial work throughout the 1950s and extending well into the mid-1960s, a range of such materials could easily have been in his studio at the time his first large canvases were painted.[18] Differentiating among these paints, much less conclusively identifying them without scientific analysis, is not possible. Such a task is made more difficult when the artist is as experienced as Warhol.

Methodology

The solubility test results reported in the 2002 Andy Warhol catalogue raisonné suggested Warhol had used of a variety of materials during 1961 – 1962. The exhibition Warhol: Headlines afforded the opportunity to more closely examine and sample several paintings dating from 1961 and 1962 that were believed to be painted in different mediums and to carry out paint medium analysis using precise instrumental techniques. Featured in the show were four hand-painted canvases employing the subject of the newspaper headline, including A Boy for Meg [1] (see fig. 1), A Boy for Meg [2] (see fig. 2), Daily News, 1962 (fig. 3), and 129 Die in Jet, 1962 (fig. 4). A Boy for Meg [1], from late 1961, is listed in the catalogue raisonné as being painted with casein, as was the second version of the painting, A Boy for Meg [2], from 1962 (given a later date because it appeared in Alfred Statler's April 1962 photographs).[19] Both Daily News, from spring – early summer 1962, and 129 Die in Jet, painted sometime after June 4, 1962, are listed in the catalogue raisonné as having been made with acrylic paint and pencil on canvas.[20] As Warhol developed his painting practice between 1961 and 1962, he apparently shifted

Figure 3
Andy Warhol, *Daily News*, 1962, 183.5 ×
254 cm, Museum für Moderne Kunst,
Frankfurt am Main, formerly Collection
Karl Ströher, Darmstadt, 1981.

3

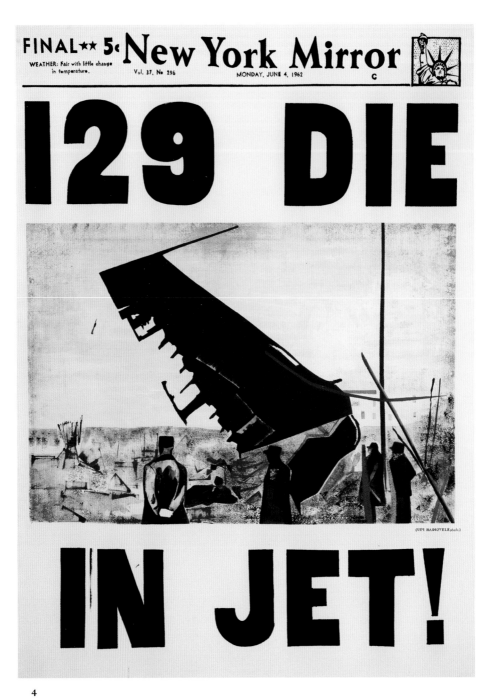

4

from casein to acrylic. Within this set of early hand-painted works, those employing a headline subject presented an ideal control group for further analysis.

A Boy for Meg [1] and *A Boy for Meg [2]* exhibit remarkably similar surface characteristics to *Daily News* and *129 Die in Jet*.[21] With the partial exception of *A Boy for Meg [1]*, the four paintings presented smooth, matte surfaces with no immediately obvious visual differences among them. Their similarities raised questions about the mediums used in the four paintings. Were they casein or early examples of acrylic paint, or something else altogether? The artist's use of inks in the silk-screened paintings that appear in 1962 is well-established.[22] Yet how Warhol moved from the small-scale commercially oriented work to large canvases and which mediums he initially employed in making that transition remain at the core of this inquiry.

The paintings were carefully examined, and samples were obtained from *A Boy for Meg [2]*, *Daily News,* and *129 Die in Jet* to identify the mediums used during this transition.[23] These micro-samples were examined by Fourier transform infrared spectroscopy (FTIR),[24] gas chromatography – mass spectrometry (GC-MS),[25] and pyrolysis gas chromatography – mass spectrometry (Py-GC-MS).[26] Infrared spectroscopy was used to determine the class of paint binders that might be present (such as proteins, oils, or acrylics), while the GC-MS procedure was used to further identify the specific proteinaceous and oil-containing binders used. The Py-GC-MS analysis protocol was used when an acrylic binder was suspected on the basis of FTIR analysis.

Analytical Findings and Interpretation

Samples from the paint layers of Warhol's *A Boy for Meg [2]* were examined, including white paint that had pooled at lower left edge, gray paint from below proper right ear, black paint from the letter "B," and blue paint along the ragged edge from under the writing "TODAY: The Leader Himself (Cont'd)." The ground or priming layer of the painting was not sampled. Examination of the paint samples by infrared microscopy indicated absorbances characteristic of protein.[27] Additionally, an ester carbonyl absorbance was observed in three of the samples, which can be indicative of drying oil or the oil component of an egg binder.[28] Drying oils, such as linseed, walnut, or poppy oil, have been used for centuries as paint binders.[29]

Because the samples from *A Boy for Meg [2]* seemed to contain proteinaceous materials as well as possibly drying oil, they were subjected to a protein-glycerol-fatty acid analysis. It was determined that all the samples contain both amino acids and fatty acids, suggesting that the paint medium included both proteinaceous and drying oil components. Large amounts of drying oil were found in the white and gray samples, with lesser amounts in the blue and black samples. The blue and black samples also contained amino acids, which are characteristic of egg, revealing the use of an egg-oil emulsion tempera paint.[30] As only one blue paint was analyzed, the results cannot be extrapolated to other blues in the painting.

Additionally, samples of the paints and the priming layers of the canvases were examined from *Daily News* and *129 Die in Jet*. Samples of the white priming from these

paintings were found to contain egg, based on infrared microspectroscopy and GC-MS as described above. These two canvases appear to have commercially prepared grounds, a fact that is consistent with the observations of other researchers.[31]

Additional samples from the paint layers of these two paintings did not appear to be proteinaceous on the basis of FTIR analysis and were examined by Py-GC-MS. Two different mediums were found in the samples from *129 Die in Jet.* The black (from letter "T" in "JET") and gray (dark gray from right edge of image) were shown to be acrylic dispersion paints containing n-butyl acrylates and other acrylic dispersion components, such as plasticizers and surfactants. The sample of bright white paint from around the copyright sign contained very little binder. However, there was no evidence of acrylic, and the fatty acid profile indicates that the bright white sample is a drying oil.[32] By contrast, all three of the samples of paint from *Daily News* were found to contain drying oil. These include an olive gray from the lower-left-most image, a black from the lower line under the word "Final" on the upper left, and a cream-colored paint from under the image of two horses. These two paintings, therefore, show that Warhol used a variety of materials. The paint samples from *129 Die*

in Jet were found to be acrylic dispersion except for the bright white paint that was a drying oil, while *Daily News* was found to be painted in drying oil.

Conclusion

In sum, the earliest work analyzed in this study, *A Boy for Meg [2]* reveals Warhol's use of egg-oil tempera paint, although the presence of casein paint in some areas cannot be ruled out. The two later works in this study, *Daily News* and *129 Die in Jet,* show a more complex use of materials than the singular designation of "acrylic" in the Warhol catalogue raisonné. Warhol used a commercially prepared ground bound with egg tempera and, in the later two paintings, drying oil in addition to acrylic and pencil in the paint layers. The variety of materials Warhol employed indicates a higher degree of experimentation during this period than previously understood. This study also points to the problematic nature of identifying paint mediums according to visual characteristics or spot-testing. As is fitting for the rich work of the enigmatic Andy Warhol, the study of additional hand-painted works from 1961 and 1962, a threshold in the artist's career, produced a deeper understanding of his selection of materials.

M.D. and J.K. initiated the discussions on the role that the paint mediums might play in Warhol's transitional work. J.K. coordinated the examination of the paintings, and M.D. provided the art-historical information and background. S.Q.L. took the samples and performed FTIR and GC-MS analysis. C.M. performed Py-GC-MS analysis. All the authors contributed to writing the essay.

1 Ellen Lupton and J. Abbott Miller, "Line Art: Andy Warhol and the Commercial Art World of the 1950s, in *"Success Is a Job in New York…": The Early Art and Business of Andy Warhol,* ed. Donna M. De Salvo (New York, 1989), 41.

2 Quoted in Andy Warhol and Pat Hackett, *POPism: The Warhol Sixties* (New York, 1980), 6.

3 Warhol and Hackett 1980, 3 – 4.

4 Georg Frei and Neil Printz, eds., *Paintings and Sculpture 1961 – 1963, Warhol 01: The Andy Warhol Catalogue Raisonné* (New York, 2002), 19.

5 Susana M. Halpine, "An Investigation of Artists' Materials Using Amino Acid Analysis: Introduction of the One-Hour Extraction Method," in *Conservation Research 1995,* Studies in the History of Art 51, Monograph Series II (Washington, 1995), 31 – 32.

6 Thanks to Matt Wrbican, chief archivist at the Andy Warhol Museum, Pittsburgh, for his verification of this information.

7 Frei and Printz 2002, 448.

8 Frei and Printz 2002, 448.

9 Frei and Printz 2002, 448.

10 Ralph Mayer, *The Artist's Handbook of Materials and Techniques* (New York, 1957), 256 – 257.

11 Mark Francis, "Simple Beauty: An Introduction to Andy Warhol's Drawings," in *Andy Warhol: Drawings, 1942 – 1987* (Pittsburgh, 1998), 11. See also Mark David Gottsegen, *Painter's Handbook: Revised and Expanded* (New York, 2006), 226.

12 Quoted in Patrick Smith, "Art in Extremis: Andy Warhol and His Art" (PhD diss., Northwestern University, 1982), 1:535.

13 Joyce Hill Stoner, "The Medium Is the Message," in *Rethinking Andrew Wyeth*, ed. David Cateforis (Berkeley, 2014), 86 – 99.

14 Elizabeth Steele and Susana M. Halpine, "Precision and Spontaneity: Jacob Lawrence's Materials and Techniques," in *Jacob Lawrence: The Migration Series*, ed. Elizabeth Hutton Turner (Washington, 1993), 155 – 159. See also Elizabeth Steele, "The Materials and Techniques of Jacob Lawrence," in *Over the Line: The Art and Life of Jacob Lawrence*, ed. Peter T. Nesbett and Michelle DuBois (Seattle, 2000), 247 – 265.

15 Michael R. Schilling, "Paint Medium Analysis," in National Academy of Sciences, *Scientific Examination of Art: Modern Techniques in Conservation and Analysis*, Arthur M. Sackler Gallery Colloquium (Washington, 2005), 186 – 205.

16 See Allison Langley and Suzanne Quillen Lomax, "Mark Rothko's Multiforms, 1946 – 1950: Transforming the Painted Surface," in this volume.

17 Suzanne Quillen Lomax, analysis report for Mark Rothko, *Untitled (Seagram Mural),* (NGA 1986.43.167), December 14, 2007, NGA scientific research department; Suzanne Quillen Lomax, analysis report for Mark Rothko, *Untitled (Seagram Mural sketch)* (NGA 1986.43.170), December 13, 2007, NGA scientific research department.

18 Wrbican, correspondence with the authors, August 2013.

19 Frei and Printz 2002, 60, 86, 101.

20 Frei and Printz 2002, 180 – 181.

21 Frei and Printz 2002, 180 – 181.

22 Frei and Printz 2002, 448.

23 Unfortunately, the authors were not able to sample *A Boy for Meg [1]*.

24 A Thermo Nicolet Nexus 670 bench was used with a Continuum microscope. One hundred twenty-eight scans were collected at 4 cm^{-1}. The samples were compressed between two windows of a Diamond Cell (Spectratech) and examined in transmission mode.

25 Hydrolyzed and silylated paint medium samples were analyzed by GC-MS to identify amino acids and fatty acids characteristic of oil and proteinaceous binders. See Suzanne Quillen Lomax and Christopher Maines, analysis report for Andy Warhol, *129 Die in Jet* (Museum Ludwig, Cologne), February 6, 2012, NGA scientific research department; Suzanne Quillen Lomax and Christopher Maines, analysis report for Andy Warhol, *Daily News* (Museum für Moderne Kunst), February 6, 2012, NGA scientific research department; Suzanne Quillen Lomax and Christopher Maines, analysis report for Andy Warhol, *A Boy for Meg [2]* (NGA 1971.87.11), August 7, 2008, NGA scientific research department.

26 Samples derivatized with tetramethylammonium hydroxide (TMAH) were pyrolyzed in the furnace of a Frontier Labs Double-Shot Pyrolyzer, and the pyrolysates examined by GC-MS. See Lomax and Maines, analysis report for *129 Die in Jet*, February 6, 2012; Lomax and Maines, analysis report for *Daily News*, February 6, 2012.

27 These absorbances include the amide I and II stretches (1650 cm^{-1} and 1540 cm^{-1}). In general, the amide II stretch appears as a shoulder on the carbonate stretch of chalk.

28 The ester carbonyl absorbance was found at 1730 cm^{-1}.

29 John S. Mills and Raymond White, *The Organic Chemistry of Museum Objects*, 2nd ed. (Oxford, 1994), 31 – 32.

30 By comparison, the presence or absence of a proteinaceous component in the white and gray paint could not be confirmed because the samples had partially decomposed.

31 Frei and Printz 2002, 14.

32 A peak corresponding to dimethyl azelate was found with a ratio to other fatty acids suggesting a drying oil.

References

FRANCIS 1998 Francis, Mark. "Simple Beauty: An Introduction to Andy Warhol's Drawings." In *Andy Warhol: Drawings, 1942 – 1987,* 29 – 41. Pittsburgh, 1998.

FREI AND PRINTZ Frei, Georg, and Neil Printz, eds. *Paintings and Sculpture 1961 – 1963, Warhol 01: The Andy Warhol Catalogue Raisonné.* New York, 2002.

GOTTSEGEN 2006 Gottsegen, Mark David. *Painter's Handbook: Revised and Expanded.* New York, 2006.

HALPINE 1995 Halpine, Susana M. "An Investigation of Artists' Materials Using Amino Acid Analysis: Introduction of the One-Hour Extraction Method." In *Conservation Research 1995,* Studies in the History of Art 51, Monograph Series II, 28 – 69. Washington, 1995.

LUPTON AND MILLER 1989 Lupton, Ellen, and J. Abbott Miller. "Line Art: Andy Warhol and the Commercial Art World of the 1950s." In *"Success Is a Job in New York …": The Early Art and Business of Andy Warhol,* edited by Donna M. De Salvo, 29 – 41. New York, 1989.

MAYER 1957 Mayer, Ralph. *The Artist's Hand-book of Materials and Techniques*. New York, 1957.

MILLS AND WHITE 1994 Mills, John S., and Raymond White. *The Organic Chemistry of Museum Objects*. 2nd ed. Oxford, 1994.

SCHILLING 2005 Schilling, Michael R. "Paint Medium Analysis." In National Academy of Sciences, *Scientific Examination of Art: Modern Techniques in Conservation and Analysis*, 186–205. Arthur M. Sackler Gallery Colloquium. Washington, 2005.

STEELE 2000 Steele, Elizabeth. "The Materials and Techniques of Jacob Lawrence." In *Over the Line: The Art and Life of Jacob Lawrence*, edited by Peter T. Nesbett and Michelle DuBois, 247–265. Seattle, 2000.

STEELE AND HALPINE 1993 Steele, Elizabeth, and Susana M. Halpine. "Precision and Spontaneity: Jacob Lawrence's Materials and Techniques." In *Jacob Lawrence: The Migration Series*, edited by Elizabeth Hutton Turner, 155–160. Washington, 1993.

STONER 2014 Stoner, Joyce Hill. "The Medium Is the Message." In *Rethinking Andrew Wyeth*, edited by David Cateforis, 86–99. Berkeley, 2014.

WARHOL AND HACKETT 1980 Warhol, Andy, and Pat Hackett. *POPism: The Warhol Sixties*. New York, 1980.

(from the National Gallery of Art, except as noted)

Daphne Barbour, senior object conservator

Barbara H. Berrie, head of the scientific research department

John K. Delaney, senior imaging scientist

Molly Donovan, associate curator of modern art

Joanna R. Dunn, painting conservator

Lisha Deming Glinsman, conservation scientist

Gretchen Hirschauer, associate curator of Italian painting

Cyntia Karnes, paper conservator, Library of Congress; former Andrew W. Mellon Fellow in Paper Conservation, National Gallery of Art

Jay Krueger, head of painting conservation

Allison Langley, associate paintings conservator, Art Institute of Chicago; former William R. Leisher Memorial Fellow for Research and Treatment of Modern Paintings, National Gallery of Art

Suzanne Quillen Lomax, organic chemist

Christopher Maines, conservation scientist

Dylan Smith, Robert H. Smith Research Conservator

Michael Swicklik, senior painting conservator

PHOTOGRAPHY CREDITS

**The Creation of Giotto's
Madonna and Child:
New Insights**

Figs. 1, 6, 10a, Greg Williams, Department of Imaging and Visual Services, NGA; fig. 2, Elisabeth Ravaud – C2RMF; figs. 3 – 5, 7 – 9, 10b, Scientific Research Department, NGA.

**Riccio in Relief: Documented
Sculpture as a Technical
Context for The Entombment**

Figs. 1, 2, 4, 22a, Lee Ewing, Department of Imaging and Visual Services, NGA; figs. 3, 6 – 10, 12, 15 – 18, 22b, Object Conservation Department, NGA; fig. 5, Dylan Smith, Object Conservation Department, NGA; figs. 11, 13, 14, photos by © Giorgio Deganello/Archivio Messaggero S. Antonio Editrice, Padua; fig. 19, © RMN-Grand Palais/Art Resource, New York, photo by Daniel Arnaudet; fig. 20, © RMN-Grand Palais/Art Resource, New York; fig. 21, © RMN-Grand Palais/Art Resource, New York, photo by Martine Beck-Coppola.

**Auguste Rodin's Lifetime
Bronze Sculptures in the
Simpson Collection**

Fig. 1, © Musée Rodin; photo by Ouida Grant; figs. 2 – 5, 7, 13, 16, 19, 20, 22, 23, Lee Ewing, Department of Imaging and Visual Services, NGA; fig. 6, Phillip Charles, Department of Imaging and Visual Services, NGA; fig. 8, © estate of Malvina Hoffman, in Heads and Tales (Garden City, NY, 1943), 87; figs. 9, 14, 15, 17, 18, Object Conservation Department, NGA; fig. 10, © estate of Malvina Hoffman, in Sculpture Inside and Out (New York, 1939), 303; figs. 11, 21, © Musée Rodin, photos by Jérome Manoukian; fig. 12, Dylan Smith, Object Conservation Department, NGA.

**Movements in Paint: The
Development of John Marin's
Watercolor Palette, 1892 – 1927**

Fig. 1, Katherine S. Dreier Papers/Societé Anonyme Archive, Yale Collection of American Literature, Beinecke Rare Book and Manuscript Library; figs. 2, 3, 5 – 10, 15, 16, 18, 19, Erica Abbey, Department of Imaging and Visual Services, NGA; fig. 4, Joseph W. Lovibond, An Introduction to the Study of Colour Phenomena, Explaining a New Theory of Colour Based Entirely on Experimental Facts with Applications to Scientific and Industrial Investigations (New York, 1905), 31, pl. VII; fig. 11, Paper Conservation Department, NGA; figs. 12, 13, Scientific Research Department, NGA; fig. 14, Alfred Stieglitz/Georgia O'Keeffe Archive, Yale Collection of American Literature, Beinecke Rare Book and Manuscript Library, © 2015 Georgia O'Keeffe Museum/Artists Rights Society (ARS), New York; fig. 17, Gallery Archives, NGA; fig. 20, Kenneth Fleisher, Department of Imaging and Visual Services, NGA.

**Mark Rothko's Multiforms,
1946 – 1950: Transforming the
Painted Surface**

Fig. 1, courtesy The Collections of Kate Rothko Prizel and Christopher Rothko; figs. 2 – 4, 8, 9, 15, table nos. 1, 2, 4, 7, 11, 14, 15, Department of Imaging and Visual Services, NGA; figs. 5, 10 – 14, 16, 17, 19, Painting Conservation Department, NGA; fig. 6, San Francisco Art Institute Archives, photo by William Heick; fig. 7, table nos. 3, 5, 6, 8, 9, 10, 12, 13, Greg Williams, Department of Imaging and Visual Services, NGA; fig. 18, image courtesy the Aaron Siskind Foundation.

**Sfumato and Sheen: Bernardino
Luini's Lady in Black**

Figs. 1, 3, 4, 11 – 13, Greg Williams, Department of Imaging and Visual Services, NGA; fig. 2, Erich Lessing/Art Resource, New York; figs. 5, 8, 10, Painting Conservation Department, NGA; figs. 6, 7, Scientific Research Department, NGA; fig. 9, Albertina Museum, Vienna.

**Andy Warhol's Early Paint
Mediums**

Fig. 1, image courtesy Acquavella Galleries, © 2015 The Andy Warhol Foundation for the Visual Arts, Inc./Artists Rights Society (ARS), New York; fig. 2, Greg Williams, Department of Imaging and Visual Services, NGA, Courtesy of the Board of Trustees, NGA, Washington, © 2015 The Andy Warhol Foundation for the Visual Arts, Inc./Artists Rights Society (ARS), New York; fig. 3, Axel Schneider, Frankfurt am Main, © 2015 The Andy Warhol Foundation for the Visual Arts, Inc./Artists Rights Society (ARS), New York; fig. 4, Foto: © Rheinisches Bildarchiv Köln, © 2015 The Andy Warhol Foundation for the Visual Arts, Inc./Artists Rights Society (ARS), New York.